The Story of Colour in Textiles

IMPERIAL PURPLE TO DENIM BLUE

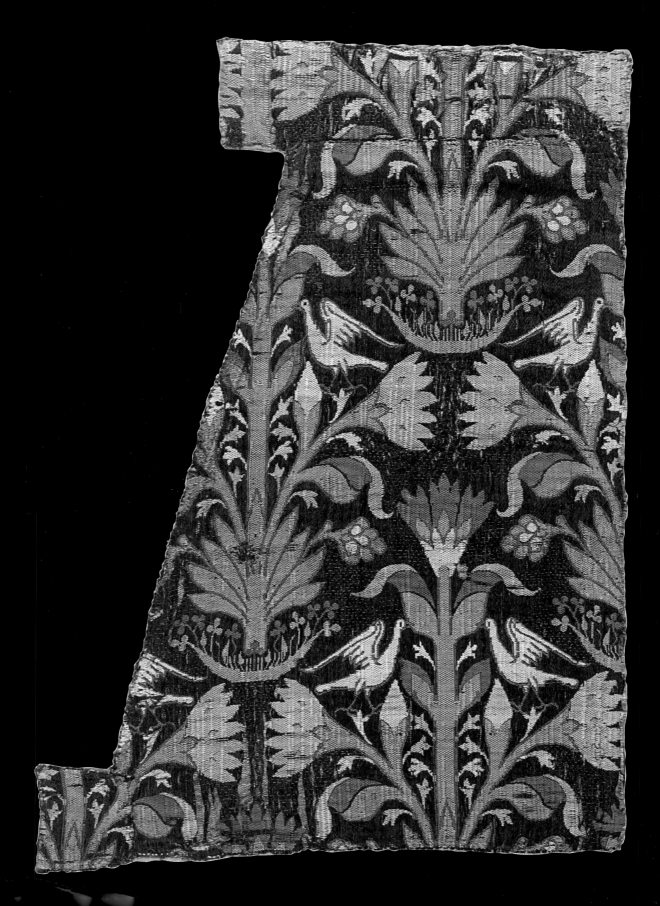

The Story of Colour in Textiles

IMPERIAL PURPLE TO DENIM BLUE

Susan Kay-Williams

B L O O M S B U R Y

LONDON · NEW DELHI · NEW YORK · SYDNEY

For Mum, Dad, Linda, but most of all for Steve,
for your endless belief and support

First published in Great Britain 2013
Bloomsbury Publishing Plc
50 Bedford Square
London WC1B 3DP
www.bloomsbury.com

ISBN: 978-1-4081-3450-4

A CIP catalogue record for this book is available from the
British Library

Publisher: Susan James
Managing editor: Davida Forbes
Copy editor: Julian Beecroft
Cover design: Eleanor Rose
Page design: Susan McIntyre

This book is produced using paper that is made from
wood grown in managed, sustainable forests. It is natural,
renewable and recyclable. The logging and manufacturing
processes conform to the environmental regulations of the
country of origin.

Printed and bound in China

Note: Everything written in this book is to the best of my
knowledge correct and every effort has been made to ensure
accuracy. Any further information that will assist in updating
of any future editions would be gratefully received.

FRONTISPIECE: Woven polychrome silk, probably made in
Granada, Spain between 1490 and 1500. This shows
the variety of greens that some dyers could produce.
From High Performance Liquid Chromatography (HPLC)
analysis of the threads the green is made from indigo
and weld; the red from madder; the blue from indigo
but no recognisable yellow has been identified in the
plain yellow areas. © *Victoria and Albert Museum*
(T167-1929)

Contents

ACKNOWLEDGEMENTS

A broad-based research book like this leads to a long thank-you list of all those who have helped me find obscure references, even obscurer pictures, and especially help with checking the familiar which still seems to have more than one date. In particular I would like to thank the too-many-to-name librarians at the British Library, the Bibliothèque Nationale and Arsenal in Paris, the Royal Society, the National Archives at Kew in Southwest London, the West Yorkshire Archive Service, the London Guildhall Library, the Courtauld Library and the National Art Library, plus all the team behind British History Online and museum staff at The Museum of Pre-Colombian Art, Santiago, Chile, the Archive of the Indies, Seville, Spain and the Museum of the City of Barcelona, Spain.

Individuals who have been very helpful include Ian Mackintosh, the archivist of the Worshipful Company of Dyers, Jonathan Hill of Jonathan A. Hill Rare Books, Philip Pearson at the Courtauld Library, Adam Gilchrist of Veedon Fleece, Ian Smith of Coloursmith, Lynn Downey of Levi Strauss & Co, Maria Hayward regarding Henry VIII, Nuria Picos Rodriguez for help with the Spanish language and Samantha Horsthuis with Dutch, David Steadman of the Coram Foundation, members of the team working on the Hallstatt textiles research, Abhijit Naikdesai of the Society of Dyers and Colourists, India, Dr Mark Evans of the Victoria and Albert Museum, Prof Arnold Nesselrath of the Vatican Museums, not to mention those who staff image rights departments from as far afield as the Art Institute of Chicago, to the Bridgeman Art Library, MAK in Vienna to the National Museum in Tokyo.

And to those who have gone before in opening up the area of historical dyes and dyeing: Dominique Cardon, Jenny Balfour-Paul, Judith Hofenk de Graaff, Robert Chenciner, Luca Mola and Michel Pastoureau who first piqued my interest in the history of colour in textiles, thank you for your work.

I would also like to thank colleagues and students at the Royal School of Needlework for your support and encouragement. And for practical support, the team at Bloomsbury Publishing, especially Davida Forbes.

And finally to my husband, Steve Williams, for his IT knowledge, which has enabled me to save, retrieve, download and rescue information and images on many an occasion, not to mention his multi-tasking as picture and reference researcher, chef and housekeeper, my very heartfelt thanks.

OPPOSITE: Today it is almost possible to have every colour in wool or silk. Shown opposite is the 'wall of wool' at the Royal School of Needlework which contains a vast array of colours, some of which are no longer made, but can come in useful for repair or restoration work brought into the commercial studio. © *Royal School of Needlework, photographer John Chase*

PREFACE

This book is an introduction to a broad, diverse and fascinating subject – how and why people coloured textiles, whether clothing, wall and floor coverings, or pieces such as tapestries that were decorative for their own sake.

In this size of book it is not possible to do more than to skim the surface of the development and history of colour in textiles. In some areas I have had to content myself with vignettes rather than a full exploration, and with a focus predominantly on Europe, only reaching out to India, China and the Americas where they came into contact with Europeans. There is much more that can be said. Some areas can be further explored through published works on specific dyestuffs such as those on madder, cochineal and especially indigo, for example.

The botanical, scientific and historic use of plant and insect dyestuffs in textiles can be pursued through the work of Dominique Cardon and Judith Hofenk de Graaff, and the social history of colour can be explored through the work of Michel Pastoureau. However, there is not currently in print a book which endeavours to give an overview of the whole history of colour in textiles, and certainly not one which straddles the great divide between the thousands of years of use of 'natural' dyestuffs and the synthetic era, introduced in Simon Garfield's *Mauve*. Those who gave the most study to this area, Anthony S Travis, Franco Brunello and Kenneth Ponting, are long since out of print.

This book aims to bring some of the work which has preceded it to light again, along with new discoveries and, hopefully, at least the occasional insight. It is aimed at the undergraduate student in textiles, who is perhaps thinking about aspects of colour history for the first time. It is also aimed at the craft dyer who wants to know more about the tradition in which they are dabbling, and indeed at anyone interested in the history of the decorative arts. While we probably have fewer extant examples of historic textiles than of any other form of art, those that do exist help us to realise that colour in textiles has been important for centuries.

I have also endeavoured to bring together a broad range of images. Inevitably, some are very familiar but would seem odd in omission; but I have also tried to find different images, including some contemporary ones which show that colour, whether added by machine or by hand, remains an important part of textiles today.

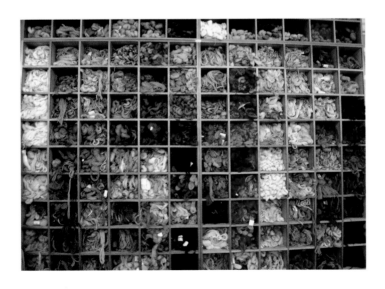

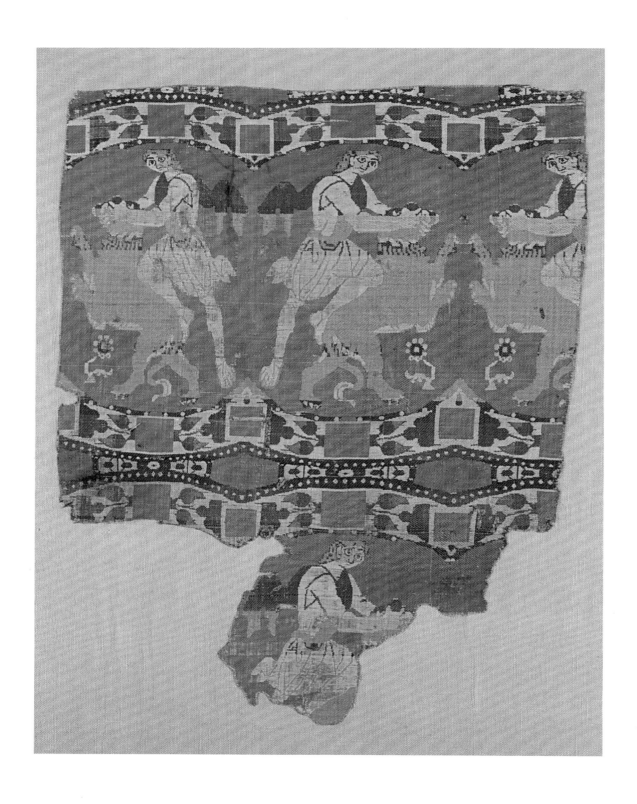

Introduction

This is a book about the history of colour in textiles, predominantly in Europe. However, colour does not exist in isolation; it has to cling to, be part of, something else. In this case the colour carriers are textile fibres, and in that regard it is worth just spending a moment thinking about the key fibres. For most of history there have been four main fibres: wool, silk, linen and cotton. Wool comes primarily from sheep and from camelid animals such as camel, llama and alpaca; fleece can also be taken from goats (mohair, cashmere, pashmina) rabbits (angora wool) and even the arctic musk ox, known as *oomingmak* in Inuit, producing qiviut fibre, an incredibly soft fine wool which is very warm. Wool has been known across the Mediterranean and European areas for centuries. The ancient Egyptians depicted flocks of sheep in tomb pictures and both Sir Flinders Petrie and Sir Marc Aurel Stein found balls of wool in their excavations dating back around 2000 years.

Sheep were almost the first domesticated animal, having been kept from as long ago as 10,000 BC. There is evidence of spinning from 4000 BC, and weaving in Britain and elsewhere in Europe certainly dates back to at least the Bronze Age. There was a

LEFT: Made between 780–900 AD probably in Syria, this figurative piece is silk twill woven in a compound weave. The story it depicts is of man overcoming the animals and was a popular theme of the time. Colours: dark blue, green, yellow, red and white. © *Victoria and Albert Museum (8558-1863)*

wool factory in Winchester, England, from at least 50 AD and the product was much admired by the Romans. Wool was warm; could be worn as felted fleece or woven; the lanolin in it helped to repel rain; and the fibre helped to regulate body temperature as it was breathable.[1] During the Middle Ages it was England's greatest export, accounting for up to three-quarters of national wealth, which is why the Lord Chancellor's seat in Parliament (now the Lord Speaker in the House of Lords) was known as the Woolsack.[2] After extensive breeding of sheep, the merino, originally from Spain, was taken to the New World in the 16th century. In 1797 English settlers took 13 merino sheep to Australia to start what would become the largest wool industry in the world by the 20th century.

Silk comes from the cocoon of the silkworm *Bombyx mori*. Of the four main fibres silk has the greatest number of myths associated with it. Originally developed in China it was kept as a state secret for centuries. How it escaped Chinese borders has led to a number of stories. The obvious route was via what later came to be known as the Silk Road, the 6500km (4000-mile) route that led from the Chinese capital, Xian, to the west following the Great Wall of China. At different times the route was considered unsafe, but it was revived during the Tang dynasty and again during the time of the Mongols, but then in the late 15th century it was superseded by the Portuguese discovery of a sea route between Europe and Asia. This led to the overland routes being abandoned except in small sections. The story of the spread of silk includes

the legend of the prince of Khotan, an ancient Buddhist kingdom on the edge of the Taklamakan Desert and a stop on the Silk Road. It is said that the prince wooed a Chinese princess so successfully that she risked the death sentence by smuggling silkworm eggs in her elaborate headdress, in order to establish sericulture in her new home. Whatever the truth of the story, Khotan did indeed become a centre of silk production by the middle of the 1st century AD. But this princess was not the only female champion of silk, chief among them was the Chinese Goddess of Silk, Lady Hsi-Ling-Shih, wife of the mythical Yellow Emperor. Oral history recorded during the Vedic period in the Mahabharata states that silk was brought to India by the 'Chinas and the Hunas from the mountains (the Himalayas) [who] brought tribute to Yudhistira [of] silk and silkworms.'[3]

In China, the domestication of the silkworm *Bombyx mori* dates to around 5000 BC. Japanese sericulture began around the 3rd century AD, as did the Persian silk industry under the Sassanids. Under their rule weavers in the imperial workshops began producing pictorial silks, which had a wide influence across the known world from Spain to Japan. But China still had a significant monopoly until the middle of the 6th century AD when it first reached the Byzantine Empire, and it was not until the 11th or 12th century that it arrived in western Europe.

Han emperors sent envoys with silk to bribe, befriend, bargain or barter with neighbouring kingdoms during the 2nd century BC. Information about silk, written on silk and linen 'paper' and describing its production and its use in trade, dates back to 100 BC.

In the 4th or 3rd century BC in the tomb of the Lady of Maschan there are colours with which to dye silk, including cinnabar and indigo, but most interesting were the white silk fabrics on which embroidery had been worked. Silk cocoons are often yellow and may be light orange or even light blue, but they are rarely white. As such there had to be a bleaching process, or a white-tinting process. Here it is identified as the latter with the white ground fabric having been achieved by means of concoctions of white lead being painted on or clamshell powder being worked into the fabric to give it its white surface.[4]

It is thought that the first sight the Romans had of silk was at the Battle of Carrhae in 53 BC in which Crassus was defeated by the Parthians. The Roman description of the battle mentions in particular the military banners made of silk which flew over the heads of the enemy causing fear and trembling in the Roman ranks, presumably because a multitude of such banners would have made quite a noise in the wind as well as being a striking sight.

Linen, coming from flax, is a plant-based fabric. For that reason, it has traditionally been considered a clean fibre, unlike wool, which had to be cleansed of its lanolin before it could be used. As such linen was often the fabric of choice for the priests of several religions: Jewish, Ancient Egyptian and Christian. It was described as 'a symbol of firmness, and of clearest splendour, since fine linen is most difficult to tear and is made of nothing mortal and becomes brighter and more resembling light the more it is cleansed by washing'.[5]

Cotton is also from a plant (the genus *Gossypium*), several varieties of which produce the familiar cotton boll from the seed. Cotton was native to India and also the Sudan/Ethiopia area, and was first recorded in the annals of the Assyrian King Sennacherib around 700 BC, which refer to 'wool-bearing trees'. It started being imported into the Levant from around 330 BC and became more important after the Islamic conquest in the mid-7th century AD. Later, of course, it was also to be found in the Americas and today is the most commonly used fibre across the globe.[6]

All the fibres from animals and insects dye comparatively easily, while all the plant-based fibres take colour less easily, which is why, as we shall see, different processes had to be developed to colour cotton and linen as opposed to wool and silk. Interestingly, we shall see that when synthetic colours were developed they too had to be specifically formulated to work with either the animal or the plant fibres, the treatments remained different, and then further new dye formulations were needed to work with the synthetic fibres when these arrived in the 20th century.

For the most part, though, this book will discuss dyes applied to these four natural fibres. During this history, spinners and weavers, as well as dyers, became

An example of colour fade. This piece is at least 100 years old. Above left, the front shows how pale the colours now look, above right, the back, which has been hidden, shows how vivid the colours were when the piece was originally worked. Colour fade is an issue that will recur through our story. *Photographs Susan Kay-Williams*

more skilled. As we will see, colour was applied to a vast array of fabrics that spinners and weavers could make, but fundamentally they comprise one or more of these four core fibres.

Another issue relates to whiteness. As we know it today, whiteness, whether from raw fleece or bleached end-goods, is much whiter than was known in former times. Sheep, especially the merino variety, have been assiduously bred over many centuries to have whiter wool. In former times, the natural colour of wool was a mixture of blacks, browns, greys and grey whites,[7] likewise, as noted above, silk cocoons are not white. So, as we shall see, achieving white in wool and silk was a long and laborious process. Recognisable white was easier to achieve in linen and cotton, which is why we see so many examples of the white linen collar or shirt depicted in art.

The opposite of whiteness, in terms of dyeing, is colour fastness and longevity of the fabric. This was undoubtedly one of the 'holy grails' of dyeing; dyers wanted the cloth to keep its colour despite exposure to sunlight, washing (or rain), perspiration, rubbing (as in wear and tear), and anything else that might impact the colour. Furthermore, the colour had to be added in a way that did not weaken or damage the fabric or thread. These are two issues that will recur throughout our story, as new developments inevitably began with a period of learning. A new colour might be achieved but maybe it did not last as long as an established colour, or the fabric disintegrated quicker, or even, on occasion, the new colours might cause what would now be described as an allergic reaction in the wearer.

The process of producing a finished textile was complex (even before it was made into clothing or home decorations) and required a large number of processes through which the dyed yarn would have to progress before it reached the dressmaker, tailor, tapestry weaver or curtain maker. For wool, in pre-industrial times the various stages of production were shearing the sheep, carding the wool, spinning the thread, dyeing the yarn, weaving the cloth, fulling it, tentering (stretching it by drying it under tension), raising the nap using teasels,[8] shearing off the nap and then planing or flattening the fabric.[9] Although wool was mostly dyed as yarn, there were actually three points at which the wool might be dyed: as fleece, known as dyed in the fleece; once spun into a yarn, known as dyed in the wool; or once woven into cloth, known as dyed in the piece.

We shall meet various historical dyestuffs in the course of this book, but I am not going to give a full history of each one, as the subject is already more than adequately covered by the work of Dominique Cardon and Judith Hofenk de Graaff. Instead I will focus on the principal dyestuffs, which are the leading dramatis personae of this story.

There is one further element absolutely critical to the beauty and longevity of the dye colour on fibre: the mordants. Mordants were the fixatives; they performed an essential role in not merely helping the colour to 'stick' to the fibre, but also in enhancing its depth. These substances could also help to produce a different colour on occasions by acting as colour modifiers, not just fixatives. Indeed, it was the discovery of mordants that really brought the craft and art of dyeing alive. Historically, there have been five major mordants or modifiers, with a sixth being added more recently. The core five are: alum, iron, copper, tin and tannins. The sixth, which was first used around the 19th century and played a major role with synthetic dyes, is chrome. We shall meet these elements as their role in our story unfolds, though, as with the dyes themselves, we can rarely point to a definite date when they were first used except to say that analytical evidence shows that all of them have been used since prehistory.

The final challenge before we begin is lack of evidence. Textiles are, without doubt, the least durable of historical objects – it is probably true that there are, say, more parchments from 16th-century England surviving today than there are historic textiles from the same period. When cloth was expensive, such as in Tudor times, it was remodelled, passed on, even handed down through wills until it fell to pieces through use. Few have been the communities like the Ottoman Empire where on the death of the ruler his clothes were laid up and preserved, giving us the wonderful selection that can be seen today at the Topkapi Palace museum, Istanbul. Elsewhere it is only a matter of chance that in rare cases we have a full costume to study; by and large we are left only with fragments. These cause our view on dyes and colours to be false for two reasons. Firstly, the preserved pieces have often been affected by the environment in which the fragments have been kept, for example in earth, in a tomb, or in a salt mine. Contemporary analysis can only tell us which dyestuffs and colour modifiers have affected the textile, but not the original colour or its saturation.

Secondly, as noted above, colours were apt to fade and so, even with a high-quality textile such as the Abraham tapestries at Hampton Court Palace, the fact that they have been hung on display for nearly 500 years means that the colours have significantly paled. The 2009 experiment to 're-colour' the tapestries with light, based on scientific analysis of the back of the tapestry, showed just how much brighter the tapestries must have looked to Henry VIII than they do to us.[10] Indeed, sometimes the 'fade' is so significant that what is left is 'blue disease'[11] or, worse, the extant colour has changed completely from that which is indicated on the back. So it is clear that colour truth in historic textiles is far from easy to establish.

Instead what we are left with are the colours of fabrics in paintings. Oil paintings certainly may have faded a lot less than the textiles they represent, but – and it is a big but – paint pigments were rarely the same as dye colours. In that regard, perhaps the single most significant colour is green as represented in paintings, as opposed to dyeing. Wonderful greens could be produced in paintings from malachite, the second most precious pigment after lapis lazuli (see Mr and Mrs Arnolfini in chapter four); however, green dye, the colour of nature in the form of chlorophyll, cannot be made either with chlorophyll or with a single dyestuff, but had to be made from overdyeing blue and yellow. Therefore, it is hard to look at a green dress in a medieval painting today and make any assumption about the actual colour of green that might have been worn. Green is the most extreme example, perhaps, but it is also true of lapis lazuli (ultramarine) blue, which is a quite different colour from an indigo blue.

Finally, of course, not many of us see colours by candlelight today, so it is hard to realise the awe and majesty of royal and, more accessibly, ecclesiastical textiles that would have been witnessed by the common people through candle- and half-light – but thinking about it makes it easier to understand the lure of metal thread embroidery, which would

have caught whatever light was available and would certainly have added a sense of spectacle and splendour to any fabric.

As for the dyers' story, so secret were their workings that few kept notebooks or sample books, or at least there are very few from before the 18th century that are still around today. Then, the pristine nature of some of the early dye books shows that actually they were produced more for the benefit of collectors than for use by practitioners. So our story has to be pieced together with help from those who have gone before to research this fascinating story. To help, the book is illustrated in colour with some hundred images which collectively try to give a sense of colour in textiles and how that has changed over the centuries, even if some of the images perhaps show more of the art of the ink and pigment maker than of the dyer.

The photographer of this picture of a cotton fabric store works for the Society of Dyers and Colorists in India. He entitled it 'Rainbow on my shelf' which fully sums up the ability of dyers today to achieve almost any colour they want, especially on the four classic fabrics: silk, cotton, linen and wool. © *Abhijit Naikdesai | SDC India*

NOTES

1. See www.sheepcentre.co.uk
2. The Woolsack is a large cushion stuffed with raw fleece. A Ceremonial Woolsack resides at the Royal Hospital Chelsea, made and embroidered by the Royal School of Needlework.
3. Hardiman, J. P., *Silk in Burma* (Rangoon: Government Printing, 1901), p.1.
4. Schoeser, Mary, *Silk* (London: Yale University Press, 2007), pp.18–19.
5. Symonds, Mary and Preece, Louisa, *Needlework as Art* (London: Hodder & Stoughton, 1928), p.24, quoted from James Yates *Texternium Antiquorum* (London, 1843).
6. 'Natural Fibres', *International Year of Natural Fibres 2009*, www.naturalfibres2009.org/en/fibres, retrieved 01 January 2012.
7. Ryder M, 'Medieval Sheep and Wool Types' *The Agricultural History Review*, 32, Part 1 (1984), pp.14–28. Indeed, Ryder contends that the first domesticated sheep in Britain were brown and of the Soay type (where the coat was combed or plucked as it was shed, rather than shorn), and that this type dates back to the Bronze Age, with black, white and grey sheep arriving in the Iron Age, and long-wool varieties in white being first seen only in Roman times.
8. In Medieval times, the nap was originally the rough layer of protruding threads on a cloth which were cut away by the shearmen to leave a smooth surface on the fabric. Later, as weaving skills improved, the word meant lifting the short fibres at the top of the cloth. This was done with the aid of a teasel, a plant that when dried has barbs on the flower that helped to lift the threads. These were then cut by the shearmen to leave a smooth and soft surface to the fabric. (From *The Shorter Oxford English Dictionary*, [Oxford: Oxford University Press, 1983]).
9. 'The Craft of Clothworking', Clothworkers' Company, www.clothworkers.co.uk, retrieved 01 January 2012.
10. Joint project of the Collection Conservation Centre of Historic Royal Palaces and Manchester University 2007–2009.
11. As we will see, green colours cannot be made from one single dye bath, they have to be made from a combination of blue and yellow dyeing. However, yellow colours are much more fugitive than blue ones so after a period of time, the yellow may fade away, leaving only the blue colour. This is known as 'blue disease'. It is particularly prevalent on tapestries, which are some of the oldest textiles we have in quantity. It often appears that the vegetation is blue, when it may well have started as green.

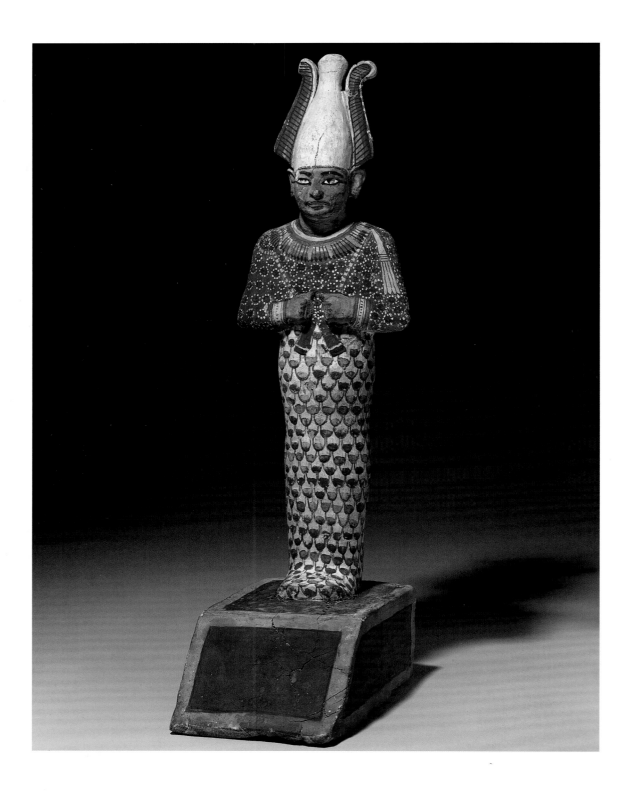

1

Fragments and Glimpses: dyes from prehistory

It is impossible to know exactly when humans first discovered that certain plants and minerals would elicit a colour that could then be applied to fibres. Indeed, it is interesting to ponder which came first: discovering that certain plants, molluscs and insects would colour fibre, or the desire to create and use colour in clothing and art. The date when we believe the dyeing of cloth began is being continually pushed back, as archaeologists discover ever older fragments in locations and environments that have helped to preserve them, including deserts, salt caves, ice in arctic tundra and arid man-made tombs. It is also likely that dyeing began in different parts of the world at different times: in China it may go as far back as 6000 BC;[1] in Mesopotamia there is evidence of organic dyes, such as those obtained from pomegranate and sumac, being used on wool during the third millennium BC.[2] In the Mohenjo-daro settlement in the Indus Valley there is evidence of both blue and red dyes that date back to the beginning of the town around 2600 BC.[3] By comparison, European dyeing began relatively recently, with the oldest discovered fragments of dyed cloth now thought to date back to 1400 BC.[4]

The earliest written references to coloured textiles include a cuneiform tablet containing a recipe for madder dyeing, dated to 1900 BC (+/- 180 years) by Dr Stephanie Dalley;[5] by 1800 BC it was recorded that the Babylonians, Assyrians and Chaldeans were wearing coloured clothes and the word for colour in Akkadian Old Babylonian, *bir-mu*, also meant coloured textiles.[6]

Undoubtedly, there is much conjecture about the context of the earliest textiles, particularly those for which we have no other information. For example, was a cloth discovered as a funerary wrapping only ever used in that context? Later we are helped by items which have more longevity: images in paintings and sculptures, words on tablets or parchments. These are vitally informative corroborative sources of information about the history of colour in cloth. For example, in an Egyptian *Book of the Dead* dating from the 18th Dynasty (from 1450 BC) Osiris is referred to as 'the lord of the red cloth', and depicted accordingly.[7] However, not every witness in a different format is truthful – paintings, for example, have often enhanced the sitter, and the same might be true of their costume. Similarly, colour in clothing has also had cultural meaning, as Anne Varichon notes.[8]

LEFT: Painted wooden figure of Osiris, the Egyptian god of the afterlife, the underworld and the dead, dating from the 21st Dynasty (1077–943 BC). His presence in the tomb was to help ensure resurrection and new life. He is traditionally depicted as a mummiform figure and hence the title of 'lord of the red cloth' as the Egyptians often coloured funeral cloths in earth reds before wrapping the body. *Osiris (BM 20868 Reg 1888,0512.124); © British Museum, used with permission of the Trustees of the British Museum*

Added to the list of things we don't know is how ancient humans discovered which plants gave colours, which gave edible produce or had medicinal properties and which were poisonous. (Of course, with a plant like rhubarb [*Rheum*], it is more a case of how they discovered which part was medicinal, which was edible, which gave a colour, and which was poisonous but had fixative properties, without this having too detrimental an effect on the testers.) In the modern world, it is the 18th century that is known as the Age of Enlightenment due to developments in scientific learning, but I would contend that the greatest age of curiosity and empirical learning was this period of early history. This is due in no small part to the separation of peoples, which meant that societies in different places were each discovering for themselves the same basic information, with evidence existing that different cultures, for example in the places mentioned above, each discovered their own forms of blue, red and yellow dye.[9]

What we do know from the fragments we have found is that from very early on humans used colour to decorate and embellish skins and, later, felted and woven textiles. Initially, paintings and textiles were coloured with earth ores – ochres of red and yellow, pigments ground from minerals and iron oxides, as seen in the wall paintings at Lascaux, France.[10] Later, our forefathers discovered that they could generate a dye from a plant. Later again they recognised the need for, and identification of, some kind of fixative, later known as a mordant, to enable the colour to adhere more tightly to the fibre to produce a stronger and longer-lasting colour[11] – to the point where, by experience or serendipity, they discovered the mordants that would be central to the dyeing industry until the coming of chemical dyes in the 19th century.[12]

One further aspect of dyeing also seems to have been present from the earliest times – the issue of how to deal with the smells and the nasty and often harmful substances that were needed to generate beautiful colours. Ingredients in colour-making could include urine, arsenic and mercury sulphide, and the work was aromatically unpleasant, an aspect that was recorded as early as the 13th century BC. In the *Papyrus Anastasi* the writer is endeavouring to

persuade students into an administrative career instead of textiles:

The lot of the dyer at home is worse than any woman's. He works on his knees in the heart of things. Never does he breathe the pure air. When he does not produce enough in a day, he is beaten like a lotus in the pond. He must give bread to the guardians just to see the light of day. The dyer's finger smells like rotten fish. His two eyes are wrecked by fatigue.[13]

Indeed, later in Egypt, the one mitigating factor whereby a Jewish woman could divorce her dyer husband was if the stench of his work was too overwhelming;[14] divorce not being granted for anything else, the smells must have been considerable.

Based on discovered fragments, the two oldest recognisable dyestuffs, excluding the earth ores, are probably madder and indigo.[15] These two plant-based substances, giving red and blue respectively, have long histories as verified by recent chemical analysis. They will reappear throughout our story but they were first used in prehistory. In Europe and the Middle East the oldest dye is probably madder (*Rubia tinctorum*), which gives a red colour.[16]

In their 20th-century study of colour words in different cultures Berlin and Kay posited that there were eleven core terms for colours used in every civilisation.[17] First among them is undoubtedly the word for red. In fact, in some cultures – Ancient Egyptian, Arabic Coptic and Chinese, for example – the words for red and colour are synonymous;[18] this is one of the factors which leads us to conclude that red is the oldest-identified, or at least oldest-named, colour. For example, in Neolithic times, three initial colours were used for painting: white from chalk, black from carbonised (burnt) wood and red from iron oxide (ground hematite). In textiles 'white' and 'black' could be found from the natural materials (white linen and wool, and black wool) but red always had to be manufactured so a dyestuff was sought to achieve this third colour, which remained important in Europe right through to the late Middle Ages.[19]

MADDER: THE PRINCIPAL SOURCE OF 'TRUE RED'

In his comprehensive book on the history of madder, Robert Chenciner notes that specific words for madder are found in Ancient Oriental, Bible-period, Classical and Old European languages and that the English word 'madder' comes from *mædere*, which in turn came from Old German and Old Norse. He cites Gustav Schaefer on the number of languages where 'madder' is synonymous with, or from the same stem as, the word for 'red'. For example, the Greek word for madder was *erythrodanon* and the word for red *erythros*.[20] Dominique Cardon notes that 'the vast botanical family of Rubiaceae takes its name from sources of red, from the Latin *ruber* (red) and *rubia* (madder)'.[21] This linguistic background reinforces madder's long history, its familiarity for many cultures – Rubiaceae plants are found in many parts of the world – and, in turn, its importance.

The earliest examples of madder-dyed fragments, from approximately 2600 BC, date to the Mohenjo-daro site in the Indus Valley.[22] Then, from around 1900 BC, there is a recipe written on an Akkadian cuneiform tablet,[23] and another appears on papyrus from the Egyptian 20th dynasty (1189–1069 BC).[24] Herodotus describes witnessing the practice of madder dyeing in Egypt in 450 BC,[25] while Dioscorides was given madder-dyeing instructions in 350 BC. In fact, so common did dyeing with madder become that it was known simply as 'the root' in Greek writings.[26] Then, a little later, that Roman chronicler of the natural world, Pliny, also describes the plant and its uses.[27]

Madder (*Rubia tinctorum*) is a shrubby plant that is no great garden beauty. However, from their 'what use might this be?' approach to the natural world, our ancestors discovered that, despite its uninteresting appearance, its root contained a significant dyestuff that would give a range of colours including bright reds, strong orange/red, salmon pinks and, with different mordants, browns; later, in combination with indigo/woad, it gave the best imitation of shellfish, purples and strong blacks. The colour obtained might depend on the soil in which it was grown, but the

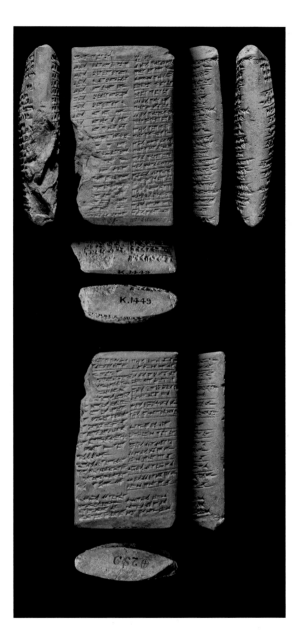

Cuneiform tablet from the Library of Ashurbanipal. Dating from the 7th century BC this Assyrian tablet contains accounts, including 109 talents of madder, for dyeing and 53 talents of red dye as well as linen and red wool. (One talent was about 30kg.) *Cuneiform tablet (K1449) © British Museum, used with permission of the Trustees of the British Museum*

Madder for dyeing may be used in chopped or powdered form. A native of many areas, in Europe it was found around the Mediterranean before it was commercially developed in the Netherlands and later France. Today madder for craft dyers comes from Turkey and Iran.
Photograph © Susan Kay-Williams

conditions for drying and storing were also important – it is after all a natural product – as one batch of madder was not necessarily going to give exactly the same colour as the next. Colours could be changed further according to the choice and concentration of mordants and colour modifiers. These factors were learned empirically through trial and error long before science analysed the differences. So, in addition to being 'true red', it was this variety of colour which gave madder its superior position as a dyestuff.[28]

What is more, because it could be cultivated, rather than having to be collected like the scale of insect kermes (see p.25), it was cheaper and more reliable than other sources. It also had a great affinity for wool, making this a natural marriage of colour and fibre until the rise of Turkey red in the 18th century gave it a new lease of life on cotton.

There were also varieties of wild madder (*Rubia peregrina*) which, while they did not give as good a colour as *Rubia tinctorum*, were widely used (as we can see from analysed fibre fragments),[29] especially in areas where *Rubia tinctorum* did not grow.[30]

Rubia tinctorum gave the best colour, having more colour per weight of roots than the wild forms, and so became the cultivated form of the plant. Indigenous across Mediterranean Europe, it was a great propagator and was later grown in more northern parts of the continent. In 1805 the English colourist George Field described in his colour diary how he grew madder in London. This may have been how the early cultivators of the plant developed it too.

I planted the madder plants in June in a small flower pot in black mould, having first taken off the roots they throve very well. Early in July I transplanted them into a bed ... at which time they had filled the pot with innumerable small fibrous roots. In August (9th) having increased in length to 10 or 12 inches and shot out laterally I layed one of the longest of the shoots which got nearly broken and another which I cut, in the manner carnations are layed for sets, pegging them down with a small hooked stick. A few days afterwards I layered several other shoots all of which have taken root and thrived exceedingly ... by which means I have multiplied my plant to 21 offshoots. The latter layers I layed without cutting and they throve equally well.[31]

As the dyestuff was all in the roots, their multiplication was important. Only when the Dutch started to cultivate the plant commercially did they breed a variety with a single main root, instead of this multiple-root version.[32]

Madder did not grow in Egypt but was imported from Palestine and has been found on analysed grave clothes from the 18th dynasty, although in a weak form – it is possible that the Egyptians had not learned how to mordant colours on cotton and linen, which were more difficult to dye than wool and silk.[33]

Madder, supported by the mordant alum (see p.27), penetrated deep into the fibre and had good colour fastness against sunlight, wear or washing. Most dyestuffs had to be worked at boiling point, but to obtain the best colour from madder it should not be at a temperature above 70°C (158°F) at any point in the process – from drying the harvested roots to dyeing the wool or cloth. Again, this must have been discovered in pre-historic times, as early-dated madder-dyed textile fragments have been found in many places.

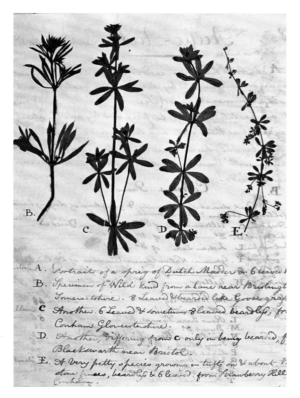

A. *Portrait of a sprig of Dutch Madder or 6 leaved*

B. *Specimen of Wild kind from a Lane near Bristol in Somersetshire. 8 Leaved & bearded like Goose graß*

C. *Another. 6 Leaved & sometimes 8 leaved beardlß, from Conham Gloucestershire.*

D. *Another, Differing from C only in being bearded, from Blackswarth near Bristol.*

E. *A very pretty species growing in tufts on & about stone fences, beardlß & 6 leaved. from Strawberry Hill Conham.*

George Field of London was a noted colourist in the early 19th century. He conducted many experiments on colour, mostly in relation to painting, which he documented in a series of notebooks. However, in the first two notebooks, he considered madder, even to the point of cultivating it and using the colour as a paint. Here he depicts several varieties of wild madder. *Illustration by George Field © Winsor & Newton, Photography Courtauld Institute Library*

Outside Europe two other madder-like plants were also important. In India munjeet (*Rubia cordifolia*) was another of the Rubiaceae family which gave strong reds. Known from at least 500 BC, munjeet was used extensively in north-eastern India, Sikkim, Bhutan, Nepal and Tibet for a range of reds and pinks.[34] And in South America, Relbunium was the local madder-like plant, used by early Paracas people from around 1000 BC; however, its colourant is purpurin and pseudo-purpurin rather than madder's alizarin.[35]

INDIGO: THE KING OF BLUES

The second or, in some parts of the world, most ancient dyestuff is indigo. Indigo (*Indigofera tinctoria*) or common indigo came from India, hence the name by which it has been known in Europe and the Mediterranean, although its name in Hindi is *nil*, which became *anil* in Arabic, Persian and later Portuguese.[36] Like madder there is a range of plants, from different genuses, that give an indigo colour in different parts of the world: woad (*Isatis tinctoria* L.) which will be discussed in chapter three, Chinese woad (*Isatis indigotica*) and Dyer's knotweed (*Polygonum tinctorium Aiton*) from Japan and China, Yoruba Indigo (*Philenoptera cyanescens*) from Africa, and Platanillo (*Indigofera suffruticosa* Miller) from Central America.[37] Researchers have found that people in many different cultural and geographical communities discovered their own ways to elicit colour from *Indigofera* and related plants.[38]

Achieving indigo as a dye was an amazing feat of experimentation because, if it was complicated to work out how to get dye from the madder root, this was nothing in comparison to the processes required to extract colour from indigo plants and then dye wool, silk, cotton or linen. As Neuberger puts it, '*The development of dyeing was not from the simple to the complicated, but rather the reverse.*'[39] As a result, there are many stories and cultural beliefs about indigo, especially in Southeast Asia and Africa, such as whether the dye vat should be worked only by men, only by women, only young women or only postmenopausal women.[40] Only now in the 21st century are some of the elements of this complex process being understood by researchers.

For a start, indigo is not initially soluble so it had to be worked to obtain a soluble form. First the colourant had to be extracted from the leaves, using water or urine and fermentation, then when '*the liquid takes on a pronounced greenish yellow colour and becomes pleasantly sweet,*'[41] alkali was added and it had to be beaten for two to three hours to introduce as much oxygen as possible. After the aerating stage the precipitate that had formed was left to sink to the

Today indigo is still made into blocks at the end of the first stage of its processing, but the quantities used by the craft dyer mean that it is distributed in powdered form rather than in blocks. However, the powder is still treated in the same way, and needs to be made into 'indigo white' by mixing it in an alkaline solution and adding a reducing agent to remove the oxygen from the dye bath. *Photograph © Susan Kay-Williams*

bottom of the tank as a sludgy residue. This residue was then decanted into vats where it was washed and heated to reduce impurities and stop fermentation. It was filtered and put onto cloths where it drained and solidified until it could be put into moulds or simply cut into blocks. All this was done simply to achieve the dyestuff.[42]

Part two was the making of the vat to achieve the soluble indigo. Dyeing with indigo is referred to as vat-dyeing because the best temperature to work it was only about 50°C (122°F). As such, the dye bath could be made in a wooden vat, rather than a metal cauldron. The vats were often buried in the earth to halfway to help them maintain an even temperature, a method that is still followed in Japan to this day.[43] To make the indigo dye soluble it has to be reduced in an alkaline medium (by adding lime or wood-ash lye or, today, sodium carbonate) to produce leuco-indigo, 'indigo white' (from the Greek *leukos* for white, although actually it is a yellowish-green colour on the surface of the dye bath). Unlike most other colours, indigo blue did not need a mordant to enable adherence to the fibre and, in addition, two other things are different for indigo.[44]

The most noticeable factor is what happens when the wool or fabric is at the point of being removed from the dye bath. It is not blue, but a petrol greenish-yellow colour. It is only when the air, specifically the oxygen in the air, hits the dyed fibre that it begins to turn blue. It is possible to see the blue colour appear to 'travel' down the fibre, giving what must be one of the most magical moments in dyeing.[45] However, it also means that it is not until about 15 minutes in the air that the dyer can check exactly what colour blue has been achieved – too dark and it cannot be lightened, though if not dark enough it can be put back into the dye bath. No other dyestuff except mollusc purple required this 'waiting period': with all other dyestuffs, the colour visible when lifted from the dye bath was final. Secondly, unlike other colours, the indigo does not penetrate through the entire fibre but rather adheres to the outside, leaving the inner parts of fibre, yarn or fabric still the original colour. This characteristic would later give denim jeans part of their quintessential appeal, the way the colour rubs off the fabric, and it would be one reason why natural indigo is still in use today.[46] As with madder, there is evidence from the Mohenjo-daro area that it was already being used, even with these complex processes, around 2600 BC.[47]

With any dyestuff, the colours achieved are strongest from the first use, or bath. Dyestuffs, like madder and indigo can be used for further dye baths, each of which will give a lighter colour. These are known as exhaust baths as the fibres absorb the remaining active dyestuff from the dyebath. The dyestuff may give only one further shade for a light colour, or several for stronger colours like blue and red.[48] However, colours from exhaust baths were often more fugitive than those from the first bath. Indigo on its own could give shades ranging from the darkest of night-sky blues in the first bath to chalky but still 'inky' blues from the last exhaust bath. Overdyeing with madder gave, using different proportions, both purples and black, but its main role in combined colours was with yellows to achieve green. Combination colours have a major role to play in the later history of colour; and the story of indigo,

which has been thoroughly documented by Jenny Balfour-Paul, will make repeated appearances in this work, indigo being one of the core colours of dyeing.

PURPLE: THE MOST BEAUTIFUL COLOUR

While madder and indigo will underpin the whole of dyeing history, there is one dye source that was at its most significant in the ancient world through to the end of the Roman period: mollusc purple. Now believed to have been discovered by the Cretans around 1600 BC,[49] slightly earlier than the Phoenicians, it was the latter who made it their signature industry at Tyre and Sidon, hence the name Tyrian purple. It was the first colour to be explicitly associated with power and wealth on account of the cost of production and the desirability of the finished product.

With a colour and trade of this importance, it is not surprising that there are several myths as to how it was discovered. According to the Greeks, it was the god Hercules who was walking his dog along the seashore when he encountered the nymph Tyros. While he stopped to talk his dog wandered off and frolicked in the seashore puddles. On his return, the dog had a special red (purple) mouth from eating the molluscs. Tyros, on seeing the colour, told Hercules that she was his if he could produce a dress in that same colour. The story goes that he wasted no time in collecting the molluscs and brewing the dye. To the Phoenicians, the dog belonged to Melkart, the Phoenician god of dyers.[50] Above all, this story illustrates an early example of the connections between colour, beauty and sex.

However, Brunello states that it was not possible for any dog to have achieved a purple mouth or nose[51] because, as John Edmonds demonstrated, the process of purple dyeing needed more stages, and more time to convert the gland of the mollusc into a dyestuff. After extensive research, Edmonds concluded that the process had to be that which we know today as the process for indigo, as he concludes 'it is inconceivable that a totally different method of dyeing could have existed for dibromo-indigo (the active ingredient of mollusc glands) but was unknown or inappropriate for indigo dyeing.' [52]

The molluscs in question included Murex brandaris, Murex purpura hyacinthina, Murex purpura blatta and Murex haemastoma. Contained within each of these is a gland which when squeezed or crushed gives a drop of juice. On exposure to sunlight the gland juice turns a number of shades but eventually stabilises as purple. However, once the gland juice turned purple, it could no longer be used for dyeing. Dyers had to work out how to use the mollusc gland juice where the colour change was the end of the process.

In the first decade of the 20th century German chemist Paul Friedländer demonstrated that it took the gland juice of 12,000 Murex brandaris to produce 1.4g of pure dye.[53] So it is not surprising that at least a whole mile of coastline around Tyre and Sidon in modern-day Lebanon comprises compacted mollusc shells from discarded carcasses.

The molluscs gave different shades of purple, some bluish and some reddish. On the blue side were Murex purpura hyacinthina and Murex brandaris, and on the red side were Murex purpura blatta and Murex haemastoma. To further complicate matters, modern researchers have proved that, just like vegetable dyes, it is possible to achieve different colours from the same mollusc just by the dyeing treatment it is given. For example, Murex trunculus, known as the banded murex from the darker coloured stripes on its shell, can give a deep red, blue-violet and dark-blue colour depending on the technique used.[54]

The Bible refers to both a blue purple and a red purple. In Hebrew both purples had their own word: blue purple was tekhelet and red purple argaman. Tekhelet was particularly important as it was used not just for the clothing of kings but for the tassels on the cloth which held the scriptures in the synagogue.[55]

Mollusc purple became one of the earliest significant industries. Purple was always a luxury colour and it is first documented in royal use in the tomb of Rameses III (20th dynasty, c.1200 BC) with paintings of richly coloured purple sails on decorated boats.[56] Around 950 BC King Solomon brought artisans from Tyre to decorate the Temple of Jerusalem with precious fabrics dyed purple.[57] According to G.A. Faber a robe of office of Tyrian

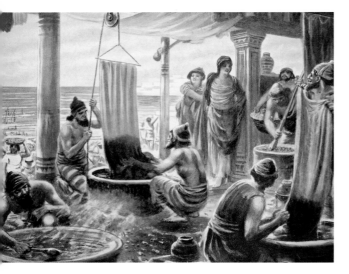

Manufacturing Tyrian purple taken from Hutchinson's *History of the Nations 1910–1915* by Dudley Ambrose. Needless to say, little of this picture can be taken to be authentic, except perhaps the proximity to the sea shore, as the molluscs needed to be processed quickly on harvesting. And of course, the one thing of which there is no evidence is the undoubted smell that would have accompanied the process. © *Private Collection, The Stapleton Collection, Bridgeman Art Library*

purple was first worn in Rome in 63 BC by the aedile (legal official) Lentulus.[58]

In many references to mollusc purple two adjectives are used repeatedly – beauty and lustre – revealing why the colour was so revered. Both Plato and Aristotle specifically talk about purple as the most beautiful colour,[59] and it was already being celebrated in poetry by Alcman in the 7th century BC[60] and by Sappho who wrote about purple straps on her sandals, and of the god Eros wearing a purple cloak on his way down from heaven, in the early 6th century BC.[61]

Pliny the Elder was not himself a lover of purple cloth, stating that '*moral corruption and luxury spring from no other source in greater abundance than from the genus shell-fish*'.[62] (Notwithstanding this opinion, when writing about the founding of Rome in 753 BC he 'dresses' Romulus and Remus in purple cloth.) He comments that purple cloth is almost as expensive as

pearls but that cloth is far less durable, and gives a description of how the colour is extracted:

The murex ... has the famous flower of purple, sought after for dyeing robes, in the middle of its throat: here there is a white vein of very scanty fluid from which that precious dye, suffused with a dark rose colour, is drained, but the rest of the body produces nothing. People strive to catch this fish alive, because it discharges this juice with its life; and from the larger purples they get the juice by stripping off the shell, but they crush the smaller ones alive with the shell, as that is the only way to make them disgorge the juice.[63]

However, Edmonds notes that 'Pliny's explanation is half right but incomplete and totally inadequate.'[64] Edmonds goes on to describe his experiments using purple pigment from murex molluscs and creating a fermentation medium from cockles (from the murex family), making the whole alkali to PH9 and keeping it at 50°C for ten days while keeping the lid on to exclude light. After this time unspun dampened wool was placed in the pot for several hours. On removing it and exposing it to the air, the material turned a reddish purple.[65]

Because of the limited availability of the natural resource, the Phoenicians were able to keep their methods secret for centuries, which also contributed to the premium price. By the first century AD Pliny commented that double-dyed Tyrian purple 'was impossible to buy for 1000 denarii per pound'[66]

Pliny cited the best sources of the molluscs as being in Asia Minor at Tyre, in Africa at Meninx and on the Gaetulian coast of the Atlantic Ocean, and in Europe at Sparta. But for all his dismissing the cult of purple, even he could not help noticing its glamour.

The official rods and axes of Rome clear it a path, and it also marks the honourable estate of boyhood; it distinguishes the senate from the knighthood, it is called in to secure the favour of the gods; and it adds radiance to every garment, while in a triumphal robe it is blended with gold. Consequently even the mad lust for the purple may be excused.[67]

Roman purple dyers had their own name, *purpurarii*,

and worked apart from the ordinary dyers in their own shops, known as *tabernae purpurariae*. Purple shades would be colours created from both blue purple and red purple, producing a range of shades: *purpura hyacinta*, *purpura amethystine* and *purpura ianthina*. One of the Roman centres of purple dyeing was Taranto, its purple cloth being known simply as *tarantina*. Used mollusc shells were so plentiful that they were formed into coastal hills and the city became so wealthy that they engraved a mollusc design on their coinage.[68]

How does a colour gain a cult following? Throughout history the answers are probably the same: it is rare, expensive, worn by the rich and famous, and not available to the ordinary person (though less so today). Purple was a striking colour – even its detractors had to recognise its intensity and fastness, qualities achieved without the use of a mordant. But it also had lustre, with different commentators writing of its response to sunlight and others describing it almost as though it was a shot fabric (one which had a warp of one colour and a weft of another, giving an almost metallic look). The poet Menander in the 4th century BC described a textile made of interwoven purple and white threads which shimmered according to the fall of light, and Philostratus wrote that 'though it seems to be dark, it gains a peculiar beauty from the sun, and is infused with the brilliancy of the sun's warmth'.[69]

The proof of the colour's durability actually came much earlier. In 331 BC Alexander the Great took the city of Susa (or Shushan) from the Persians. Plutarch records that one of the trophies was 5000 talents (25kg/55lb) of purple cloth found in Susa's treasury. The recording of this war prize reveals its importance and the writer comments specifically on the quality of the fabric and of the dyed colour. However, the telling detail is the revelation that this same cloth had actually come from the Greek city of Hermione, a city known for its purple dyeing, which had been captured by the Persians nearly 200 years earlier.[70]

It was written that purple cloth was particularly valued by Alexander. When his father Philip II died the following year, the dead king's body was

Chemical analysis of this purple and gold woven roundel (orbiculus) with geometric pattern featuring circular flowers and quatrefoils has identified that the dye was Tyrian purple and the gold is metal thread. Egyptian, from the 2–4th century AD. *Purple roundel T10069 © MAK Austrian Museum of Applied Arts/ Contemporary Art, Vienna*

wrapped in a wool tabby cloth of Tyrian purple with a wide edging of gold metal threads featuring mythological creatures, fragments of which have been found in his tomb.[71] Ironically, in the same campaign Alexander destroyed the city of Tyre and with it the purple industry he so admired. However, Alexander would only live a further nine years while Tyre's dyeing industry was fully re-established long before Pliny's day.

Not surprisingly for a colour of such power and status, purple has made appearances in some of the world's great literature. Alciphron, a Greek writer of antiquity, wrote a story about the loss of a slipper of Egyptian linen dyed with purple from Hermione, while Virgil in the *Aeneid* described Aeneas as wearing a

'cloak
Aglow with Tyrian dye upon his shoulders –
Gifts of the wealthy queen, who had inwoven
Gold into the fabric'[72]

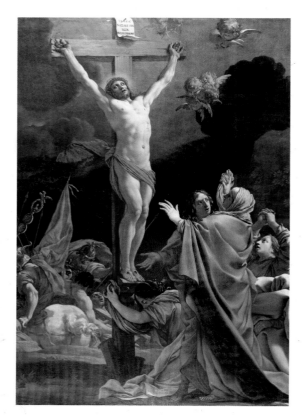

Christ on the Cross painted by Michel Dorigny (1617–63) is one of the few depictions that show Christ as described in the Gospels of Mark and John wearing a purple cloth as part of his humiliation along with the sign saying 'King of the Jews'. Most painters have chosen to paint him in a white cloth, in response to the resurrection. © *The Louvre, Paris, Giraudon, The Bridgeman Art Library*

In the Bible there are 23 references to purple across the Old and New Testaments. However, here we see something of the changing perception of purple over the time period and political changes between the Old and New Testament periods. In the Old Testament purple is shown as positive, high-class and revered, being used by priests, for holding the scriptures, and by virtuous women. '*And he made the ephod of gold and blue and purple and scarlet and fine twined linen. And they did beat the fold into thin plates and cut it into wires to work it in the blue and in the purple and in the scarlet and in the fine linen*'.[73] This description relates to the garments of the priests. It was also at the centre of the work on Solomon's temple where the overseer was, among other things, familiar with purple dyeing.

In the Old Testament it is also considered suitable for the clothing of the virtuous woman, '*she maketh herself coverings of tapestry; her clothing is silk and purple*'.[74] However, in the New Testament, purple is treated somewhat differently. The writers of the Gospels and the letters of the New Testament saw themselves as being different from the Romans who had put Christ to death. By now purple was only allowed for the Imperial family and the likes of Nero and Caligula had had people murdered for wearing purple, or wearing a more beautiful gown than their own.[75] As such the memories of the writers would be of the 'royal purple' and its negative connotations. Therefore, the way it is used in the New Testament changes. In three of the Gospels they talk about Christ being given a cloth to wear while he is on the cross. In Mark and John[76] this is said to be purple, in mockery of his claims to be the Son of God.[77] The final reference, in the Book of Revelation, depicts the end of the world approaching, and now it is the whore of Babylon who is clothed in purple and scarlet;[78] colours that were perceived by the writers as too rich and self aggrandising for good Christians.

As the Roman Empire lurched to its demise, rulers repeatedly reinforced the purple-wearing laws to try to stop it being freely available. The Emperor Diocletian (300 AD) made the purple factories of Tyre state monopolies in an endeavour to contain who could buy it,[79] but by this time it was too late: purple could not be contained, the black market for purple was extensive.

The industry was not destroyed with the fall of the Roman Empire, but was seriously damaged when the Arabs conquered Tyre in 638 AD. However, Sidon continued to produce the colour and during the Byzantine period the Emperor Justinian established a purple dye works in Constantinople and made extensive use of double-dyed purple for the wardrobe and internal decorations for himself, his wife Theodora and his household.[80]

Perhaps stimulated by official visits, purple became a desirable colour even where there was no access to marine molluscs. In northern Europe dyers discovered lichens. Lichen purple from *Ochrolechia tartarea* has been found in 3rd-century artefacts from Schleswig-Holstein, and lichen dyes have been used across northern and western Europe since prehistory.[81]

KERMES: THE FIRST INSECT DYE

The European insect dyes are known as kermes and grain. Evidence of their use, according to Brunello, goes back to a Cretan dress from the end of the 15th century BC containing blues from indigo, yellow probably from weld and reds from madder and kermes.[82] In Homer's time, around the 7th century BC, Sardes, the capital of Lydia, was so well-known as the centre of kermes dyeing that it was referred to as 'the red bath of Sardes'.[83]

Kermes and grain are two distinct types of insect dyes, but the nomenclature is not simple. The word 'kermes' comes from the Persian *kirmiz*, which in turn comes from the ancient Indo-European *K'rmi* meaning larva or worm. 'Kermes' was originally the Persian name for Armenian cochineal (an anachronistic name as it was used long before Mexican cochineal was found or named), now more accurately called Armenian carmine (*Porphyrophora hamelii*) as the dyeing ingredient contains carminic acid.[84] Armenian carmine came from Eastern Europe and the Levant.

Polish cochineal, (again anachronistically named) *Porphyrophora polonica*, was also known as Saint John's blood because the time for collecting the insects was around the feast of St John, 24th June, when they hatch and emerge from the grassland in which they live. The red dye source in the Pazyryk textiles of Siberia, dating from the 4th century BC, which include the oldest-known examples of felted material, have been analysed and found to contain *Porphyrophora polonica*.[85]

Dyer's kermes is a different insect known as *Kermes vermilio*, and it is found only on the kermes oak (*Quercus coccifera*) so comes from areas where the kermes oak grows around the Mediterranean.[86] *Kermes vermilio* contains kermesic acid as the active ingredient and was known throughout the Middle Ages as *grana*, or grain, as it was marketed when the insects were dead and dried and as such resembled shiny dark-red berries. But it could also be sold in pulp form, when it would have looked even more like a vegetable product than an insect.

Knowledge of whether the kermes was an insect or a berry may have varied according to whether people saw the insect in situ or only after it had been turned into a dyestuff. In Biblical times scarlet garments are described in Hebrew as made with *tola'at shani* or 'the worm that shines'.[87] But Pliny described kermes as 'a berry that becomes a worm,[88] so even this generally acute observer of the natural world could not quite imagine, or at least did not witness, kermes as live insects.

The reasons for the expense of the kermes and grain dyes was that neither of these insects gave a large amount of dye so that tens of thousands of insects were needed to make 1kg (2.2lb) of dyestuff, and millions were needed to dye one bale of cloth given that recipes suggested a ratio of anything from 100 to 800 percent dyestuff to fibre.[89]

OTHER ANCIENT REDS

Safflower is mentioned as a dyestuff from antiquity across Southeast Asia. It is also mentioned in Persia from the 6th century BC and in China from at least the 2nd century BC, from where it was taken to Japan. Some varieties can also be used to dye yellow, but it is best known for red and has often been used to make cheaper reds than are obtainable from madder or kermes.[90]

Henna has been traced to its usage on statues of the Old Kingdom period in Egypt, around 2500 BC. While still best-known as a body paint, it is also used for dyeing orange-red shades on silk and wool in places like India and Morocco.[91]

EARLY USES OF RED: THE COLOUR OF WAR

Researchers are generally agreed that the Roman army was clothed in red when in battledress.[92] One can easily imagine the terror it would instil in less well-organised forces to be faced with hundreds of similarly dressed warriors, with their red coxcomb-topped helmets and cloaks. It is generally considered that these would have been dyed with madder, though proof is scarce. Pliny talks about kermes as being 'a dye reserved for the military costume of our generals',[93] which would seem to reinforce the idea that the foot soldiers' uniforms would be dyed in the less costly madder.

There is more confusion over the appearance of the Spartan army. The Spartans had severe laws against dyeing and banished dyers from the community. In the Spartan language the word *dolun* meant both to dye and to deceive, dyeing being considered an act against, or a falsification of, nature.

However, this law was relaxed or ignored for the Spartans' battledress, which was dyed scarlet apparently because they believed red clothing would hide the stains of blood and make their warriors appear invincible – though they insisted that the dyeing be done by the Perioecians, whom they considered an inferior class of people.[94] Of course, fresh blood stains might be 'hidden' by a red garment, but once dried would be more likely to appear brown or even black. Though perhaps if the soldier survived these would be considered 'badges of merit'.

YELLOW DYES

After the strong colours of red, blue and purple, the final major colour which, when mixed with those above, could help produce almost the entire range needed, was yellow. But while there are yellow dyestuffs that have been known since antiquity, such as saffron, the problem is actually the variety of plants available. Every region has its own yellow-giving plants and these are too many to go into here.[95] However, we will briefly consider saffron and

Saffron is used for culinary purposes as well as dyeing and today grows in Spain, Turkey and Iran. It has always been costly due to the methods of harvesting and the shrinkage between the vast quantity of saffron crocus collected and the final dried product. *Photograph © Susan Kay-Williams*

in chapter three, weld, the quintessential European yellow dye.

Saffron is gathered from the stigma of the saffron crocus. It originated from Persia and was used long before the Christian era. The Arabs brought it to Spain around 800 AD, but saffron had been grown in India for centuries and reached China via the Silk Route. In England it was grown in Saffron Walden, and the town still bears a crocus on its town arms. Like kermes, saffron harvesting is very labour-intensive: first the flowers are gathered, then the stigmas are removed and finally dried – a process which reduces every 100kg (220lb) of flowers to just 1.25kg (2.75lb) of active colourant. As a result, it has always been very expensive.[96]

Saffron was reportedly used in the Roman period, mostly for dyeing silk yellow. It was extensively cultivated in Abruzzo and Sicily, but despite this has been found in very few of the thousands of textile fragments analysed.[97] One verified example is from the second Jewish uprising against the Romans in AD 132–135. Here saffron yellow was found on both linen and wool cloth (combined with madder for oranges and indigo for greens and with both madder and indigo for black).[98]

The Greek writer Dioscorides wrote of the use of saffron and Plutarch noted that it was used in particular for women's clothing. This would seem to reinforce references in several cultures to its use in dyeing underwear, chosen for its pleasant smell as well as colour, a practice which continued until the Middle Ages.[99]

ALUM AND OTHER MORDANTS

Dyers must have discovered quite early that simply boiling wool in a bath of dyestuff did not give a strong colour and that it had poor durability, notwithstanding that it may not have been washed as often as clothing today. They recognised that they needed something to fix the colours. Early experiments focused on two types of material: mineral salts and organic products. In the former category were salt crystals or crusts, mud and metal oxides. In the latter category were items such as urine, excrement, blood, animal fats and plant solutions.[100] All of these elements can be considered in the category of mordants – fixatives that would help to extract stronger colours and keep the fibre colourfast longer.

Again, we do not know when the use of alum as a mordant began but it has been found in cotton fabrics at Mohenjo-daro dating back to around 2600 BC, and trade records from Mesopotamia dating to 1300 BC cite an Akkadian word for 'alum mordanted' madder implying alum was being traded beween the Indus Valley and Egypt along with dyes and wool.[101]

Historical recipes featuring all of the fixatives listed above have been discovered, and items such as urine were used in huge quantities for millennia as a staple of the textile industry. However, the abiding and quintessential mordants have been mineral salts: alum and iron, with later copper, tin and tannins and from the early 19th century, chrome. Of these, the most important is alum. In 1540 Vanoccio Biringuccio in his posthumously published *De la Pirotechnia* wrote *'alli tentori di panni e lane, non le altrimenti necessario chel pane al'homo'* [alum is no less necessary

Mordants are fixatives, helping the colour to adhere to the fibre and bringing out as much colour from the dyestuff as possible. In addition, some mordants will also colour modify the original colour. Depicted here are the four classic mordants: *clockwise from top left;* the white crystals of alum (potassium aluminium sulphate); blue crystals of copper (copper sulphate), which can also bring a greening effect to colours; white powder of tin (stannous chloride) which brightens colours; and the green powder of iron (ferrous sulphate) which saddens colours. *Photograph © Susan Kay-Williams*

to dyers of wool and woollen-cloth than bread is to humankind].[102]

So important was it that in 1948 academic and scientist Charles Singer examined alum's historic role, illustrating its impact not simply on the textile industry but on world economics.[103] Indeed, alum has been mined or quarried all over the world; one of the earliest places was in the western Egyptian desert, now called El-Shab, the Arabic for alum. The finest alum was known as potash alum because it did not colour-modify the dyes – unlike halotrichite, alum which also includes iron, inevitably saddening the colour achieved.

By the Middle Ages, alum had been found in Asia Minor and then Europe.[104] This availability allowed it to be produced in huge quantities to satisfy the rapidly expanding textile business stretching from India to Europe.

Purifying potash alum was a complicated process requiring a series of stages, which is why early alum contained more impurities; however, the process was certainly known by Roman times. Cardon described the process, which started with alunite or alumstone being heated at 700°C. The stones were then piled up and water was poured on them until they were reduced to a paste. Next was lixiviation of the paste in boiling cauldrons; lixiviation is the extraction of a soluble constituent from a solid mixture by washing or percolation. This caused the alunite to break up into soluble alum and alumina. The saturated solution of potash alum was decanted off, to crystallise into pure potash alum, with the final weight of alum being only about a third of the starting weight of rock.[105]

Iron mordants are colour modifiers as well as fixatives, tending to give sadder reddish-brown and black colours. Iron mordants were known in antiquity and were probably used in Egypt and India before alum mordants, as witnessed by the fabrics found in the tomb of Tuthmosis IV (early 18th dynasty), whereas examples of madder mordanted with alum

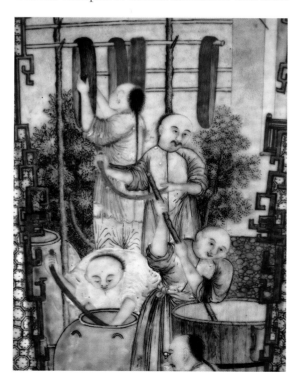

LEFT: Detail of men dyeing silk in China taken from a Ming Dynasty (1368–1644) ceramic vase. © Golestan Palace, Tehran, Iran, Giraudon, The Bridgeman Art Library

have only been found back to the 21st dynasty.[106] Unfortunately, the climate in India is not conducive to keeping fabrics in any condition for three thousand years so there are few examples extant.

Copper mordants also have a long history. As well as being fixatives, they also colour-modify, giving a green tinge. The Stockholm Papyrus (3rd–4th century AD)[107] refers to creating verdigris by dissolving copper in vinegar to obtain a green colour. Like the major dyestuffs, alum, iron, tin and copper mordants continue to be used throughout this story.

FIVE COLOURS OF CHINA

China has an extensive dyeing history showing more sophistication at an earlier period than either Egypt or Asia Minor. For example, black was always a complex colour to achieve yet it was the royal colour as early as the Xia period (21st to 16th centuries BC).[108] Grave finds include pieces dyed in madder for red, indigo for blue and gardenia for yellow, all of which show a colour-fastness revealing a high technical standard and knowledge of mordants. The Chinese chronicle of Choo King refers to dye workshops of 3000 BC as already having a long history.[109]

By the Chou period (1122–770 BC) there was a specialised crafts department, overseen by the Ministry for Earth, for the collection and extraction of vegetable dyestuffs, while the Ministry of Heaven had a department which dealt with questions concerning bleaching, printing and dyeing according to the Chinese calendar. As bleaching at this time was a prolonged and complex process of endeavouring to whiten fibre and cloth by means of, among other things, dew and sunlight, the time of year when this should be done would seem to have been a practical as much as a spiritual necessity.[110]

Both sericulture and dyed garments were celebrated in songs and poems in the Shi Jing, or Book of Odes, from around 1000 BC.[111] During the Han period (206 BC to 220 AD) the theory of the

Fragment of linen cloth from Egypt, possibly a mummy wrapping, dating from around 1400 BC to 600 BC. Microscopic analysis shows it is actually edged with red and blue stripes, though the red has almost completely faded. *Egyptian linen fragment (BS 6517) © British Museum, used with permission of the Trustees of the British Museum*

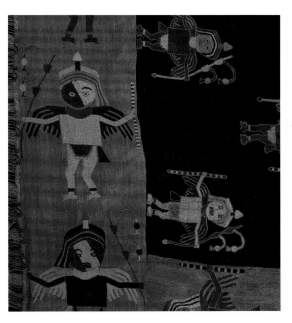

Paracas woven woollen textile. It is only in the later Paracas textiles that the source of the red dye has been identified as cochineal. Many of the earlier pieces use red from *Relbunium*. The Paracas people were advanced dyers and weavers. *© Museo del Oro, Lima Peru, Giraudon, The Bridgeman Art Library*

elements and the wu-shing colours were developed: black, yellow, red and blue/green, with white added later when the imperial colour became yellow.[112] China became connected to Asia Minor through the Silk Route, along which dyestuffs and mordants were some of the first commodities to be traded from around 650 to 100 BC.

EGYPT

Blue was particularly revered and reserved for royalty in Ancient Egypt. Early examples of a blue stripe being woven into linen mummy cloths date back to the 5th Dynasty (2400 BC). Evidence of blue dyes on wool can be found from the period of the Middle Kingdom (from 2040 BC) and especially the New Kingdom (from 1560 BC). [113]

By the 16th century BC coloured clothing (blues, reds and yellows) was common in many Mediterranean countries, while the earliest extant examples of textile art, in the form of woven tapestry, date back to the 18th Dynasty in the tomb of Tuthmosis IV (around 1400 BC).[114] The tapestries contain red, blue, green, yellow, brown and grey colours. Woven in colour blocks there are slits between the colours which were later sewn up. The tapestries show a richness and brightness which reveal a good technical knowledge of dyeing.[115]

SOUTH AMERICA

As with Europe, we do not know when dyeing and weaving began in South America, but thanks to the Peruvian climate we do have some wonderful

early examples of textiles, especially from the Paracas people who lived between 1000 and 200 BC. From the extant funerary textiles we can see that they had already produced more than a hundred shades.[116] From chemical analysis we also know that they mordanted with alum and used indigo and many local plants but, perhaps surprisingly, their principal red came from Relbunium (*Relbunium microphillium*) not cochineal, which is only found in later Paracas textiles and then those from the Nazca period (200 BC to 200 AD).[117]

GREEKS AND COLOUR

Until quite recent analysis of some Greek buildings and statues there had long been an assumption that the Greeks existed in a white-only world for their temples and clothing. Now we know this to be untrue either for buildings or for clothing.[118] Indeed, as a result of exploration and growing prosperity they were influenced by the Persians and even Indian textiles brought via the Silk Route, so had access to coloured clothing, whether dyed or, as Aristotle noted, embroidered.[119]

Aristotle was interested in many subjects, writing on everything from rainbows to philosophy, but he was particularly interested in colour contrast and made comments on the subject as a result of observing textile manufacture and embellishment.

Bright dyes too show the effect of contrast. In woven and embroidered stuffs the appearance of colours is profoundly affected by their juxtaposition with one another (purple, for instance, appears different on white and on black wool), and also by differences of illumination. Thus embroiderers say they often make mistakes in their colours when they work by lamplight, and use the wrong ones.[120]

As John Gage writes, 'This is a remarkably clear formulation of the problem now known as metamerism, by which colours that appear to match under one sort of light, seem different under another.'[121] The issue was not fully explored until the 19th century and is an issue embroiderers can still recognise today.

A further indication of Greek interest in colour can be found in the Leiden and Stockholm papyri from the late 3rd and early 4th centuries AD. These contain content that comes from the works of Bolos, sometimes called the pseudo Democritus of Mendes, in the Nile delta, who is thought to have lived between 200 and 100 BC. Papyrus *Graecus Holmiensis* (Stockholm), found in 1828 is half-filled with Greek dye recipes, while Papyrus *Leydensis* (Leiden) contains about 70 recipes for fake purples (as opposed to the murex purple) and use of the mordant Phrygian stone (alum).[122] Fake purple was a big issue at the time and it was not unknown for buyers to want to taste the fabric in order to determine whether it was murex purple or a combination of red and blue dyes. This was less about the final colour than a case of reassuring themselves that they were getting what they paid for.[123]

ROMAN DYE SHOPS

One of the oldest excavated dye houses is the Roman example at Athribis in Lower Egypt found by Flinders Petrie in 1908.[124] Others include the dye houses in Pompeii[125] and the recently excavated Roman dye house in Barcelona, which was found under the city's museum.[126]

From this evidence it is clear that the dye shops needed to be quite large, especially if more than one colour was to be worked. There also needed to be access to water, by a river or well, because large quantities of water were needed at every stage in the process. There was also dirty water to be got rid of once used, so a running water course was always needed (and ideally after the water had run through the town). Having said that, it was in the dyer's interest that the dye bath was only thrown away when it was completely exhausted. Greek dyers referred to yarn having 'drunk its fill' in the dye bath with all the dye being absorbed into the wool so as not to waste expensive materials.[127]

If woad or indigo blue dyeing predominated the vessels would be wooden dye vats; other colours required higher temperatures, up to boiling point, for which metal cauldrons were needed. A means

This dyers' workshop was discovered in Barcelona under the city museum dating back to the Roman period when the city was known as Barcino; archaeologists found traces of blue dye in the tray which is now lit blue. The dye shop is next door to a laundry. *Roman Dyebath* © *Barcelona Museu d'Història de la Ciutat*

of heating was also required, as were facilities for washing the fibre to degrease it – wool that still contained lanolin would not take a good colour.

Brunello notes that Ubonious had two dye houses in Pompeii on opposite sides of the street. He attributes this to the dyer being very successful in his business, but it seems just as likely that Ubonious was separating the red dyeing areas (a possible madder substance was found in a flask in the more complete workshop) from other colours.[128] This was very common, so as not to contaminate one colour with another and later we will even see it stipulated by law.

In fact according to the Roman playwright Plautus in his satire, *Aulularia*, commonly translated as the *Pot of Gold* in which he comments on the wardrobe of a fashionable man, every colour had its dyers. Plautus identified *flammarii* (dyers in orange); *violarii* (dyers in violet), *crocearii* (yellow dyers or, more accurately, saffron dyers), *spadicarii* (brown dyers) and *carinarii* and *purpurarii* (both mollusc purple dyers).[129] Utilising a range of colours like this, the 'fashionable man' would have been a dandy, long before the word was invented.

Large dyeing vessels were needed to ensure all the wool or fibre was submerged, so that it would take an even colour. A dry area would also be needed to keep the dyestuffs and stop them spoiling. In the Petrie example there is evidence of an upstairs area which could have been the store for the dyestuffs. Water would undoubtedly be splashed around as fibre was moved from mordanting to dyeing to washing, and dyers would not want their expensive dyestuffs to be damaged. There might also need to be an area for meeting customers, plus there would need to be outdoor space for drying the finished wool or tentering cloth.[130] There would also need to be space for collected urine – in Pompeii large jars for this purpose were actually left in public squares so that citizens could do their civic duty. Urine was used in the dyeing process

and especially the fulling process. After the urine had fermented for 10 to 15 days, it would release ammonia. When then applied to the cloth it would combine with the fatty substances in the textile to act as an ammoniac detergent to clean the finished cloth.[131]

It is often said that the Romans loathed blue and saw it as the colour of the barbarians. This may have been true of woad, but at the Barcelona site there is specific evidence of blue dyeing from Egyptian minerals. In the Barcelona dye house, there is a shallow container with a water run-off area. Researchers have found traces of blue colour, suggesting that this might have been used for washing dyed materials where colour would have come off and become trapped in the corners.[132]

There were even Roman dyers who re-dyed cloth which had faded or been stained, which indicates that this must have been a recurring event; *offectores* re-dyed faded cloths and garments, while *infectores* dyed new materials.[133]

EARLY EUROPE – HALLSTATT

In Hallstatt, Austria a former salt mine which dates back to 1400 BC, has been a centre of archaeological activity for some years and the textile finds have been particularly interesting, almost all of them on wool. Pieces have been dated to both the Bronze

Age (1400 BC onwards) and the Hallstatt period (800–400 BC). Chemical analysis has shown that the dyers were able to dye insect reds, probably weld yellow and woad blue, plus greens, browns and blacks, as well as using undyed natural colours of wool: white, grey, brown and black. Garments included patterns such as stripes and the earliest evidence of plaid cloth dates from 1200 BC.[134]

Researchers have been able to undertake extensive analysis of the fragments, learning, for example, that woad was used for more than just blue. By processing it in different ways, picking it at different times and mixing it with different colour modifiers the researchers identified violet, pink, green and beige, as well as several shades of blue, all obtainable from the same plant.[135]

NOTES

1. Schoeser, Mary, *Silk* (London: Yale, University Press, 2007), p.17.
2. Walton Rogers, Penelope, 'Dyes and Dyeing', in Jenkins, David (ed.) *The Cambridge History of Western Textiles* (Cambridge: Cambridge University Press, 2003), p.25.
3. Dwivedi, B, 'The bazaar dyer: Embroidery in India', *Ciba Geigy Review*, no.3 (1972) pp.20–26.
4. These fragments were discovered at the salt mines in Hallstatt, Austria. See *Prehistoric textiles from the salt mine of Hallstatt in Austria. Dyestuff analysis, experiments and inspiration for contemporary application*, Prof Regina Hofmann-de Keijzer. http://edelstein-center.com/color-symposium/files/iECS%20201.
5. Chenciner, Robert, *Madder Red: A History of Luxury and Trade: Plant Dyes and Pigments in World Commerce and Art* (Richmond: Curzon, 2000), p.34.
6. Chenciner, p.35.
7. British Museum BP Special Exhibition, 'Journey through the Afterlife: Ancient Egyptian: Book of the Dead', 4 November 2010–6 March 2011.
8. Such a discussion not being the purpose of this book, readers are directed to Varichon, Anne, *Colors: What They Mean and How To Make Them* (New York: Abrams, 2006).
9. See Jenkins, David (ed.), *The Cambridge History of Western Textiles* (Cambridge: Cambridge University Press, 2003) for an introduction to the various 'starting points' in Egypt, Mesopotamia, Arabia and greater Europe, for example.
10. Varichon, pp.218–19.
11. Wizinger, R, 'Tannin Black and Logwood Black', *Ciba Geigy Review*, no.2 (1973) p.4.
12. Singer, Charles, *The Earliest Chemical Industry: An Essay in the Historical Relations of Economics and Technology Illustrated from the Alum Trade* (Folio Society, 1948).
13. Varichon, pp.169–71.
14. Quoted in Chenciner, p.214 from Baron SW, *A Social and Religious History of the Jews* (New York: 1952) Vol IV, p.166.
15. Dwivedi, p.20; Balfour-Paul, Jenny, *Indigo*, (London: British Museum Press, 1999), pp.1–2; Chenciner, pp.11–12.
16. Pastoureau, Michel, *Blue: The History of a Colour*, (Princeton: Princeton University Press, 1999), pp.14–15.
17. Berlin, B and Kay, P, *Basic Colour Terms: Their Universality and Evolution* (Stanford, Calif. : CSLI Publications, 1999).
18. Schaefer, G, 'The Cultivation of Madder', in 'Madder and Turkey Red' *Ciba Review*, no.39 (1941), pp.1398–432.
19. Pastoureau, pp.15–16; Gage, John, *Colour and Meaning: Art, Science and Symbolism*, (London: Thames and Hudson, 1999), pp.71–3.
20. Chenciner, p.21.
21. Cardon, Dominique, *Natural Dyes: Sources, Tradition Technology and Science* (London : Archetype, 2007), pp.107–21.
22. Dwivedi, pp.20–6; Cardon, p.119.
23. Chenciner, p.35.
24. Faber, G A, 'Dyeing in Greece', in 'Dyeing and Tanning in Classical Antiquity' *Ciba Review*, no.9 (1938) p.287.
25. Hofenk de Graaff, Judith H, *The Colourful Past: Origins, Chemistry and Identification of Natural Dyestuffs* (Riggisberg: Abegg-Stiftung; London: Archetype, 2004), p.94.
26. Brunello, Franco, *The Art of Dyeing in the History of Mankind*, tr. Hickey, B (Vicenza: N. Pozza, 1973), p.96.
27. Pliny, *Historia Naturalis*, Book XIX from *Natural History with an English Translation*, tr. Rackham, H (Cambridge: Harvard University Press, 1940).
28. Cardon, p.108.

29. For example see Wouters, Jan, 'The Dye of Rubia peregrina I: Preliminary Investigations' in Dyes in History and Archaeology, 16/17 (2001), pp.145–57; Hofmann-de Keijzer, Regina and van Bommel, Maarten R 'Dyestuff Analysis of Two Textile Fragments from Late Antiquity', Dyes in History and Archaeology 21 (2008), pp.17–25.

30. Cardon, p.122; Sandberg, Gösta, The Red Dyes: Cochineal Madder and Murex Purple: A World Tour of Textile Techniques (Asheville, NC: Lark Books, 1997), pp.78–9.

31. Field, George, Manuscript Notebooks, no.1 (1806).

32. Schaefer refers to madder roots being 'the thickness of a quill' (p.1399).

33. Chenciner, p.33.

34. Cardon, pp.129–34; Hofenk de Graaff, pp.111–15.

35. Cardon, pp.162–6; Hofenk de Graaff pp.130–2.

36. Vetterli, WA, 'The History of Indigo', in 'Indigo' Ciba Review, no.85 (1950), p.3070.

37. Cardon, pp.335–86.

38. See for example Jenkins.

39. Neuburger, M C, 'Medieval Dyeing Technique', in 'Trade Routes and Dye Markets in the Middle Ages' Ciba Review, no.10 (1938), pp.337–8.

40. Balfour-Paul, pp.126–8.

41. Haller, R, 'The production of indigo' in Indigo Ciba Review, no.85 (1950), pp.3072–5.

42. Cardon, pp.339–44.

43. As seen on a visit to a master indigo dyer in Kyoto.

44. Balfour-Paul, p.116.

45. See Cardon, pp.339–44 to unpack the mystery.

46. Balfour-Paul, p.87.

47. Balfour-Paul, p.18.

48. Hardman, Judy and Pinhey, Sally, Natural Dyes (Ramsbury: Crowood, 2009), p.90.

49. Born, Wolfgang, 'Purple in Classical Antiquity', in 'Purple' Ciba Review, no.4 (1937), p.111.

50. Varichon, p.135.

51. Brunello, p.58.

52. Edmonds, John, Tyrian or Imperial Purple Dye (Little Chalfont, Bucks: 2000), p.39.

53. F E 'The Estimation of Purple Today' in Purple Ciba Review, no.4 (1937), pp.128–9.

54. Sandberg, p.26.

55. Ziderman, Irving I, 'Revival of Biblical Tekhelet Dyeing with Banded Dye-Murex' in Kirby, Jo (ed.), Dyes in History and Archaeology, vol.16/17, (London: Archetype, 2001), pp.87–90.

56. Symonds, Mary and Preece, Louisa, Needlework as Art (London: Hodder & Stoughton, 1928), pp.48–9.

57. 2 Chronicles 3.14.

58. Faber, G A, 'The Roman Dyers', in 'Dyeing and Tanning in Classical Antiquity' Ciba Review, no.9 (1938), p.291.

59. Plato in Republic, 421c–d, and Aristotle in discussion of colours and music.

60. Alcman in Maiden Song. See translation by Bowra, CM, Greek Lyric Poetry from Alcman to Simonides (Oxford: Clarendon Press 1961).

61. Barnard, Mary, Sappho: A New Translation, (Berkeley; London: University of California Press, 1999) poem 15.

62. Pliny, Book IX LII, tr. Rackham.

63. Pliny, Book IX, LX, tr. Rackham.

64. Edmonds, p.17–18.

65. Edmonds, pp.27–8.

66. Pliny, Book IX LXIII, tr. Rackham.

67. Pliny, Book IX LX, tr. Rackham.

68. Brunello, p.92. Corinth in Greece also featured the purple molluscs on their currency.

69. Philostratus, Pictures I section 28.

70. Chenciner, p.36–7.

71. Allgrove McDowell, Joan, 'The Mediterranean', in Harris, Jennifer (ed.), 5000 Years of Textiles (London: British Museum, 1993, p.59.

72. There are several references to Tyrian purple, especially in book one.

73. Exodus 39: 2–3. The Bible contains no information about Joseph's coat of many colours – the most colourful garment mentioned.

74. Proverbs 31.22.

75. Varichon, p.137.

76. Mark 15: 17 and 20; John 19: 2 and 5.

77. In Matthew, Christ is attired in a red robe which has the same significance, though here he is stripped of it before being put on the cross.

78. Revelation 17: 4.

79. Faber, p.294.

80. Gage, p.25.

81. Grierson, Su, The Colour Cauldron (Perth, Scotland: 1989), p.169.

82. Brunello, p.90 (although as it is a painted depiction it is uncertain how Brunello makes this assertion).

83. Faber, G A, 'Dyeing in Greece' in Dyeing and Tanning in Classic Antiquity Ciba Review, no.9 (1938) p.284.

84. Cardon, pp.646–52.

85. Phipps, Elena, Cochineal Red: The Art History of a Colour (New York : Metropolitan Museum of Art, 2010), p.9. Both madder and Polish carmine have been found in this textile.

86. The area of kermes oaks is diminishing and kermes vermilio is now an endangered species.

87. Cardon, p.616.

88. Pliny, Book III II. tr. Rackham.

89. Monnas, Lisa, Merchants, Princes and Painters: Silk Fabrics in Italian and Northern Paintings, 1300–1550

(New Haven, Conn.; London: Yale University Press, 2008), p.25.

90. Koren, Zvi C, 'A Successful Talmudic-Flavoured HPLC Analysis of Carthamin from Red Safflower Dyeings', in Kirby, Jo (ed), *Dyes in History and Archaeology*, no.16/17 (2001) pp.158–66.

91. Hofenk de Graaff, p.48.

92. Chenciner, p.39; also Elaine Norbury at The Textile Society 'Early Textile Study Group Conference: Colour', 19–20 November 2010.

93. Pliny, *Book III II*. tr. Rackham.

94. Brunello, p.92.

95. See Cardon, chapters five and seven, or Hofenk de Graaff, pp.165–231.

96. Based on Cardon, p.303.

97. Cardon, pp.302–7.

98. Abrahams, D H and Edelstein, S M, 'A Study of the Textiles from the Colour Standpoint', in Yadin, *The Finds from the Bar-kokhba Period in the Cave of Letters (Judean Desert Studies)* Israel Exploration Society (Jerusalem: 1963), pp.270–9.

99. Brunello, p.95.

100. Cardon, p.20.

101. Schoeser, Mary, *World Textiles: A Concise History* (London: Thames and Hudson, 2003) p.37.

102. Cardon, p.20.

103. Singer, Charles, *The Earliest Chemical Industry* (London: Folio Society, 1948). It could be said that alum is one of the 'unsung heroes' that has stimulated trade for centuries – without it the textile trade would not have flourished – yet it is unknown by most people.

104. Aluminium actually makes up more than eight per cent of the earth's crust, which means that it is widely available, if not always easily accessible.

105. Cardon, pp.23–4.

106. Cardon, ibid.

107. Brunello, p.100.

108. Dusenbury, Mary M, 'Language of Colour in Ancient Japan', conference paper given at The Textile Society 'Early Textile Study Group Conference: Colour', 19–20 November 2010.

109. Varron, A, 'The Growing, Weaving and Dyeing of Silk in the Ancient Orient and Classical Antiquity', in 'The Early History of Silk' *Ciba Review*, no.11 (1938) pp.369–75.

110. Sandberg, p.71.

111. Schoeser (2007), p.18

112. Scott, Philippa, *The Book of Silk* (London: Thames and Hudson, 1993), pp.23–4. We still do not know how the Imperial yellow colour was made and what has given its longevity of colour without fading. See Wilson, Ming (ed.) *Imperial Chinese Robes from the Forbidden City* (London : V&A, 2010) pp.16–17.

113. Schoeser (2003), p.36

114. Harris, Jennifer, 'Tapestry' in Harris, Jennifer (ed.), *5000 Years of Textiles* (London: British Museum, 1993), p.24.

115. Varron, A, 'The Origins of Tapestry Weaving', in 'Tapestry' *Ciba Review*, no.5 (1938), p.161.

116. Taranto, Enrique and Marí, Jorge, *Argentine Textiles* (Buenos Aires: Maizal Editions, 2003), p.29.

117. Phipps, Elena, 'Pre-Columbian Red', conference paper given at The Textile Society 'Early Textile Study Group Conference: Colour', 19–20 November 2010.

118. Gage, p.20.

119. Brunello, p.104.

120. Aristotle, *Meteorology*, 375a, tr. Webster, (Oxford: Clarendon Press, 1923).

121. Gage, p.14.

122. Hofenk de Graaff, p.2.

123. The issue of colour fraud will recur through history and each time the customer has to find ways to identify the true colour from the false.

124. Flinders Petrie, W M, *Arts and Crafts of Ancient Egypt* (London: 1910).

125. Faber, pp.291–4.

126. Beltrán de Heredia Bercero, Julia, *Los restos arqueológicos de una fullonica y de una tinctoria en la colonia Romana de Barcino* (Barcelona: Complutum, 11, 2000) pp.253–9.

127. Faber, p.287.

128. Brunello, p.111.

129. Brunello, p.104.

130. Tentering was the stretching of a finished cloth to maintain its size and shape before fulling. The word gives us the common phrase 'to be on tenter hooks'.

131. Brunello, pp.113–14.

132. Beltrán de Heredia Bercero, Julia and Jordi y Tresserras, J, 'Nuevas aportaciones para el studio de las *fullonicae y tinctoriae* en el mundo romano' in D. Cardon, M. Feugère (eds), *Archéologie des textiles des origins au Ve siècle* (Montagnac: Editions Monique Mergoil, 1999) pp.241–6. The researchers found two balls of Egyptian blue dye based on pastel or pigment and there are further traces on the dye bath.

133. Brunello, p.111.

134. Bender Jøgensen, L, 'Pre-Roman Iron Age 700–1 BC' in Jenkins, David (ed.), *The Cambridge History of Western Textiles* (Cambridge: Cambridge University Press, 2003), pp.52–70.

135. Joosten, Ineke, van Bommel, Maarten R, Hofmann-de Keijzer, Regina, Reschreiter, Hans, *Micro Analysis on Hallstatt Textiles* (2011; available to download at: http://www.eu-artech.org/files/Ext_ab/Joosten.pdf).

2

The Dark Ages: surprising colour

As the Roman Empire gave up its stranglehold on Europe and the Near East, new communities emerged and we see dyeing expertise in different places, especially among the Copts in Egypt. Further into Western Europe dyeing crops and skills are developing, promoted by leaders such as Charlemagne. Despite limited written information, found fragments show there are still many stories of dyed textiles and their contribution to European development and trade.

BYZANTINE PURPLE

When the Western Roman Empire fell in 476 AD the manufacture of purple in Europe ceased almost entirely, apart from a few enterprising private dyeworks in the Levant, Upper Egypt and Sicily.[1] However, it was still a major colour in Byzantium, reaching the height of splendour under Justinian (482–565), who established an imperial dyeworks for purple in the 6th century at Constantinople.[2]

Alongside the dyeworks Theodosius then established a weaving factory for the imperial family to produce the robes of state. The purple produced there by a predominantly female workforce was known as *blattae byzantinae* and was made from a mixture of *Murex brandaris* and *Purpura haemastoma*.[3] By the 10th century the Byzantine *Book of the Prefect* defined very clearly the many different shades of imperial purple that were forbidden to private manufacture, as well as certain types of tailored silk garments which could only be worn by the imperial family. At the time there were already five private silk guilds and this book listed many of the regulations of dyeing and textile production.[4] The book also listed the penalties for inappropriate use of dyes, but even spoiling a dye vat could be detrimental. It is recorded that a Jewish dyer spoilt a vat of imperial purple. His children were held for ransom and he had to go to friends in Egypt to raise the ransom money.[5]

The imperial workshop continued well into the medieval era especially for the production of luxurious silks. There was a major technological development at this time: a way was found to preserve the shellfish for six months after killing them. Previously they had had to be used immediately, and hence the major centres were coastal towns; now the molluscs could be transported and worked elsewhere.[6]

Purple was so closely linked with the idea of ruling in the Byzantine mind that the heir to the throne, if born while his father was ruling, was referred to as *Porphyro gennetos* or 'born in the purple'. The Emperor Constantine VII lived up to this billing, displaying a passionate fondness for purple robes,[7] as well as the more notable achievement of being one of the rulers responsible for the copying of classic Greek texts to ensure their survival.

IRISH PURPLE

We now know that mollusc purple could be and was created in many more places than the Mediterranean, including South America, Japan and even Ireland. Writing in 680 AD, Aldheim, Bishop of Sherborne, listed the virtues of the chaste, which included weaving, because *'it is not a web of one uniform colour and texture without any variety of figures that pleases the eye and appears beautiful, but one that is woven by shuttles filled with threads of purple and many colours flying from side to side and forming a variety of figures and images in different compartments with admirable art'*.

This sounds like an early example of keeping the virgins of the parish busy with complex weaving requiring concentration so they could not be idly thinking of young men. But the Bishop was himself particularly keen on such fabric. It is recorded that he possessed a robe *'of a most delicate thread of purple adorned with black circles and peacocks'*, while Symonds and Preece note that this was *'probably the purple dye derived from the shellfish on the west coast of Ireland [which was] known to the Phoenician navigators and sought by them many centuries before and greatly admired by the Venerable Bede.'*[8]

FROM IMPERIAL PURPLE TO ROYAL RED

Scarlet reds, especially those made from kermes, were almost as highly priced and prized as purple. The Persian kings of the Sassanian dynasty (224–651 AD) were among the first to have royal robes of scarlet. The Persian king Homisdas, as described by the 4th-century commentator Vopiscus, sent the Roman emperor Aurelius (270–275 AD) a mantle of red wool, reported as being brighter than imperial purple. From that time, Roman dyers were told to search out this new dyestuff: kermes. They went to India but returned empty-handed, saying only that it appeared to be from some kind of plant.[9]

However, by 301 AD the dye source had been identified because when Diocletian compiled a list of 'maximum tariffs for manufactured items', the scarlet wool from Nicaea in Bithynia (in present-day Turkey) was second only to purple. Its price was 1500 denarii and demands for scarlet frequently formed part of the tribute imposed on a conquered nation.[10] Purples were less often asked for as tribute because not all conquered countries had access to purple and it was not necessarily something the Roman leaders wanted to encourage.

SILK IN BYZANTIUM

Around 552 AD Justinian reputedly introduced silk production into the West after sending monks to China to obtain silkworm eggs and to learn as much as possible concerning sericulture. At least, that is one interpretation of events; the other is that the two monks actually undertook a two-year industrial-espionage mission which ended when they hid silkworm eggs and cocoons in hollow bamboo sticks. These sticks were then imported to the Mediterranean via Abyssinia in order to break the Persian monopoly.[11]

However, the introduction of sericulture to Byzantium was not without its issues. The Byzantine scholar Procopius noted:

Justinian has handed the entire silk market to an Imperial Treasurer, Peter Barsumas, a Syrian. The dyers and weavers work for him only and he is the only one from whom you can acquire silk. As soon as he was appointed to the post, Barsumas increased the price of silk. An ounce of silk dyed an ordinary colour costs six gold pieces. Material dyed imperial purple is taxed 24 gold denarii or more. The Emperor profits immensely from this monopoly, but Barsumas enriches himself even more. The silk merchants are ruined. The silk workers of Tyre and Beirut as well as the weavers and dyers are reduced to poverty, many of them have now emigrated to Persia.'[12]

Around the late 10th and early 11th century Byzantine tastes for striking polychrome silks were tempered by a new fashion for subdued monochromes in off-whites, buffs, golden yellows, olive green, plain

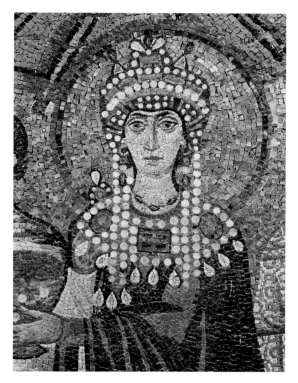

In this mosaic from Ravenna made in 547 AD, the wife of the Emperor Justinian, Empress Theodora, is depicted wearing an imperial purple robe. © *Byzantine School, San Vitale Ravenna, Italy, Giraudon, The Bridgeman Art Library* (from *Theodora with her court of two ministers and seven women*)

reds and deep blues. The dyes most commonly used were indigo, madder, kermes, brazilwood, sumac and saffron, as well as iron (colour-modifying) mordants.[13]

COPTIC DYEING

The Copts or Christian Egyptians lived between around 500 and 800 AD and were experienced dyers, as can be seen in the significant number of pieces that still survive. They had the skill to produce really strong vibrant colours – oranges, reds, blues and especially greens – yet they used only four core dyestuffs: madder (or other plant from the Rubiaceae family), Persian berries or weld for yellow and indigo.[14]

Some Coptic dye recipes have been found in the manuscript known as Papyrus Berlinensis 8316, which also includes information on dyeing processes.[15] However, Coptic dyeing skills were lost when the population was overthrown by the Arab invasions of the late 8th century. Repeatedly throughout history, towns and cities have been destroyed by invaders, forcing the population to flee, and while theoretically they could take their skills with them, the practical requirements of dyeing would be left behind. Setting up a dye workshop meant a significant investment even before the dyer had purchased dyestuffs and mordants. What is more, issues like the difference water could make to the outcome[16] were not understood at this time, so different colours might be achieved using the same ingredients in different locations. If populations became dispersed, skills were often completely lost.

On the other hand, the Arab invaders brought dyeing knowledge to their new conquest of Spain, along with a new dyestuff crop, saffron. Madder, saffron, and woad were in great use in the Arab world from around 600 AD. Imported indigo brought via the Silk Route was also used in Arab states, and by 1000 kermes was being used for scarlet dyeing from Persia to Arabic Spain.[17]

CHRISTIANITY AND DYEING

In 313 AD Emperor Constantine the Great accepted the Christian faith and a new era began. Although the books of the New Testament had been written by this time, there were additional writings over the next 300 years which became known as the Apocrypha. Two are of particular note as they contain stories featuring dyeing.

In the Arabic Infancy Gospel of Thomas, considered to have been written around the 6th century, we meet the young Jesus, who is already performing miracles. One example takes place in the dyer's workshop:

On a certain day the Lord Jesus, running about and playing with the boys, passed the shop of a dyer, whose name was Salem; and he had in his shop many pieces

This object has the most vibrant colours, showing what could be achieved by Christian Egyptian dyers, especially the bright green, which was not achieved in Europe until well into the Middle Ages. Coptic Warrior, Egypt, *Portion of Hanging with Warrior, 5th/6th century, 401–600 AD,* linen and wool, plain weave with weft uncut pile and embroidered linen pile formed by variations of back and stem stitches. Grace R. Smith Textile Endowment, 1982.1578, The Art Institute of Chicago. *Photography © The Art Institute of Chicago.*

of cloth which he was to dye. The Lord Jesus then, going into his shop, took up all the pieces of cloth, and threw them into a tub full of indigo. And when Salem came and saw his cloths destroyed, he began to cry out with a loud voice, and to reproach Jesus, saying: Why hast thou done this to me, O son of Mary? Thou hast disgraced me before all my townsmen: for, seeing that every one wished the colour that suited himself, thou indeed hast come and destroyed them all. The Lord Jesus answered: I shall change for thee the colour of any piece of cloth which thou shalt wish to be changed. And immediately He began to take the pieces of cloth out of the tub, each of them of that colour which the dyer wished, until He had taken them all out. When the Jews saw this miracle and prodigy, they praised God.[18]

In the apocryphal Gospel of Philip, considered to have been written in the 3rd century, dyeing is used metaphorically in two contrasting ways: firstly, with reference to the permanence of being touched (dyed) by God; and secondly, referring to Christ coming for all nations (at the time there were 72) and invoking the sense of Christ washing clean the sins of all people.

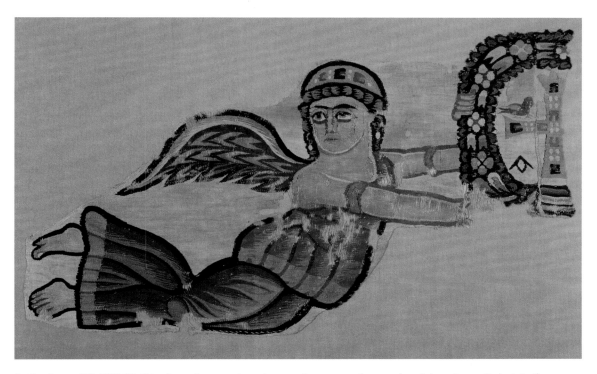

Dating from 400–599 AD this piece of woven tapestry may have come from a church hanging as it depicts the bejewelled cross in the centre inside a ring of flowers being carried by winged angels. It is worked in red, yellow and green colours, but they are not as striking as those of the warrior. © *Victoria and Albert Museum (349–1887)*

47 *God is a dyer. Just as the good pigments which are called permanent then label the things which have been dyed in them, so it is with those whom God has colored. Because his hues are imperishable, [those who are tinted] become immortal through his hand's coloring.*

58 *The Lord went into the dyeworks of Levi. He took 72 complexions (colours), he threw them into the vat. He brought them all up white, and he says: This is how the Son of Mankind has come to you—as [a] dyer.*[19]

As we know from other Bible stories, references are always to things with which people would have been familiar, in this case the activities of the dyer's workshop.

The period between the 7th and 9th centuries was a developmental time in the life of the Christian Church. Following the Pontificate of St Gregory the Great (590–604 AD) the papacy was on a more confident footing, and some clerics began to desire a new level of splendour for their liturgical vestments, leading to the use of bright colours and especially gold. Each bishop established his own colours and usage, so liturgical customs varied from diocese to diocese.[20]

In England, not only colour but embroidery was being added to religious vestments and hangings.[21] Following the death of St Cuthbert, Bishop of Lindisfarne, in 758, his shrine became a place of pilgrimage. In 934 King Athelstan presented gifts at the shrine, in particular a stole and maniple. When St Cuthbert's tomb was opened in 1828, these vestments were found and removed to Durham Cathedral where they are now on display. The stole and maniple are worked all over with *Opus Anglicanum* embroidery in gold, red and brown threads. Both items bear the same inscription, identifying them with Ælfflæd, Athelstan's stepmother, recording the fact that she

St Cuthbert's stole from Durham Cathedral is the oldest surviving religious textile in Britain. It features *Opus Anglicanum*, English work, in metal and silk threads. This part of the heavily worked stole depicts Saint Joel.
© *Durham Cathedral Library*

had made them for Fridestand, Bishop of Winchester from 905 to 931.[22] Both his stepmother and Athelstan's four sisters were noted embroiderers. These items are the earliest surviving clerical vestments in Britain.[23]

There were those, however, who thought colour was not appropriate for all situations. In the 8th century the Venerable Bede stated his view that the linen cloth in which Joseph of Arimathæa had wrapped the body of the crucified Christ was pure, because it was in a natural state, and as such was the most appropriate cloth for shrouds; a commentary against those who had their tombs fitted out with rich silks or dyed cloth in recognition of their wealth and social standing.[24]

From the late Carolingian period onwards, Benedictine monks were recommended to take no interest in the colour of their habit but simply to use the natural colours in fleece, which spun together would make dark grey or black to reflect humility and temperance, thus enabling them to focus on spiritual matters.[25]

EUROPEAN CLOTHING

But while monks might have eschewed colour in their own clothing, they were the more observant of it in others. Chevalier, in the first edition of the *Ciba Review*, quotes an 8th-century monk at the monastery of St Gallus describing visitors, including their red trousers and scarlet leggings, the grey or blue cloak, surmounting yellow or green coat and red cap.[26] However, Pastoureau contends that the versions of green and red in Western Europe in that period would have been paler, sadder versions of the colours we know today.[27]

Charlemagne, King of the Franks and from 800 Holy Roman Emperor crowned by the Pope on Christmas Day, issued a series of decrees in relation to clothing. The first was that the peasants should wear black and grey made from combing the fleece, although shearing had started by now, in something of an early sumptuary law.[28] But later he issued instructions that every householder was to grow their own dyestuffs.

The *Capitulare de Villis vel Curtis Imperialibus* records an edict ordering the cultivation not just of flax and sheep but also of *waido*, *vermiculo* and *varentia* – woad, kermes and madder – in farmyard gardens throughout the Empire (at the time comprising France, Belgium, Holland, and large parts of Northern Italy and Northern Spain).[29] His aim was to have self-sufficient households.[30] France was probably cultivating madder even before Dagobert I's reign (622–638), in the area of St Denis near Paris, and possibly from the time of the Gauls, who

were certainly growing and using woad. Caesar had considered the Gauls skilful dyers, and imperial dyeing and weaving factories were established in Narbo and Toulon.[31]

ISLAMIC CEREMONIAL TEXTILES

Curtains were an early addition to buildings in Islamic states; they allowed areas to be cordoned off for private meetings or to hide the Caliph from public eyes. The curtains became focal points for embellishment with embroidered texts or other motifs from the 8th to 12th century.[32] After the death of a ruler an inventory was made of their possessions including textiles and furnishings. In 809 following the death of Caliph Harun al-Rashid, the tally in the official inventory was 4000 curtains of unspecified materials, 1000 curtains of pure silk and 300 brocade curtains. In particular, one set of Bahnasā curtains was of enormous length – 30 ells, which would equate to between 16 and 18m (52½m and 59ft). A century later the Abbasid Caliph Al-Muqtadir, who ruled from 908 to 932, had recorded in his inventory some 8000 curtains; the oldest of these was about 100 years old, so some were obviously handed down and brought out only on special occasions.[33]

The importance and splendour of some of these curtains is confirmed by the Arabic reports on the reception of Constantine *Porphyro gennetos*, Johannes Rhadinos and Michael Toraxas by Caliph Al-Muqtadir in Baghdad in 917. Two accounts by different people quote the number of curtains suspended in the castles of the Fatimid Caliph as 38,000 – a number calculated by the keeper of the Caliphal Treasury. In a separate note, this event was also the occasion for some 22,000 carpets to cover the floors. Sadly, nothing remains of any of these textiles, not least because around 1068 the Fatimid treasure houses of Caliph Al-Mustansir were plundered. Textiles were a great prize and the theft included 200 packages of curtains amounting to some 1000 silk curtains of varied sizes and colours, including ones

This piece of figurative silk was woven between 900 and 1100 in Constantinople. It depicts a griffin with an eagle's beak and is thought to relate to the mythical story of the beast strong enough to carry an elephant. The colours are blue, tan (thought to be a faded red) buff and white. © *Victoria and Albert Museum (764-1893)*

worked with metal threads.[34]

The Abbasid Dynasty (750–1258) took the colour black to a devotional level. They venerated Ali, the Prophet Muhammad's son-in-law, whose assassination gave birth to the Shiite Muslim movement. In his honour, the Abbasids imposed the colour black on every aspect of the court life in Baghdad from official clothing to containers for official documents.[35] Undoubtedly their dyers could produce a black of good quality, something that was not available in Europe until the late 14th century.

EARLY WRITINGS ON DYEING

From the 8th century comes a manuscript, found in the middle of the 18th century, which showed that the Italian city of Lucca already had a thriving textile industry. *Compositiones et tingenda musiva* is about the colouring of mosaics but also includes information on dyeing leather and cloth. This is the first medieval writing about dyeing in Europe.[36] Also, the *De Coloribus et artibus* contains some dye recipes including woad, but is mostly about pigments.[37] The following century dyeing again played a 'bit part' in an important document, this time the *Mappae Clavicula*, interpreted by its English translators as 'A Little Key to the World of Medieval Techniques'. This is primarily a treatise on colouring glass but it features a few recipes for dyeing, especially leather or skins, some of which reference the Stockholm and Leiden papyri. However, they are not particularly helpful recipes for the uninitiated.[38] Here are a couple:

127. The purple dye from the murex

Murex is engendered in every sea, more than in island places. It is a little shell, which has in it a place for blood, and the blood is a reddish purple: from this the purple dye is made. It is collected like this. Take the murex and collect the blood with the flesh and take some brine from the sea and put them together in a pot and leave it.

128. Yellowish-purple

Take Alexandrian alum; grind it properly, and put it on a dish and pour boiling water over it; stir it for a time and let it settle. Afterwards strain off the hot water and agitate; then put in more hot water and agitate it; and place in [the alum solution] whatever you have to dye. Cover it and leave it for 2 days. After this stir it, let it settle and leave it there 3 more days, and after this stir it around in the same way and leave it another 8 days and agitate it not more than twice a day. Then take it out and put in more alum. Then make another batch of dye and put it in, and next take clean urine from good wine and healthy men and take this urine and clarify it once, and afterwards put it in a copper cauldron; and take the same murex and wash it once lightly in water. After this grind it, and put it in thin cloths and wash it down in the urine in the cauldron. After this take some pig's blood and rub it washing it also well in the same way. One pound of pig's blood to 3 oz. of murex ... After this wash once a little pig's blood and rub it down; put it in the cauldron and make it boil a second time, and a third, in the same way, namely, one pound of the dye, one pound of murex with blood.[39]

INTERNATIONAL TRADE

International trade in wool, dyestuffs and finished textiles in Europe really began around the 9th century thanks to the increasing quantity and quality of production. Merchants came to Flanders from the 9th century onwards to sell wools and dyes and to buy finished textile goods which subsequently found their way across Europe to cities such as Marseilles and Vienna, and countries as far-flung as Portugal, Poland and Russia. The epicentre of this trade was Bruges which, thanks to its wide river, became the heart of the textile trade on the western coast of Europe. It is the textile trade which brought prosperity, power and culture to Flanders and helped to create the Flemish cities of Ghent and Ypres as well as Bruges.[40] Brunello writes that the history of the textile industry in these cities is the history of Flanders itself, alternating between war (and poverty) and textile prosperity.[41]

This period also saw an increase in envoys and emissaries between courts and countries. In 968 Bishop Luitpold visited Constantinople as the envoy of Otto the Great, King of Germany and Holy Roman Emperor. It is told that the Bishop was allowed to purchase precious silks from the court manufactory but was stopped at the border and forbidden to carry them home as the guards believed that Europeans were unworthy to wear such fabrics. The Bishop protested and said the Byzantine Emperor himself had encouraged him to select the finest and costliest fabrics for the church of Cremona. When they still demurred, he boasted that '*in Germany such fabrics are worn by beggars and shepherds*'. The astonished guards asked where they were able to get such

Polychrome woollen twill textile found by Sir Marc Aurel Stein at Loulan cemetery, Xinjiang, China, dating from the 3rd or 4th century AD. Loulan was on what later came to be called the Silk Road trading route. As with the Coptic warrior (see p.38), this piece indicates a high level of dyeing skill on wool. Stein Textile Loan Collection. On loan from the Government of India and the Archaeological Survey of India. *Copyright: Government of India © Victoria and Albert Museum (Stein 585)*

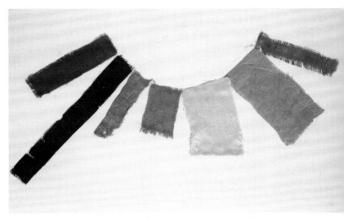

These silk fragments were found by Sir Marc Aurel Stein in Cave 17 of the Mogao Grottoes, a centre of Buddhist pilgrimage near Dunhuang, China. They date from the 7th to 10th centuries. Silk dyeing in China was very accomplished and the orange pieces even have a glaze which has not been identified. Stein Textile Loan Collection. On loan from the Government of India and the Archaeological Survey of India. *Copyright: Government of India © Victoria and Albert Museum (Stein 639, 1-3)*

fabrics, and the Bishop replied, '*from the merchants of Venice and Amalfi*'.[42]

By the 8th century, madder was also being exported into England via London. There are madder finds in London dating back to the 10th century, and Walton Rogers has also found an example in York from a century later of grey wool dyed with madder.[43]

By then others were already travelling further afield for dyestuffs. The Silk Route had been providing dyestuffs since Greek times, but this had gradually diminished until the 9th century, when contact with the east overland began to bring new materials and new techniques for dyeing and/or dyed textiles.

In the Indian province of Kirman there were indigo plantations as far back as the 10th century. From Gujarat there is evidence of block-printed textiles in a range of colours: reds, blacks, browns and even a brownish violet with alum or iron mordants.[44] At the eastern end of the European land mass, by 951 the Persian geographer Istakhri reported on commercial activity in Azerbaijan including trade in madder, saffron and linen, with the madder being sold not just in that country or in the early Islamic Caliphate but as far afield as India, as it was considered a superior-quality product.[45]

The Chinese also traded in dyes along the Silk Route with India and Persia from the 7th century. Resist dyeing was known at least as early as the 7th or 8th century in China, as seen in extant fragments, especially as found by Sir Marc Aurel Stein. During his travels in China and India he found an amazing range of textile fragments showing bright colours singly and in combination.[46]

Fragments are still the most common textile finds from this period, but we do begin to see whole textiles. In Japan, for example, there is a Sassanid temple banner from the mid-6th century, the Tenjukoku Mandala kept in the Chuguji convent, which is also the oldest embroidered fabric in Japan. But the finest and most extensive collection from this period, is in the Shōsō-in at the Tōdai-ji temple at Nara, the major repository of historic textiles in Japan. The Shōsō-in was built to contain gifts in honour of the Vairocana Buddha

and in particular the imperial treasures left by the Emperor Shōmu.[47]

The Japanese had followed the principles of the Chinese wu-shing colours but their taste was for the intermediate colours. These they combined in an elaborate system called *kasane-iro* in which kimonos were worn in layers, each layer being a graduated shade from the one beneath. The names of the colours were often linked to nature – for instance, 'azalea layers', which were shaded from palest to deepest vermilion pink, or 'maple layers', going from autumn crimson leaves to faded ochre[48] – reflecting the Japanese sensitivity to the natural world and especially to the changing seasons. The routine achievement of these shaded colours, up to ten layers, indicates a high skill level among Japanese dyers in this period.

Koketsu plain silk sash dyed in a double grid pattern in indigo. This piece dates from the 8th century and comes from the Shosō-in, the ancestral collection of textiles in Nara, Japan. *Nara Textile (1337)* © *Nara Ancestral Collection at the Tokyo National Museum*

NOTES

1. Wild, John Peter, 'The Later Roman and Early Byzantine East 300–1000' in Jenkins, David (ed.), *The Cambridge History of Western Textiles* (Cambridge: Cambridge University Press, 2003), p.151.
2. Zollinger, Heinrich, *Colour: A Multidisciplinary Approach* (Zürich: Verlag Helvetica Chimica Acta; Weinheim; Chichester: Wiley, 1999), pp.164–5.
3. Born, Wolfgang, 'Purple in the Middle Ages' in Purple *Ciba Review*, no.4, pp.119–23.
4. Muthesius, Anna, 'Byzantine Silks' in Harris, Jennifer (ed.), *5000 Years of Textiles* (London: British Museum, 1993), p.75.
5. Muthesius, Anna (2003) 'Silk in the Medieval World' in Jenkins, David (ed.), *The Cambridge History of Western Textiles* (Cambridge: Cambridge University Press, 2003), p.349.
6. Born, p.121.
7. Born, p.121.
8. Symonds, Louisa and Preece, Mary, *Needlework Through the Ages* (London: Hodder & Stoughton, 1928), p.165.
9. Brunello, Franco, *The Art of Dyeing in the History of Mankind*, tr. Hickey, B (Vicenza: N. Pozza, 1973), p.106.
10. Born, Wolfgang, 'Scarlet' in Scarlet *Ciba Review*, no.7 (1938), pp.206–14.
11. Brunello, p.120.
12. Brunello, p.121.
13. Muthesius (2003), p.349.
14. Wouters, J et al, 'Dye analysis of selected textiles from three Roman sites in the Eastern desert of Egypt: A Hypothesis on the Dyeing Technology in Roman and Coptic Egypt', in Kirby, Jo (ed.), *Dyes in History and Archaeology*, vol.21 (2008), pp.1–16.
15. Brunello, p.122.
16. The role of water in dyeing would not be fully understood until scientific analysis and more extensive travel became common in the 19th Century. See Partridge, William, *A Practical Treatise on Dying of Woollen, Cotton and Skein Silk with the Manufacture*

of Broadcloth and Cassimere Including the Most Improved Methods in the West of England (originally published New York: H. Walker and Co. 1823; repr. with notes by KG Pointing by Edington, Wilts: Pasold Research Fund, 1973), pp.87–92.

17. Vogelsang-Eastwood, Gillian, 'The Arabs AD 600–1000', *The Cambridge History of Western Textiles* (Cambridge: Cambridge University Press, 2003), p.163.

18. Infancy Gospel of Thomas, section 37, available at: www.intratext.com/IXT/ENG1022.

19. Gospel of Philip, available at: www.metalog.org/files/philip.html.

20. Pastoureau, Michel, *Blue: The History of a Colour*, (Princeton: Princeton University Press, 1999), pp.35–6.

21. Wilson, David, *The Bayeux Tapestry* (London: Thames and Hudson, 1985), p.201.

22. Symonds and Preece, pp.169–70. *Opus Anglicanum*, literally 'English work', was the height of English embroidery using silk and gold thread, and came to be highly prized in the Middle Ages by Popes and other rulers.

23. Morris, Barbara, *The History of English Embroidery* (London: V&A/HMSO, 1951), p.3.

24. Symonds and Preece, p.24.

25. Pastoureau, Michel, *Black: The History of a Colour* (Princeton: Princeton University Press, 2008), p.39.

26. Chevalier, A, 'Medieval Love of Colour', in 'Medieval Dyeing' *Ciba Review*, no.1 (1937), p.28.

27. Pastoureau (2008), p.16.

28. Butler Greenfield, Amy, *A Perfect Red: Empire, Espionage and the Quest for the Colour of Desire* (London: Doubleday, 2005), p.23.

29. Brunello, p.130.

30. Leix Alfred, 'Dyeing and Dyers' Guilds in Medieval Craftmanship' in Medieval Dyeing *Ciba Review*, no.1 (1937), p.11.

31. Faber, GA, 'The Roman Dyers', in 'Dyeing and Tanning in Classical Antiquity' *Ciba Review*, no.9 (1938), p.293.

32. Khalili Nasser D, *Visions of Splendour in Islamic Art and Culture* (London: Khalili Family Trust, 2008), p.27.

33. Helmecke, Gisela, 'Textile for the Interiors: Some Remarks on Curtains in the Written Sources' in De Moor and Fluck (ed.), *Clothing the House of the 1st Millennium AD from Egypt and Neighbouring Countries* (Tielt, Belgium: Lannoo Publishers, 2010), p.51.

34. Helmecke, ibid, p.50.

35. Varichon, Anne, *Colors: What They Mean and How To Make Them* (New York: Abrams, 2006), p.232.

36. Hofenk de Graaff, Judith H, *The Colourful Past: Origins, Chemistry and Identification of Natural Dyestuffs* (Riggisberg: Abegg-Stiftung; London: Archetype, 2004), p.3.

37. Hofenk de Graaff, p.245.

38. Brunello, p.125.

39. Smith, Cyril S, Hawthorne, John G (tr.), *Mappae Clavicula: A Little Key to the World of Medieval Techniques* (Philadelphia: American Philosophical Society, 1974), p.46.

40. Gutman, AL, 'Flanders in Cloth-making', in 'Flanders' *Ciba Review*, no.14 (1938), p.469.

41. Brunello, p.149.

42. Geijer, Agnes, *A History of Textile Art* (London: Philip Wilson Publishers Ltd., 1979), p.13.

43. Walton Rogers, Penelope, 'The Anglo Saxons and Vikings in Britain 450–1050', in Jenkins, David (ed.) *The Cambridge History of Western Textiles* (Cambridge: Cambridge University Press, 2003), pp.124–31.

44. Juvet-Michel, A, 'The Dyeing and Knotting of Oriental Carpets', in 'Pile Carpets of the Ancient Orient' *Ciba Review*, no.15 (1938), p.514.

45. Chenciner, Robert, *Madder Red: A History of Luxury and Trade: Plant Dyes and Pigments in World Commerce and Art* (Richmond: Curzon, 2000), pp.41–4.

46. Scott, Philippa, *The Book of Silk* (London: Thames and Hudson, 1993), p.24.

47. Kennedy, Alan, *Japanese Costume: History and Tradition* (1994), pp.6–7.

48. Best, Susan Marie, 'Japan', in Harris, Jennifer (ed.), *5000 Years of Textiles* (London: British Museum, 1993), p.143.

3

New Skills and Burgeoning Trade: the Middle Ages

This period of 400 years saw the dawn of a new society across Europe, the development of significant towns and cities and increasing wealth through trade, leading to a growth in the importance of the textile trade. Indeed, by 1400 more than a third of the Florentine population, some 16,000 people, earned its money from the cloth trade,[1] a figure that would have been similar in other textile centres.

Throughout the Middle Ages, European dyers were increasing their knowledge and rediscovering some of the dyestuffs known in early history (stimulated not least by the arrival of silk in Western Europe around the 10th century), and by the end of this period had reached a high level of skill. With growth and new demands came the advent of regulation, an increasing presence through the course of subsequent centuries. This had two aspects: to protect the skills and special knowledge built up within cities and states; and to ensure an appropriate match between price and quality. During this period there was also an expansion in the range of colours available; however, the increased wealth of the merchant class led to the introduction of sumptuary laws restricting the import of luxury goods in order to maintain the social status of the nobility, and this in turn encouraged the development of black textiles.

The leading centres of dyeing during this period were the Italian city states: Venice, Florence, Pisa,

Lucca and Genoa.[2] Italian textiles, especially silk, were the height of luxury, as first seen represented in Giotto's fresco cycle from 1305 in the Scrovegni Chapel in Padua and undoubtedly as witnessed in life by clerical vestments.[3]

Flanders also had a significant reputation for textiles, although initially this was for high-quality cloth production requiring the work of up to 70 specialists.[4] Until the 13th century, the cloth was sent to Florence for dyeing, though not dyed until purchased so that it could be produced in the colour desired by the customer. The roles of Germany and France at this time were in the production of key dyestuffs, especially woad, and, although madder is mentioned in Anglo-Saxon manuscripts, England's principal role was in rearing the sheep which gave the best wool.[5]

The other new feature of this period was a movement towards the commercial imperative: profit and the growth of the role of cloth merchants. In Prato, businessman Francesco di Marco Datini worked with dyer Nicolò di Piero di Giunta del Rosso to explore dyeing developments, and formed the first Dyers Company in Prato (Compagnia della Tinta). Datini analysed all the elements of dyeing and cloth production, noting that dyeing only accounted for 15.5 per cent of the wholesale price of the finished cloth[6] versus the perceived 'added value', although elsewhere it could account for up to a third of the costs.[7]

THE MASTER DYER

Establishing a dyeing workshop was neither a cheap nor quick activity. First, a long apprenticeship was required in order to learn all the secrets of dyeing as little was ever written down.[8] The apprenticeship usually lasted seven years and was followed by a period as a journeyman dyer working for a number of master dyers.

In many cities there were two types of dyer, those who dyed for the mass of the population and those who had the skills to dye the most luxurious fibres and cloths with the most expensive dyes. In order to become one of the latter, it was necessary for the dyer to pass a test, often assessed by his fellow master dyers, themselves members of the relevant guild. The candidate had to produce a masterpiece, that is, to dye a bale of woollen cloth, a consistent colour. It was always dyed 'in the piece', i.e. as a whole after it had been woven, as it was much more difficult to dye cloth than fleece or yarn.

In places like Venice and Florence, there was a third group of dyers, those qualified to dye silks, these were very few in number and were considered not merely master craftsmen but artists.[9]

In the early medieval period the masterpiece had to be in red, as the most expensive and sought-after colour. Later, with the rise in popularity of blue clothing the masterpiece colour was changed to blue. As will be seen, as customers became more demanding and dyeing became more complex, by the 17th century multiple masterpieces in a series of colours, including complex colours, had to be produced in order for a French dyer to gain admission to the ranks of the dyers of *Le Grand ou Bon Teint*.

MEDIEVAL REDS

Madder remained at the heart of red dyeing in the Middle Ages as the principal red dye, especially on wool. By 1282 Duke Guido of Spain was acknowledging Flanders as the largest producer in Europe,[10] though the plant was grown from Germany to England, as we can see in market records from centres such as Basle, Como, Strasbourg and Prato,

The Last Supper by Giotto di Bondone in the Scrovegni (Arena) chapel Padua, Italy c.1305. It was commented that this fresco by Giotto was the first depiction of people attired in fine Italian fabrics which were then becoming popular. © *The Last Supper, Scrovegni (Arena) Chapel, The Bridgeman Art Library*

and the Madder Market in Norwich.[11] Such was the trade that it already generated considerable revenue and taxes. But where there is a taxed commodity there will also be inappropriate trading, so that by the 14th century in major centres such as Flanders and Artois, detailed regulations had already been established on the proportion of madder to 'detritus' (earth and other filler materials) in the barrel, a topic we will return to later.[12]

But the stars of red dyeing in the medieval period were kermes and grain, known across Europe from at least the beginning of the 12th century. They were the most costly dyes, used for deep red, purple and deep pinks, principally on silk.[13] But the insect reds were also used for the most luxurious woollen cloth, known as a scarlet (possibly first written as 'scarlatto' by Petrus Mauritius in 1157);[14] indeed, the

Brazilwood was used as a dyestuff for centuries, though as it was a fugitive red, it was mostly used as a topping-off colour and was banned from being used for the best quality fabrics such as Venetian scarlet. *Photograph © Susan Kay-Williams*

colour achieved through the use of kermes became synonymous with the cloth itself: Venetian scarlet (*Scarlatti Venezianni di grana*).[15] This scarlet fabric was the most carefully dyed and finished of all fabrics, so as to give the softest texture. As such it was truly a luxury fabric that could only be afforded by the wealthiest families and members of the Church, at least during the early Middle Ages.[16] In 1211, Gervais de Tilbury refers to it as the fabric of kings and such was its perceived value that it was given as a gift at tournaments.[17] From the 11th century, the best wool came from England, with Henry III, Holy Roman Emperor from 1046 to 1056, demanding of the Count of Cleves three pieces of scarlet cloth woven specifically from English wool.[18] Moreover, German records from monasteries in the 13th century reveal that the monks requested the Polish carminic insects as part of the annual tribute or tithe from the faithful for use in their dyeing operations.[19]

The red insect dye was extremely bright, shiny and colourfast and gave us common terms such as 'ingrained'. Apart from Venice, it was used extensively in a number of other Italian dyeing centres including Lucca, Genoa and Florence. In France, cities like Montpellier, Marseilles and Narbonne issued edicts in the 13th century stating that high-quality cloth should only be dyed with kermes to obtain red, while in Montpelier kermes could only be worked by dyers born in that city. There were even orders to increase the quantity of red dye used and overdyeing with madder, but to no avail.[20] They still could not equal the colour of Venetian red which Brunello attributed to the Venetians' use of alum and tartar mordants.[21]

But madder, grain and kermes were not the only medieval red dyes. A new source, brazilwood (*Ceasalpina sp.*) became a significant item of maritime trade into Venice from the Levant from at least the 13th century,[22] though probably earlier as it is mentioned in an Act of the Scottish Parliament under King David, who reigned from 1124 to 1153,[23] and it has also been found on analysed samples of red textiles from as early as the 11th century. It continued being imported from the east via land trade routes until the fall of Constantinople in 1431. Then there was a short gap in its history until the sea routes to the east and west were discovered in the late 15th and early 16th centuries. Brazilwood is a tree and the dyestuff is to be found in the heartwood.[24]

In Venice and Genoa brazilwood's primary role was as a 'topping off' colour to add extra redness to a fabric. Unfortunately, on its own it can be quite fugitive and, as a result, has had quite a chequered history. For example, it was forbidden from being part of the recipe for Venetian scarlet in the city's statutes of 1243,[25] and in France was repeatedly banned from the top echelon of dyeing, *le grand teint*, even as a topping off colour.[26] It was especially forbidden from use on all soft cloths as it hardened them.

Apart from scarlet, the highly fashionable colour of the 14th and 15th century, especially for silk, was *paonazzo*, a purple made from dipping threads in red dye and then in *vagello*, a blue dye based on indigo to which madder, alum and bran had been added.[27]

Dyeing was always a complex trade requiring a great deal of knowledge gained through apprenticeships of up to seven years, but there was also further complexity in terms of pricing. To produce scarlet cloth, the dyer only had to dye the fabric in one bath. To dye *alessandrino*, *paonazzo* or, later, black required multiple baths, so the dyer charged more.

However, with the final tariff actually being decided by the merchant, the pure scarlet colour ended up being the most expensive[28] – anything up to twice the price of a black or other overdyed textile.[29]

Red remained the most important, expensive and powerful colour in the Middle Ages almost everywhere except France, where the newly acceptable blue colour from woad was adopted by the monarchy and nobles by the end of the period.[30]

INFLUENCES ON COLOUR: CRUSADES AND HERALDRY

Heraldic insignia were first created for the Crusades in the second half of the 12th century, as a way of identifying people under armour and helmets. Originally, the heraldic emblems were crests, three-dimensional insignia worn on the tops of helmets. The insignia moved onto clothing, becoming two-dimensional when soldiers wearing metal armour went to fight in the warmer climates of the Levant. Sun on metal made wearing armour extremely uncomfortable, so they added surcoats (long material covers in light colours, especially white) over their armour to mitigate the heat. In 1095 Pope Urban II had commanded that the red Christian cross be displayed as the universal symbol of their aim, and it was a small step to apply this to their surcoats and then add other signs of their allegiance.[31]

Heraldry is based on five colours, known as tinctures, and two metals. Red, blue, green, purple and black are the tinctures (known in heraldry as *gules*, *azure*, *vert*, *purpure* and *sable*), while the metals are gold and silver (known as *or* and *argent*, and depicted as yellow and white). However, there is no sense of different shades in heraldry; any blue is azure, whether shown as dark or light.[32]

The royal recognition of heraldry began at similar times in England and France, both of which were involved in the Crusades. Embryonic France, as a developing nation under guidance from Abbot Suger and Bernard of Clairvaux in the early 12th century, chose to put itself under the protection of the Virgin Mary. To illustrate this, one of the motifs associated

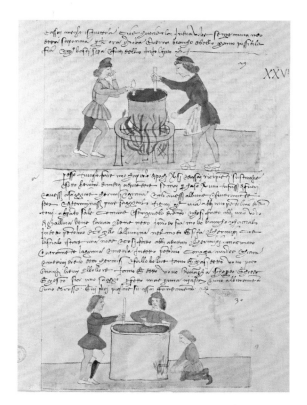

Dyeing Silk from *Precetti dell'Arte della Seta* (Rules of the Silk Guild). The Venetians were the first State to set down the rules and regulations of dyeing in order to preserve their high-quality reputation as the middle classes grew and the demand for upmarket textiles burgeoned. *© Biblioteca Medicea-Laurenziana, Florence, Italy, The Bridgeman Art Library*

with her, the fleur-de-lis, was adopted as the symbol of the country.[33] Gradually, this was given more prominence under the reign of (Saint) Louis IX and came to denote kingship or royalty. When during the reign of Philippe Auguste in the late 12th century an emblem was sought for the royal arms, the choice seemed obvious, although it was not until Charles V's reign around 1370 that the French king's personal arms were formalised as three gold fleur-de-lis on a blue background (*azure*, three *fleur-de-lis or* in heraldic language). This remained the symbol of the French king, with multiple fleur-de-lis for royalty or monarchy, right through to the Revolution.[34]

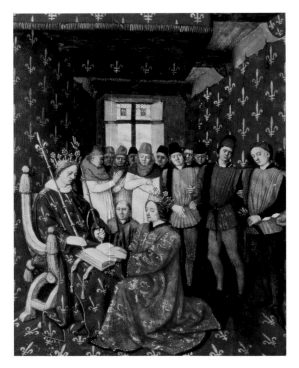

English King, Edward I (1239–1307) pays homage to the King of France, Philippe IV le Bel (1268–1314), for the Duchy of Aquitaine. Edward can be recognised by the *lions passant* on his robe while Philip the Fair and the entire room are clothed in blue cloth covered with the fleur-de-lis. © *Fr 6465 fol.301v (vellum), French School, (14th century) / Bibliotheque Nationale, Paris, The Bridgeman Art Library*

In England, the symbol of the three lions, still in use today on the shield of Her Majesty Queen Elizabeth II,[35] was created under the reign of Richard I (the Lionheart, 1189–99). He changed the shield from two lions rampant, as used by his father Henry II, to three lions *passant guardant*[36] (on all fours and facing out) on a red background (*gules* three lions *passant guardant or*)[37].

But heraldry perhaps had its greatest boost from the mythical King Arthur, who was given his own arms (*azure* three crowns *or*, three gold crowns on a blue background) in the late 13th or early 14th century.[38]

The reason for including heraldry here is because its use of colour had a growing influence on the dominance of textile colours through the Middle Ages into the Renaissance.

THE COMPLEXITY OF WHITE

Today we take bright white textiles for granted. However, in the Middle Ages 'white' was a relative term. The original sheep of England were like Soay sheep, with brown coats,[39] and even by 1000 AD sheep were still more likely to be greys, blacks, browns or one of a range of shades of off-white. Until around the 14th century only linen could be rendered fully and easily white – hence its use for collars and shirts – but even this was a laborious process. To bleach fleece was a complex task, requiring repeated treatment which might include alkalizing, rinsing, flattening beating and laying out cloth in the sun on fields to attract the early morning dew; it might take weeks to achieve the desired whiteness. In addition, dipping in hot lyes, sour milk, lime water, cattle dung or pigeon droppings, as well as air-drying, might be used individually or severally.[40] The sunlight requirement also made it a seasonal activity, while sun-whitened fleece or cloth often faded or changed colour after a short time.

Silk cocoons were any colour from off-white to yellow, light blue or orange, so they also required an intensive and complex process for whitening known as sulphurization, following which the fabric still required lengthy blueing to achieve whiteness, making it a very expensive, not to mention aggressive, treatment of the threads.[41] So it is perhaps to be expected that we find references even to upmarket textiles, such as a wedding trousseau, as including '*two others pure, clean white, inclining to yellow*'.[42] As a consequence of the whitening process white silks from this period, especially velvets, have a very poor survival rate.

White silk was, however, the chosen colour of royal mourning in France at this time. The queen was often widowed young, due to war or disease,

and spent the rest of her life at the court wearing white. So often was this repeated that these women became known as the 'White Queens' and were considered something of a drain on the court as they often survived for years, even decades after their husbands' deaths.[43]

This allegiance to white only changed following the death of Charles VIII in 1498. His wife, Anne of Brittany, wore black clothes. Today, we make an easy connection between black and mourning, but we should not forget that in 1498 black was a very fashionable colour, so it is perhaps not surprising that its role in mourning quickly caught on across the courts of Europe – from France to Burgundy and then to the Spanish Habsburg court including Catherine de Medici, Marie de Medici and Anne of Austria, by which time it was the accepted colour.[44]

White textiles were also at the heart of one of the most symbolic debates of the age, contested by (Saint) Bernard of Clairvaux and Peter the Venerable of Cluny. Bernard of Clairvaux had insisted the Cistercians wear white robes as an act of piety. However, as we have seen, to achieve white textiles required a lot of work. Peter the Venerable, the head of the great Benedictine monastery at Cluny, wrote to Bernard in 1124, accusing him of 'excessive pride' in wearing white robes (the Benedictines wore robes in a naturally-occurring black). Peter the Venerable's question was whether the absence of colour was perfect submission to God or pride and vanity.[45] Bernard of Clairvaux responded that black was the devil's colour, a view which Pastoureau contends was the start of colours having symbolic meaning. Underlying this debate was the issue of Bernard's position as head of an increasingly popular order, and the loss of taxes due to Cluny from Clairvaux by order of the Pope. With this background, the feud was maintained until 1146, by which time the Cistercians were known as the white monks.[46]

Bernard's key issue was about the nature of colour: is colour light or a material overlay? His answer was if the former, then divine, if the latter then it was manmade and as such was an evil addition to God's work (notwithstanding that the black Benedictine robes came from undyed wool).

Haarlam in the Netherlands was a major centre for bleaching cloth as witnessed by the number of pictures in which the bleaching fields feature, especially in the 17th century. In this picture by Jan van Kessel the Elder, one can get an idea of the quantity of cloth being bleached as well as the length of a bolt of cloth. *Bleaching fields of Haarlem*, Kessel, Jan van, the Elder (1626–79) © *Felbrigg Hall, Norfolk, UK / National Trust Photographic Library/John Hammond / The Bridgeman Art Library*

Bernard believed that colour was artificial, a mask and a vanity, hence his striving for the 'colourless'. In the opposite corner was Abbot Suger of the church of St Denis in Paris. He believed that God was light and that He should be venerated through all colours as colours were light, and that nothing was too beautiful for the House of God.[47] In the extensive reconstruction of his church around 1130–40 he introduced colour in every possible form: stained glass, vestments and paintings. St Denis was particularly known for blue in the stained-glass windows, as later seen, but with a slightly different shade, in Chartres. Suger particularly highlighted the conjunction of blue and gold in his writings *De consecratione*, in which he said these colours above all evoked divine light and presence.[48]

St. Bernard in a Cistercian habit with a chained devil behind him. St Bernard is glowingly depicted in his white habit while the devil is black. From a *Book of Hours*, probably Bruges, c.1500–05. *MS 1058-1975 f.161v (vellum), Flemish School, (16th century)* © Fitzwilliam Museum, The Bridgeman Art Library

LITURGICAL COLOURS

During the early years of the Church, each bishop chose his own colours for Mass and for key events in the Church's year; nothing was standardised. In 1195 Cardinal Lothar of Segni outlined a standardised approach to liturgical colours in *De sacro sancti altari mysterio*, and when in 1200 he became Pope Innocent III he decreed that henceforward there should be formal, consistent colours for the Church's year.

The four colours set down were white, black, red and green. White evoked purity and innocence; it was to be used for the highest holy days, such as Easter Sunday and Christmas Day. Black was for abstinence, waiting and penitence so was to

be used for Lent, Advent, for Masses for the dead and especially for Good Friday. Red evoked blood, especially Christ's blood and the martyrdom of the saints; it was to be used for Saints' days and especially Pentecost.[49] However, this still left a significant part of the year with no colour. Innocent III chose green, which to the medieval mind was the mid-colour between red, white and black.[50] Gradually, there was a shift towards these colours because of the esteem in which Innocent III was held by the Catholic Church. They remained unchanged until the Council of Trent in the 16th century when during the time of Pope Pius V the fifth colour, violet, was added for Lent and Advent, a practice which still applies today.[51]

The establishment of the liturgical colours illustrated that the Church as a whole wanted to celebrate Mass through colour. At a time when the majority of the population were illiterate, colour was one way to communicate ideas to the congregation. In the same way weaving could be used to explain some of the Christian tenets, such as the Trinity – God the Father, Son and Holy Ghost – as the warp, weft and thrum of a fabric tightly enmeshed – three separate elements making one as described by Beatus of Liébana around 1109 in his commentary on the Apocalypse.[52]

THE CULT OF THE VIRGIN

The Church was at the heart of life in Europe in the Middle Ages, and was in many ways responsible for the most significant colour development. During the 12th century the Church changed its perception of the Virgin Mary. Previously seen as the mourning mother from the end of Christ's life, to be depicted in sombre tones of black and brown, with the Church's change of focus to the risen Christ came a change of role for the Virgin. A risen Christ did not need anyone mourning for him; instead the Church now saw Mary as someone to be cherished and venerated in her role as the mother of Christ, so paintings changed to depict her as the young mother of an infant Jesus.[53]

From this re-evaluation came the cult of Mary. Gone were the heavy dark colours; instead she was precious but young and was now to be depicted in a new palette. In the 12th century, led by Abbot

From the time of Pope Innocent III, green was the colour chosen for the period in the Church's calendar between the major Christian festivals, and became known as Trinity as it principally followed on from Pentecost, the bringing together of God the Father, the Son and the Holy Spirit. Here the symbol of the Trinity is represented on this altar frontal at the Cathedral of the Holy Trinity, Gibraltar. *Photograph © Susan Kay-Williams*

Following the Council of Trent in the 16th century additional colours were introduced into the liturgical calendar to represent Lent and Advent, both considered periods of waiting and preparation. Purple is the colour chosen for this period. Illustrated here is the Lenten altar frontal from a church in Iceland. *Photograph © Susan Kay-Williams*

The Syon Cope with Scenes from the Life of Christ, is one of the finest surviving English clerical vestments, made between 1300–20, although it has been cut down from the original chasuble. It is made of linen, embroidered with metal threads and silk. In terms of colour, what now appears brown would have been red, though it is impossible to know the shade, and we must therefore assume the green has faded too, although it has stayed green, without 'blue disease'. © *Victoria and Albert Museum (83–1864)*

The right-hand panel of *The Wilton Diptych* made for Richard II and painted between 1395–99 using egg tempera on oak. The painting of the Virgin and Child show the quality of the blue from lapis lazuli and how well it was set off by the gold.
Right hand interior Wilton Diptych, Master of the Wilton Diptych, (fl. c.1395–99) © National Gallery, London, UK / The Bridgeman Art Library

With a rising nouveau riche many grateful merchants wished to pay their respects to the Church by commissioning new works of art. However, such a gesture was rarely just a simple sign of piety; it could also reflect the merchant's wealth and so bring them status. Not surprisingly, the fashion for Mary in a blue mantle spread.[56] And so expensive was lapis lazuli that it was common for the painter to have written into the contract how much ultramarine the commissioning patron required. Furthermore, as Abbot Suger had noted, ultramarine blue went wonderfully well with gold, adding to the richness and therefore the worshipfulness of a painting.[57]

Perhaps one of the most elegant depictions of Mary in ultramarine is the *Wilton Diptych*, the devotional work that was made for the English King Richard II in 1395, which 'sings' with blue and gold for Mary, the Christ child and the angels.

THE RISE OF BLUE FOR TEXTILES

In the ancient world, blue had been considered little more than a background colour – for example, in the frescoes at Pompeii – and was not included in the rainbow colours by any of the ancient Greek or Roman writers. Mentioned in an Egyptian manuscript of 1552 BC (now called the *Ebers Papyrus*) as both a medicine and a dyestuff, in Western Europe blue-giving woad's textile story begins in the 13th century AD. As Pastoureau writes, 'the rise of blue was not just a minor feature of Western history but the expression of important changes in the social order, including systems of thought and modes of perception'.[58]

The use of lapis lazuli as a pigment coincided with dyers learning how to use woad as a reliable dyestuff, a transition that took some time. In the 12th century there were dyeing guilds, such as those in Scotland,[59] which forbade any involvement with woad on pain of expulsion. By the 13th century attitudes had changed and for the next four hundred years the livelihoods of whole communities, especially in Germany and France, revolved around

Suger among others, bright blue, the colour of sky, was being freshly considered the colour of purity and spirituality.[54] Coinciding with this awakening to blue was a newly available rare pigment from Afghanistan: lapis lazuli (ultramarine). It was one short step to make this precious pigment into the Marian colour, imbued with her qualities of humility and divinity, especially as at this time blue was seen as a warm colour.[55]

woad as a commercial crop.[60]

Woad (*Isatis tinctoria*) has many elements in common with indigo, in particular the dyestuff indigotin, to the extent that chemical analysis of found fragments cannot determine whether something was dyed with indigo or with woad.[61] Woad blue is a vat dye made from fresh, or more often dried, woad leaves in a two-stage process. The dye bath needed to be kept at a constant temperature, around 50°C (122°F), like indigo, and after potash was added, the mixture had to be stirred very carefully so as to introduce as little oxygen as possible. Just like indigo when the fibre is removed, the blue colour only appears once the fibre has been exposed to the air outside the vat.[62]

However, the process for preparing the fresh woad is different. The end product of the first stage is dried balls of fermented leaves, where with indigo it is the sediment. The yarn needs to be in the vat longer for woad (between 20 minutes and two hours depending on the strength of the vat and the colour required) than for indigo, and woad gives significantly less colour for weight of leaves than does indigo.

A further significant difference was that the woad vat, unlike the indigo vat, could not be refreshed. If managed carefully, it was possible to get two or three fresh sets of wool or cloth dyed from each woad vat on day one and probably for two further days before it was completely exhausted. After that a new vat had to be created.[63]

In Germany during the late medieval period woad provided a third of the income of Thuringia, contributing to the medieval city of Erfurt and the university at the heart of the five *Waidstadte* or woad towns.[64] In France there were two main woad-producing areas, Normandy and Picardy/Languedoc, their varieties being known as *Guesde* (or later *Guede*) and *Pastel* respectively. Their crop was referred to as 'blue gold' and Languedoc was known as the *pays de cocagne* ('land of the woad ball'), a phrase which came to mean exceptionally profitable land,[65] which has a certain irony as woad was a nutrient-hungry crop depleting the soil in which it grew.[66] In Spain woad was grown in Seville.

German Erfurt was part of the Hanseatic League of trading cities and merchant guilds along the coast of Northern Europe, which exported to foreign markets such as England, Flanders and Holland. Florence also had an insatiable demand for the crop, importing both French and German woad to supplement locally grown plants.[67] England did grow some woad of her own in Lincolnshire and Glastonbury but was principally a major importer. Like any grown crops there were different grades, and in each growing area there were central storehouses where the woad could be thoroughly inspected and appropriately priced prior to sale.

FRANCE, ENGLAND AND WOAD

France grew enough woad for its own use and exported it to England and Flanders. Woad sales were such a significant activity that in 1281 Edward I of England set down rules for the assessment of consignments, enabling merchants to sample their quality before agreeing the price. In particular it was written that '*The mayor shall have the power by his office to cause all the dyers of the town to be sworn that they will make the assay well and truly for the town and for the merchants, and that when they have thus been sworn the oath shall last for their lifetime.*'[68] This oath sounds like the start of what was later, certainly by 1344, to become the role of the 'woad broker' in the Dyers' Company in London, where a named individual had the responsibility to ensure that the woad sale would favour neither buyer nor seller, a role that continues in the company to this day, though now in an honorary capacity. So, in 1344, '*Gilbert le Pipere 'dieghere' was elected a broker of woad by merchants of woad and good men of the Dyers, and was sworn to act justly in his duty towards vendors and byers.*'[69] However, the observance did not always follow the spirit of the post and, in 1433 during the reign of Henry VI, London dyers went to court to obtain permission for woad imports to be handled fairly rather than for the financial benefit of just some members of the guild.[70]

Woad became subject to all sorts of constraints during the Hundred Years' War, a series of battles between England and France from the 1340s to the

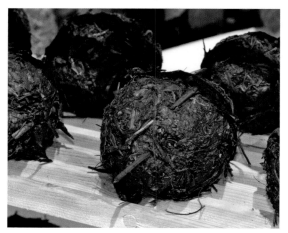

The woad plant is quite hardy and self seeds vigorously from the multitude of black seeds produced, but it is the leaves from which the blue and other dyes are produced by picking and processing them in different ways. Woad is, however, a hungry plant, denuding the soil of many nutrients, which was not beneficial to the soil if the crop was grown on the same land repeatedly. *Photograph © Susan Kay-Williams*

Woad balls are the outcome of the first stage of processing woad. These will now be dried and then they can be transported, stored and eventually used. These were produced by the research team working on dyeing techniques of the prehistoric Hallstatt-Textiles, funded by the Austrian Science Fund (FWF): L431-G02. See chapter one. *© Anna Hartl*

1460s. During this time, whenever the countries were at war, woad from France was arrested on arrival in England and only released for sale once the particular battle was over and a peace, or at least a truce, was in force. The English monarchy had many claims on France through its Norman heritage, but being so far away they were difficult to control. Hence the constant wars throughout the reigns of Edward III, Richard II, Henry IV, Henry V (most famously, the battle of Agincourt) and Henry VI, and the fight for Orléans against Joan of Arc, after which the English lost all claim on French lands.

The impounding of woad deprived English dyers of much-needed raw materials, but much more it deprived the French merchants of their profits, which the English rulers did not want ploughed back into the war effort until peace or a truce was agreed.

June 20 1343, Windsor
To William de Clynton, earl of Huntyngdon, constable of Dover castle and warden of the Cinque Ports. Order to dearrest without delay 15 tuns of woad which he

arrested on 10 June last by pretext of the King's order... to deliver them to Nicholas Camberlayn, merchant of Amyas or ... his serjeant to do his pleasure therewith... as after the truce began in Britanny between the king and Philip de Valesio, he caused 15 tuns of woad to be taken to England by [his sarjeant] to do his pleasure therewith and the woad was arrested at Faversham in the house of Philip son of Philip Nhete...[71]

War, however, is expensive as Edward III discovered. He introduced taxes to be paid in sacks of wool, which did not please merchants or the monasteries who were the main farmers of the Middle Ages. In 1284, 200 monasteries are recorded as exporting wool to Flanders,[72] and indeed, as an indicator of the importance of trade, during the war Flanders chose to side with the English so that they did not lose access to the high-quality wool needed for the best cloths.[73]

To add to the political difficulties, which caused so many problems for medieval dyers, England was not just at war with France in this period. There are letters to Henry VI from the Duke of Milan

pointing out that a consignment of woad which had been seized from one of his subjects should be released because England was at war with Genoa, not Milan.[74]

By the first half of the 13th century there had been a volte face in opinion about blue fabrics, a view which came about due to the development of heraldry, the re-interpretation of the clothing of the Virgin Mary and the dyers' ability to create strong, even blues in cloth. As such, blue had become a prestigious colour for fashion and influential ruling, political and fashionable figures were now seen wearing it and were portrayed wearing it. Saint Louis (Louis IX 1226–70) was the first king, French or otherwise, regularly depicted in blue robes, as opposed to the more usual red for medieval monarchy.[75]

Such was the progression to blue clothing that by the late medieval period woad was the most frequently used dyestuff, especially on wool. As a result of the quantity being produced the woad dyers and clothworkers were known as 'blue nails'.[76] Any dyer wanting to set up a woad dyeshop had to produce a masterpiece in blue, even if they had previously produced one in red, because blue did not become the standard masterpiece colour for some time. Indeed, Milan did not change it from red until the 15th century, while Paris was probably the last place to change, not doing so until the late 16th century.[77]

The other sure sign of increasing trade is increasing tax. During the 13th century we start to see taxes on dyestuffs and especially on woad. The French *Livres des Métiers* of 1268, the record of the statutes of every guild in the city, detailed the tolls to be paid on dyestuffs entering the city at the Seine bridge. Ordinary dyes (woad, madder) were charged at 2 denars per cartload, with *graine*, *écarlate* (probably kermes) and pepper at 4 denars, although potash and alder bark were free of charge.[78] At the same time, in Erfurt 'woad pennies' had been levied from as early as 1230.[79]

The final sign of the rise of blue (woad) as a fashionable colour in the 13th century was when violent conflicts broke out between merchants of madder, the former dominant-colour dyestuff, and those of woad, the new fashion. It was only the luxury scarlets, dyed with kermes, which stopped blue from becoming the only colour.[80]

WELD AND OTHER EUROPEAN YELLOW DYES

Weld (*Reseda luteola*) was to yellow what madder was to red: a core dyestuff across Europe, known to Pliny as the best yellow dye and commercially available from centres like Florence from around 1200.[81] Dyers' broom (*Genista tinctoria*) was also used for yellow except in Venice, where it was forbidden in favour of weld by the 1243 regulations.[82] Weld was said to give the most beautiful colour on wool and silk and continued to enjoy this position until after the introduction of some of the New World yellows in the 16th century.

An attractive plant in the flower garden, though it grows readily in the wild, weld was less fugitive than most other local yellows, especially when used for combined colours (green, orange). It needed to be used at a ratio of 100 percent fibre to dye, boiled to achieve the best colour, and it always needed a mordant.[83] Its inherent dyestuff is known as luteolin. Weld was used on all four main fabrics – wool, silk, linen and cotton – and was noted for giving a softness to the wool or cloth, which was not always the case with other dyestuffs.[84] Weld grew in most European countries and was grown as a crop in early medieval England in Yorkshire, Essex and especially Kent.[85]

This is not to deny that saffron, which gave more golden tones than weld, still had a role in Europe. Indeed, from the early 14th century the Swiss city of Basel was a centre of saffron cultivation, due to land transport routes between India and the West becoming unpredictable and expensive. The growing process was supervised assiduously and became a lucrative trade for them until early in the 15th century, with export markets in England, Germany and Flanders. When a consignment of goods was ambushed on its way to Basel, the eight bags of saffron taken were the most valuable part of the cargo, and the city pursued what turned out to be a lengthy feud to recover them.[86]

Weld was the most commonly used plant to give a good yellow colour on wool in Europe. It was also noted that it gave a softness to the wool, something which was not common with other dyestuffs. However, all yellows are more fugitive than reds and blues so yellows in historic textiles are often shadows of their former selves, and where combined with blue to make green, today perhaps only the blue may still be visible, leading to what is called 'blue disease'. *Photograph © Susan Kay-Williams*

Other yellow dyes were more localised, and relatively easy to source as yellow is the colour most likely to be achieved from plants however, many of them were quite fugitive. One useful yellow dye in France and Germany was yellowwood, which was used from at least the 13th century right through to the 19th. Native to Provence, it could be used to achieve a range of colours with different mordants and colour modifiers: pale yellow on its own, a stronger yellow with alum, red when treated with potash or ammonia, white with a solution of lead and olive green when combined with sulphur.[87]

Yellow on its own was not considered a strong colour in the medieval period, often being seen as a colour of separateness or difference. In France, from the period of Louis IX in the mid-13th century, Jews were obliged to wear yellow pointed hats, a requirement that continued until the Revolution.[88] In many city states prostitutes were required to wear certain colours to indicate their trade. In Venice at different times in the 14th and 15th centuries that colour was yellow, elsewhere in Europe prostitutes were forced to wear the socially even more disgraceful stripes.[89] As Pastoureau puts it, the only acceptable yellow to the medieval mind was gold, seen as a spiritual, divine and heroic colour, not to mention the colour of trade.[90]

One of the principal uses of yellow was in creating green which, though the most abundant colour in nature, could not be produced from an individual dye bath. For a strong green, blue and yellow, usually woad and weld,[91] had to be overdyed. In England these colours were variously known as Saxon, Lincoln and Kendal greens.[92] Greens are also mentioned in the oldest collection of German dye recipes found in the Innsbruck manuscript written about 1330.[93]

One further dyestuff, known to the Greeks and Romans, was only rediscovered in the 14th century, when a Florentine traveller came across it in the Levant. Orchil or orseille, or rocella (*Roccella tinctoria DC*), is a lichen dye which gives blues and purples. Orchil collecting was a perilous activity, requiring the collectors to be hung on ropes over cliff faces from which they could pick the orchil lichen.[94] It is often referred to as having been a Florentine monopoly for 200 years, although there is some evidence of its use in both Spain and Venice.[95]

REGULATIONS, PROHIBITIONS AND COLOUR FRAUD

Attitudes towards dyers began to change in the 13th century as the market for fine textiles increased, thanks to a growing middle class and increased wealth. Skilled textile workers were in demand across Europe with particular competition to attract dyers, whose work was very complicated, required a high level of knowledge and added so much value to the finished cloth.[96] However, as dyeing became more important to city economies, civic leaders introduced regulations to control the trade. The first

to be written down pertained to Venice, created by the dyers themselves in 1243. Called *Capitolaribus de Tinctorum*, they included details of how dyeing was to be undertaken, but also included rules on apprenticeship, the location of dye shops in relation to the town (regarding water sources), the rights and obligations of the dyers and specifically the approved and forbidden dyestuffs and processes.[97] Further rules for Venice were published in the *Mariegola della Lana* (Rules on Wool) of 1270.[98]

Lucca was next in 1255, with a document signed by a staggering 86 dyers,[99] a huge number given the modest size of this medieval city, which was principally known for silk weaving. Such a number seems to indicate that in Lucca the dyers were equal to the silk weavers, especially given the local decree that Lucchese dyers would only dye cloth woven in Lucca, and only new cloth or thread to ensure that the cloth had a good durability.[100]

In Venice during the 13th century there was a protectionist attitude to their textiles. The new silks and best-quality cloth were reserved for people of the Venetian Republic, and, in an attempt to protect local knowledge, only inferior cloth was available for export. Partially this could be put down to the ravages of the Black Death in the early part of the century, killing up to three quarters of the Venetian population, including many skilled artisans.[101] Such an arrangement, however, was the complete opposite of most states.

Flanders in particular focused on export and high-quality trade, producing fabric that was colourful, brilliant and unusual, though it was also one of the most regulated states for dyeing.[102] First the mordanting and the dyeing had to be done by separate workshops. Only alum, ashes of conifer or slaked lime were allowed as mordants. The same bath could not be used twice and, to ensure that all the mordant was used up, the finished bath had to be emptied in front of the house.[103] The dyers were then further subdivided, as blue and red workshops (*blauwververs* and *roodzieders*) had to be separate by law. One group was allowed to work with red and yellow dyes: madder (locally grown only), brazilwood, mignonette and weld. Another group was allowed to use woad, with these blue

dyers allowed to make black and green cloth, too. Indeed, Flemish dyers had a good reputation for a special Flanders green despite having no direct access to yellow, as well as a deep blue called *manteaux de Frise*.[104] Using high-quality wool from England, their luxury dyed fabrics in a range of vibrant colours (ten reds, six blues, three greens and several blacks, greys and browns) were exported to the courts of France, Burgundy and Artois.[105]

Being allowed to dye with just one dyestuff was a restriction that applied not only to Flemish dyers; the same was true in German and Italian states, particularly in relation to the most important dyes: kermes, woad and madder. Apart from the dyestuffs, restrictions related to the quality of the dyes and their use.[106]

In France, the first city statutes on dyeing were produced between 1243 and 1247 and then further enhanced in the *Livres de Métiers* of 1268,[107] which also had a separate section for tapestry makers, a stand-alone guild. Tapestry weavers were responsible for the dyeing of their own colours, so important were the colours for individual commissions. They only worked with the best-quality yarns and dyes and were only allowed to weave during daylight hours.[108] Preparing colours for a tapestry is an onerous job. All the weft yarn needs to be dyed at the same time to ensure a consistent use of colour across the piece, and the weaving needs to be done in a good light, as colour choices have to be made all the time. Even though there was a comparatively small colour repertoire, the important thing was the shading and blending of the colours, made more difficult by being woven on the side and from the back. So costly were tapestries, the highest form of textile art, that the guild was only allowed to receive orders from churches and the nobility.

By the 14th century more towns had regulations for dyeing. Venice updated its regulations in 1305 and the new *Capitolare dei Tintori di Venezia* differed greatly from its predecessor. Simultaneously, Pisa published the *Breve Tinctorum*, which bears a remarkable similarity to its Venetian counterpart in content and wording. Notably, the Venetian regulations of 1305 contain one historically important reference, the first mention of indigo as a dye in Europe.[109]

According to W.A. Vetterli, indigo was known in Europe from the 12th century and in London by the 13th, but in very small quantities; these were mostly purchased through the market in Baghdad, which was a central trading point for Indian and Persian commodities.[110] But while dyers could produce ten times more dyed material from indigo than from the same weight of woad, the cost was 30 to 40 times higher. However, before the Venetian Republic came to include the mainland, the city's dyers did not have the space for dyestuff agriculture and as such avidly welcomed the new dye, especially once they understood how it should be used (notwithstanding the woad growers suggestion that it had diabolical properties in an age where such association meant far more than it would today).[111]

Of course, where there are regulations there are always those who will try to avoid them, so prohibitions and penalties were also prescribed. In this regard, two of the big issues were colour-fastness and passing off, where a dyer made something that looked as though it had been made with first-class dyestuffs but in fact was made using more fugitive dyes. The penalties could be severe. For example, in 1360 in Troyes, dyers and weavers were forbidden to use ox blood, green nutshells, orseille and alder, which could all be fugitive if not used with the right mordant.[112] In Paris, the fine for using false or fugitive dyes was 20 Paris sous, but this was nothing compared to the statutes in some Italian cities such as Lucca and Florence. For example, in the latter city a statute of 1301 decreed that materials not dyed according to regulation should be burned and both dyer and customer be subjected to a fine. If the dyer could not pay the fine, the fee was the loss of one of his hands. Given the physical nature of dyeing, this would amount to a career-ending punishment.[113]

But there were not just fines for fugitive dyeing, as regulation also meant there were taxes to pay for actually undertaking the dyeing processes in the first place, depending on where they were done. In 13th-century France a tax of 6 sous was exacted for dyeing on royal ground, another of 4 sous was taken for doing so on the territory of the Knights Templar, and a further 4 sous was due *pour les planches* – that is, for washing the cloths or yarns after dyeing, a vital part of the process.[114]

GUILDS

The 14th century was the high point of the guilds not only in Italy but also in France, Spain, England, Germany and Flanders.[115] Guilds could provide solid support to fellow merchants in a particular trade. On the other hand, if a particular group was subject to a more powerful guild, life could be very hard. Such was the case in Florence.

The textile trade was a major industry in Florence but it was highly controlled by just two guilds: the weavers, the Arte della Lana, and the cloth merchants, the Arte della Calimala. Florentine dyers devoted themselves to finishing foreign-woven cloth from Flanders, France, Germany or even England, improving them by bleaching or, mostly, dyeing, but the Florentine guilds severely restricted the role of the dyers.[116] In 1260 the dyers, soap makers and madder dealers received permission from the Duke of Athens, then overlord of Florence, to form their own guild. This outraged the Arte della Lana and, as soon as the Duke's Signoria, the Duke's representative in Florence, was ousted, just eight months later, the dyers were forced once more to become the underlings of the weavers and merchants.[117]

The Arte della Calimala demanded an annual declaration of fealty, and also arbitrarily fixed the prices to be paid to dyers regardless of the dyestuff used. In 1317 they published the *Statutum Universitatis Artis Lanae*, a very detailed collection of regulations in four books containing at least 18 chapters on dyeing.[118]

By 1371 it was perhaps not surprising that the dyers had gone on strike over wages, refusing to work for the Arte della Lana. In 1377 three new guilds were formed including that of the dyers', though this only lasted until 1382, when the power of the old-order families and guilds was re-established.[119]

ENGLISH DYEING

In the period 1000 to 1300 English dyeing was quite limited. Indeed in the early 12th century being a dyer was not something to be proud of, being considered to have low professional standards.[120] Dyers could

The coat of arms of the Worshipful Company of Dyers features three sacks of madder on the shield, which is supported by two leopards rampant guardant whose spots are multi-coloured, as appropriate for dyers, fire issuing from their ears and mouth, both ducally crowned *or* (gold), and on the crest there is a wreath of the colours, with three sprigs of a grain (kermes) tree erect *vert* (green) *fructed gules* (with red 'berries'). I am indebted to Ian Mackintosh, archivist of the Dyers' Company for this information. © *Worshipful Company of Dyers*

become members of other guilds or corporations but they had to comply with certain restrictions such as being prohibited from working with woad, as happened in Florence and other cities during the 11th and 12th centuries. Also, being at the far edge of Western Europe made it more difficult and expensive to acquire large quantities of dyestuffs, which had to be transported overland. Few raw materials seemed to grow happily in England, so the country remained mainly an importer of dyestuffs. Nonetheless, in 1187 or 1188 the Dyers' Corporation of London was established, making it possibly the first one in Europe.[121]

The textile industry still focused mainly on wool production until the mid-14th century, when Edward III put out the call to encourage Flemish dyers and weavers to come to England, thus enabling the English textile trade to develop.[122] His message received a good response during unsettled times in Flanders. With Flemish help England at last produced a cloth that could compete on the international market until, by the second half of the 14th century, the Flemish textile workers were recognised with their own guild in the City of London.[123] This improved the status the city had enjoyed with the Hanseatic League on the Baltic coast, since the reign of Henry III in the previous century, as an established trading port selling high-quality English wool.[124]

In recognition of this growth in the textile trade, every English tradesman was compelled by law to belong to a guild and, having chosen one, to remain in it. By 1355 there were already 32 guilds in London and by 1377 this number had risen to 48.[125] It was around this time that the guilds or companies began to adopt a distinctive style of dress, for which reason they came to be known as 'livery companies'.[126]

By the late 14th century there were finally several English fabrics which attracted international interest in towns like York (which had 59 dyers listed in 1400), Beverley, Stamford and Coventry. Lincoln was licensed to produce green, scarlet and grey; York red and purple; Beverley blue and red, known as pan de carleta[127] and Coventry blue, which was famed for the solidity of its blue colour and its colour-fastness. As such it was Coventry blue which gained the nickname 'true blue'.[128] However, not all international trade may have gone smoothly: in 1419 the *Liber Albus*, which has been ascribed to the legendary Lord Mayor of London Sir Richard Whittington, takes the part of the dyer against the interference of the 'merchant

strangers',[129] a rare occurrence in any city of a leader siding with the dyers.

That England had a less sophisticated dyeing industry at least throughout the late Middle Ages is perhaps indicated by the lack of regulation and the lack of any formal division between dyers of the high-class colours and those of the common colours; this was in contrast to the Italians, French and Germans who by this time had strict divisions and much regulation.[130]

DYER HIERARCHY

Just where dyers sat in the hierarchy of occupations depended on where the dyer worked. In Flanders during the period from the 12th to the 14th centuries the dyer was considered the highest level of artisan, the aristocracy of the textile workers, because of their specialised skills and knowledge.[131] On the other hand, in Florence, as we have seen, they were subjugated by the weavers and wool merchants. This was undoubtedly linked to profits, as an independent guild would demand higher pay.

In Paris around 1230 Queen Blanche of Castile made her own intervention in the debate by authorising that only weavers in two of the city's workshops could dye in the new woad blue to meet the demand for woad-dyed cloth. This infuriated the Parisian dyers, with the dispute lasting for nearly 40 years until the dyers were allowed to dye blue. However, it was not until 1375 that French weavers were finally forbidden from dyeing.[132] What we cannot know, however, is the extent to which the notoriously conservative dyers brought this on themselves by not wanting to give up their reds. Paris was probably the last city to require the masterpiece in blue. It is also a fact that the Paris dyeing industry was not large, with only 16 practitioners in 1287. While this had doubled to 35 dyers by 1300, the number of weavers had risen to 367, four times more than in 1292.[133]

In addition to a hierarchy among the various cloth trades, there was from quite an early date, especially in Germany, Italy and France, a hierarchy of skill in terms of the abilities of the dyers themselves. At the lowest level there were those who could dye simple colours, while the higher level was for those who could work with the more complicated and expensive dyestuffs, producing the masterpiece and passing the stringent tests of their peers. In France, there were two highly defined categories of dyer: *Le Petit Teint* and *Le Grand Teint*. In Germany the best dyers were known as *Schönfärber*, while the rest were called black dyers, *Schwarzfärber*. There was also a separate category of woad dyers (*Weitaere*) that was subject to examinations to test the full array of blue tones as well as greens obtainable with weld.[134] In Venice dyers were also divided into two classes, the Greater and Lesser Arts,[135] and in Florence those permitted to dye red with kermes and madder were elevated to the *tintori d'arte maggiore*.[136]

SUMPTUARY LAWS

Sumptuary laws began in the 13th century and grew out of the ruling class's response to the growing wealth of the merchant class, who could now afford the rich fabrics and adornments traditionally reserved for the nobility. Most sumptuary laws were about fashion and related to women, with prohibitions or limitations placed on the fabrics that could be used, as well as appropriate styles of dress, deployment of accessories, colours and dyestuffs. A secondary purpose was the protection of local trade. In 1326 a law was passed in England forbidding the wearing of foreign fabrics – unless of course one was truly wealthy and had an income of more than £30 per annum.[137]

In England the earliest sumptuary laws were enacted in 1336 followed quickly by others in 1337 and 1363. Under these laws, the yeomen and artisans could not wear silk, rings, jewels or buttons (buttons being new and very fashionable).[138]

Some of the sumptuary laws were motivated by a wider economic perspective, especially after the Black Death in the middle of the 14th century. Rulers in Italian city states wanted to see reinvestment in business and trade, not in personal adornment or silly fashions, as they referred to platform shoes. These were regulated to stop them growing to ridiculous heights in several Italian cities such as Siena and Milan.[139]

Sumptuary laws continued into the 16th century, though were often completely ignored by the nobility or the nouveau riche. In Rome in 1473 the municipal councillors set a maximum tariff for the articles that people could wear at 80 ducats; Cesare Borgia's satin shoes alone were said to cost 500 ducats, but no doubt he could afford to ignore such details.[140] Equally, the merchant classes found their own way around the regulations by wearing unregulated black cloth.

THE RISE OF BLACK

The growing fashion for black cloth came from three factors: the increase in sumptuary laws across Europe; significant figures, such as Philip the Good of Burgundy, starting to wear black and thus bringing it to prominence; and, perhaps most practical, dyers learning how to dye a rich saturated black colour around the period 1360–80 – prior to this the colour had been somewhat sludgy and blue, grey or brown-tinged, rather than a sable black.[141] The rising middle class, headed quite often by the textile merchants themselves, desired colours and fabrics of status but did not want to run foul of the sumptuary laws. Black was not included in these laws so the merchants' desire for it encouraged dyers to improve the quality of black dyeing. As a result black became the most splendid of cloths, hiding its luxury behind its supposedly restrained colour. In France high-quality black cloth started to be called *sobelins* or *sabelins*, from sable, as a mark of its perceived prestige value,[142] and by the end of the 14th century it was inventoried in rulers' wardrobes across Europe, including England, where it was worn by Richard II's entire court.

Initially, black was produced from lampblack, but this rarely coloured evenly and washed out quickly. Then dyers moved on to barks and roots containing tannins such as alder, walnut and chestnut, but these reacted badly in the sun and tended to fade. If they were combined with materials rich in iron salts their colour stayed longer, with the iron acting as a mordant, but the fabric often deteriorated more quickly. Iron filings dissolved in vinegar could also give a beautiful black, but this was fugitive and corrosive. In fact, the best black colour was achieved

Philip the Good, Duke of Burgundy, painted by Rogier van der Weyden in the 14th century. Following the death of his father, Philip always wore black which contributed to dyers learning how to create 'rich' saturated black fabrics, as Philip's sartorial choice led to others choosing black clothing. Vellum, French School, 14th century
© *Bibliotheque Nationale, Paris, France / The Bridgeman Art Library*

by using a madder and woad base overdyed with tannins such as gall nuts, which were expensive but coloured well.[143]

By the late 14th century, black was being seen as the new sober, civic and professional colour, which could also have rich undertones when worn by civic rulers and appealed to the merchant class by giving them their own status while still adhering to sumptuary laws.[144]

NOTES

1. Andres, GM, Hunisak, J and Richard T, *The Art of Florence* (New York; London: Artabras, 1999).

2. Brunello, Franco, *The Art of Dyeing in the History of Mankind*, tr. Hickey, B (Vicenza: N. Pozza, 1973) pp.135–6.

3. Ponting, Kenneth G, *Discovering Textile History and Design* (Aylesbury: Shire, 1981).

4. Leix, A, 'Technical Peculiarities of Flemish Cloth-Making and Dyeing', in 'Cloth-making in Flanders' *Ciba Review*, no.14 (1938) p.485.

5. Edmonds, John, *The History of Woad and the Medieval Woad Vat* (Little Chalfont: J. Edmonds, 2000) , p.11.

6. Munro, John H, 'Medieval Woollen Textiles' in Jenkins, David (ed.), *The Cambridge History of Western Textiles* (Cambridge: Cambridge University Press, 2003), pp.216–7.

7. Muthesius, Anna, 'Byzantine Silks' in Harris, Jennifer (ed.), *5000 Years of Textiles* (London: British Museum, 1993), p.349.

8. Even as late as 1892 Walter M Gardner, one of the founders of the Society of Dyers and Colorists, a society established to share and disseminate information on commercial dyeing, could write that 'The fact that Messrs Matheson find it commercially possible to undertake work of this character [printing and distributing books on specific dyestuffs], illustrates in a notable way how fast and how far we have travelled during the last 20 or even 10 years, although the old idea of keeping things secret dies hard.' Gardner, WM, *Logwood and its use in wool dyeing* (New York: Matheson, 1892), p.4.

9. Robinson, Stuart, *A History of Dyed Textiles* (London: Studio Vista, 1969), p.28.

10. Chenciner, Robert, *Madder Red: A History of Luxury and Trade: Plant Dyes and Pigments in World Commerce and Art* (Richmond: Curzon, 2000), p.46.

11. Brunello, p.146.

12. Chenciner, p.141.

13. Monnas, Lisa, *Merchants, Princes and Painters* (London: Yale University Press, 2008), p.25.

14. Brunello, p.124.

15. Pastoureau, Michel, *Blue: The History of a Colour*, (Princeton: Princeton University Press, 1999), p.60.

16. Munro, p.213.

17. Born, Wolfgang, 'Scarlet', in 'Scarlet' *Ciba Review*, no.7 (1938) p.213.

18. Leggett, WF, *Ancient and Medieval Dyes* (New York: Chemical Pub. Co., 1944).

19. Born, p.212.

20. Brunello, p.138.

21. Brunello, p.148.

22. Mola, L, *The Silk Industry of Renaissance Venice* (Baltimore; London: Johns Hopkins University Press, 2000), p.130.

23. Hopkins, David, *The Art of the Dyer 1500–1700* (Bristol: Stuart Press, 2000), p.29.

24. Brunello, p.131.

25. Brunello, p.140.

26. *Lettres Patentes: Statuts, ordonnances et reglemens que sa Majesté veut être observerz par les marchands maîtres teinturiers en grand et bon teint des draps, serge et autres étofes de laine de toutes les ville et bourgs de son Royaume* (Paris, 1669) section V.

27. Mola, p.112.

28. Monnas, p.25.

29. Cardon cites a Florentine example from 1442 where the price of scarlet cloth was 35–40 florins while perse blue, another highly prized colour, was 17–20 florins, which, as she points out, was still not cheap. Cardon, Dominique, *Natural Dyes: Sources, Tradition Technology and Science* (London : Archetype, 2007), pp.614–15.

30. Pastoureau (1999), p.62.

31. Symonds, Mary and Preece, Louisa *Needlework Through the Ages* (London: Hodder & Stoughton, 1928), p.199.

32. Boutell, Charles, *English Heraldry*, 10th edition, (London: Reeves & Turner, 1908), p.43.

33. Pastoureau, Michel, *Heraldry: its Origins and Meaning* (London: Thames & Hudson, 1997), p.100.

34. Pastoureau (1999), p.60.

35. HM Queen Elizabeth II's shield is quartered: two quarters represent England and bear the lions 'passant guardant'; one quarter represents Scotland with the lion rampant; and one the harp for Ireland.

36. Eve, GW, *Decorative Heraldry: A Practical Handbook of its Artistic Treatment* (London: 1897), p.31.

37. On the continent the lions were referred to as leopards, confirmed in February 2012 in a conversation at the College of Arms, London. The supporters on the coat of arms of the Worshipful Company of Dyers are still referred to as leopards, from conversation with the archivist (November 2011).

38. Pastoureau (1997), p.89.

39. Ryder M, 'Medieval Sheep and Wool Types' *The Agricultural History Review*, 32, Part 1 (1984), pp.14–28.

40. Brunello, p.258.

41. Deruisseau, LG, 'Colours in the Renaissance', in 'Dress Fashions of the Italian Renaissance' *Ciba Review*, no.17

(1939), p.603.

42. Vogelsang-Eastwood, Gillian, 'The Arabs AD 600–1000', *The Cambridge History of Western Textiles* (Cambridge: Cambridge University Press, 2003), p.163.

43. Pastoureau, Michel, *Black: The History of a Colour* (Princeton: Princeton University Press, 2008), p.71.

44. Varichon, Anne, *Colors: What They Mean and How To Make Them* (New York: Abrams, 2006), p.30.

45. Gage, John, *Colour and Meaning: Art, Science and Symbolism*, (London: Thames and Hudson, 1999), p.84.

46. Pastoureau (2008), pp.65–6.

47. Pastoureau (2008), p.61.

48. Pastoureau (1999), p.44.

49. Catholic Encyclopaedia Online, www.newadvent.org/cathen/04134a.htm.

50. Pastoureau (1999), p.41.

51. Catholic Encyclopaedia Online, www.newadvent.org/cathen/04134a.htm/liturgicalcolours

52. Zollinger, Heinrich, *Colour: A Multidisciplinary Approach* (Zürich: Verlag Helvetica Chimica Acta; Weinheim; Chichester: Wiley, 1999), pp.164–5. According to the Shorter Oxford English Dictionary 'thrum' has a couple of meanings, one being 'unincorporated threads', which would not work in this context, but it can also mean pile, as in a velvet, which would work admirably, meaning the three dimensions of the fabric – warp, weft and pile – were all inter-connected.

53. Specifically, painting Mary as the mother of the young Christ child allowed artists to depict her as a young and attractive woman.

54. Pastoureau (1999), pp.50–2.

55. Fouret, Claude and Vasseur, Marine, *Petites histoires: de la couleur et du travaille du Moyen Age à nos jours* (Paris: Somogy Editions d'Art, 2004), p.10.

56. Finlay, Victoria, *Colour: Travels Through the Paintbox* (London: Sceptre, 2002), p.324.

57. Pastoureau (1999), p.44.

58. Gage (1999), p.31.

59. Pastoureau (1999), p.85.

60. Bird, W, 'Guilds in Medieval England and Scotland', in 'Medieval Dyeing' *Ciba Review*, no.1 (1937), p.25.

61. Balfour-Paul, Jenny, *Indigo*, (London: British Museum Press, 1999), p.33.

62. Hofenk de Graaff, Judith H, *The Colourful Past: Origins, Chemistry and Identification of Natural Dyestuffs* (Riggisberg: Abegg-Stiftung; London: Archetype, 2004), p.244.

63. Balfour-Paul, p.36.

64. Cardon, p.345.

65. Balfour-Paul, p.34.

66. Ball, Philip, *Bright Earth: the Invention of Colour* (London: Viking, 2001), p.228.

67. Leix, Alfred, 'Medieval Dye Markets in Europe', in 'Trade Routes and Dye Markets in the Middle Ages' *Ciba Review*, no.10 (1938), p.329.

68. 'Close Rolls, Edward I: May 1281' in *Calendar of Close Rolls, Edward I: Vol.2: 1279–1288*, British History Online, Maxwell Lyte (ed), 1902, http://www.british-history.ac.uk/reportaspx?compid=112793estrquery=dyers, pp.120–6.

69. *Calendar of Letter-Books of the City of London: F: 1337–1352*, Reginald R. Sharpe (ed.) (1904), folios xci–c Aug 1344, pp.110–21. Available at British History Online, http://www.british-history.ac.uk/report.aspx?compid=33537.

70. *Calendar of Letter-Books of the City of London: K: Henry VI*, Reginald R. Sharpe (ed.) (1911), folios 131–40 1433–34, pp.172–82. Available at British History Online, http://www.british-history.ac.uk/report.aspx?compid=33719.

71. *Calendar of Close Rolls, Edward III: Vol.7: 1343–1346*, HC Maxwell Lyte (ed.) (1904), pp.68–70. Available at British History Online, http://www.british-history.ac.uk/source.aspx?pubid=1088

72. Bird, p.24.

73. Gutman AL, 'The Influence of Cloth-making on Flemish History', in 'Cloth Making in Flanders' *Ciba Review*, no.14 (1938), p.474.

74. *Calendar of State Papers and Manuscripts in the Archives and Collections of Milan: 1385–1618: Milan 1549*, Allen B Hinds (ed.) (1912), pp.19–21. Available at British History Online, http://www.british-history.ac.uk/source.aspx?pubid=1038

75. Pastoureau (1999), p.52.

76. Munro, p.211.

77. Parisien dyers were required to create their masterpiece in woad following the statutes of King Francis I in 1542. See Pastoureau (1990), p.190.

78. Wescher, H, 'Dyeing in France before Colbert', in 'Great Masters of Dyeing in Eighteenth Century France' *Ciba Review*, no.18, (1939) p.621.

79. Balfour-Paul, p.35.

80. Pastoureau (1999), p.64.

81. Hofenk de Graaff, p.216.

82. Brunello, p.136.

83. Dean, Jenny, *The Craft of Natural Dyeing: Glowing Colours from the Plant World* (Tunbridge Wells: Search Press, 1994) p.40.

84. Robinson, p.27.

85. Cardon, p.176.

86. Brunello, p.149.

87. Wescher, p.632.

88. Fouret and Vasseur, p.2.

89. Pastoureau, Michel, *The Devil's Cloth: a History of Stripes and Striped Fabric* (1991) pp.13–14.

90. Pastoureau, Michel, Simonnet, Dominique, *Le petit livre des couleurs* (Paris: Editions du Panama, 2005) p.80.

91. Though in England dyer's broom (*Genista tinctoria*) was also used extensively. Cannon, John and Margaret, *Dye Plants and Dyeing* (London: Herbert Press, 1994) p.110.

92. Balfour-Paul, p.30.

93. Hofenk de Graaff, p.3.

94. Ponting, Kenneth G, *A Dictionary of Dyes and Dyeing* (London: Bell & Hyman, 1981), p.7.

95. Monnas, p.24.

96. Bird, pp.23–8.

97. Brunello, p.136.

98. Brunello, p.138.

99. Brunello, p.140.

100. Pastoureau (1999) p.190.

101. Schoeser, Mary, *Silk* (London: Yale, University Press, 2007), p.41.

102. Phillips, Clare, 'The Earliest Times to 1550', in Ginsburg, Madeleine (ed.), *The Illustrated History of Textiles* (London: Studio Editions, 1991), p.30.

103. Brunello, p.142.

104. Brunello, p.150. Green could have been made from woad being processed as a standard dye when it will give yellow, as opposed to the usual processing to create blue.

105. Gutmann, AL, 'Technical Peculiarities of Flemish cloth-making and dyeing' in Cloth Making in Flanders *Ciba Review*, no.14 (1938), p.487.

106. Hofenk de Graaff, p.3.

107. Pastoureau (1999), p.67.

108. Geijer, Agnes, *A History of Textile Art* (London: Philip Wilson Publishers Ltd., 1979), p.87. The statutes of 1258 are known as *The Book of Etienne Boileau*. The publication of this book showed that tapestry was already an established art form.

109. Brunello, pp.93 and 144.

110. Vetterli WA, 'The History of Indigo', in Indigo *Ciba Review*, no.85 (1951), pp.3066–71.

111. Brunello, p.145.

112. Wescher, p.623.

113. Brunello, pp.140–1.

114. Varron A, 'Taxation on Mediaeval Dyeing', in 'Medieval Dyeing' *Ciba Review*, no.1 (1937), p.34.

115. Smith HG, 'Emblems of English Tradesmen and Merchants', in 'Guild Emblems and Their Significance' *Ciba Review*, no.13 (1938), pp.455–8.

116. Brunello, p.135.

117. Leix Alfred, 'Dyeing and Dyers' Guilds in Mediaeval Craftsmanship', in 'Medieval Dyeing' *Ciba Review*, no.1, (1937), p.10.

118. Leix, p.11.

119. Leix, p.10.

120. Edmonds (2000), p.20.

121. Archives of the Worshipful Company of Dyers.

122. Schaefer, Ch G, 'Notes on the History of Tapestry-Weaving in England' in Tapestry *Ciba Review*, no.5 (1937), p.165.

123. Leix, p.12.

124. Symonds and Preece, p.221.

125. Smith HG, 'Emblems of English Tradesmen and Merchants', in 'Guild Emblems and their Significance' *Ciba Review*, no.13 (1938), p.455.

126. Munro, p.220.

127. Duke, Dee and Edlin-White, Rowena, *The Medieval Dye Pot* (Nottingham: Woolgatherers, 2001), p.7.

128. Recorded in Ray, John, *A Compleat Collection of English Proverbs* (London: 1670), p.178. Available on Google Books, http://books.google.co.uk/books.

129. Bird, p.25.

130. Hopkins, David, *The Art of the Dyer 1500–1700* (Bristol: Stuart Press, 2000), p.23.

131. Brunello, p.150.

132. Pastoureau (1997), p.67.

133. Wescher, p.620.

134. Hofenk de Graaff, p.3.

135. Brunello, p.151–2.

136. Reininger, Walter, 'The Florentine Textile Industry of the Middle Ages', in The Textile Trades in Medieval Florence *Ciba Review*, no.27 (1939), p.963.

137. Bird, pp.24–5.

138. Butler Greenfield, Amy, *A Perfect Red: Empire, Espionage and the Quest for the Colour of Desire* (London: Doubleday, 2005), p.23.

139. Pastoureau (1999), pp.86–7.

140. Deruisseau, L G, 'Robes of State Affairs of State', in Dress Fashions of the Italian Renaissance *Ciba Review*, no.17 (1939), p.611.

141. Pastoureau (2008), pp.26, 90–6.

142. Pastureau (2008), p.73.

143. Cardon, p.417.

144. Pastoureau (2008), p.100.

4

Richness and Restraint: the 15th century

The 15th century saw transition from the medieval world into the Renaissance, beginning in Italy. In this century there is further evidence of increasing trade wealth, but also of colour fraud, which led to the introduction of trading standards. The papacy itself becomes involved in the textile trade, but by the end of the period there are the first signs of rebellion against conspicuous consumption, especially in Florence.

In the previous couple of centuries, European dyers had made a quantum leap forward in skills and professionalism to meet the demands of the burgeoning textile trade. By 1400 there were 40,000 looms in Bruges alone.[1] The Genoese exported beautiful velvets across Europe to centres such as London, where livery companies purchased them to make ceremonial clothing.[2] Some of these garments survived until the 20th century – we find reference to them in books from the 1920s[3] – but were then destroyed in the bombing raids on London in the 1940s. As more places developed their textile business, so more regulations were introduced in places such as Orléans, whose first dyeing statutes were issued in 1411.[4] In Florence Gargiolli wrote *L'arte della seta*, with the aim of collecting in a single volume the activities of the *setaiolo*, the silk workers. It contained all the information needed to practise the profession and produce the fashionable colours of the day, including the method of hank dyeing, and listed 40 dye-houses in Florence,[5] usually worked by a master, his family and only one or two assistants, the total number being restricted by law.[6]

SELVEDGES AND COLOUR FRAUD

As the dyers' skills and resources increased, (there were now six red dyes in Italy: madder, kermes, grain, lac, orchil and brazilwood),[7] they could select less costly dyestuffs but make an end product that looked and felt like the most expensive dyestuff had been used. The proof, though, would come to light later, after the merchant or customer had paid for the goods. Sometimes where the most fugitive dyestuffs had been used, the fastness of the colour was very limited. Authenticity, guarantee of quality and knowledge of the dyestuffs used became very important in protecting the reputations of textile cities. This was brought to a head with a series of court cases in Venice in 1453 around the use of red dyes.[8]

Unscrupulous merchants were mixing reds rather than using pure insect dyes for scarlet, and then trying to pass off the finished cloths as singly dyed. However, the colour did not have the fastness of pure kermes. As a result, new laws were introduced in Venice in 1457, according to which it was forbidden to mix kermes.[9] It was the same when dyeing with grain, the only exception being that dyers could give a topping to grain-dyed woollen cloth, using kermes, as had been done traditionally. Not only could the reds not be mixed with each other, dyers were forbidden from mixing any of the reds with indigo, orchil, vitriol (sulphate of iron or copper which would act as a colour modifier) or anything else. The final colours

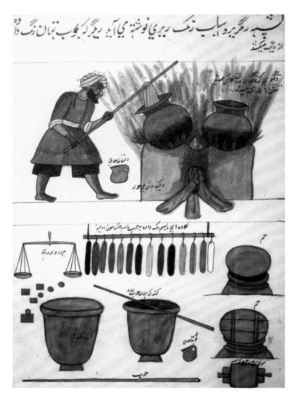

An Arabic dyer dyeing skeins of wool and displaying the tools of his trade. Here we see two dye pots in the fire and a range of skeins of different colours below; ink on vellum. © *Private Collection, Ken Welch, The Bridgeman Art Library*

were to be examined by the *Sazadori* (assayers) of the silk office and only then might they achieve the two seals with the crown that indicated official approval. Before the cloth could be sold, though, the merchant was obliged to place his own seal on each bolt of cloth to show that it had been duly registered at the office of the *Consoli dei Mercanti*. If this was omitted or the cloth failed inspection in any way, then perpetual infamy for the dyer would follow, with his name being emblazoned on the Rialto Bridge.[10]

As a longer-term approach to this problem cities began to specify selvedge colours to identify which dyestuffs had been used. In Venice from 1457 these were: two green threads with a gold thread in between indicating kermes; two gold stripes if dyed crimson; a central white stripe if grain; yellow if lac; and deep blue/turquoise if brazilwood.[11]

In Lucca in 1376, heavy velvet or satin cloth had been given a white selvedge while inferior-quality velvet or satin had a yellow edge; however, by 1382 the inferior quality was reassigned a blue selvedge.[12] Genoa passed new regulations in 1432 to allow the mixing of reds, but in 1466 this was forbidden again, together with a complete prohibition on the use of lac; in the same year Genoa added a blue-striped selvedge to distinguish red morello, their special red, from the use of cheaper brazilwood. By 1429 Florence had already prohibited the mixing of the kermes, grain and brazilwood to achieve *paonazzo*, and they were quick to follow the Venetians in developing selvedge colours.[13]

Soon the practice of defining selvedge colours spread to other dyeing cities. In Leiden the most valued textile was Leiden black cloth. This was made by weaving with blue wool but incorporating a selvedge of undyed wool. After weaving, the entire cloth was dyed in madder red, producing a black cloth with red selvedges, thus guaranteeing the quality.[14]

There was a slightly more extreme position in England in 1484, when during the reign of Richard III there was a case of fraud in both the colour and the size of the cloth. The discovery was that smaller cloths were being stretched on tenters to make them appear bigger than they had been when made, and that dyers were using fugitive colours; both of which practices led to poor-quality textiles.

Dyers within many cities, boroughs and towns of this your said realm of England habitually dye a great quantity of fine cloths as well as coarse cloths with imported orchil and cork, called jarecork, the colours made with orchil and cork are so false that the same colours never last but fade away, to the great harm of all those who wear or own any of the cloth thus dishonestly dyed. Also the said dyers habitually dye many cloths of various colours and fasten and sew great rushes called bull rushes upon the selvages of the same cloth in order to make the same cloths appear to be of one colour and the selvage of another colour so the buyers of the said cloths could or might easily believe that the same cloths have been dyed out of the

wool, to the great harm of you, most dread sovereign lord and of all your true subjects ... as a result of this imperfect and false making, dyeing and dishonest dealing, merchants of foreign countries who used to buy cloths made and dyed in this your said realm hardly dare to buy any of the said cloths to the great disgrace and dishonour of the same realm ... wherefore, unless a remedy is provided by your most noble grace, it is probably that the destruction of cloth-making in your whole said realm will consequently ensue, which God forbid.'[15]

This discovery led to a new Act which specified what size the cloth should be, how it should be dyed, tentered and fulled, and specifically how anyone found dyeing with orchil and jarecork would be subject to a fine of 40 shillings (40s), except for the allowance that cork grown in England could be used in the woad vat, provided that the same wool was *'perfectly boiled and maddered'*. If any cloth did not comply with these regulations, it would be seized and cut in three pieces, and the dyer sued.

RICH FABRICS

By the 15th century, dyers could dye the deepest, richest shades of silk thread. These could then be further enhanced by weaving using two colours, a weft of crimson for black or dark blue velvets which would not be seen on the surface but would give an underlying deepness and richness to the overall colour of the fabric. Venetian fabrics,[16] due to long-established trade routes, were much in demand from places like Constantinople, the centre of the Ottoman court.

At the end of the 14th century, English king Richard II, known for his extravagance had purchased many Italian velvets from cities like Lucca, including what came to be known as pile-on-pile velvet (having at least two different heights of velvet pile) – the most luxurious of fabrics.[17]

John Munro has calculated that in England the most expensive scarlet in the wardrobe of English King Henry VI was valued at £28 10s, at a time when the daily wage of a skilled mason was 8d a

Venetian cloth dyers demonstrating their trade and skills in the 18th century, though the central panel references back to the 16th century, and centre stage is Venetian scarlet, Italian School (18th century). © *Museo Correr, Venice, Italy, The Bridgeman Art Library*

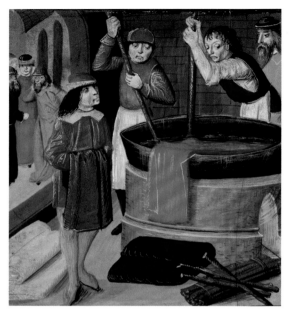

This is probably the most famous image of dyeing as an activity, found as a miniature in this book from Flanders from 1482 now in the British Library. What it demonstrates, however, is the colour choice of the manuscript illustrator and his image of the dye house, rather than reality. A finished bolt of blue cloth would not be set so close to the red dye bath, and in any case at this time it was forbidden to dye red and blue in the same workshop in Flanders. Secondly, the green tights are achieved from an ink for the artist, rather than anything the dyer could achieve. *Roy 15 E III f.269 Dyeing cloth, from Des Proprietez des Choses by Bartholomaeus Anglicus, 1482 (vellum) / British Library, London, UK / © British Library Board. All Rights Reserved / The Bridgeman Art Library*

day (about 3 pence). Moreover, as Munro points out, of all the English Kings of the period, Henry VI was the most ascetic and the least extravagant, with wardrobe costs far less than those of many other monarchs.[18] Edward IV's wardrobe account of 1480 showed him purchasing plain velvet dyed the most expensive colour, crimson from the carmine insect dyes, costing between 14 and 20 shillings a yard. Even fancier velvets in other colours only retailed at 8 shillings a yard.[19]

MR AND MRS ARNOLFINI

One of the most iconic paintings of this century is van Eyck's painting of Mr and Mrs Arnolfini.[20] Mr Arnolfini was a cloth merchant from Lucca. The fact that he could afford to commission this piece from the painter to the Duke of Burgundy shows the wealth that was now available to cloth merchants.[21] Much has been written about this picture by art critics and historians, but for me its most striking aspect is Mrs Arnolfini's dress. First, it is clearly in wool, not silk, though her husband, being from Lucca, the silk town, one might have expected a silk gown. Secondly, it was the fashionable style and length depicted in other paintings of the place and period. However, the fact that it is green must be commented on in terms of the requirement for dyers to make a masterpiece. Clara Hicks in her recent book comments that the colour is 'last season' and that Mr Arnolfini is wearing the more fashionable colour in silk velvet.[22] However, to me this is not the point. Van Eyck painted Mrs Arnolfini's dress in malachite which, just like lapis lazuli, could be used beautifully smoothly to give a strong, even saturation of colour. Dyeing cloth was completely different and most complex of all was achieving a bright green like this, which would have required two even baths of blue and yellow over something in excess of a 35-metre length.[23] While silk was always dyed in the yarn, woollen cloth, as depicted here, was often dyed in the piece, that is after weaving which takes us back to the requirements of the masterpiece in green – to dye evenly not just in one colour but two. Many of the other complex (overdyed) colours, the blacks and purples, were darker, but here we have a bright green which would need a real master dyer to achieve. Flanders was highly noted for its skills in green dyeing so this may be a tribute to local dyers, albeit at this time blue and red dyers (*blauwververs* and *roodzieders*) were separated in Flanders and had to swear an annual oath. Not only this but the number of dye vats per workshop was limited and there was even a rule as to when a new woad vat could be started, so as to avoid working on a Sunday (given that a new vat needed constant watching and work for the first few days).[24]

A green colour of this vibrancy could not be achieved without a combination of blue and yellow. However, one theory suggested by A.L. Gutman is that Flemish Green could be produced purely from woad.[25] By picking the woad in a different season and working it like other non-vat dyes, dyers found it could give a yellow colour.[26] The cloth would still be overdyed but this could all have been done in a single workshop as blue dyers were allowed to make green.

By this time, as Monnas has shown,[27] sumptuous woven fabrics in silk were available to the rich featuring pomegranates and other designs in fabrics with different coloured warp and weft threads as well as metal threads; those textiles celebrate the skills of the weaver, while in my view, this portrait of the Arnolfinis, where each of the main textiles featured is a single solid colour[28] celebrates the art of the dyer.

BLACK AND BLUE: THE CONTINUING RISE

The popularity of black continued to grow in the 15th century. For example, in Venice, aside from the Doge and the senators (who were required to wear red), all male citizens from the age of 25 were obliged to wear long black formal gowns in public, so the availability of fine black silk and wool was very important.[29] By the end of the century there came to be two types of black: the rich, colour-saturated black velvets, luxury woollens and silks, and the more austere black cloths representing the virtuous and moral colour that in the next century became associated with Luther and the Protestant Church.[30]

This moral perspective for black was started by Savonarola, who rose to power in Florence at the end of the century, imposing a strict dress code of unadorned black, even confiscating and burning brightly dyed fabrics as part of his bonfires of the vanities.[31] Though his 'reign' was only short-lived – he was burnt to death in 1498 – black remained a Florentine colour, gradually becoming richer, transformed into sumptuous black while still managing to retain a sense of restraint, sobriety and

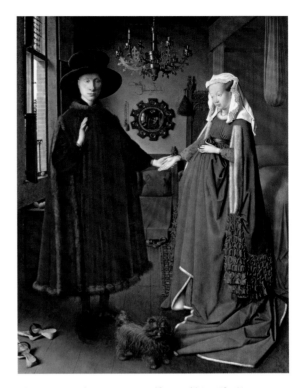

The Portrait of Giovanni Arnolfini and his Wife Giovanna Cenami (*The Arnolfini Marriage*), painted in 1434 by Jan van Eyck, has been explored for its symbolism in every facet, although least has been written about the colour of Mrs Arnolfini's robe and how this represented a masterpiece of double dyeing (oil on panel). © *National Gallery, London, UK / The Bridgeman Art Library*

standing. Instead, it was the likes of Luther who stuck with the strict, unadorned blacks.[32]

In terms of creating black, the new approach was to provide a blue base before dipping the cloth in a walnut, alder or chestnut bath. However, though it was contrary to strict regulations, red dyers often made a more successful black via the old method of first dipping in madder and then in secreted woad vats. This also enabled them to make solid greens from the yellow they were allowed to dye and a range of purples from using madder over woad.[33] Many black fabrics were also overdyed with iron mordants which, like the bleaching process for

white fabrics, significantly weakened the fibres.[34]

Blue also grew in popularity this century. Huge quantities of woad were produced throughout Thuringia and Saxony, so much so that these regions were considered the 'country's gold and silver mines'.[35] In 1480 purchase of woad in Erfurt was limited to citizens of the town alone, a deliberate policy of protectionism.[36]

Indeed, notwithstanding the rise of black for the rich, Pastoureau contends that by the end of the Middle Ages the hierarchy of colours had been reorganised and blue dominated, evoking for the upper classes royalty, nobility, fidelity and peace. The trend started in France but even for the common populace it became the favourite colour in Europe, usurping red and always staying ahead of black in general popularity.[37] Moreover, dyers, especially in Italy, had developed a number of blue shades of interest to the fashionable. As Monnas notes, one of the most challenging colours for the dyer was *alessandrino* dyed with orchil. This was so complicated that to achieve a good and even colour on silk the dyer could charge 75 per cent more than for ordinary blue with orchil (*azzuro*).[38]

COMPETITION

Fortunes were being made in textiles, and the major textile centres wanted to preserve their reputation. By 1429, Venice had its own hall, the Dyer's Guild, and a charter, the *Mariegola dell'arte dei Tintori*, containing the recipes of the guild.[39]

In France, Charles VII established the Monopole du Commerce de la Soie in Lyon in 1450, as a way to centralise the silk industry in France so that it could compete with the influx of Italian goods; by 1466, Louis XI had established the first royal manufactory there.[40] Just a few years earlier, around 1443, Jean Gobelin had developed his version of scarlet dyeing and set up a workshop in the Paris suburb of St Marcel on the banks of the River Bièvre. Eleven years later he bought the adjacent building and continued to further develop the workshop. By the 16th century, the family's wealth had grown to such an extent that they owned much of Bièvre, and scarlet in France was

usually prefixed as 'Gobelins' scarlet, so distinctive had it become.[41]

THE PAPACY AND TEXTILES

During the 15th century the papacy was to make a series of pronouncements which would have a major impact on the textile trade. The first of these related to European dyeing after the fall of Constantinople to the Ottoman Empire in 1453. The second related to the division of the world between the Pope's favoured explorer nations: Spain and Portugal.

With the loss of access to mollusc purple, in 1464 Pope Paul II decided to replace clerical purple with red from kermes for cardinals' attire.[42] However, the power shift from west to east had also blocked routes to the principal mordant, alum, which up until then had come from one of three sources: near Constantinople, at Phocaea (which had supplied Europe for several centuries through a Genoese monopoly),[43] and Đebinkarahisar in eastern Anatolia, which supplied parts of Italy.[44]

Unlike mollusc purple, kermes red needed a mordant, so it was extremely fortuitous that, simultaneous with the Pope's decree on clerical colours, one John de Castro discovered alum near Tolfa in the area of Civitavecchia just west of Rome – land leased by the papacy from the Medici. Although some say the Pope needed several demonstrations of its value, others contend the Papacy considered it a godsend against the over-spending of past popes,[45] he leased the mining rights from the Medici and then made a spiritual virtue of it, commanding all Christian traders to forsake their former alum suppliers and buy only from the papal lands as sales would pay for the war against the Islamic world.[46] As a monopoly of the Holy See, however, they also felt able to raise the price, charging people more than they had paid for Turkish alum.[47]

One of the pronouncements completely outside the influence of any textile merchants but which started a series of edicts of significant consequences for the next 200 to 300 years, was the papal bull of 1481, *Aeterni regis*,[48] in which the Pope summarily

gave all new lands south of the Canary Islands to Portugal. Although there was knowledge of land to the east from the trade routes, and was the original destination of Columbus's journey, there certainly had not been any known to the west.

However, following Columbus's return from the Americas, in 1493 the Spanish petitioned the Pope, Alexander VI who, in the bull *Inter caetera* amended the boundary for exploration and 'ownership' from a line of latitude to a line of longitude at 38° west or 100 leagues from the Azores, with Spain able to claim everything to the west and Portugal areas to the east as far as Africa.[49] However, Portugal objected, realising the vast lands, and therefore the profits, to be made in the west, and appealed to the Pope for a further redrawing of the map. In 1494, by the Treaty of Tordesillas, Pope Alexander moved the dividing line to 46° 37′ west, giving Portugal access to the east coast of South America.[50] This still did not deal fully with the land to the east and in 1506 Pope Julius II ratified the bull *Ea quae*, negotiated by the monarchs of both countries which gave Portugal exploration rights to a line of longitude half way through Australia.[51]

What remains odd about this to modern readers is that no other nation questioned Spain and Portugal's right to have the world divided between them. Financially, these papal edicts helped to make Spain an extremely wealthy nation for the next 300 years. However, they did not stop people from other countries exploring: John Cabot (originally Caboto), from Italy like Columbus, travelled to England and gained royal assent from Henry VII to '*find, discover, and investigate whatsoever island countries, regions or provinces which before this time were unknown to all Christians*'. In March 1496 he set sail on the *Matthew*, reaching Newfoundland on 24 June 1497 and claimed it for his new king.[52]

Meanwhile, the Portuguese were not forgetting their original right to explore and claim everything to the east of Europe, so in 1497 Vasco da Gama discovered the sea route to India via the Cape of Good Hope, arriving on 20 May 1498. De Gama knew of the potential riches of the Indies and was able to return with a wonderful selection of both dyestuffs and dyed and printed textiles. This marked a major development in dyestuff and textile

Extracting alum from the Papal lands near Civitavecchia was a timely discovery for the Papacy faced with growing debts, but it was also a chance to issue a rallying call against the Ottoman infidels. Mining the rock was just the first stage in a complex process to produce the final alum crystals suitable for dyeing; see chapter 1. *C1440 (colour litho) Italian School British Library London © British Library Board All rights reserved Bridgeman Art Library*

Cardinals in the Catholic Church today still wear bright red as decreed by Pope Paul II in 1464. *Cardinals in 2004 (photo) © Private Collection / The Bridgeman Art Library*

Woven silk damask dating from the 15th century made in Spain with Islamic geometric patterns. The fibres of this piece have been analysed using HPLC the analysis showed indigo for blue, kermes for red and weld for yellow. © *Victoria and Albert Museum (711-1907)*

trade as materials could be transported more easily by ship without incurring the heavy duties and taxes of the land route. With Spain and Portugal both bringing dyestuffs to Europe directly by ship, this broke the control of Venice, which thereafter began to lose its power as a trading hub.[53]

The late 15th century saw a new period for Spain with the marriage of King Ferdinand and Queen Isabella bringing together the kingdoms of Aragon and Castile. Unified Spain brought an end to the Moorish occupation, but it did have one detrimental effect on dyeing – many of the Jewish dyers in Moorish Spain were ousted along with the Moors, and their trade secrets for dyeing, colour mixing, mordanting, etc. were lost. Moreover, the expulsion of the Moors saw knowledge of what is now known as Turkey-red dyeing disappear until the 18th century.[54]

Spain did not take any new knowledge about dyeing to the New World. The knowledge exchange was all in the opposite direction, especially, though not solely, through the new dyestuffs: cochineal, old fustic, logwood, American indigo, etc. As Tarante and Marí note, '*Although the arrival of the Spanish conquerors marked a turning point in the history and development of our continent, their influence was not enriching regarding dyeing techniques.*'[55] Indeed, as those arriving from Spain could not work with alpaca, the local camelid wool, because it did not start white enough or whiten easily enough, they imported their own sheep, merinos, which had by now been developed to rival the quality of wool produced by English flocks.[56]

NOTES

1. Phillips, Clare, 'The Earliest Times to 1550', in Ginsburg, Madeleine, *The Illustrated History of Textiles* (London: Studio Editions, 1991), p.30.
2. Phillips, p.23.
3. Symonds, Mary and Preece, Louisa, *Needlework as Art* (London: Hodder & Stoughton, 1928), p.218. Symonds and Preece reference textiles of the Fishmongers and Saddlers' Companies, sadly no longer surviving.
4. Escudier, Denis, 'Documents sur les metiers de la teinturerie à Orleans (XVIIe et XVIIIe siècles)', in *Pigments et colorants de l'antiquité et du Moyen Age*, (Paris: CNRS, 1990), p.227.
5. Brunello, Franco, *The Art of Dyeing in the History of Mankind*, tr. Hickey, B (Vicenza: N. Pozza, 1973), p.163.

6. Chenciner, Robert, *Madder Red: A History of Luxury and Trade: Plant Dyes and Pigments in World Commerce and Art* (Richmond: Curzon, 2000), p.180.
7. Mola, L, *The Silk Industry of Renaissance Venice* (Baltimore; London: Johns Hopkins University Press, 2000), pp.108–9.
8. Mola, p.113.
9. Muthesius, Anna, 'Silk in the Medieval World', in Jenkins, David (ed.) *The Cambridge History of Western Textiles* (Cambridge: Cambridge University Press, 2003), p.350.
10. Mola, p.115.
11. Monnas, Lisa, *Merchants, Princes and Painters: Silk Fabrics in Italian and Northern paintings, 1300–1550* (New Haven, Conn.; London: Yale University Press,

2008), p.319.

12. Monnas, p.319.

13. Muthesius, p.350.

14. Hofenk de Graaff, Judith H, *The Colourful Past: Origins, Chemistry and Identification of Natural Dyestuffs* (Riggisberg: Abegg-Stiftung; London: Archetype, 2004), p.326.

15. Richard III: January 1484, *Parliament Rolls of Medieval England*, Act 27. An act concerning dyeing and wool and cloth.

16. Monnas, p.24.

17. Monnas, Lisa, 'Italian Silks 1300–1500', in Harris, J (ed) *5000 Years of Textiles* (London: British Museum, 1993), pp.168–9. Available at British History Online http://www.british-history.ac.uk/report.aspx?compid=116561.

18. Munro, John H, 'Medieval Woollen Textiles', in Jenkins, David (ed.) *The Cambridge History of Western Textiles* (Cambridge: Cambridge University Press, 2003), p.216.

19. Monnas (2008), p.24.

20. The painting by van Eyck is in the National Gallery, London.

21. Monnas (2008), p.9.

22. Hicks, Carola, *Girl in a Green Gown: The history and mystery of the Arnolfini portrait*, (London: Chatto and Windus, 2011), p.30.

23. See Hicks p.29 for a note on Wimbledon School of Art's recreation of the dress, which required 35 metres of fabric.

24. Hofenk de Graaff, p.326–7.

25. Gutman, AL, 'Technical Peculiariteis of Flemish Cloth-making and dyeing', in 'Cloth-Making in Flanders' *Ciba Review*, no.14 (1938), p.487.

26. There is also evidence of this technique from the Hallstatt textiles; see chapter one.

27. Monnas, (2008), p.181.

28. Mr Arnolfini's robe and the bed hangings are each single-coloured, although there are obviously woven motifs on the red bed hangings and Mr Arnolfini's robe is a rich-coloured velvet.

29. Born, W, 'Scarlet' in Scarlet *Ciba Review*, no.7 (1938), p.213.

30. Pastoureau, Michel, *Black: The History of a Colour* (Princeton: Princeton University Press, 2008), p.104.

31. Strathern, Paul, *Death in Florence: The Medici, Savonarola and the Battle for the Soul of the Renaissance City* (London: Jonathan Cape, 2011), p.260.

32. Varichon, Anne, *Colors: What They Mean and How To Make Them* (New York: Abrams, 2006), p.231.

33. Pastoureau, p.106. Grierson also contends that blue was considered essential as the base colour for complex colours such as black, green and purple (p.208;

Grierson, Su, *The Colour Cauldron: History and Use of Natural Dyes in Scotland* [Perth, Scotland: Su Grierson, 1989]).

34. Monnas (2008), p.160.

35. Leix, Alfred, 'Dyes of the Middle Ages' in Medieval Dyeing *Ciba Review*, no.1 (1937), p.19.

36. Leix, Alfred, 'Dyeing and Dyers' Guilds in Medieval Craftsmanship' in Medieval Dyeing *Ciba Review*, no.1 (1937), p.15.

37. Pastoureau, Michel, *Blue: The History of a Colour*, (Princeton: Princeton University Press, 1999), p.124.

38. Monnas (2008), p.24.

39. Leix, p.11.

40. Varron, A, 'The Development of Lyons as the Centre of the French Silk Industry' in Silks of Lyons *Ciba Review*, no.6 (1938), p.174.

41. Varron, A, 'The Gobelins: A Family of Dyers' in Tapestry *Ciba Review*, no.5 (1938), p.170.

42. Zollinger, Heinrich, *Colour: A Multidisciplinary Approach* (Zürich: Verlag Helvetica Chimica Acta; Weinheim; Chichester: Wiley, 1999), p.153.

43. Wild, John Peter, 'The Later Roman and Early Byzantine East 300–1000', in Jenkins, David (ed.), *The Cambridge History of Western Textiles* (Cambridge: Cambridge University Press, 2003), pp.140–52.

44. Chenciner, p.230.

45. Norwich, John Julius, *The Popes: A History* (London: Chatto & Windus, 2011), p.259.

46. The money raised helped pay off the Papacy's debts but also supported artistic purchases, so not all of the income from alum went towards the war against the infidel.

47. Born, p.221.

48. Gardiner Davenport, Frances, *European Treaties Bearing on the History of the United States and its Dependencies to 1648* (Washington DC: Carnegie Institute of Washington, 1917), p.49.

49. Norwich, p.261.

50. Aughton, Peter, *Voyages that Changed the World* (2007), p.50.

51. Marchant, Leslie Ronald, *The Papal Line of Demarcation and Its Impact in the Eastern Hemisphere on the Political Division of Australia, 1479–1829* (Greenwood, Western Australia: Woodside Valley Foundation, 2008).

52. Aughton, p.66.

53. Balfour-Paul, Jenny, *Indigo*, (London: British Museum Press, 1999), p.41.

54. Khalili Nasser D, *Visions of Splendour in Islamic Art and Culture* (London: Khalili Family Trust, 2008), p.36.

55. Taranto, Enrique and Marí, Jorge, *Argentine Textiles* (Buenos Aires: Maizal Editions, 2003), p.29.

56. Taranto and Marí, p.16.

5

Broadening Horizons: the 16th century

The 16th century marked the High Renaissance and expansion of European exploration across the world for new dyestuffs and fabrics. However, a fear of the new and its potential impact on trade also emerged, leading to prohibitions and taxes, as much as to opportunities for entrepreneurs. It was the start of the Golden Century for Spain as the riches of the New World arrived, but by the end of the period much of Europe would also have begun to benefit.

The century certainly saw its share of artistic splendour, from the work of Raphael, Da Vinci and Michelangelo through to Holbein and El Greco, but it was not without religious difficulties: Martin Luther and the Reformation and Henry VIII breaking away from the Church of Rome. Arising from these schisms, the upheavals that had the most direct impact on the textile trades were the Wars of Religion in France (1562–98), in which French Protestants (Huguenots) were persecuted, even massacred, with many forced to flee the country.

It was also the start of a more ignominious period, that of the slave trade from Africa, originally to Spain and Portugal and subsequently to the Americas, where slaves eventually were brought into the textile trade through indigo plantations.

Exploration, the artistic renaissance and the development of scientific enquiry (Galileo, Paracelsus, Copernicus) meant that by the end of the century the Middle Ages was a distant memory. And for dyers, too, the 16th century was the dawn of an exciting age that brought new challenges.

THE RAPHAEL CARTOONS/ BRUSSELS TAPESTRIES FOR THE VATICAN

It is rare to find original designs for textiles that date back 500 years.[1] It is even rarer for the original finished objects still to exist, but such is the case with the remarkable cartoons and tapestries commissioned by the Medici Pope Leo X in 1515, from Raphael and Pieter van Aelst respectively, for the lower walls of the Sistine Chapel (see pages 78–9).

The brief to Raphael was to depict the stories, drawn from the Acts of the Apostles, of St Peter and St Paul and the founding of the early Church. Because both cartoons and tapestries survive, this series offers perhaps the most complete demonstration of the different issues facing painter and tapestry weaver when it came to the choice and use of colours in art and textiles in the early 16th century.

Raphael and his assistants painted the cartoons as full-scale designs. As far as we know, Raphael was not given any instruction on the colours that he was to use, but he chose a limited colour palette: lead white, azurite blue, malachite green, vermilion and red lead, lead tin yellow, yellow, red and brown earth colours and carbon black. In addition, there was some use of vegetable or insect dyes, but these have faded on the paper.[2]

In Raphael's painting showing Peter healing the lame man, with John the Evangelist looking on,

Peter is dressed in a light blue robe and a golden cloak. The two principal figures stand out, not simply from their position in the centre of the piece as defined by the columns, but also from the choice of colours, which even after 500 years still look vivid and eye-catching. On the left of the picture there are two nude cherubs painted in a full range of pink skin tones, though it is considered that some of these may have faded.[3] Elsewhere characters are dressed in reds, whites, yellows and soft blues. The unusual pillars with their twisted sections and carved and embellished surfaces, based on the antique spiral column that formed the screen of the sanctuary in the old basilica of St Peter's,[4] add a further complexity, as does the depth in the painting, where lights illuminate the central interior darkness, adjacent to a view out to the hills through the open wall on the left.

Looking at van Aelst's tapestry, the first obvious thing is that it is worked in mirror image. It would have been woven on the side, to give the finished piece added strength, and from the back. The design was cut into strips and the outlines transferred to the warp threads. Each section would be woven and then rolled, across the 575cm (19ft) of its width, so that the weavers would not see the whole piece until it was cut from the frame. While the weavers would be used to this approach, they had no opportunity to stand back and see the overall effect, unlike painters. If Raphael wanted to highlight a fold or garment here or add a touch of contrast there, after his team had finished, it could be achieved quite easily. There was no such opportunity for van Aelst, who had to make all the colour choices for consistency, contrast and impact right at the beginning, ensuring that even though his team could not see it, the colours on the right edge, as they finished, matched those on the left edge where they had started.

The tapestry also reveals the smaller range of colours available to the weaver. Dyers in the early 16th century could still produce only a comparatively limited colour palette.[5] In particular, there were few colours that gave good skin tones. The weavers could not match the range of flesh colours available to painters, who, for instance, could mix vermilion or red lead with white lead to achieve a whole range

of pinks. There was no white dye to achieve the same effect. This lack of skin-tone dyes can be seen in the achievement of the 'colour of a young woman's cheek' 'Incarnato di cremisi' in Venice in 1527, some six years after the completion of these tapestries, being the subject of an official announcement.[6] So, even allowing for colour fade in textiles, the exposed areas of skin – the arms, legs and faces of all the figures, not just the cherubs – looks pale. In fact, it was not unknown for weavers to 'modify' the woven colours with paint to achieve better-coloured faces or exposed limbs.[7] The city authorities in Brussels passed a law against painting tapestries in 1538, but even they made exceptions for flesh.[8]

The main change, however, is to the colours of the costumes of the principal characters, starting with the colour of St Peter's cloak. This is a consistent change throughout the series of tapestries so that he can be easily identified, but the colour is changed from shades of golden yellow to red with a darker blue robe. The obvious question has to be 'Why?' Was this just the weavers making their mark regardless of the colours on the cartoon, or were there other issues? I would contend that the weavers chose to make these changes for very specific reasons, knowing the limitations of the colour range with which they had to work both in terms of longevity and strength of colour. They knew that there were endless yellows but none that really gave a golden look in wool, nor any with great depth. They also knew that yellows were the most fugitive of colours while red and blue were the most long-lasting. Furthermore, because red and blue could be made with greater or lesser strength or depth of colour, the dyer could also achieve a series of shades.

In other words, these two colours, red and blue would give the widest range of shades with which to best reproduce Raphael's use of colour and light in the folds and creases of the clothing worn by St Peter. To enhance the colour perception the weavers could use hatching[9] in different shades. Therefore the experienced weaver would realise these were the colours he needed to do justice to Raphael's paintings. The blue came from an indigotin dye, probably woad, while from recent chemical analysis of the red dye we know this was madder.[10]

The Healing of the Lame Man cartoon designed by Raphael and painted by his studio team. It is hard to believe that these were 'just' designs – later designers often do not complete the entire work, leaving notes instead to indicate colour or similar patterning, but these are painted in full and as such have been much admired in their own right, not just as an inspiration for the tapestries. *The Royal Collection © 2011 Her Majesty Queen Elizabeth II*

This does not mean, however, that only the strongest colours were used. Yellow is in evidence, though often edged with red, as in the jacket of the lame man, and underpinned at the sides and in the sleeve with blue hatching to help give definition to the garment even after it has faded.[11] What is more surprising is the choice of orchil, a lichen dye, for the purple-red colour. It was already known to be fugitive yet they chose to use it. One can only conjecture why, but perhaps because of the very limited range of purple-giving dyestuffs at this time, as well as an inability to imagine they would still be seen 500 years later. At any rate, the purple has long since faded to brownish colours.[12] The green that can be seen so clearly in the original cartoon was painted in malachite, but no green-dyed wool, requiring blue and yellow overdyeing, possessed the longevity of malachite paint.

One further difference between the painting and the tapestry is the use of metal thread. While gold was used in paintings, Raphael did not use it here because these were cartoon designs, never meant to be displayed in their own right. The weavers, however, incorporated gilt-wrapped threads in the weaving of the columns, giving added sparkle and lustre that was much in evidence to the Pope and his guests in the candlelight when the first seven tapestries were displayed on 26 December 1519. Vasari commented that *'the completed work was of such wonderful beauty that it astonishes anyone who sees it to think that it could have been possible to weave the hair and the beards so finely and to have given such softness to the flesh merely by the use of threads. The tapestries seem to have been created by a miracle rather than by human skill.'*[13] Inevitably, the metal threads have become

The Healing of the Lame Man tapestry, one of a series woven by Peter van Aelst and company based on the cartoons of Raphael at the behest of Poe Leo X, to hang on the lower walls of the Sistine Chapel. © *Vatican Museums*

tarnished by 500 years of dirt. It would be impossible to try to lift the dirt from the metal threads without doing irreparable harm to the surrounding threads so the piece now looks flatter in colour and shine than it would have originally; nevertheless, thanks to being kept in the rarefied confines of the Vatican, these tapestries are in remarkable condition considering their age.

NEW WORLD, NEW DYESTUFFS

When he first discovered it, Pedro Alvarez Cabral thought Brazil was only an island and named it Vera Cruz. In 1501 it was renamed Santa Cruz, but when the Portuguese laid claim to the whole territory they named it Brazil due to the large number of *Caesalpina* trees, making it the only country to be named after a dye source.[14]

Notwithstanding this new source of the dye, brazilwood continued to be controversial throughout this century. In 1524, Henry VIII of England banned it from being used to make scarlet, while in Venice it was only permissible for use on cotton, where the dyers did not expect to get a good colour and refused to use the more expensive madder and kermes.[15]

Brazilwood was not the only heartwood dye discovered in the Americas, the other being logwood. At first, it was thought logwood might be a substitute for woad or indigo, with a much easier dyeing process than the vat method those materials required. However, it was quickly found to be quite fugitive

Logwood was the principal new heartwood dyestuff from the New World, especially northern America. Initially banned as a blue dyestuff as it was considered much more fugitive than indigo or woad, it came into its own as a black and dark purple dyestuff for which it was used into the 20th century. *Photograph © Susan Kay-Williams*

as a blue, so much so that use of it as a blue dye was outlawed in some European states, including Venice and, in 1588, by Elizabeth I of England.[16]

Logwood, though, proved to be very versatile; with different mordants it could be grey, purple or black and it was here that it found its true calling. In these colours, especially black, it proved to be strong, with good lightfast properties. What is more, dyeing black with logwood was a less complicated process either than using gall nuts or overdyeing woad and madder. By 1608, English dyers were trying to use logwood to obtain black, but at least one was taken to court, with the register of 21 October stating that though the dyers disclaimed the use of any logwood yet the contrary was proved.[17] As black clothing continued to grow in popularity, despite the ban not being lifted in England until 1660, logwood became the quintessential black dye source right through to the 20th century.[18]

The most significant of the discoveries from the New World was what was first described as the berry or fruit of the nopal cactus, as a result being referred to as *grana cochinilla* or cochineal. When Cortés and his crew landed in Mexico in 1519, he saw Aztec farmers harvesting the 'berries' and was amazed by the colours they achieved using this dyestuff in their clothing. He started shipping cochineal back to Spain and by 1523 had received a decree from King Charles V to send back as much as possible, not least because he could see the potential for taxes.[19]

It was not until the development of the microscope that cochineal could finally be identified by Europeans as an insect,[20] a delay easily explained when one considers that only the Aztecs and those Spanish who ventured west had seen the insect alive on the plant. Commercial protectionism by the Spanish was so strong that no one in Europe saw a live female cochineal for several centuries. What was made available was always the dead and dried end product, not conducive to being identified as an insect given that the process of gathering, drying, bagging and transporting it over thousands of miles would have worn away recognisable signs, such as legs, for example, leaving a hard, silvery-red 'berry'.

The Spanish were adamant about retaining a monopoly over their finds from the New World, and they succeeded for nearly two centuries by keeping non-Spanish adventurers at bay and making all imports from the Americas go through the city of Seville, to keep a tight control over taxation and distribution. In the 18th century the French sent a spy, Nicolas-Joseph Thiery de Menonville, to try to steal the secrets of cochineal farming. He managed to learn how they were produced and even stole some plants containing cochineal insects. By the time he reached Saint Domingue (Haiti) he had lost most of the plants and struggled to establish a colony although he was granted the title of *botantiste du roi* in recognition of his efforts. However, these efforts finally caught up with him and within three years, before he had been able to send any cochineal back to France, he died of a fever.[21] The Spanish retained their monopoly.

Cochineal became the second most valuable export from Mexico after silver, and ships laden with the precious cargo became targets for piracy. In 1597, the Earl of Essex captured a Spanish convoy and seized their entire consignment of 24,950kg (55,000lb) of

cochineal, worth over £80,000, an enormous sum for the time. Queen Elizabeth allowed her favourite to sell it as a monopoly on very favourable terms, even banning others from importing any more cochineal for two years.[22]

What made cochineal so desirable was the quality of the red dye it gave. While kermes still continued to be used, at least until the early 17th century, cochineal quickly saw off the Polish carminic insect, and soon became the most important red dye in European textiles.[23] This did not, however, mean that cochineal was accepted instantly. As we have seen, Venice was the most stringent of dyeing centres, particularly keen to protect its reputation.

So it was not until 1543 that the Venetians officially put cochineal to the test, documenting the whole process. The dyers gathered at the silk office. One was handed three skeins of silk to mordant with alum; at the same time they placed the three varieties of cochineal they intended to test in bowls of water to soften them. The following week they met again and three experiments were undertaken simultaneously by three different master dyers. The chosen dyers each dyed a skein of silk and as a control, a fourth skein dyed in kermes was provided by another master silk dyer. When all four were compared as being equally good, the *provveditore* overseeing the test collected everything that had been used and ordered the administrator of the guild to keep it all in the silk office '*in everlasting evidence of the event*'. This obsessive keeping of the evidence was, Mola contends, a way for the dyers to skirt any objections from the city authorities, who usually made the rules about permissible dyestuffs. With one exception, the Venetian dyers accepted the test and moved quickly to use the new dye.[24]

The Florentines and the Genoese had different approaches. In Florence a couple of years earlier Lapo da Diacceto had undertaken experiments with cochineal and found very striking results on silk. Because creating and selling luxury textiles was considered a matter of state importance, Cosimo I de' Medici, Grand Duke of Tuscany, gave Diacceto protection while he continued his experiments and then the Florentine Republic quickly adopted cochineal dyeing.[25] In contrast the Genoese were

Dried cochineal beetles prior to being pounded to a powder for use as a dyestuff. It is easy to see how Europeans thought they were a berry rather than an insect. *Photograph © Susan Kay-Williams*

much more sceptical and deliberately shunned the new dyestuff for fear of it affecting their reputation. In the end, however, it was their pocket that was affected: because other cities adopted the new dyestuff more quickly, they gradually realised that they were missing out on French and German trade. So finally, in 1550, the Genoese dyers hurriedly petitioned the State to change its stance.[26] One common element agreed in each city was that the new dyestuff had to have its own selvedge colours.

In Venice in 1557 the *Consoli dei Mercanti* demanded the *setaioli* apply green selvedges with a silver thread in the middle to all velvets, damasks and satins dyed with cochineal, as opposed to kermes cloth, which featured a gold thread. For less expensive fabrics, the selvedge had to contain a thread of white silk if using the foreign cochineal.[27]

Unfortunately, however, cochineal attracted the same kind of adulteration as madder. This reduced the potency of the colour and could also lead to other side effects such as detritus adhering to the yarn or fabric causing uneven dyeing. This was a major problem as it could result in the cloth having to be redyed in order to be considered fit for sale, at great expense to the dyer.[28]

From recent chemical analysis of garments and other textiles thought to date from the 16th century, the conclusion could be drawn that by 1550 the kermes trade had all but disappeared, replaced by cochineal.[29] However, it must be remembered that we can only analyse the fabrics we have, which are few, so for this reason it would be wrong to assume that all use of kermes disappeared after the mid-16th century. It is also known that the Venetian authorities actively fought for kermes use to be continued, and for cochineal and logwood to be ignored, through three Acts of 1558, 1569 and 1574, thus implying that kermes was still being used in some quarters, even if in general these laws were being ignored. It would be equally wrong to assume that all parts of Europe moved to cochineal at the same time. As de Graaff notes from extant examples originating in the Netherlands, cochineal did not become significant there until the 1580s, not least because of madder's commercial importance.[30]

1548, *THE PLICTHO*: THE FIRST BOOK ON DYEING FOR PROFESSIONALS

The first printed book containing dyeing recipes was *T Bouck vā Wondre*, published in Brussels in 1513. However, the book was intended for domestic use and dyeing was not its primary aim.[31] The first practical book on commercial dyeing, complete with recipes, was written in Italy by Giovanventura Rosetti. Commonly known as *The Plictho*, the full title in English is *Instructions in the art of the dyers which teaches the dyeing of woollen clothes, linens, cottons and silk by the great art, as well as by the common*. Rosetti worked in the Venetian Arsenale in logistics and procurement, a task which must have taken him to a number of Italian cities because as well as Venice he collected recipes from Florence, Genoa and other places over a period of 16 years. The writing of the book leads to a number of questions: why did he devote 16 years of his 'spare time' to writing a book of no direct use to himself, but which, according to his own hand, was for

the 'encouragement of anyone who wished to ply the craft of dyer'.[32] He dedicated it to the people of Venice, but it is not clear how he obtained the recipes from the notoriously guarded dyers in the first place. For centuries, nothing had been written down about the processes and secret recipes that dyers followed. Knowledge was learned on the job, indentured as an apprentice for seven years then as a journeyman working with different masters, before endeavouring to earn enough to set up shop and undertake the practical examination of a masterpiece in order to become a master dyer.[33]

That dyers were cautious about their secret recipes is shown by the fact that in the 16th century the Venetian dyers even invented a 'white ghost' to protect their secrets and to try to generate superstitious respect from the citizens. Citizens were reluctant to give this because the dyers were perpetually associated with unpleasant smells and pollution of the canals. [34]

If Rosetti's reasons for writing *The Plictho* are uncertain, it is also an unusual title although Edelstein sees *Plictho* simply as the forerunner of the modern Italian word *plico*, which means a collection of important papers or instructions.[35] What we do know is the breadth of its contents and also that it was so popular it went through five editions in Italian during the 16th and 17th centuries with a sixth edition in French published in the early 18th century.[36] There is also a debate as to whether 1548 was the first edition of this book, as there is an edition which has as its date imprint MDXL (1540). Edelstein and Borghetty undertook extensive research on this matter in the 1960s and I would tend to agree with their conclusion that the printer of that book, working in reverse, simply transposed two of the roman numerals in error, so the publication date should have read MDLX (1560).[37]

Edelstein describes this as a most important book in the history of technology;[38] one of the first manuals or books of instructions in any subject. But what was the reaction of the dyers of Venice, Florence, Lucca and Genoa on its publication as it laid bare their dyeing secrets? Two thoughts occur: first that Rosetti talks about paying for the recipes, and secondly that none of the new dyestuffs are

mentioned. The book was not published until 1548, five years after the Venetian dyers performed their industry-changing tests on cochineal, but there is no mention of the substance in *The Plictho*. Was this commercial protection? Quite probably. It stands to reason that they would not be prepared to give up the recipes for their new dyestuffs, but were more willing to share those that had been used for centuries, especially if they had now been superseded.

The Plictho gives a fascinating insight into the dyers' trade, complete with a variety of recipes that show the enormous lengths that professional dyers would go to in order to achieve a good colour. Altogether *The Plictho* contains 108 recipes, including 35 for red; no other colour has as many recipes, which seems to indicate not only the variety of dyestuffs for red, but also its enduring popularity. Of these 35, 16 are for dyeing wool including Venetian scarlet, 12 are for dyeing silk and just four are for dyeing linen and cotton, giving a good indication of the greater complexity and less satisfactory results of dyeing cotton and linen.[39]

The quantities in *The Plictho* suggest industrial scale: four pounds of alum, 12 pounds of wool and ten pounds of grain (comprising six from Provence and four from Corinth) for a recipe for scarlet. In contrast, a recipe from *Segreti del Rev Donno Alessio Piedmontese* or *Alessio Piedmontese's book of secrets*, first printed in Venice in 1555, a domestic book of household lore that was also popular and frequently reprinted,[40] has quantities of half an ounce each of brazilwood and *Kermes vermilio* and a nut of alum. But it is not only quantity that highlights this second recipe as being for the domestic market. The mixing of brazilwood with kermes indicates that it was used for lower-grade textiles.

After the recipes for red, *The Plictho* contained 21 for black, the second largest number, indicating its growing popularity. What is surprising, however, is that most of the recipes require a combination of iron salts with tannins from oak galls, sumac or alder bark. Brunello, Edelstein and others comment on the fact that the overdyeing of two or more colours, such as madder and woad, is not mentioned[41] (especially as we now have chemical analysis that proves this technique was used),[42] but perhaps it was another

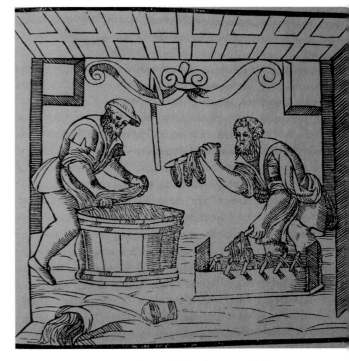

One of the images in the first published commercial book on dyeing, which in turn was one of the first ever scientific manuals on any subject, the *Plictho*. Here skeins of wool are being dyed; a second illustration shows dyeing in the piece. These are the two principal approaches to dyeing: yarn or cloth. Photograph © *Susan Kay-Williams*

sign that there were still commercial secrets the dyers wanted to keep to themselves and, of course, there is no mention of logwood.

The greatest surprise is in the recipes for blue, because there is no mention of vat dyeing at all; therefore de facto there cannot be reference to woad or the newly emerging indigo, both of which are vat dyes. Instead the book refers to orchil for blue, used with weld and verdigris for green. This seems a rare omission but no reason has been put forward as to why there are no vat-dye recipes. Perhaps the blue dyers were simply still too protective. However, for all the questions *The Plictho* provokes, it is a fascinating book and shows the important role of textiles to trade in the 16th century.

Crimson-flowered broad bean is currently the only known variety of this plant which has a coloured flower, as opposed to the common white flower. It is now a heritage variety under the care of Garden Organic's heritage seed library. *Broad bean flower © Herbie Knotts*

di fava or 'broad-bean flowers although he does not specify what colour this was. What is interesting about this is that, as any contemporary vegetable gardener will know, broad-bean flowers are white, except for one heritage variety known as crimson-flowered broad bean. Now, while one cannot make any assumption that after 500 years of horticulture the name of a 16th-century colour of silk and the colour of this bean's flowers are related, it does offer a convincing reason why a dye shade would be given such a name.[45]

By the 16th century, Mola contends, there is also evidence of new greens, the fashionable colours in Venice being *foglia d'alloro* (laurel leaf), *verde d'erba* (grass green), *verdegaio* (lively green), *verde porreo* (leek green) and even one called *festechino* described as the colour of 'the fields under crop in April'. Even blues had a major expansion to their range, from the very dark to the lightest blue, with special pride and protection being given in Venice to the shade *colombino*, a shade referred to as the colour of the iridescence of the neck of a pigeon.[46]

NEW COLOURS

Dyers have always sought new colours achieved through experimentation. By the 16th century the impetus was fashion and their greatest opportunity was with the dyestuffs of the New World: fustic, annatto, logwood, brazilwood and cochineal, as well as indigo from the east, mixed with a variety of mordants to achieve new colour combinations. Indicative of this burgeoning range of colours, the names became more fanciful too. One 16th-century English book lists the shades of red as from '*lustie gallant to maiden's blush*' incorporating '*Catherine pear, carnation, incarnate, sangwyn, stammel, flame, gingerlin, murrey and peach*'.[43] In Italy the main red shades for silk were *incarnate*, *rosasecca* and especially the purple-red *paonazzo*, which had been known since the 14th century.[44]

In the late 16th century, the Venetian Giovan Andrea Corsuccio recorded the range of new colours and shades that the dyers were creating, including ruby red for silk. Corsuccio also called a colour *fiori*

INDIGO IN EUROPE

From the beginning of the 1520s Portuguese explorers were bringing Indian indigo, or *anil* as they called it, into Europe via the sea route. While quantities were small, they attracted great interest. Places like Venice and England were keen to use the new material, as neither had a significant woad industry.[47] The Emperor Ferdinand, on the other hand, referred to indigo as the Devil's Dye as a way of dissuading superstitious dyers from trying it; in 1577, it was even prohibited from being used in the German states,[48] likewise in France, in efforts to protect the native woad industries . However, there were some frustrations with the new dyestuff because dyers did not know how to get the best out of it and were using a process known as the Orpiment bath. Orpiment is another name for arsenic and as such it had an injurious effect on any one or thing with which it came into contact. In the end, it was the woad dyers who helped to solve the problem by using woad's fermentation process on the indigo.[49]

Even adventurous Venice banned the use of indigo on wool in 1588. However, in 1589 the Venetians learned a new recipe from Constantinople, where the dye had been used for some time, and this turned around indigo's fortunes, especially when dyers realised that the new material had more strength of colour per pound than woad.[50] Indigo as well as logwood was banned in England by Elizabeth I in 1581 and their use forbidden until 1660, although it was hard to enforce and like logwood, indigo was in common use before the Act was repealed.[51]

THE WARS OF RELIGION IN FRANCE

At the beginning of the 16th century, the dyers of Paris handled around 600,000 articles per annum, but the Wars of Religion in France, which lasted for most of the second half of the century, had a particularly deleterious effect on the dyeing and textile industry.[52]

It was in the 1570s that France first issued statutes to set prices for different fabrics and different colours and the different places it could be sold. These were very specific and extensive pieces of legislation which ran through to the 1620s without the prices the dyers and weavers could charge changing at all. However, as we have seen, the same Act being renewed is more often an indication that it was being ignored, rather than slavishly followed.[53]

But the biggest challenge to the French textile industry was the fact that most of its practitioners were Huguenots. As a result of the wars, the number of Huguenot communities declined from 2150 to fewer than 750 due to destruction or migration. Surviving communities fled to more sympathetic countries including England (where they settled at Spitalfields in London and in Kent and East Anglia), the Netherlands, Flanders, Switzerland and Germany. By the time of the Edict of Nantes in 1598, which brought the wars to an end, Paris was dyeing fewer than 100,000 articles a year.[54]

With the textile industry in France decimated, the appearance of indigo represented a further threat, so in 1598 the French authorities issued the first ban on its import and use.[55] For much of the following century, the French would continue to try to protect the indigenous woad industry through home consumption and endeavouring to maintain exports to countries like England.

COMMERCIAL DEVELOPMENTS IN MADDER

The Netherlands had been the major centre of madder growing for centuries, but by the 16th century greater quantities were needed. The Dutch were extremely good horticulturalists at this period in everything from the tulip to the carrot. They cultivated new varieties with the characteristics they desired (e.g. the orange carrot) and in the case of madder they developed a variety with a small compact rhizome[56] rather than the thin, long rambling roots described by Field in Chapter 1 (see p.18). This made cultivation more manageable, when between 20,000 and 30,000 plants could be planted per acre,[57] while at the equally important stages of drying and grinding, a thicker root meant less outer husk needed to be removed.

After this, the madder could be packed and stored away from the light for up to two years whereupon the best madder '*has the shade of the saffron colour and gives off a strong but not unpleasant odour*'.[58] The finest Dutch grade was known as *Krap*, although in Germany the word *Krapp* was used for madder in general.

COLOUR AND POWER IN THE 16TH CENTURY

While blue and black were increasingly popular colours for clothing – it was de rigueur for young men of good houses to have their portraits painted in black by the 16th century[59] – the ultimate colour of power remained red, especially for the first half of the century. This can be seen in the portraits of nobility such as the founder of the Medici clan, Cosimo de' Medici, painted

This painting is of an unknown young man by an unknown Flemish painter depicts a serious case of social climbing in his posture, his location and, above all, by being clad head to toe in extravagant red cloth. Velvet, silk, satin and fine blackwork embroidery on his shirt, he is the epitome of the nouveau riche. *Portrait of a Man in Red*, 1520–30 (oil on panel), Flemish School, (16th century). *The Royal Collection © 2011 Her Majesty Queen Elizabeth II / The Bridgeman Art Library © Royal Collection. Used with permission.*

posthumously in 1530 by Jacopo Pantormo. Being mindful of his rightful position, it was Cosimo who commented that 'a gentleman could be made from two yards of red cloth', a caustic put-down to the nouveau riche – not that such comments stopped them, as can

be seen from the portrait of an unknown Flemish young man dressed from head to foot in red. While Cosimo was painted in a loose red patrician gown and hat, the young pretender attired himself from top to toe in many more than two yards of red fabric; and it is not just any red fabric, as the sheen and texture of the ensemble suggest silks, satins and velvets. Moreover, his exposed collar and cuff exhibit exquisite blackwork embroidery, another sign of fashion and wealth in the sixteenth century. And if that was not enough, while Cosimo is pictured in a domestic setting, the young man stands on a mountaintop.

In this case, Luther concurred with Cosimo, though from a completely different perspective. To Luther, the New Testament references to red and purple, as epitomised in the reference to the whore of Babylon in Chapter 1 (see p.24), made the clothes of the Catholic clergy downright abominable.[60] He opposed all displays of coloured clothing, keeping to black.

For the English royal family of the early 16th century, Henry VIII and his family, as Maria Hayward has discovered, purple was undoubtedly the colour of royalty. Following his sumptuary laws, the only ones aimed at men,[61] from 1510 onwards, purple was to be worn only by or with consent from Henry himself. In this context, it is interesting to note that there are no pictures of Henry in purple; the extant pictures of the monarch show him in red.[62]

This family portrait (p.88) painted circa 1545 by an unknown artist depicts Henry, his son the future Edward VI and Jane Seymour (included posthumously), Mary Tudor and Elizabeth, all resplendent in reds and golds. Why so, if Henry believed that purple was the royal colour? Perhaps because red was the English royal colour, representing for a Tudor monarch the victorious red rose of Lancashire, and thus for portraits a manifestation of history and divine right.

It is interesting to note in this painting another of the contrasts between what is painted and the known reality. The backcloth to this picture is a dark blue carpet. We know the carpet existed because it was inventoried, except for one significant point of difference, that the background in the original carpet was actually red, not blue. To meet the needs of the painter in setting off the royal family, the background

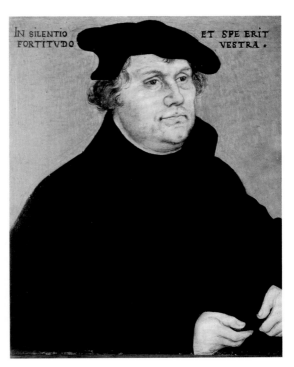

Cosimo de' Medici (*Il Vecchio*), painted posthumously in 1518 by Jacopo Pontormo. He was painted in red as befitted his station as the head of the dynasty that was banker to Europe. *Cosimo de Medici, Cosimo de' Medici (Il Vecchio) (1389–1463) 1518 (oil on panel), Pontormo, Jacopo (1494–1557) © Galleria degli Uffizi, Florence, Italy / The Bridgeman Art Library*

Martin Luther depicted by Lucas Cranach the elder in Reformation black. Luther's comfortable clothing had nothing ostentatious or flamboyant about it, this style and colour was 'moral' black. *Martin Luther, c.1532 (oil on panel), Cranach, Lucas, the Elder (1472–1553) © Museum der Stadt, Regensburg, Bavaria, Germany / The Bridgeman Art Library*

colour was changed.[63]

By the end of the century, the move to black from red was virtually complete. As we have seen, the means by which black could be made were varied and had the potential for significant adulteration. Venice recognised that the methods for dyeing black were changing, but in this instance, for once, they did not keep to their meticulous standards, which had consequences that greatly contributed to the decline of the Venetian dyeing trade. The technique called in *goro e crescente* was a method for dyeing black originally used for dyeing haberdashery such as silk ribbons and embroidery threads. These fashionable items were frequently dyed with poorer, less fast colours than those used for fabric. However, in this

case the issue was not merely the fastness of the colour, but rather that the *in goro* dye bath contained many impurities which clung to the silk. Degummed silk needed some weight adding to help the material drape – achieving a silk weighted to what it had been before degumming was called *à pari*, but adding extra weight was called *above pari*. While equal weighting was good for the silk, overweighting had negative effects on the silk's colour and longevity.[64] As silk was sold by weight at this time not length, the unscrupulous traders made more money from the heavier weight of silk while the actual quality of the dyeing was not as good because of the presence of impurities in the excess weighting. Silk ribbons were bought as fashionable items, changing the ribbons

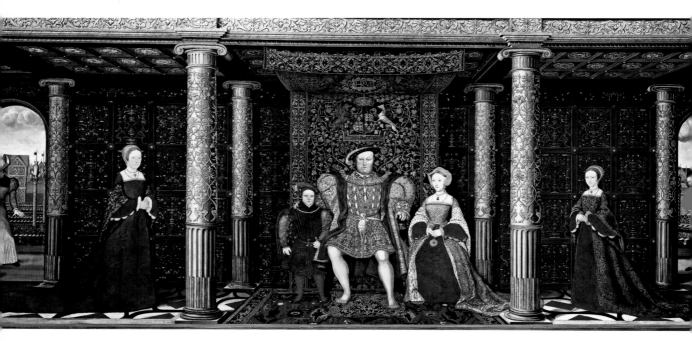

In use, this picture is often reduced to the central third, Henry VIII with Jane Seymour and their son the future Edward VI, but in our context it becomes more fascinating when it includes Mary, on the left and Elizabeth on the right. The entire royal family is dressed in English royal red. *The Family of Henry VIII*, c.1545 (oil on canvas), English School, (16th century). *The Royal Collection © 2011 Her Majesty Queen Elizabeth II / The Bridgeman Art Library*

on one's bonnet being considered fashionable, so no great longevity was expected from the colour or ribbon, but this was not the case with silk fabric which was expensive and customers wanted the colour and the fabric to last longer.

When the *in goro* technique began to be used by some unscrupulous yarn and fabric dyers out to make a quick profit, there was outrage and in 1580 the Venetian dyers petitioned the government to outlaw the practice. Unfortunately, on this occasion the authorities were not quick to act, looking to the potential impact on revenue rather than reputation, and by 1584 they had still not ruled on the matter. At this point the Venetian dyers took matters into their own hands, with the silk guild creating the regulation of 1546 requiring black to be made with Istrian gall nuts as the only way to dye black.

However, the black silk-dyeing market was growing exponentially and not surprisingly many dyers continued to use the *in goro* techniques. The

silk guild was furious and continued to petition for the 1546 regulations to be enforced.

The reputation of Venetian dyeing had been based on superior quality for high prices, but by the end of the 16th century, as a result of this dispute, this was no longer the case. While there was certainly a market for cheaper fabrics, Venice's customers, wanting quality products, began to look elsewhere to the luxury black velvet produced in Genoa, and the reputation of Venetian dyers never recovered.[65]

ELIZABETH I

By the end of the century black had become a dominant colour even for royalty. Elizabeth I's costume as queen moved markedly from the bright reds of her father (and her own youth) to black as the new colour of power, and white as the colour of purity

and virginity, as can be seen in a number of portraits. Elizabeth, one of the first monarchs to draft an edict to control images of herself,[66] even referred to black and white as 'my colours'[67] often embellished with jewels and embroidery in her portraits. As we have seen, fabric required extensive bleaching to achieve whiteness, and over the period of wear the level of 'whiteness' would deteriorate in a way that a painted image in oils does not. As a result of the complex processes needed to achieve them, both black and white were luxury fabrics, expensive even before embellishment, but now more readily available at the newly emergent Spitalfields silk-weaving area. So this was no austerity code, as Elizabeth's gowns were completed with lavish embroidery (her embroiderer earned sums second only to her tailor, such that when her first embroiderer, David Smyth, died he left enough money for a row of almshouses to be built).[68]

Elizabeth was not as profligate in the money she spent on clothes as some of her successors would prove to be, but she certainly did wear elaborate costume. However, she was less enamoured of the process of dyeing. During her reign she banned all woad dyers from working within five miles of a royal palace, whether or not she was in residence.[69] In practice, of course, it is not five miles from the City of London, where dyeing had been carried out for centuries, to Whitehall, where her main palace was sited, and it is only just five miles to Greenwich, the location of one of Elizabeth's favourite palaces.

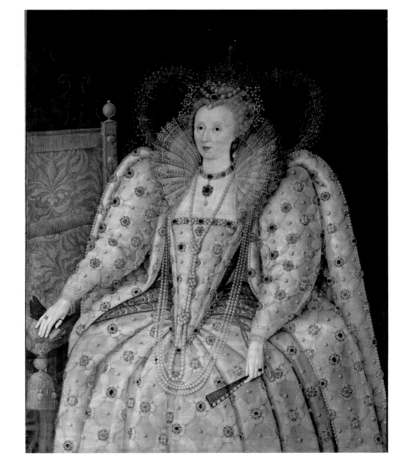

Elizabeth I was known for her preference for black and white clothing. Notwithstanding that she handed down many of her clothes to her ladies in waiting and had other pieces re-made, the aggressive treatment to achieve good black and white clothing meant that we have very little physical evidence of her wardrobe today other than in pictures. *Elizabeth I of England and Ireland* (1533–1603) (oil on canvas), English School, (16th century).
© *Palazzo Pitti, Florence, Italy / Giraudon / The Bridgeman Art Library*

NOTES

1. Raphael died at the age of 37 in 1520 and did not see the tapestries completed. The cartoons were brought to England in 1623 by the Prince of Wales, later Charles I. Passionate about tapestries, he established the Royal Manufactory at Mortlake and commissioned a set from the Raphael cartoons. The cartoons were reassembled and mounted onto canvas for an exhibition at Hampton Court Palace in the 1690s. They have been on loan from the Crown to the Victoria and Albert Museum since 1865. The original tapestries remain in the Vatican Collection.

2. Evans, Mark, 'The Commission and the Cartoons', in Evans, Mark and Browne, Clare, *Raphael Cartoons and Tapestries for the Sistine Chapel* (London: V&A Publishing, 2010), p.20.

3. Evans, Mark, Browne, Clare, with Arnold Nesselrath, *Raphael Cartoons and Tapestries for the Sistine Chapel* (2010), p.93.

4. Evans and Browne, p.83.

5. Phillips, Barty, *Tapestry* (London: Phaidon, 1994), p.34.

6. Mola, L, *The Silk Industry of Renaissance Venice* (Baltimore; London: Johns Hopkins University Press, 2000), p.118–19; as described by Corsuccio.

7. Tapestry was paid as piece work, and even into the 17th century those working on the flesh tones were often paid more than those working the flowers, because more shading was required, to get a more natural look.

8. Leix, A, 'Falsifying the Colours of Tapestry', in 'India its Dyers and its Colour Symbolism' *Ciba Review*, no.2 (1937), p.65.

9. Hatching – the technique of weaving one row of colour followed by one row of contrast, at the extreme, black or white, but often a series of hues of the core colour – is one of the quintessential methods of shading within tapestries. See for example Russell, Carol K, *The Tapestry Handbook* (London: A&C Black, 1991), p.91.

10. Strobel de, Anna Maria, 'Weaving the Sistine Chapel Tapestries', in Evans, Mark and Browne, Clare, *Raphael Cartoons and Tapestries for the Sistine Chapel* (London: V&A Publishing, 2010), p.36–7.

11. Colour aside though, it should be noted how faithfully the weavers managed to render the details of the paintings. This was a significant achievement, not least as the cartoons themselves introduced Renaissance design to tapestry for the first time. Campbell, Thomas, 'Tapestry', in Harris, Jennifer (ed.), *5000 Years of Textiles* (London: British Museum, 1993), p.191.

12. Strobel, p.36.

13. Vasari, Giorgio, [*A selection from*] *Lives of the Artist*, tr. Bull, George, (1979) pp.227–8.

14. Today, caesalpina can only be found in Brazil as specimen trees at places such as the national botanic gardens in Rio de Janeiro.

15. Brunello, Franco, *The Art of Dyeing in the History of Mankind*, tr. Hickey, B (Vicenza: N. Pozza, 1973), p.139.

16. Balfour-Paul, Jenny, *Indigo*, (London: British Museum Press, 1999), p.57.

17. *State Papers Domestic: Elizabeth Addenda 1580–1625*, Addenda James I – Vol.39: October 1608, Mary Anne Everett Green (ed.), (1872), pp.510–11, available at http://www.british-history.ac.uk/source.aspx?pubid=716, retrieved 3 February 2012.

18. Ponting, Kenneth G, *A Dictionary of Dyes and Dyeing* (London: Bell & Hyman, 1981), p.129.

19. Butler Greenfield, Amy, *A Perfect Red: Empire, Espionage and the Quest for the Colour of Desire* (London : Doubleday, 2005), p.74.

20. Finally fully explained with diagrams by Leeuwenhoek in the 18th century; published in *Philosophical Transactions* of the Royal Society in 1704.

21. Thiery de Menonville died in Port-au-Prince in 1780. See Butler Greenfield, pp.221–34.

22. Statute at Westminster Palace 4 February 40 Elizabeth (1598), *Calendar of the Cecil Papers in Hatfield House*, R.A. Roberts (ed.), vol.8, February 1598, pp.36–49. Available at http://www.british-history.ac.uk/report.aspx?compid=111727, retrieved 31 December 2011.

23. Golikov, Valery, The Technology of Silk Dyeing by Cochineal. II The Experimental Investigation of the Influences of Types and Concentrations of Cations in Kirby, J (ed) (2001) *Dyes in history and archaeology* 16/17 (2001), pp.10–12.

24. Mola, pp.121–4.

25. Mola, p.121.

26. Cardon, Dominique, *Natural Dyes: Sources, Tradition Technology and Science* (London: Archetype, 2007), p.630.

27. Mola, p.124.

28. Butler Greenfield, pp.137–8.

29. Golikov, p.12.

30. Hofenk de Graaff, Judith H, *The Colourful Past: Origins, Chemistry and Identification of Natural Dyestuffs* (Riggisberg: Abegg-Stiftung; London: Archetype, 2004), p.82.

31. This book was mostly for household management so the dyeing recipes were for domestic use – usually for when its advice on spot removal had not worked, given the expense of cloth at this time.

32. Rosetti, Giovanventura, *The Plictho: Instructions in the Arts of the Dyers which Teaches the Dyeing of Woollen Cloths, Linens, Cottons and Silk by the Great Art as*

well as by the Common (Venice: Augustino Bindoni, 1548), tr. Edelstein, Sidney M and Borghetty, Hector C (Cambridge Mass.; London: M.I.T. Press, 1969), preface p.2.

33. Huebner, J, 'Early History of Dyeing', in Rowe and Clayton (ed.), *Journal of the Society of Dyers and Colourists (The Jubilee Edition)*, (Bradford: SDC, 1934), p.2.

34. Brunello, p.184.

35. Rosetti, p.xiii.

36. Although it has to be said that the French edition was a poor and incomplete translation.

37. The evidence includes the lack of any licence to publish in 1540, the more complex typeface in the 1548 edition and the 'wear and tear' on the illustrations.

38. Rosetti; in this respect it is of much wider value than simply a book for commercial dyers.

39. Like the Venetian rules, brazilwood is predominantly mentioned in relation to dyeing cotton where it was not expected to achieve a good colour.

40. Alessio Piedmontese became Alexis of Piedmont in the French and English translations of 1556, 1559 and 1568, with a further expanded version translated into English in 1615 which was welcomed as 'newly corrected and amended and also somewhat enlarged in certayne places which wanted in the first edition' (frontispiece).

41. Brunello, p.190.

42. Hofenk de Graaff, Judith H, *The Colourful Past: Origins, Chemistry and Identification of Natural Dyestuffs* (Riggisberg: Abegg-Stiftung; London: Archetype, 2004), p.315.

43. Ashelford, Jane, *The Art of Dress: Clothes and Society 1500–1914* (London: National Trust, 1996), p.33.

44. Mola, p.133.

45. Mola, p.133.

46. Mola, p.131.

47. Brunello, p.196.

48. Leix, Alfred, 'Dyeing and Dyers' Guilds in Medieval Craftsmanship' in Medieval Dyeing *Ciba Review*, no.1 (1937), p.15.

49. Balfour-Paul, p.56.

50. Ponting, Kenneth G, *A Dictionary of Dyes and Dyeing* (London: Bell & Hyman, 1981), p.108.

51. Equally, in the 1580s Queen Elizabeth attempted to stop the woad speculators who were planting woad instead of food crops because they could realise up to six times the price, but this was rescinded in 1601. Balfour-Paul, p.38.

52. Wescher, H, 'The Decline in French Dyeing', in 'Great Masters of Dyeing in 18th Century France' *Ciba Review*, no.18 (1939), p.650.

53. *Edict du Roi pour la reformation, police, reiglement sure les façons & tainctures des draps, estamets, sarges et autres estoffes de laine, qui se sont en ce Royaume, avec c'estat de ce qui sera payé pour chacune pièce desdits draps, estaments & sarges* 1571, Paris, re-issued 1581.

54. Brunello, p.186.

55. Balfour-Paul, p.56.

56. Cardon, p.108.

57. See the list of Madder Certificates issued by the Royal Society of Arts, for example in 1767: John Crow of Faversham 20,000 plants per acre; Thos Giles of Brabourn 20,000 plants per acre; John Dudlow of St Mary's Northgate 30,000 plants per acre (RSA Archives).

58. Sandberg, Gösta, *The Red Dyes: Cochineal Madder and Murex Purple: A World Tour of Textile Techniques* (Asheville, NC: Lark Books, 1997), p.81.

59. Pastoureau, 2008, p.104.

60. Pastoureau, 2008, p.124.

61. Hayward, Maria, *Rich Apparel: Clothing and the Law in Henry VIII's England* (Farnham: Ashgate, 2009).

62. Hayward, Maria (ed.) *Dress at the Court of King Henry VIII*, (Leeds: Maney Pub., 2008), p.5.

63. I am grateful to Maria Hayward for this observation.

64. Hofenk de Graaff, pp.286–7.

65. Monnas, p.24–5.

66. Arnold, Janet, *Queen Elizabeth's Wardrobe Unlock'd: The Inventories of the Wardrobe of Robes prepared July 1600* (Leeds: Maney, 1988), p.14. Arnold notes that the proclamation was drafted by Sir William Cecil in 1563, although she could find no evidence of it actually being used.

67. Arnold, p.90; although Arnold also notes from the Stowe and Folger inventories that Elizabeth actually had clothes in several other colours.

68. Arnold, p.190.

79. Balfour-Paul, p.38.

6

Mystery, Art and Science: the 17th century

The early 17th century was a time of upheaval in Europe. In 1620, the Pilgrim Fathers set sail for the New World, marking the beginning of centuries of European migration. Spain was at war with the Netherlands as the latter fought for self-government and by the middle of the century England had experienced civil war and had executed its king, leaving the country in the power of a new ideology under Oliver Cromwell.

The end of this short-lived experiment in republicanism, culminating in the Restoration of the monarchy in the shape of Charles II in 1660, coincided with a renewed energy across Europe. The new king gave patronage to the founding of the Royal Society as a body intended to bring together the finest scientific minds of the day. In France, Louis XIV appointed Jean-Baptiste Colbert as his financial comptroller, who immediately set about restoring the fortunes of French industry. The fledgling American states were looking at the development of new industry to survive. The Dutch were looking to develop their own state and were staking a major part of their economy on the cloth trade. Meanwhile, Spain was struggling to keep its monopoly on the cochineal trade which Europe had now embraced wholeheartedly, even if it still did not know exactly what cochineal was. So, the state of dyeing in this century is well summed up by the phrase above – *mystery, art and science* – taken from an English patent for madder cultivation, granted in 1624.[1]

THE UNION FLAG

Following Elizabeth I's death in 1603 James VI of Scotland became James I of England and the two countries became united. One of the early textile-linked decisions was the new flag. The two countries were happy individually to use their own flags on land; but the fleet at sea needed to be able to display a single, unifying ensign. A number of suggestions were considered but the final choice was the Scottish flag of St Andrew as the base with the blue ground and white saltire (cross), overlaid with England's red cross of St George, except that in heraldic convention, the colours red and blue could not abut each other, but had to be interspersed with either yellow representing *or* (gold) or white representing *argent* (silver). So, taken from the background of the English flag, a white border was added between the red cross and the blue background. This flag was put to immediate naval use (which might explain why it was referred to as the Union Jack)[2] but was not used on land until 1707 when a further Act of Union was passed under Queen Anne. It did not become the recognisable icon we know today until 1801, after the addition of the flag of St Patrick to represent Ireland.[3]

Today such work would lead to questions in parliament about the cost of the 'rebranding exercise', but the cost of this flag would pale alongside James's own wardrobe expenses. Where Elizabeth I had spent around £9,000 on her wardrobe in the last

This 19th century woven fabric from the collection of the Royal School of Needlework features a variation on the first union flag of England and Scotland, as the red cross of St George is depicted in pink, but it is clearly without the Irish flag of St Patrick. RSN1162 woven brocade. *Photograph © Susan Kay-Williams.*

three years of her life,[4] James spent three times that in one year.[5] But more than clothing he loved tapestries, going so far as to establish a tapestry-weaving workshop in Mortlake in 1619.[6] Charles I continued the tradition; it was he who bought the Raphael Cartoons from the Vatican to have his own set of tapestries woven. But he did not stop there. He commissioned and bought many further sets, often based on paintings from his collection[7] although he was not always a speedy payer: in 1643 Charles owed his weavers £3,937,[8] clearly working in the king's service at Mortlake was no guarantee of a reliable wage. Nevertheless, royal support for textiles was seen across Europe. In the same year that Charles I set up the manufactory at Mortlake, Christian IV of Denmark purchased property in Copenhagen,

where he established a street of textile workshops employing 11 dyers and 52 master weavers[9] although previously King Frederik II had employed tapestry weavers at Elsinore between 1581 and at least 1586, making a series of tapestries for Kronenborg Castle.[10]

DREBBEL AND TIN SCARLET

By the beginning of the 17th century cochineal had all but replaced kermes, not least because cochineal had a higher concentration of dyestuff to weight. And, whilst Spain still had the monopoly on imports, once it reached Seville it was now more easily available.[11]

However, the art of dyeing still relied more on empirical evidence observed through practice than on a scientific understanding of that evidence gained through analysis. Moreover, serendipity often played a role in significant discoveries: the story goes that the Dutchman Cornelius Drebbel placed a bath of cochineal by a window and that, in preparing the bath, aqua regis[12] splashed onto the tin of the window frame, so that drips of tin chloride fell into the bath, causing it to turn scarlet. Whatever the accuracy of this story, Drebbel moved to East London and set up a dye company in Bow in 1607. At first, the new colour was known as Dutch scarlet but it soon became better-known as Bow scarlet.[13]

We also know Drebbel managed to keep his method secret, save for sharing it with one man, his future son-in-law, a dyer named Abraham Kuffler who married Drebbel's daughter Anne in 1623. It was almost ten years before the scientific discovery was made that it was the addition of tin to the dye bath that elicited the bright scarlet colour. Drebbel does not appear to have been much of a businessman, but, with the help of his sons-in-law, Kuffler's brother marrying Drebbel's second daughter, by 1627 the new scarlet was well-known. Following Drebbel's death the Kufflers made the company profitable, even setting up a sister company in Holland making scarlet cloth.[14]

DYESTUFFS IN ENGLAND

Indigo was used throughout the century in England, although it was not officially allowed until 1660 with the Restoration of the monarchy.[15] It is easy to see the rise of indigo through the port records at Bristol. In 1613 they record 224lb of indigo being imported against 255,360lb of woad. By 1655 the figures were 11,816lb of indigo and no woad.[16] Apart from the significantly changing balance, the figures also offer a clue as to the ratio of colour from woad versus that from indigo, with indigo giving much the stronger tone.[17] However, woad did not lose its role entirely. The process of creating vats with indigo and woad may have been different, but woad began to be added to the indigo vat as a fermenting agent,

helping to dye colours such as navy blue. Moreover, it was 1737 before indigo was approved for use in France and Germany.[18]

As England developed its colonial reach, indigo was one of the crops that could grow in colonies both east and west from Bengal and Gujarat to plantations in Virginia and the West Indies. Through the East India Company indigo became the most important traded crop (and for the Dutch East India company, too); indeed, on at least one occasion investors in the English East India Company, known as 'adventurers', were given a dividend in indigo.[19]

England also imported most of its madder, principally from Zeeland in the Netherlands. An abiding issue was adulteration of the ground madder with sand and other materials. So big an issue was it that, in 1631, George Bedford was appointed as the king's officer for inspecting and marking (sealing) all madder on its importation so that he could check the amount of other matter that was in each barrel. However, by 1632 there was a petition to parliament; Bedford's overzealous concern about the quality of the madder was having a number of detrimental effects. First, it was impossible actually to sort the madder from the detritus, secondly, the dyers were already used to working with impure madder, but worse than this the extra hassle and cost to the madder producers meant that crops were being diverted from England to France, which, as the petitioners pointed out, was detrimental to the king's coffers. As a result, it seems that Mr Bedford's post was withdrawn and business returned to normal.[20] But that was not the end of the matter.

The issue re-emerged after the Restoration in the Act for the Importing of Madder Pure and Unmixed, 1662, wherein the ratio of 'adulterant' to pure madder root was set down at a maximum of 1kg (2lb) of other materials in each hundredweight (51kg/112lb) of madder root.[21] However, this was one of the shortest-lived laws on the statute books in England – repealed only a year later, following petitions by merchants, who explained that they were experienced in mixing a dye bath by eye to achieve the results they needed and anyway that such purity in the madder was almost impossible to achieve. That same year a Zeeland statute set the same limit for Krap-grade

madder from the Netherlands for export. However, their statute was reissued in 1671, 1699 and 1735, which probably indicates the level to which it was ignored although it remained in force throughout this period.[22]

So, whereas in the previous centuries the laws, especially in Venice, had been about the quality of the output, and formal acknowledgement of the dyestuffs used, as witnessed by the selvedges, from the 17th century the law started to look at the quality of the raw materials and what might be termed value for money.

PATENTS IN ENGLAND

No one really knows when patents were first established. Originally, they were a privilege granted by the monarch or other ruler for a manufacturer to maintain a monopoly for a number of years. In England, the first patent was awarded in 1449 by Henry VII to a Flemish stained-glass maker to protect the methods he was using (brought from Flanders and new to England) to make the windows for Eton College. Today England has the most complete and uninterrupted record of patents of any country.[23]

Elizabeth I issued about 50 patents whereby the recipients were able to exercise monopolies on their process of manufacture for up to 21 years. These were for materials such as soap, alum, starch and iron, all of which were used in dyeing as well as other trades. However, this monopoly process became subject to abuse and in 1610 James I was forced to revoke all patents in the face of the dual opposition of judicial and public criticism. A few further patents were awarded, commencing in 1617, but it was in 1624 that the Statute of Monopolies introduced the concept of the doctrine of public interest and made illegal all monopolies except those '*for the term of 14 years or under hereafter to be made of the sole working of any manner of new manufactures within this Realm to the true and first inventor*'.[24] There were 31 patents relating to bleaching and dyeing this century listed in the abridged summary published in 1857.

The first patent which specifically refers to cloth and colour is patent number 14 of 1619, issued to

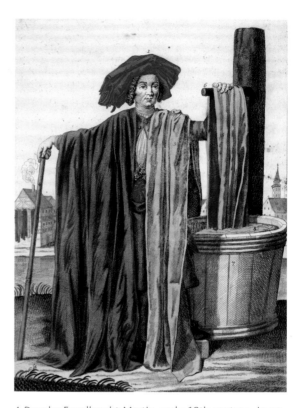

A Dyer by Engelbrecht Martin, early 18th century. As we have seen before, often the painted depiction of dyeing bears no relation to actual practice. Here we have a dyer holding completed single-colour cloths right next to a vat of pink dye, from which he is bringing out a cloth of a rather unlikely colour. Furthermore he is producing the pink cloth from a vat rather than a dye bath – a vat is only used for indigo or woad, which is worked at a lower temperature than other colours. © *Private Collection, The Stapleton Collection, The Bridgeman Art Library*

a George Wood who was granted one of the old monopoly-style patents for 21 years to be the sole person printing and staining cloth within England and Wales, in return for an annual fee.

Patent number 28 from 1624 gave William Shipman permission to grow madder and '*to put in use the misterie, arte and science of breaking, drying, dressing and preparing the same for dying for one and twenty years*', though there was a sting in the tail. In granting the patent the fee was '*on condition of the*

payment of the like amounts as are levied on the various madders imported.[25] In other words, the crown in 1624 needed all the taxation it could generate, so instead of supporting an increase in the amount of locally grown product instead of imports, the crown considered it could not stand the potential loss of income, hence the levies. Shipman established his plantation but by 1636 the fees to be paid to the king had increased to 10s for every ton of best madder, 7s for second grade and 4s for the lowest grade. There were also tithes to be paid to the Church.[26]

However, hopes of increasing madder growing were ruined by the Civil War, which bankrupted Shipman's madder corporation. It took until 1664 for another person, James Smith, to come forward to seek a bill for growing madder in England. This patent system in England remained unchanged until 1852, by which time it was hopelessly out of date.[27]

THE AGE OF CURIOSITY

The 18th century is commonly known as the Age of Enlightenment, but I have been particularly struck by the fact exhibited through many papers and minutes from the Royal Society in Sprat[28] and Birch[29] that before enlightenment, what in the 21st century we'd call an 'outcome', there has to be a question, a sense of curiosity that asks not just 'what?' but 'why?', 'when?', 'what if?', 'why not?' and 'how?'. In other words, the latter part of the 17th century, as the prelude to the Age of Enlightenment, could be seen as the 'age of curiosity', often facilitated by a growing range of tools such as microscopes to help scientists understand the world. The minutes of the Royal Society edited by Birch make fascinating reading precisely because they are not the mundane committee-type meetings listing simply those present, apologies, matters arising, finance and any other business. Instead they show the openness of the membership to learning about scientific topics, and their readiness to research new areas of which they actually knew very little; indeed, from meeting to meeting they flit from one new topic to the next.

In 1662, Sir William Petty, one of the Founders of the Royal Society, along with Sir Christopher Wren, said that he would speak about dyeing. Printed in Sprat's *History of the Royal Society*, it is the first article on commercial dyeing printed in English.[30]

Petty may have been the son of a cloth merchant but he did not have detailed knowledge of dyeing. His paper is a summary of the ingredients of textile dyeing and an overview of some of the issues which Petty the scientist has tried to consider within the bigger picture of 17th-century knowledge. For example, he obviously encountered a difference of opinion on the use of arsenic, writing: '*Arsenick is used in Crimson upon pretense of giving lustre, although those who pretend not to be wanting in giving lustre to their silks, do utterly disown the use of Arsenick*'.[31]

He uses common 17th-century terms for colours – Bow scarlet, as discussed above – and he differentiates between two methods of producing black cloth which he names Spanish black, calling this true black made with iron and steel, as opposed to Flanders black, for which the use of oak galls and iron salts were prohibited.[32]

But Petty also reveals the imperfect state of knowledge, too. He puts cochineal under the animal category reluctantly, referring to '*cochineel (if the same be any part of an animal)*',[33] and at one point refers to '*kermes-berries*'.[34] He also questions the scientific role of alum, writing that '*the very true use thereof seems to me obscure enough notwithstanding all the narrations I could get from dyers about it*'. He later says that the dyers have told him that the alum helps the wool (or other fibre) to better take and fix the colour,[35] but seems to remain sceptical, perhaps because the dyers knew it but could not explain it.

He shows a rather partisan interest in woad, referring to English woad as the strongest and describing how it is processed by comparing the fermentation stage of the vat to the fermentation of beer, having greenish flowers on top of the dye vat just as the beer has its yeast crown. But, presumably prompted by his sources, or perhaps from seeing a woad vat being developed himself, he continues, '*The making and using Woad is one of the most mysterious, nice and hazardous operations in dyeing*', while recognising that it gives the deepest and most

lasting colour, comparing it to the skin of a damson. In comparison, the new upstart indigo, which he acknowledges gives a stronger colour, he described as '*only a mealy concrete juice of faecula dryed in the sun … (and) made into cakes*'.[36]

Finally, he talks about the weighting of silks and gives some commercial information on its impact. The washing process which removed the gum from the silk could reduce 1lb of silk (450g/16oz) to just 12oz, but if dyed black, a process which might require the silk to be dyed in several baths, the dyed silk, absorbing impurities as well as colour could reach anything up to 30oz, almost double the original weight. As discussed in the previous chapter silk was sold by weight, so there were fortunes to be made by unscrupulous dyers who repeatedly dipped the silk in the dyebath. During the initial inspection for buying the vendor would stress what a fine quality it was but after purchase, on closer inspection purchasers might find the quality was not as expected and both colour and the silk itself might last less time than was anticipated.[37] Here, England was not alone. In Amsterdam in 1626, ordinances specifically forbade dyeing silk in more than one bath of gall nuts, specifically to stop the fibre absorbing more weight from the dye bath.[38] In Genoa in 1650, the *setaioli* accused the dyers of overweighting their silk, stating that it made the silk appear '*rotten and burnt-like*' and that in under two weeks it changed appearance to '*a puce coloured hue.*'[39]

Petty's paper was considered important at the time, but the lack of direct knowledge or practical interest at the highest levels in England contrasted markedly with the situation in France.

COLBERT AND DYEING IN FRANCE

France grew two of the major dyestuffs, woad and madder, as commercial crops. They grew enough woad for the home market and for export to England, their main export market, so it was certainly in their interests to see the trade continue in the face of strong competition. In fact Colbert was keen to develop it and ordered new madder planting around Avignon from 1670.[40] To France, indigo and other new dyestuffs were a threat, which was fought against with repeated legislation throughout the century, such as the Edict du Roi 1601 in which the king threatened the death penalty to anyone found using the '*deceitful and injurious dye called inde*'.[41]

From the middle of the century, Louis XIV assumed absolute power and appointed Jean-Baptiste Colbert as his finance minister. Colbert was the man charged with the mission of breathing life back into French industry. Coming from a family in the textile business in Rheims, he first focused on cloth-making and especially on dyeing. In 1669 he had the king approve a set of regulations for the dyeing industry, in the *Lettres Patentes* which also gave rules and permissions for dyers in the different cities. By 1671, with the help of textile entrepreneur Monsieur D'Albo he had published a complete set of instructions, known as the *Instruction générale*, on the application of the regulations.[42] These would be updated and revised in 1688 and examined and rewritten in 1737, but became the bedrock guidelines of the French dyeing industry for the next century.

The regulations began by reinforcing the separation of the two types of dyer: those of '*le Grand ou Bon Teint*' who were able to use the best ingredients and make the finest colours, and those of '*le Petit Teint*' who produced the bulk of the dyeing for the general populace, as well as for ribbons and embroidery threads. The separation was very real, *le Grand ou Bon Teint* dyers were only allowed to use certain ingredients and would be fined and banned from dyeing for even having in their workshop such items as brazilwood, campeachy wood, yellow wood, fustic, sunflower, annatto, orchil, bastard saffron or even logwood, because all were considered, to a greater or lesser extent, fugitive colours. Colbert was convinced that colours should not just be beautiful on the day they were sold but should last as long as the material itself. The dyers of *le Petit Teint*, on the other hand, were equally banned from having access to dyes such as woad

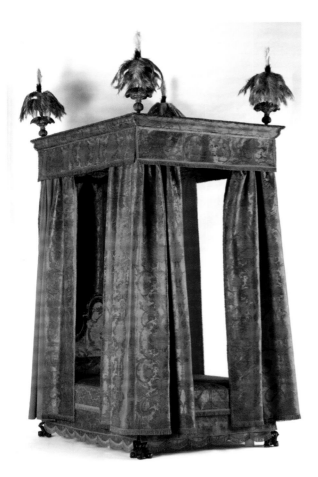

By the 17th century cochineal was the predominant dyestuff for red. Here we see an entire set of bed hangings where the red dye is from cochineal. This is the Boughton bed commissioned by the first Duke of Buccleuch in the late 17th century for his new home, Boughton House in Northamptonshire as a state bed (i.e. one to be seen, not necessarily slept in).
© *Victoria and Albert Museum (W67 1-34 A-O 1916)*

or cochineal.[43]

In reinforcing the *Grand* and *Petit Teint* distinction, Colbert was then confronted with an urgent issue of capacity. For example, in Paris he realised that there were only three dyers technically skilled in *le Grand Teint*, which was not enough to meet the lavish needs of the court of the Sun King, Louis XIV. So, by a separate *Lettres Patentes* of 1669 permission was given for three more dyers of *le Grand Teint* to be appointed, subject to meeting the requirements to be a master dyer and renouncing all the ingredients and practices of *le Petit Teint*.[44]

THE MASTERPIECE IN THE 17TH CENTURY

As we have seen, for a dyer to become a master dyer, he had to produce a bolt of cloth in a beautiful and even colour, initially red and subsequently blue. By the 17th century, Colbert needed more accomplished dyers if the French textile industry was to thrive. The 1669 regulations set out the qualification procedure for a potential master dyer: that within 15 days of his election he has to present dyed samples on specified fabrics in twelve colours: '*noir de Garence, Minime, rouge de Garence, couleur de Prince, Ecarlate rouge, Rose seiche, Incarnat, Coulombin, couleur de Rose, Vert-gay, Bleu turquin & Violet*'. Then there is a requirement for a further four pieces on a different fabric to be available for inspection after a further month: '*Ecarlate rouge, noir de garence, rouge cramoisi and couleur de pensée*'.[45]

Furthermore, he listed the approved ingredients to be used by the master dyer: '*Pastels de Lauragais, Albigeois, Languedoc and other places, vovaide, couperose, sumac, galle à l'epine and d'Alep, alun, gravelle, tartre, garence, gaude, cochenille, graine d'écarlate, pastel d'écarlate, arsenic, argaric, talmerital, bourre de chévre, cendre, gravellée and indigo*'.[46]

Perhaps the most interesting is not the goat oil (*bourre de chévre*), used for scouring the cloth, but the mention of indigo, because at that time indigo was forbidden. Here was the chief finance minister of France including this ill-trusted ingredient. One can only speculate as to why; perhaps the influence of M D'Albo. As a textile entrepreneur he may well have been aware that indigo was a far more powerful blue colourant than woad and was a sign of the future, but its position at the end of the list perhaps shows its last-minute inclusion, whereas cochineal and kermes are shown together. In the *Instructions* indigo is

described as a 'couleur fausse', a false colour, and there are comments indicating that it is more expensive than pastel (referred to as the best colour in the world). But its very inclusion shows that there was something of a wave of opinion that would not be silenced for long.[47] As such it was initially suggested being used as part of the woad vat,[48] but inevitably, by 1672 Colbert gave Abraham van Robbais a first provisional authorization for the use of indigo.[49]

The *Instruction générale* went on to set down how colours were to be made, especially the complex colours such as black. Colbert specified that for good-quality black the recipe required indigo, pastel, alum, tartar and *garence* (madder), or nut gall, copperas and sumac, both of which recipes could give '*la perfection du noir*'.[50] Colbert even allowed the dyers of *le Petit Teint* to use nut galls, copperas and sumac to make black, although he did offer a guarantee for customers that black dyed by dyers of the *Grand Teint* would last longer.[51] In all the *Instruction générale* contains 21 sections, which give the different colours and how they are to be made, indicating the growing variety of colours in the 17th century. Greens now included *les verts herbus* (vegetation green), *verts gais* (gay green), *verts naissans* (young green), *vert de perroquet* (parakeet green), yellow greens, sea greens and brown greens.[52]

Colbert's manual had a wider influence on Europe, leading to the production in Frankfurt in 1683 of *Ars tinctoria fundamentalis – oder Gründliche Anweisung zur Färbe-Kunst*, a translation with additions from the French original.[53]

TAPESTRY WOOLS AND SILKS

Francis I was the first to establish tapestry weaving in France at Fontainebleau in the 1530s, though Flanders was still the tapestry-making centre. Henri IV had looms set up in Paris, at one time at the Louvre, and then in 1607 he granted *lettres patentes* to two Flemish weavers who established 50–80 looms in Paris, near to the Gobelins dye works[54] and 20 in Amiens using the new low-warp looms.[55] But it was Colbert who brought the tapestry weavers and the dyers

together at Gobelins in 1662/3 naming it the Royal Manufactory, to be joined by Parisian craftsmen from other industries in 1667.[56] Designs were produced specifically for the manufactory by Rubens, Simon Vouet and other leading artists. It is not surprising, therefore, that in the 1671 *Instruction générale* tapestry wools had their own section stating specifically that they should be produced using *le Grand ou Bon Teint* '*for the perfection of colour and nuance*'.[57]

Not only were dyeing and tapestry-making now performed all on one site, but Colbert and the first director of the new Gobelins, painter Charles le Brun,[58] established there the first centre for colour and dyeing research, and it would continue to play an important role until as late as the 19th century.[59] And even by the end of the 17th century many more colours and shades had been developed especially to meet the needs of fashion and the growing interest in interior design, and in particular for the production of the royal tapestries.

Colbert did not just focus on dyeing but equally on the Lyonnais silk industry, though at the start of the 1660s it would have been hard to describe it as such. Indeed, Colbert wrote to the Provost of Lyon describing his dismay at the '*anarchy prevailing in manufacture*', with pieces produced differing greatly in widths, lengths and, above all, quality. He immediately enacted a number of regulations – for instance, establishing a standard width – to bring order to an industry he saw had enormous potential to make the city the leading centre for silk in Europe.[60]

DUTCH REGULATIONS

Leiden was a major centre of dyeing and cloth manufacture during the 16th and 17th centuries with woollen cloth being the most important export. In 1606, more than half a century after it had first arrived in Europe, Leiden dyers, for whom maintaining standards was of paramount concern, finally asked permission from the city government to use indigo, recognising that other Dutch cities that were already using it, such as Delft, Rotterdam, Gouda and Haarlem, had gained a significant commercial advantage. It was finally in common use by 1615,

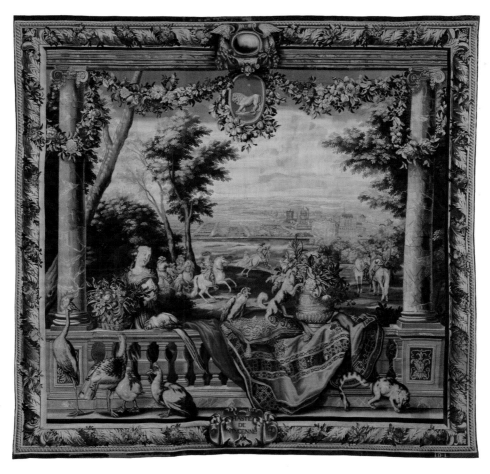

Following the appointment of Charles le Brun as director of the tapestry manufactory at Gobelins in 1667, a series of new types of tapestry were created. Many featured or inferred the King Louis XIV or his patronage while another series, as featured here, focused on the months of the year, in this case July. All of them went to adorn the King's residences, especially Versailles. *July: Vincennes, © Victoria and Albert Museum*

by which time the Leiden dyers' guild had even come to trade agreements with the merchants who transported the indigo to even-out the worst price fluctuations.[61] However, woad was still in significant use as late as 1617, when an Erfurt woad merchant sold 125,000 guilders of the dyestuff to Holland, Flanders and England.[62]

Other legislation in the Dutch dyeing industry related to black, where Leiden and other cities did not allow black made using gall nuts and copperas until the very end of the century[63] and blue dyers were kept separate by law from black dyers.[64] Dutch dyers had a reputation for the fine quality of their dyeing. In fact, as the century drew on, increasing amounts of cloth, known as 'Hollands',[65] were sent from England to be dyed in the Netherlands, so that in 1698 the English dyers found it necessary to request a debate in parliament to complain about the quantity of cloth which was leaving the country undyed for this purpose. They contended that English and Irish wool was still acknowledged as the finest for

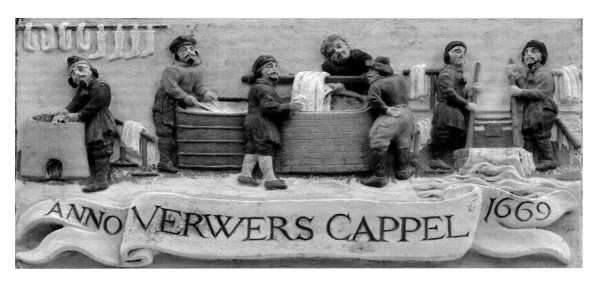

This ceramic plaque on the side of a church in the Netherlands recognises the trade and activities of dyeing. In this one plaque dating from 1669 we see the principal activities of dyers: cleaning or mordanting the wool on the left, vat dyeing in the wooden vessel, dyeing to a higher temperature in the brick dye-bath and dyeing in the piece on the far right hand side. The one curiosity is the sock-shaped items: it would not be usual to dye socks in the piece, it is much more likely to dye the yarn from which socks are made. © *Marien Krijger*

cloth but that duties on dyeing were detrimental to cloth being finished in England, which in turn had a negative impact not just on the dyers but on the treasury.[66] Following the petition, a debate was held in parliament on 18 May during which it was recognised that unless some way was found to remove the duties on finished cloth, the dyeing and related industries in England would soon be lost with more and more material being shipped to Europe 'white' because other countries could buy their dyestuffs cheaper without the taxes applied in England.[67]

VENETIAN LEGISLATION

By the early 17th century it had become cheaper to take the sea route to India, bringing products back to western Europe and then re-exporting them to the Levant. As a result, Venice no longer held its pivotal place as the trading crossroads between east and west, and with that loss went some of its prosperity. As is often the case in such circumstances, officialdom clings to the past, ignoring new trading circumstances and seeking to protect trade through legislation, a tactic destined to have the opposite effect. Between 1604 and 1612 a range of new laws was enacted in an effort by the silk guild to protect standards and interests, but these had the opposite effect.[68] In 1607, Venetian dyers petitioned for formal permission to use logwood, which they had been using unofficially for some time. This was granted for all fabrics except wool cloth.[69]

With red fabrics the state prohibited the use of different colours in the warp and weft. But by then it was common for the warp (the background colour) to be of a less costly red than the weft (the colour that would be seen); and, in the most elaborate velvets, it was sometimes only the pile that was in the most costly colour, with both the underpinning warp and the weft in a cheaper colour.[70] It would be easy to say that this was gross deception and a way for the weavers, in particular , to make a profit, but it could also be the case that customers were less willing to pay the more expensive prices Venice had formerly been able to demand, and this was simply a

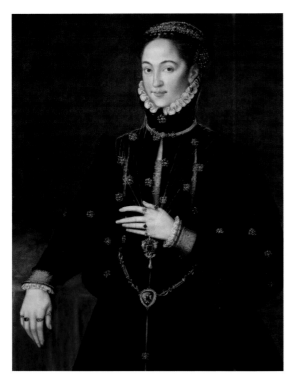

From Spain, expensive black clothing spread across the continent as 'the new red', as worn here by the *Marquesa of Las Navas at the court of Philip II. c.*1559 (oil on canvas). *Mor, Sir Anthonis van Dashorst (Antonio Moro) (1517/20–76/7) © Hospital Tavera, Toledo, Spain / The Bridgeman Art Library*

pragmatic solution.

By 1612 the senate was considering black again. They wanted purity for Venetians, so their compromise was that all black fabrics for the Venetian state had to be made in the traditional manner, overdyeing blues and reds; in the case of cloth for foreign markets they finally, begrudgingly, accepted that Venice would only able to compete if it employed the *in goro* technique of using gall nuts and copperas. The long-lasting dispute between dyers and state in this matter was a bitter one that further added to Venice's decline as the world centre for dyeing.[71]

But the other reason for Venice's decline was the success of Colbert's regime in France. At the beginning of the 1660s, Colbert ordered large quantities of Venetian silk for the French court, but by 1666, just a few years later, the court was supplied almost solely by home producers.[72]

COCHINEAL LEGISLATION

For a century, the Spanish had kept non-Spanish out of much of the New World, but by the 17th century many more countries wanted access to the New World's riches. In 1614 Philip II enacted a law specifically prohibiting foreign merchants from trading in cochineal at source, on pain of death; they could only purchase it once it reached Seville. Then in 1618 he endeavoured to put a further prohibition on the local merchants in New Spain, demanding that they auction off their crops to the King's agents. This, however, was doomed to failure as the merchants found many different ways to hide or withhold supplies until the law was finally repealed in 1622.[73]

Of course, resourceful European merchants were not going to content themselves with simply waiting at home for the fleet to arrive, and in 1625 a Dutch fleet managed to capture Spain's entire Veracruz fleet, undoubtedly laden with silver and cochineal.[74]

INDIENNES, KALAMKARIS, CHINTZES AND CALICOS

While Spain had gone west, the Dutch, English and Portuguese went east, establishing trading companies from India right across the Far East. They sought goods such as pepper and spices, as well as dyestuffs such as indigo, which, just like cochineal, was available in sufficient quantities and of a high enough value to make up the complete cargo for a single ship or even an entire fleet. However, the original intention of the English had been to find a new market for their broadcloth. During their initial visits, such as the journey to Surat in 1608, they were often greeted rapturously as they brought novel items from the west. However, interest in wool broadcloth soon waned as the people of India and

A late-17th/early-18th century floor spread, possibly from Burhanpur, India. This fragment shows the classic Mughal floral design executed in the complex resist and mordant-dyeing techniques which came to be known in Britain as 'chintz'. © *Victoria and Albert Museum (IM69 & A 1930)*

other Far Eastern states saw that their own cotton cloth was better dyed, with faster colours, and was cheaper,[75] using techniques that the Indians had thus far kept secret.[76] Both British and Dutch East India Companies were soon bartering cloth from India for spices from other eastern states.[77]

So it was that before long the anticipated export trade of British broadcloth to the east had been supplanted by a major import business of Indian cottons to Europe and later Africa as part of the slave-trade triangle. Just as broadcloth had initially been novel to the east, Indian cloths were novel to the west and caught the public's imagination. Indeed, in the 1680s merchants expected to sell around 200,000 pieces in trade to England and

Holland, although much more went to other parts of Asia.[78] In fact, between 1600 and around 1800 India was the major exporter of textiles world wide.[79]

The fabrics which the East India Company imported became known as Indiennes, chintzes or calicos, named respectively after the country of origin, the Hindu word meaning 'spotted' and Calcutta, the new trading port the British established in 1691. Kalamkaris came from the Coromandel coast of south-eastern India.

Cotton takes dyes differently from wool, and Indian dyers had learned that a more effective way of dyeing was through printing or painting directly onto the white cotton cloth with or without the use of

resists.[80] Original stencils for dyeing were made from hardwood, with the pattern on the wooden block in raised sections which, in the next century, would come to be made from metal. The raised pattern was either covered in mordant or dye, depending on the stage of the process. The block was then pressed onto the cloth, with different pattern pieces kept in the right alignment through the placing of hooks or markers on the edge of each pattern block. A separate pattern piece would be used for each colour of each piece. This meant that for a fully polychrome cloth many pattern blocks were required, all carved by hand.[81] The motifs used on these early pieces often comprised birds and flowers or a 'tree of life' design.

In addition, India had its own dye sources – indigo, obviously, and, for red, *munjeet* (see p.19) or *chay*, another member of the alizarin-bearing madder family. With an alum mordant, chay produced a glowing red, with an iron mordant a soft brownish black, and with both alum and iron mordant a range of violets and browns.[82]

However, it was not long before an Englishman applied for a patent to make the first Indiennes in England. William Sherwin was granted patent number 190 in August 1676, for 14 years, for his invention of a *'new and speedy way for printing of broad callicoe and Scottish cloth with a doubled necked rowling presse which being the only true way of East India printing and steyning'*.[83] He established his factory in West Ham, East London and by 1700 the English Indiennes business was well established although he had a limited colour palette based on madder, with indigo and weld being added later.[84] Two years later a printing workshop was established in the Netherlands, and, while initially banned in France in the vain hope of protecting the French silk industry, it was not long before Indian cottons began arriving in the country, with their popularity peaking in 1685.[85]

The following year, however, prohibitions in the form of heavy duties were introduced to protect European wool and silk industries; successively, these laws prohibited the importing of Indian cloth into France (1686), England (1700) and Prussia (1712). However, this was not necessarily as helpful to the home market as it might appear. William Sherwin, whose factories along with those of his neighbours now employed some 400 workers, was among those who petitioned the House of Lords against the prohibition on Indian cottons as he wanted to use these as the base for his printed textiles. He was turned down.[86]

ENGLISH ALUM

England could never grow enough dyestuffs for its needs so most had to be imported. After the dyes, the second most important ingredient was the mordant alum. Since the 16th century, the principal source outside Turkey, which was a long way from England and in Ottoman hands, was the papal lands at Civitavecchia. This, too, did not sit well with Protestant England. In 1606, James I granted a monopoly to the Alum Company, headed by Sir Thomas Chaloner. He brought alunite miners from Tolfa in Italy to Yorkshire and first established workings at Guisborough.[87] The terms of the monopoly forbade any import of alum into England after two years on the assumption that enough alum for home consumption would be in production by that time (approximately 1800 tons per annum). Furthermore, the company would pay the crown £700 per annum to compensate for lost import revenues. However, progress was not as smooth as Chaloner had hoped it would be. For a start, a competitor, Sir Richard Hoghton, ignored the monopoly and set up his own mine in the fierce rival county of Lancashire, selling his product directly to the dyers around Bolton and Wigan in the heart of the important Lancashire textile area. Chaloner could not complain too much as his workings were not yet able to meet the dyers' needs, so he diplomatically came to an agreement with Hoghton. Elsewhere English dyers continued to import.[88]

It was 1635 before the Alum Company was able to achieve 1800 tons per annum and even that yield was not continuously maintained. It was not until the 18th century, when alum production finally moved to the Yorkshire coastline, east of Guisborough (between Whitby and Scarborough), that it began to be more profitable.[89]

THE EARLY AMERICAN TEXTILE TRADE

The first established communities in newly colonised North America were mostly along the eastern seaboard. The first recorded American dyer is John Cornish of Boston who, going by the inventory of his shop, drawn up on his death in 1695, had galls, brazilwood, madder, fustic, green vitriol and some auxiliaries; however, no blue-giving dyestuff, neither woad nor the more likely indigo or logwood, is listed.[90] Madder would have come from England, but the other items were available in the Americas.

During this century indigo planting began in Virginia. Grown inevitably by slave labour, with Caribbean indigo it became a major export crop to the home country. In fact a British parliamentary act of 1660 went so far as to prohibit indigo, fustic and cotton from being transported out of the empire.[91]

Britain had a difficult relationship with its most headstrong colony. After all, the citizens comprised those who had willingly decided to leave for the new country and they were not expecting the range of prohibitions put upon them by the English parliament. For example, they experienced frequently changing rules on cloth manufacture and export. In the early 1600s James I sponsored the planting of mulberry trees, for silk production, in Jamestown, Virginia.[92] Other raw materials for cloth manufacture were locally available in the form of cotton, wool from the sheep they had taken with them, and the new dyestuffs – local yellows, logwood and indigo. Parliament even encouraged production. There is correspondence from 1633 encouraging a Mr Richard Lane to plant madder, saying *that Mr Lane be afforded every facility for planting his madder*, including an allowance of '*32 servants for salary*'.[93] In other words, Britain was keen for the Americas to have a cloth industry but wanted to keep control of it, and thus used as many disincentives as they could to deter trade with other countries or colonies. These included financial disincentives in Virginia in 1628; banning all but specially licensed foreign ships from trading with the colonies between 1650 and 1696; decreeing that all goods must arrive in England either in English ships or in those from the goods' own country of origin; in 1699, banning the export of woollen cloth to anywhere, including other colonies; and, in 1719, completely banning weaving in the Carolinas.[94] Needless to say, none of these prohibitions was ultimately successful or even enforceable.

NOTES

1. *British Patents Abridged Vol.14 Bleaching, Dyeing and Printing Calico 1617–1857* (London: British Patent Office, 1859) Patent no.28 to William Shipman.
2. There are several suggestions as to why the Union Flag is called the Union Jack.
3. Gordon, WJ *Flags of the World past and present: their story and associations* (London: Frederick Warne, 1915).
4. Arnold, Janet, *Queen Elizabeth's Wardrobe Unlock'd: The Inventories of the Wardrobe of Robes prepared July 1600* (Leeds: Maney, 1988). Elizabeth was always painted in full pomp but her wardrobe accounts show clothes being remade by her tailor and re-embellished by her embroiderer on a regular basis.
5. James and his son, Charles I, were profligate spenders on textiles, both those to be worn as well as those for decorative purposes, especially tapestries. They commissioned tapestries from the manufactory at Mortlake worth many thousands of pounds.
6. Campbell, Thomas, Harris, Jennifer (ed.), *5000 Years of Textiles* (London: British Museum, 1993), p.193.
7. Phillips, Barty, *Tapestry* (London: Phaidon, 1994), p.70; Gutmann, AL, 'The Great Age of Tapestry-Weaving in France', in Tapestry *Ciba Review*, no.5 (1937), p.153.
8. Schaefer, Ch G, 'Note on the History of Tapestry-Weaving in England', in Tapestry *Ciba Review*, no.5 (1937), p.168.
9. Phillips, p.68.
10. Geijer, Agnes, *A History of Textile Art* (London: Philip Wilson Publishers Ltd., 1979), p.165.
11. In 1608 the quantity of cochineal imported from the Indies to Seville was 485 cases, valued at 333,437 ducats. Cited in the *Calendar of State Papers Relating to English Affairs in the Archives of Venice*, Horatio F. Brown (ed.), Volume 11: 1607–1610, November 1608, pp.186–94.

Available at http://www.british-history.ac.uk/report.aspx?compid=96951, accessed 25 August 2011.

12. Aqua regis is a mixture of nitric and hydrochloric acids.

13. Petty, Sir William (1667) 'An Apparatus to the History of the Common Practices of Dying', in Sprat, Thomas, *History of the Royal Society* (London, 1667), p.288.

14. Butler Greenfield, Amy, *A Perfect Red: Empire, Espionage and the Quest for the Colour of Desire* (London : Doubleday, 2005), pp.181–2.

15. Chassagne, Serge, 'Calico Printing in Europe Before 1780', in Jenkins, David (ed.) *The Cambridge History of Western Textiles* (Cambridge: Cambridge University Press, 2003), p.515.

16. Hopkins, David, *The Art of the Dyer 1500–1700* (Bristol: Stuart Press, 2000), p.33.

17. Cooper, Thomas, *A Practical Treatise on Dyeing and Callicoe Printing* (Pennsylvania Philadelphia: Thomas Dobson, 1815). Cooper wrote that colour elicited from 5 lb of best indigo would need to be matched by 200 lb of woad.

18. Balfour-Paul, Jenny, *Indigo*, (London: British Museum Press, 1999), p.58.

19. Balfour-Paul, p.49.

20. The Calendar of state papers records the petitioners commenting 'It is as impossible to find madder without sand as wines without lees. The dyers that use the madder have means enough to make themselves amends upon such as sell it to them without this officer's help'. *Calendar of State Papers Domestic: Charles I, 1631–3*, Bruce, John (ed.) (1862), vol.229, pp.471–95. Available at http://www.british-history.ac.uk/report.aspx?compid=52183, retrieved 4 February 2012.

21. *Charles II Statutes 1662: Journal of the House of Commons: 27 Feb 1662* (1802), vol.8, p.374. Available at http://www.british-history.ac.uk/report.aspx?compid=26466.

22. Miller, Philip, *The Method of Cultivating Madder as it is now practised by the Dutch in Zealand* (London: 1758), p.11.

23. Intellectual Property Office, the operating name of the Patent Office website, history of Patents in England accessed 26 August 2011. www.ipo.gov.uk/about/history.htm.

24. Statute of Monopolies as published in *British Patents Abridged Vol.14 Bleaching, Dyeing and Printing Calico 1617–1857* (London: British Patent Office, 1859), preface.

25. Patent 28/1624 to William Shipman – the tax level varied from: crap madder two shillings per hundredweight, to mill madder at two pence per hundredweight for what might be considered the sweepings from the floor. *British Patents Abridged Vol.14 Bleaching Dyeing and Printing Calico 1617–1857* (London: British Patent Office, 1859), p.3.

26. A tithe was usually ten per cent of the income, but see chapter seven for more information.

27. Levinstein, H, 'British Patent Laws – Ancient and Modern' in *The Jubilee Edition of the Journal of the Society of Dyers and Colourists* (Bradford: SDC, 1934), p.83.

28. Sprat, Thomas, *History of the Royal Society* (London: Royal Society, 1667).

29. Birch, T, *History of the Royal Society of London for Improving of Natural Knowledge from its First Rise* (London: A Millar, 1756).

30. Petty, p.288.

31. Petty, Sir William, 'An Apparatus to the History of the Common Practices of Dying', in Sprat, Thomas, *History of the Royal Society* (London: Royal Society, 1667), p.288.

32. Petty, p.287.

33. Petty, p.291. The earliest suggested date for confirming that cochineal was an insect was by French naturalist Plumier in 1666. Born, W, 'Scarlet', in 'Scarlet' *Ciba Review*, no.7 (1938) pp.217–8.

34. Petty, p.296.

35. Petty, p.289.

36. Petty, p.301.

37. Petty, p.304.

38. Hofenk de Graaff, Judith H, *The Colourful Past: Origins, Chemistry and Identification of Natural Dyestuffs* (Riggisberg: Abegg-Stiftung; London: Archetype, 2004), p.316.

39. Mola, L, *The Silk Industry of Renaissance Venice* (Baltimore; London: Johns Hopkins University Press, 2000), p.137.

40. Brunello, p.288.

41. *Edict du Roi, contenant prohibition et défence de l'usage de l'inde et Anil, et entree dans la Royaume* 15 April 1601 (Paris: Mettayer & L'Huillier)

42. Albo/Colbert, *Instruction Générale pour le teinture des laines et manufactures* (Paris: 1671). Although Monsieur d'Albo worked on the *Instruction* with or for Colbert, neither name appears on the cover.

43. Brunello, p.302.

44. Lettres Patentes, *Statuts, Ordonnances & Reglemens que sa Majesté veut être observez par les Marchands Maîtres Teinturiers en grand et bon teint de toutes les Ville et Bourgs de son Royaume* (Paris: 1669), section 1, p.25: refers specifically to there being only three master dyers in Paris at this time, and provision is made for three more.

45. Lettres Patentes, *Règlemens et statuts généraux pour les longueurs, largeurs et qualitez des draps, serges et autres étoffes de laine* (Paris: 1669), section IV.

46. This list appears in both Lettres Patentes and the *Instruction*. While the dyestuff list remains the same,

the spellings vary and in later editions some spellings have changed completely for both dyestuffs and the colours they dye: vovaide becomes *vouëde* by 1688.

47. *Instruction* (1671), pt 2, section xii.

48. *Instruction* (1671), pt 2, section viii; indigo to be used in support of Normandy woad.

49. Pastoureau (1999), p.128.

50. *Instruction* (1671), pt 1, section iv; pt 2, section xxix.

51. *Instruction* (1671) pt 5, section lxvii.

52. *Instruction* (1671) pt 4, section lv.

53. Hofenk de Graaff, pp.6–7.

54. The Gobelins dye factory had been around for two centuries before it was turned into the tapestry and dyeing workshop by Colbert.

55. Phillips, Barty, *Tapestry* (1994), p.44.

56. Campbell, p.194.

57. *Instruction* (1671), pt 6, section lxxxix.

58. Le Brun's designs included a series that either featured the monarch, Louis XIV, or some of the historical and mythical figures with whom he wished to be identified. Campbell, p.194.

59. The work of Chevreul in the 19th Century would establish the dye works at Gobelins as the leader in shades that could be achieved, see chapter eight.

60. Varron, A, 'The Development of Lyons as the Centre of the French Silk Industry', in 'Silks of Lyons' *Ciba Review*, no.6 (1938), p.177.

61. Hofenk de Graaf , p.329.

62. Leix, A, 'Dyes of the Middle Ages', in 'Medieval Dyeing' *Ciba Review*, no.1 (1937) p.19.

63. Hofenk de Graaff, p.289.

64. Hofenk de Graaff, p.330.

65. Balfour-Paul, pp.44–5.

66. *Journal of the House of Commons: Vol.12: 1697–1699* (1803), pp.73–75 Available at http://www.british-history.ac.uk/report.aspx?compid=39542, retrieved 6 April 2010. Dyers petition 29 January 1698.

67. *Journal of the House of Commons: Vol.12: 1697–1699* (1803), 18 May 1698, pp.274–6. Available at http://www.british-history.ac.uk/report.aspx?compid=39631, accessed 6 April 2010.

68. Mola, p.131.

69. Mola, p.120.

70. Mola, p.120, p.166.

71. Mola, p.137.

72. Herald, Jacqueline, 'Italian Silks 1500–1900', in Harris, Jennifer (ed.), 5000 *Years of Textiles* (London: British Museum, 1993), p.174.

73. Butler Greenfield, pp.141–3.

74. Butler Greenfield, p.160.

75. Irwin, John, 'Indian Textile Trade in the Seventeenth Century', *Journal of Indian Textile History*, no.1 (1955), p.6

76. Kumar, Ritu, *Costumes and Textiles of Royal India* (Woodbridge, Suffolk: Antique Collectors Club, 2006), p.4.

77. Cloth was even weighed against pepper or cloves. Guy, John, *Woven Cargoes: Indian Textiles in the East* (London: Thames and Hudson, 1998), pp.8–9.

78. Guy, p.7.

79. Irwin, John and Brett, Kathrine, *Origins of Chintz* (London: V&A Museum, 1970), p.1.

80. Kalamkaris tended to be painted with mordant while in other areas the block was more common. Guy, pp.22–3 and pp.34–5 for a first-hand account of painted chintz.

81. Sandberg, Gösta, *The Red Dyes: Cochineal Madder and Murex Purple: A World Tour of Textile Techniques* (Asheville, NC: Lark Books, 1997), p.117.

82. Hall, Margaret, 'India and Pakistan: Historical Development and Trade', in Harris, Jennifer (ed.), 5000 *Years of Textiles* (London: British Museum, 1993), p.105.

83. *British Patents Abridged Vol.14 Bleaching Dyeing and Printing Calico 1617–1857* (London: British Patent Office, 1859) p.8.

84. Petzold, Andreas, 'The Dawn of the Modern Era 1550–1780', in Ginsburg, Madeleine, *The Illustrated History of Textiles* (London: Studio Editions, 1991), p.46.

85. Chenciner, p.187.

86. Reinhardt, C and Travis, Anthony S, *Heinrich Caro and the Creation of the Modern Chemical Industry* (Kluwer, Dordrecht: Kluwer Academic Publishers, 2000) p.27.

87. The production of alum has produced many myths, not least that the Pope, incensed to lose Catholic miners to Protestant England, declared an anathema against Chaloner and the miners. This myth was perpetrated by Lionel Charlton, who wrote a history of Whitby in the 18th century and was still current into the mid-20th century. It is cited by Scharfer in *Ciba Review*, no.29 (1941), p.1407, but was debunked by Singer in 1948. Singer, Charles, 'The Earliest Chemical Industry' (London: Folio Society, 1948), pp.199–200.

88. Chenciner, p.231.

89. Hopkins, p.19.

90. Brunello, p.263.

91. As we shall see in the next century, the British wanted to keep all crops grown within their colonies, supplied only to Britain. At various times the British court prohibited trade, even with other colonies, in order to keep Britain supplied.

92. Schoeser, Mary, 'Colonial North America', in Harris, Jennifer (ed.), 5000 *Years of Textiles* (London: British Museum, 1993), p.252.

93. *Calendar of State papers Colonial America and West Indies* April 1633, vol.1, 1574–1660, Sainsbury, W N (ed), 1860, available at British History Online, www.british-history.ac.uk/report.aspx?compid=69102, p.161–5.

94. Schoeser, p.252.

7

Analysis, Understanding and Invention: the 18th century

The new focus in the 18th century was on science and the sharing of knowledge through books and articles. In the appendix of the 1859 publication of *Patents for Inventions 1617–1857 in England, category 14: Bleaching and Dyeing*, the Patent Office listed every book or article published in any European country or any British colony they could trace. There are seven entries for the 16th century, 13 for the 17th and 134 for the 18th.[1] This vastly increased quantity of publications after 1700 also reflects the growing importance of textiles in world trade. On one side, textiles helped fund the slave trade, but they also stimulated a fashion market that spread beyond the upper classes to the general populace with affordable new fabrics and colours.

SCIENCE AND DYEING

The 18th century marks a move away from the carefully guarded knowledge of the Middle Ages towards a shared scientific understanding. The greatest scientific advances were made in France. Five men are of particular note: Charles François du Fay de Cisternay (known as Du Fay), Jean Hellot, Pierre Macquer, Le Pileur D'Apligny and Claude Berthollet. Between them they advanced exponentially the knowledge and processes of dyeing. Indeed, in the Patent Office list more than 50 of the titles for this century are French, illustrating their serious interest in the subject. By

comparison, there are almost no papers cited from Italy until the 1790s.

The new French approach was first seen with Du Fay's revision of Colbert's *Instruction générale*. Following the death of Louis XIV in 1715, there was a sense that the laws needed reviewing and updating. The task was given to Du Fay, the first in a distinguished line of dye theorists. It was Du Fay's aim to establish the norms of dyeing for the new century. He began by taking nothing for granted and worked to confirm and explore every aspect of the original work, especially regarding colour fastness, before he would reissue the *Instruction générale*. He disclosed his findings in a public lecture which was also later published.[2]

It took him eight years to complete the work. Influenced by Newton and his theories on colour and also an increasingly scientific approach to dyeing, Du Fay focused on the classification of colours, using his research to question whether dyeing was a chemical or a physical reaction; this represents the first time anyone had applied Newton's theory to a practical application.[3] He also added methods for testing the quality of the dyeing, an aspect of the process for which there had previously been no scientific approach. He was aware that for the previous 60 years the level of colourfastness of any particular dyestuff had been determined by Colbert without any scientific justification. Indeed, Du Fay was aware of disputes that had arisen, especially regarding products that, destined for his majesty's manufactory

of tapestries at Gobelins, seemed to be less '*Grand ou Bon Teint*' than was required.[4]

As Hellot tells us, '*Du Fay did the experiments in his own home, woollens of all colours with every ingredient true or false*'.[5] He even experimented with dyestuffs that were not available in Paris but were used elsewhere locally: '*he collected every drug which he thought might possibly be used for dying and tryed them without any regard to the prejudices of the Dyers, concerning their good or bad qualities.*'[6] Du Fay tested the dyes by submitting the samples to baths of boiling alum (specified as Rome alum), white soap or red tartar, then washing them and leaving them in sunlight over 12 days in summer or 18 days in winter. Hellot continues, '*This trial was evidently decisive, the true colours being not at all, or but very little the worse, whereas the false were almost intirely faded.*'[7] His revised regulations were published in 1737. As a result of his research he was to be the first to surmise that dyeing was much more of a chemical phenomenon than a physical one.[8]

While Du Fay's work was framed by the 1671 *Instruction générale*, other writers were free to examine dyeing from any perspective. The first was Jean Hellot, whose early contribution was *Théorie chimique de la teinture des étoffes* (Chemical theory of dyeing textiles). Published in 1740, it was the first work in which the more theoretical aspects of dyeing were discussed. Hellot's main work was *L'Art de la Teinture des Laines et Étoffes de Laines* (The Art of Dyeing on Wool and Woollen Cloth), published in 1750.

Despite claiming a fully scientific approach, Hellot's conclusions initially seem to take a somewhat backward step after that of Du Fay; Hellot said that dyeing was more of a physical than a chemical reaction. However, we have to examine Hellot's source material. Unlike Du Fay, who had examined almost every known dyestuff, Hellot focused his research on indigo. As we have seen, indigo is a vat dye which behaves very differently to most dyes both in the method of application and in the manner of adherence to the fibre. Indigo is literally more physically trapped in the fibres than other dyestuffs; hence one can see how Hellot came to his conclusion.[9] Undoubtedly, his work contributed to

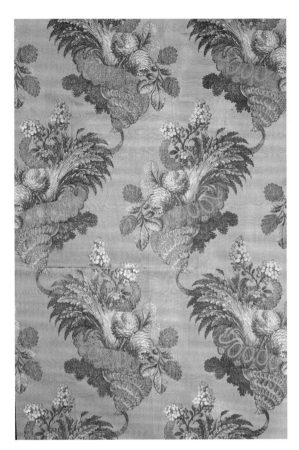

This piece of silk was made in Lyons between 1735 and 1740. It combines the most expensive of materials with the most complex of weaving techniques. It is a brocaded silk which makes use of polychrome silk and real silver thread to create the pattern. The technique of brocading allowed different colours to be introduced into the pattern of a fabric in specific, sometimes, very small areas. As such it was highly complex for the weavers.
© *Victoria and Albert Museum (T170-1965)*

indigo's increasing popularity as a dyestuff over the next century.

Hellot took a systematic approach in the first detailed treatise on wool dyeing, ensuring that this book became the standard for dyeing manuals of the future. He included precise quantitative instructions – amounts of dyestuff, time required in the dye bath and the necessary temperature, as well

as colour mixing with particular reference to blue and red: 'I shall now begin with the simple combination of two colours, in the same order in which I have described them singly. When I have given the colours resulting from their first degrees of combination, I shall join them by threes; continuing in the same manner till I have exhibited every colour existing in nature and imitated by art'.[10] This was an enormous advance after the vagueness of previous manuals. He did, however, continue the concepts of *grand* and *petit teint*.

Hellot continued working with indigo and in 1760 conducted an experiment distilling indigo in the presence of quicklime, in the process accidentally discovering aniline (based on the Indian name for indigo).[11] A century later this substance would revolutionise the dyeing industry, but at that time Hellot did not realise the value or potential of what he had found.[12]

The third French scientist to write about dyeing was Pierre-Joseph Macquer. Appointed to the chair of chemistry at the Jardin des Plantes in Paris in 1749, during that year he established how to use the recently discovered Prussian blue to dye silk, by using a combination of iron (II) salts and potassium hexacyanoferrate (III).[13] Prussian blue was a significant colour breakthrough, offering a brilliant and lighter colour of blue than the usual darker tones of indigo or woad. It was enthusiastically adopted by silk dyers all over Europe.[14]

In 1763, Macquer published his book *Art de la Teinture en Soie* (The Art of Dyeing on Silk). He quickly identified that dyeing was a chemical reaction arising from the affinity between dye and fibre, and as such it is Macquer who is seen as the father of all research into chemical affinity.[15]

He was also the person responsible for making first use of Drebbel's scarlet recipe on silk,[16] where previously it had only been used on wool; while women everywhere should celebrate him, as he is also credited with creating the process by which silk rustles (a sound the French refer to as *craquant*) which is part of the pleasure of wearing certain types of silk.[17] Macquer significantly expanded scientific knowledge about dyeing including, as Edward Bancroft later put it, '*to have formed just conceptions of the*

nature and uses of alum, and of different metallic solutions, as mordants, in dying.'[18] He was made inspector of the dye works in France and published the first *Dictionary of Chemistry* in 1766. He died in 1784 but had left word that Berthollet should succeed him.

The fourth work was by the rather oddly titled *Le Pileur d'Apligny* (meaning the 'pulveriser of flatness'),[19] obviously the nom de plume of an unidentified person, possibly referring to the fact that cotton was dyed by painting or printing on the flat fabric. Published in 1776, his book *L'Art de la Teinture des Fils et Étoffes de Coton* (The Art of Dyeing Cotton Thread and Cloth), set alongside the aforementioned works, completes a series on dyeing the principal fibres (as linen dyes in a similar way to cotton).

Le Pileur is not the scientific equal of Macquer or even Hellot, but his book was the first work on the practicalities of dyeing vegetable fibres, which up to that point had not had the same focus as wool and silk.[20] He also includes the first published recipe for the complicated Andrinople[21] red, or Turkey red, as well as those for a variety of more common dyes.

It has been noted that England had a paucity of books on dyeing, so it is interesting that the works of Hellot, Macquer and Le Pileur had been translated into English as a single volume by 1789. The curiosity is over who did the translation, a person who clearly decided to remain anonymous.[22] Whoever he was, he was a man of the times, as the preface begins, '*Whether our good neighbours the French be our natural enemies or not, certainly they are our most powerful rivals in commerce and manufactures: in this sense they are our enemies, let us not therefore, from pride or ill humour, spurn their instruction.*'[23]

The translator goes on to highlight the very different position of dyeing in France, writing that

'*the government in France, aware of the importance of colours in their various manufactures, hath confided the Art of Dying as an object deserving peculiar attention. Those who practice this art in that kingdom are subject to certain regulations and frequent inspection. The Dyers of the true, and of the false dye, are distinct occupations and some of their best chemists have been employed in experiments partly designed to distinguish precisely the true from the*

false dye, but with the general intention of improving the art.[24]

He also challenges the English dyers, whom he considers will always lag behind their neighbours until they *'make themselves acquainted with the chemical theory of the art they profess.'*[25]

But his most astute comments concerned what today would be called the importance of repeat customers. *'Few people can estimate the intrinsic value of manufactured woollens, silks or cottons, but men, women and children can judge of their colours, on the beauty of which, therefore, the first sale of a new manufacture must depend, and the continuance of that sale will also depend more on the permanency of the colours than of the strength of the stuff; a faded gown is given to Mrs Betty, long before it is worn out.'*[26]

The last of the significant 18th-century French chemists was Claude Berthollet. Recognised not only by the scientific community in his own country, he also held a post at Turin University and membership of learned and scientific societies in England, Italy and the Netherlands. In 1784, as Macquer requested, he was made inspector of the dye works in France and, as he wrote in his 1791 book, he concentrated his energies on research into dyeing and *'particularly into the scientific study of the chemistry of dyeing now, for the first time being explored'.*[27] But he started by discovering a new, quicker method of bleaching.

BLEACHING

As we have seen, the historical bleaching process was long, laborious and led to degrees of whiteness that might not stay white for long. But in the 18th century a number of factors changed. First was the large-scale arrival of cotton from India,[28] which was naturally whiter than wool and could be made into lighter fabrics such as calicos and muslins. Then there was scientific investigation culminating, in this regard, in the discovery of chlorine by Swede Karl Wilhelm Scheele in 1774. In turn this led Berthollet to his discovery in 1785 of the chemical bleaching process using oxygenated muriatic acid.[29]

Such was the reaction to his work when

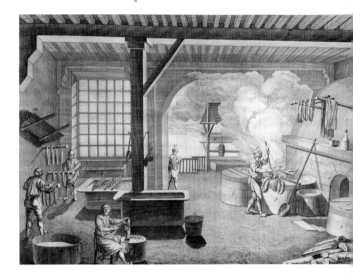

A silk dyer's workshop, from the *Encyclopedie des Sciences et Metiers* by Denis Diderot, published c.1770. His encyclopaedia focused on work and science. Engraving French. © *Private Collection The Stapleton Collection, Bridgeman Art Library*

presented to the French Academy of Sciences that he immediately focused on commercialising the process. But it was another ten years before he published a guide to the process, only after he had realised that the dyers and bleachers were not readers of papers presented to learned societies.[30]

However, at least one Englishman read the paper as the English translation was published before Berthollet's own book.[31] The reason for the international interest was due to time, ease and therefore money. As Berthollet wrote, the impact of his technique was in reducing the time for bleaching from months to days.[32] Prior to Berthollet, the gold standard of whiteness was the *'blanc de Cholet'*, Cholet being the name of the town where it was perfected and seen as a sign of quality; it was a process which took four months to achieve and was risky throughout.[33] Berthollet's process, by comparison, meant the process could be finished in just two or three days, without difficulty. Furthermore, the work did not just have to be done in summer. It was a revolution for both textile and paper manufacturers.

Berthollet took ten years to publish a guide to

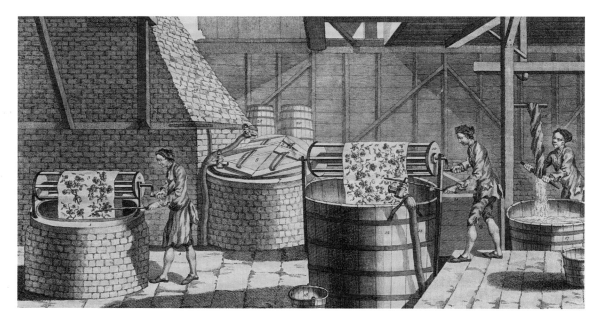

In this engraving, dyers are shown dyeing printed calicos in the piece, illustrating the point at which the cloths are immersed in the dye bath after they have been painted with mordants that will cause the colours to stick to the cloth during this process. © *Science and Society image library, Science Museum*

bleaching, in part because he was simultaneously working on his magnum opus, the two-volume *Elements of the Art of Dyeing*,[34] in which he continued where Macquer had left off, focusing on the chemical affinity of fibres and dyes. The first volume is devoted to the mordants, the fibres and especially the acids and other ancillaries of dyeing. In the second volume he turns to the dyestuffs.

Berthollet also gives one of the first overviews of the history of dyeing. It is, however, very much of its time and worldview. For example, while praising early Indian arts and crafts, he cannot resist saying that they were perfected elsewhere. He quotes from Beaulieu, who reported that '*the Indian processes are so complicated, tedious and imperfect, that they would be impracticable in any other country, on account of the difference of the price of labour*'. He then plays the 'European superiority' card by adding, '*European industry has far surpassed them in correctness of design,*

variety of shade and facility of execution, and if we are inferior to them with respect to the liveliness of two or three colours, it is only to be attributed to the superior quality of some of their dyes, or perhaps to the length and multiplicity of their operations.'[35]

He concludes, summarising that his book outlines for the practising dyer the chemistry of the processes he uses as well as suggestions for improvements, though he is pragmatic enough to realise that dye baths are 'living' organisms and as such that some of his suggestions might not always be appropriate: '*Experiments which relate to dyeing, are attended with peculiar difficulties. Since the beauty of a colour depends on a nicety of shade, which the slightest circumstance may affect.*'[36]

Elements was published in 1791, and translated into English the same year; Berthollet also found time to translate a work by Carl Wilhelm Pörner, director of the Meissen porcelain factory, his *Instructions on the Art of Dyeing and in particular on the Dyeing of Wool*.[37] This was the one German article in the 18th century in the Patent Office list. In the light of what we will see in the 19th century from Germany, it is perhaps surprising that there was so little written only a century earlier.

GROWTH OF COLOURS

Throughout this century scientific discoveries, new experiments, new partially synthetic dyes and new ancillaries with which to mix the dyestuffs meant that there was a comparative explosion in the number of colours and shades now available to the dyer, which continued to grow for both animal and vegetable fibres. Pastoureau notes that during this century the number of named blue colours (naming in commercial terms meant that the colour was reproducible and would be marketed) increased substantially: where at the beginning of the century there were only about 13 named blues, by 1765 there were 24 common terms for blue, of which 16 shades were light blues, demanding more skills of the dyer.[38]

In France in 1775 Queen Marie Antoinette selected a brown taffeta to be made into a gown. The king remarked that it was the same colour as a flea and for the whole of that season flea-coloured fabrics became the rage, with other flea-related shades providing further choice – *ventre de puce* (flea's belly), *tête de puce* (flea's head), *cuisse de puce* (flea's legs)[39] – and spread across Europe. A season or so later Marie Antoinette chose another colour for her gowns, and this time it was her brother-in-law (later Louis XVIII) who said that the colour was like the queen's hair. The new colour was immediately named '*cheveux de la reine*', the price more than doubled overnight and for complete authenticity the queen sent samples of her hair to Lyon and the Gobelins factory.[40]

By the end of the century there was a new spirit and a new colour: the Romantic movement was born, due in no small part to Goethe's novel *The Sorrows of Young Werther*, whose hero, full of unrequited love, wears a blue coat and buff breeches. Young German men were wont to copy Werther's appearance and a fashion fad was born which led to the rise of blue clothing, to paintings on the theme of Werther and even an opera.[41]

To meet this fashion for blue, by 1770 Britain was importing almost one million pounds in weight of indigo per annum from its colonial plantations in Bengal and South Carolina,[42] where the first indigo plantation had been started by the young Eliza

Indigo manufacture, Central Carolina, from *Le Costume Ancien et Moderne, Volume I*, plate 51, by Jules Ferrario, published c.1820s–30s. From this picture it is easy to see the tanks set into the hillside, arranged so the indigo processing starts in the top tank and ends up as sediment in the lowest tank, from where it is drained and left out to dry in the trays on the tables in the centre of the picture (colour litho), Fumagalli, Paolo (19th century). © *Private Collection / The Stapleton Collection / The Bridgeman Art Library*

Pinkney Lucas,[43] who endeavoured to support the family while her father was away in the Caribbean.[44] With Prussian blue also available for clothing, the range of blues and greens was broadened dramatically over this period. By the end of the century green was the most fashionable colour for bedroom furnishings.[45]

Black still had a role to play, too, for while the Romantics might have preferred blue, those enamoured of the Gothic, also stimulated by a Goethe book (this time it was *Faust*), remained true to black.[46] It was claimed that Manchester black was the best kind, followed by Rouen black. At the French court the debutantes made their first appearance in a black dress,[47] and it was also the century in which dyeing black with logwood became common. The Frenchman Giros de Gentilly found a way to use tin salts with logwood and developed the fashionable colour *prune de monsieur* – a burgundy-purple shade.[48]

Blue was the adopted colour of the Romantic movement that began towards the end of the 18th century, especially following the success of Goethe's novel *The Sorrows of Young Werther* about a love-sick young man who wears a blue coat. This example from the Victoria and Albert Museum, London, shows the attention to detail of cut, button and cuff that made this a highly fashionable item in blue and green ribbed silk, hand woven and hand sewn. © *Victoria and Albert Museum (Circ 455– 1962)*

ENGLISH MADDER

As we saw, there were efforts to grow madder commercially in England in the 17th century. However, the increasing taxes and especially the tithe to the Church had a detrimental effect, not least because of the potential for loss of income when the tithe was due. If there was no one to inspect the crop (to work out the tithe amount), it could deteriorate rapidly, reducing the value of the crop.[49] However, in the mid-1750s new initiatives occurred to try to promote madder growing and make Britain less reliant on the Dutch, because English merchants were aware of the precariousness of taking all their supply from one country, especially in times of war.

Philip Miller was a fellow of the Royal Society and gardener to the Worshipful Company of Apothecaries at Chelsea.[50] He had 30 years of experience of madder growing gained in Zeeland, Netherlands and England. He was well aware of the strategic importance of madder and the financial boon it was to the Dutch, Miller noted that on average they earned £180,000 a year from the crop.[51]

In 1758, Miller put forward his case for madder growing, pointing out that, unlike the Dutch, the English farmers would not need to build ridges in which to plant the madder to ensure that the roots were not steeped in water. He also proposed that the industry could be a form of social enterprise, as many people were required to plant the almost 30,000 plants per acre. Miller advocated that this could be an occupation for the poor '*at a time of the year when they most want it*' – that is, the bleak wintertime.[52] Partially in response to Miller's book and after pressure from growers, Parliament changed the tithe to a flat payment of 5s per acre, a rate that would remain in force for the next 14 years.[53]

Miller did, however, recognise that it was not just a matter of growing the madder but also of processing it, too. Even he had to acknowledge that the buildings in Zeeland '*may be thought too expensive and unnecessary*', but his paper still included the plans because he hoped that innovative Englishmen would improve on the original mechanics.[54]

Then a new party came onto the scene. Launched in 1754 the Society for the encouragement of the Arts, Manufacture and Commerce[55] wanted to encourage enterprise, to which end the secretary to the society, William Shipley, proposed four objects for a prize. One was madder growing, which the Society thought was highly suitable for encouragement – so much so that they persisted in promoting it for over 20 years in an endeavour to establish madder as a permanent feature of British agriculture.[56]

Indeed, to begin with there was some success, albeit it due to the subsidy of £5 for every acre planted with madder. From 1761 to 1766, some 78 claims were made, representing nearly 300 acres.

By the end of the campaign, in 1779, the total cash awarded was £1,500 and the society claimed that it had stimulated the production of enough madder to threaten the Dutch monopoly, causing the price of Dutch madder to drop, making the experiment at least a short term commercial victory. Certainly, the customs records show madder imports decreased between 1764 and 1767.[57] Some farmers continued to grow madder. Indeed, the prize for the largest crop from one acre was not claimed until 1777, when one John Crow achieved 18cwt 2qrs 18lb (where normally 10 cwt would be considered a good yield).[58] However, British growers could never provide enough for the country's needs, especially with the increasing popularity of Turkey red.

The French also started a campaign during this period to promote madder growing for self-sufficiency. Henry-Louis Duhamel du Monceau was so impressed with Philip Miller's booklet that he produced a 54-page instruction book on growing and drying madder entitled *Elements of Agriculture*.[59] They, too, did not have an easy start until they began importing madder seeds from Smyrna in 1789, after which madder was established in the South of France, in Normandy and in Poitou. Unlike the British, the French growers had government support and, of course, a more favourable climate.[60] Some of the British farmers bemoaned either the wetness or the dryness of the season in explaining why their madder failed. '*Mr Giles hired the land of me which was in very good order and if it had succeeded I intended to have been a madder planter myself and notwithstanding all this expense or care the greatest part of the madder is destroyed occasioned I apprehend by the wetness of the season.*'[61]

In comparison, French madder dyeing expanded so that while they were still importing 50,000 livres when Turkey red dyeing first took hold in France, by the late 18th century they were producing more than the Dutch for both the home trade and for export.[62]

Meanwhile in Spain in the 1750s Juan Pablo Canals, son of Esteban Canals, set up laboratories and experimental workshops to apply scientific methods to the industrial cultivation and exploitation of all dyestuffs, especially madder, a crop that had been somewhat ignored after the import of cochineal

Following his experiment with growing madder (see chapter one) George Field developed a 'dye' which he wanted to use to paint on cloth in the manner of Turkey red. Seen here in his painting of the madder plant, it is quite a vivid, purple-ish red rather than a true Turkey red. © *Winsor & Newton, Photography Courtauld Institute Library*

from Mexico. His work benefited the Spanish fabric printing and dyeing industry, and his success was rewarded with a baronetcy and by being appointed director general of the royal dye works.[63]

TURKEY RED

The textile 'holy grail' of the 18th century was the deep bright-red colour for cotton known as Turkey red (or originally Andrinople Red), the name deriving from where Europeans believed to be the original source of the recipe, as the details of the process had been brought to France by Turkish immigrants. Greek dyers also came to France – inevitably, they were let go by some dye-company owners once their

skills had all been transferred – but eventually they arrived in Mulhouse, where they made a base and which became the epicentre of Turkey Red dyeing in the 19th century.[64]

Le Pileur d'Apligny named the French pioneers of Turkey red as Messrs Fraquet & d'Haristoy at Darnétal near Rouen.[65] Brunello states that the first European dyer who succeeded in achieving Turkey red was a firm in Leiden followed by a company in Rouen in 1747.[66] Cardon agrees with D'Apligny on location, Darnétal near Rouen, but cites Messrs d'Haristoy and Goudard.[67]

England, however, lagged behind and so in 1756 the Royal Society of Arts (RSA) offered another prize to anyone who could discover a way of dyeing cotton a fast red, an achievement of special interest to the cotton milling industry in Manchester, which was heading for world leadership in cotton manufacture.[68] The RSA would repeat this offer in the early 19th century to which George Field replied with a hand-painted and printed rose.[69]

In Scotland in 1785, David Dale and George Macintosh set up a Turkey red dye works in Dalmarnock with Frenchman Pierre Jacques Papillon, who had brought the technique from Rouen; by 1790, Papillon had moved on and set up the Turkey red industry in the Vale of Leven near Loch Lomond.[70]

Turkey red was a very complicated process – different methods describe up to 30 steps[71] – and it could take a month to produce a finished cloth; hence factories and their environs had to be large with space for many cloths at various stages of completion. If dye pots in general had to be watched over by master dyers who could tell quickly if something needed modifying, this was even more the case with Turkey red dyeing. It was such a delicate process with so many opportunities for it to go wrong – affected by the climate, air or water individually or collectively – that the overseer had to be on hand at all times to make small changes.[72] Moreover, for many years European producers still struggled with producing a finished fabric as colourfast as that produced in India.[73]

However, with colourfastness secured, they could now begin to develop the new printed patterned cloths, which soon became highly fashionable.

EDWARD BANCROFT AND QUERCITRON

One of the most curious figures in the history of dyeing is probably Edward Bancroft. His curriculum vitae would read self-taught scientist, inventor/discover, dyer, writer, spy. Born in the American colonies, he had no formal training but established his scientific credentials with the publication of an essay on the natural history of Guyana in 1769.[74] This was well received and in 1773 he was elected to the Royal Society in London with Benjamin Franklin as one of his sponsors.[75] He had moved to France as secretary to the American commissioners in 1769 and he corresponded with leading dye chemists throughout the world, including Berthollet. Altogether he patented three natural dyes, and the East India Company considered him the leading expert on dyes, consulting him on such matters as the introduction of lac dyes into England in 1790.[76]

With his discovery of the dye properties of the inner bark of the American black oak (*Quercus tinctoria* W. Bartram), Bancroft became one of only two discoverers of natural dyes whose name is known.[77] Today called quercitron, it gives a bright yellow colour. He brought samples to England in 1775 and gained a monopoly for its import by act of parliament.[78]

Bancroft researched the topic of dyeing thoroughly, examining it from a scientific and a practical perspective. It was he who noted that the paper given at the Royal Society by Sir William Petty was the first in English.[79] He coined the terms 'substantive' and 'adjective' dyestuffs.[80] He invented several processes for dyeing textiles, which, along with his research, led to the publication of *Experimental Researches Concerning the Philosophy of Permanent Colours and the Best Means of Producing Them by Dyeing, Calico Printing, etc.*, printed in London in 1794.[81]

As a result of the research into dyeing and colour this century, by its end dyers were able to create not only more colours, but a greater range of each colour and so more names needed to be invented. Generally names of colours started to become

RIGHT: At the end of the 18th century lac from India became the 'new' red dyestuff. It was not new, it had been used for centuries (and not just in India), but the East India Company sought Bancroft's advice on importing it to Britain. Lac is the resinous secretions of a number of insects, in particular the *Coccoidea* family of insects. *Photograph © Susan Kay-Williams*

BELOW: A poster on the breeding and processing of cochineal and lac as dye sources 'showing their utility to man'. (1845) *© Science and Society image library, Science Museum*

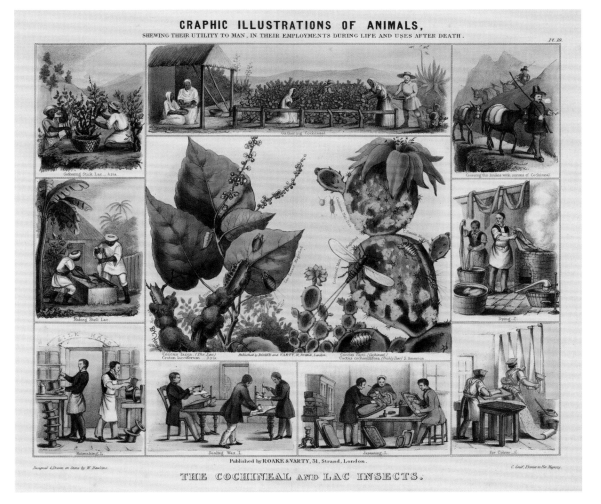

CRAPHIC ILLUSTRATIONS OF ANIMALS,
SHEWING THEIR UTILITY TO MAN, IN THEIR EMPLOYMENTS DURING LIFE AND USES AFTER DEATH.

Published by ROAKE & VARTY, 51, Strand, London.

THE COCHINEAL AND LAC INSECTS.

linked to recognisable things and be reproducible such as mud grey or mouse gray, which would be identifiable, that is one can perceive what kind of colour mouse grey might be because it relates to a known object.[82]

Unfortunately for Bancroft his monopoly on quercitron coincided with the American War of Independence, which stopped all commercial shipping between America and Britain. In the meantime, he offered to become a spy for the British crown on the American leaders in France by working in the office of Benjamin Franklin.[83]

After the war, Bancroft complained that his salary from spying was overdue and persuaded the British government to recompense him by extending his monopoly. A new bill put to parliament got stuck in the House of Lord, although it had been passed in the Commons, but Bancroft was able to maintain his monopoly until 1799.[84] Quercitron became popular with dyers all over Europe, giving a brighter yellow than fustic and for the first time challenging weld.

CALICOS AND CHINTZES

There are very few western reports of calico printing from this period still extant. Serge Chassagne cites possibly the only one, the *genuine eastern technique of colouring fabrics* as observed at Pondicherry around 1734 by the captain of a visiting merchant ship. The calico was washed in rice water, then weighted and soured. The motif was drawn with a pen, painting the cloth with alum by hand without thickening the areas to be coloured, with wax protecting the rest of the cloth. It was then plunged in a dye bath of madder or chay, the Indian plant from the Rubiaceae family, and washed in the milk of water buffalo mixed with goat excrement.[85]

Once observed, though, Europeans wanted to see if they could utilise these methods, too, as chintzes and calicos were all the rage and manufacturers were keen to supply their clients regardless of the import bans. Some looked for cotton supplies from America, but many producers simply ignored the edicts so as to meet the needs of a growing market.[86] The British government tried to impose premium excise duties

on cottons, supposedly to protect the British linen industry, eventually allowing Indian cotton to be printed for the export market from 1721.[87] But in France and Germany there were even public burnings of the material.[88]

At the beginning of the 1730s there was significant development in resist dyeing. Using a new method known as the 'cold bath' the indigo was dissolved by adding iron sulphate to the alkaline bath.[89] This process, which spread to Germany in about 1740, was also helped by thickening the wax or resin with Senegal gum, even pipe clay and beef fat. Moreover, at the lower temperature it did not melt, so the blue dye stayed more easily in the unwaxed areas and was less able to migrate into the waxed area.[90]

Alongside improving the wax process, the indigo was now 'improved' to allow it to be applied with a brush. The catalyst to this improvement was the use of arsenic trisulphide. Arsenic has been used in the dyeing industry for centuries but this specific use, while certainly helping to make the application of indigo easier, also meant it was a far more hazardous and toxic process, so much so that an alternative, less noxious approach was soon adopted, though this did not quite match the success of the arsenic mixture.[91] The painting method could also be used to create different colours by first painting different mordants onto the cloth and then dyeing it so that at the end there were a range of different shades all based on madder. Wax resists could also be painted onto the cloth, and removed after dyeing, leaving white areas which could then be painted with a brush or blocks.[92] But creating green was still challenging, requiring overdyeing and other additional processes.

A development of the 1750s was copperplate blocks for printing. Invented by Francis Nixon of Dublin, in 1756 this process was brought over to England to create some wonderful printed textiles, typically pictorial or narrative textiles with far more detail than had previously been possible.[93]

By the second half of the century there were already three calico printers in Lancashire, including Robert Peel's (who was the father of the future Prime Minister), which was destined to become a huge plant. One of Peel's best successes was the Parsley print. Based on a design suggested by his daughter,

it successfully replicated the highly crenellated edge of the parsley leaf. It became widely sought after and was even known as the Nancy pattern after his daughter.[94] But colourfastness was still a problem. The Royal African Company asked that cloths with strong yellows and greens were not sent to Africa, as they were not colourfast.[95]

Throughout this century there were technical advances, especially relating to spinning and weaving, which set up the textile industry for the major advances and output of the 19th century, particularly in centres like Manchester. Kay's flying shuttle, Arkwright's improved spinning jenny and his showpiece Masson Mills in Matlock Bath, Derbyshire all helped to improve production time and quality while bringing down the price.[96] In dyeing, by comparison there were few advances for wool and silk – even the equipment stayed the same – but there were advances in printing calicos.

By 1783 Scot Thomas Bell had registered two patents on inventions relating to printing cotton fabric on a rotary press in several colours at once. His machine remained the prototype even as different methods of powering it, such as steam and later electricity, became available.[97] Single-colour printing of patterns on dress materials had begun in Preston Lancashire as early as 1790. In the same year the first manual for printing on cloth in England was published by Charles O'Brien, which today provides a fascinating insight into the working methods of the era.[98] And once English producers were finally allowed, legally, to print cottons, development was very swift. In 1779, six million pounds weight of cotton were imported; by 1790 this had risen to 46 million pounds, a figure that continued to grow through the 19th century.[99]

The other 18th-century development on calico was resist printing using preheated moulds of lead or tin for the hot application of wax or tallow with a cloth laid out on a bed of sand. This process was described in 1760 by the Chevalier of Quérelles in *Traité sur les toiles peintes dans lequel on voit la manière dont on les fabriques aux Indes et en Europe*, and in 1766 the Abbé Jaubert wrote about it in the 16th volume of Diderot's encyclopedia.[100]

In France, the major printer of textiles was Christoph Philipp Oberkampf. He started as an

Made on the Coromandel Coast, this chintz napkin or table cover is printed and painted in the format of a palempore, or hanging, with large-scale, French-style designs facing a central coat-of-arms. The arms are those of Michel Bégon and Elizabeth Beauharnais, who were married in 1711. © *Victoria and Albert Museum (T5-1913)*

apprentice at Rhyner's factory in Basel and from there went to France, arriving just as the ban on printed textiles was lifted. He set up a small factory near Paris before moving to Jouy-en-Josas in 1760. From the beginning he aimed for quality, sourcing smooth Indian cotton initially from England, before importing it directly from French East India[101] and used only the colours of the *grand teint*. His *bleu de pinceau*, produced from a very concentrated vat of indigo thickened with gum, was deservedly famous, as was his madder on a mordant of iron; and he introduced bleaching as soon as Berthollet had spread the word.[102]

Oberkampf first came to London in 1773, visiting many of the major manufactories and taking careful notes. Dublin and London printers had enjoyed an almost complete monopoly on copperplate printing until then, albeit there was still a ban (until the following year) on the production of printed cottons for home consumption, so as to protect the silk industry. Oberkampf had acquired a copper-plate machine in 1770 and applied his learning to produce some of the company's most famous pictorial printed cottons, known as toiles de Jouy, designed by Jean-

Robert Jones & Co. cloth, designed 1 January 1769 as a furnishing fabric. Made of linen and cotton (as this was during the prohibition of all-cotton cloth) it was printed with engraved metal and wooden blocks, but also hand-painted blue (known as pencilled). The engraved printing blocks allowed for more detail and a larger scale of pattern than had previously been possible. © *Victoria and Albert Museum (T140-1934)*

Baptiste Huet, making it the foremost printing workshop in France.[103]

By the 1740s British-made printed textiles dominated the market for womens' gowns. Alongside this, in France the first engravings of ladies' fashion (hence the term fashion plates) were being produced and circulated, and later in this century, when the Lyon silk weavers introducing the first seasonal collections of fabrics to stimulate demand, the growth in a fashion market for more than just the very rich could be said to have begun.[104]

CLOTH OF THE COMMON PEOPLE IN ENGLAND

In London in the 18th century times were hard for the working class and, with an absence of contraception, many women found themselves with children but no means to keep or support them. Women in this situation had a new option from the mid-1700s onwards – to give the children to the Foundling Hospital in London.[105] In most cases, this was the last these mothers and their children saw of each other; however, those receiving the children were good-hearted optimists who asked for a token to be left by the mother which might be recognised by anyone reclaiming the child in the future. On some 5,000 occasions the item left was a piece of cloth cut from the child or mother's clothing. These remnants give a fascinating insight into the range of materials available to working-class women, and where more lavish materials were included the assumption is made that this had been handed down to be reused or remade. For example, one sample is a blue silk, a rich fabric, but the piece also includes the selvedge, a part of the fabric that would not have been included in the original garment. The visibility of the selvedge and frayed edge suggests that this may have been an offcut.[106]

John Styles, who has made a study of these pieces, comments that they are predominantly executed in a single colour (much cheaper than multiple colours), but he notes the wide range of patterns, with remarkably few examples of the same cloth in the 5,000 or so samples.[107] When I questioned Styles on the predominant colour of the fragments,

Sample from one of the more than 5,000 fabric tokens left as the recognition memento with babies placed at the Foundling hospital in the 18th century. Here the cloth is a blue silk – this would have been unusual for someone giving up their child, except the obvious selvedge in pink and yellow implies that the owner had had to make do with off-cuts, so was probably a maid or other servant. *(Foundling 1254, a girl admitted 29 May 1755) © Coram Foundation*

Many of the samples from the Foundling babies' files are simple printed cottons, often in monochrome colours, but here there is a pattern and three colours, although we can tell this is not of the highest quality from the way the blue and pink infill colours do not match up exactly with the outline of the bird. *(Foundling 13476, a boy, admitted 20 June 1759) © Coram Foundation*

Designed by Anna Maria Garthwaite for Spitalfields silk manufacturers, this is a complex piece of weaving involving an additional weft thread in the background to produce the self-coloured pattern, and the coloured flowers are brocaded with additional warp threads, requiring a more skilled weaver to ensure the pattern was consistent. It would have been made for a ladies' gown. © *Victoria and Albert Museum (T192-1996)*

he commented that the majority of them were blue or had blue patterns on white, which echoes what we know from high society where blue clothing was becoming more popular.[108]

ITALY

Venice had had a declining influence on dyed cloth over the previous 200 years, even losing the production of cloth for fezzes for the Turkish market to Yorkshire.[109] So it was particularly questionable that in 1713 the dyer Alessandro Ceroldi of Padua, then part of the republic of Venice, was not only granted the equivalent of a patent monopoly for his method of producing black using logwood, but all the other dyers in Venice were expected to produce black in the same way and to pay a royalty of two coins to Ceroldi for his lifetime and for 20 years thereafter for every piece of cloth made using his method. Perhaps inevitably, the Venetian dyers considered this new method, referred to as the Dutch and English recipe, to be not as colourfast as their previous methods and resented the royalty requirement.[110] Whatever the political machinations that had led to this extraordinary monopoly being granted, the net effect was the complete demise of the Venetian dyeing industry. Most of the dyers moved outside the republic, leaving only the street names to indicate the dyers' former pre-eminence among the city's industries.[111] The Ceroldi dye-process law was never revoked during the period of the republic, and any dyers who tried to avoid paying the royalty or, more likely, tried to use the old methods, were actively tried and condemned.[112]

In the later 18th century the government of the republic of Venice endeavoured to stimulate the dormant dyeing industry. First Pietro Arduino published *Memorie di Osservazioni e di esperienze sopra la cultura egli usi di Piante che server possono alla tintura*, concerning the growing and using of plants for dyeing. Then in 1773 Alvise Rubellis produced a report on the state of dyeing in the republic which highlighted areas for improvement. Here they were helped by the fashion for the latest colours which led to a 'colour orgy'.[113] Further books were published in 1793 and 1794, but

the Venetian industry was now a long way behind the rest of Europe and would never recover.[114]

Genoa on the other hand continued to thrive. In 1765 Jean Jacques de la Lande recorded that the most important manufacturing industry in Genoa was still that which produced high-quality black velvet, the beauty of which he attributed to the quality of the local water. They also had a good reputation for greens, yellows and sky blues, but second to black was Genoan crimson, identifiable by its slightly pink tinge. Brunello gives some of the credit for the maintenance of standards in Genoa to the *Excellentissimo Magistrato della Seta* (the most excellent silk magistrate), who insisted on first-class cochineal being used.[115] Macquer attributed the quality of the fabric to the Genoese dyers' more sparing use of soap in the mixture for black than for other colours. By this time it was also possible for the manufacturers to supply the dyers with the exact quantity of dyestuffs for the quantity of material they were providing and the colour they required.[116]

NOTES

1. The Patent Office list is not complete, for example it includes the English translation of Berthollet's *Art of Dyeing* but not the French original. At times it can seem selective, for example including the 1785 extension Act for Bancroft's monopoly on quercitron but not the original 1775 one, and a number of relevant titles are not included. However, it is a valuable point of reference. As noted, the list includes translations which is helpful to show how quickly knowledge transferred from one country to another.

2. Du Fay, 'Observations de quelques couleurs dans la teinture' in *Mémoires de l'Academie des Sciences* (Paris, 1737).

3. Hofenk de Graaff, Judith H, *The Colourful Past: Origins, Chemistry and Identification of Natural Dyestuffs* (Riggisberg: Abegg-Stiftung; London: Archetype, 2004), p.8.

4. Du Fay, *Instruction générale*, introduction (Paris, 1737).

5. Hellot, Jean, *L'art de la teinture des laines et des étoffes de laine* (Paris: Widow Pissot, 1750), p.12.

6. Hellot, p.13.

7. Hellot, p.13.

8. Bancroft, Edward, *Experimental Researches Concerning the Philosophy of Permanent Colours and the Best Means of Producing Them* (London: T Cadell & W. Davies, 1794), p.xl.

9. Brunello, Franco, *The Art of Dyeing in the History of Mankind*, tr. Hickey, B (Vicenza: N. Pozza, 1973), p.229.

10. Hellot, Jean, *The Art of Dyeing on Wool and Woollen Cloth*, (tr. anonymous) (London: 1789), p.192.

11. *Anil* was the Portuguese, Arabic and Persian name for indigo, based on the Hindu word *nil*.

12. Hellot, Jean, unpublished notebooks; Brunello, p.228.

13. Hofenk de Graaff, p.10.

14. Meanwhile, in Germany Barth had discovered the first semi-synthetic dye by dissolving indigo in concentrated sulphuric acid in 1740. It was named Saxon blue for the location where it was made, and the particular type of sulphuric acid made from the distillation of iron sulphate, which was distinctive to Saxony. Cooksey and Dronsfield, Alan T, 'Pre-Perkin Synthetic Routes to Purple', in *Dyes in history and Archaeology*, no.19 (2003), p.118. Later in the century, in 1771, the next significant semi-synthetic was picric acid, a yellow, though it was not fully recognised until the mid-19th century.

15. Brunello, p.231.

16. Macquer, Pierre-Joseph, in the *Mémoires de l'Academie Royale des Sciences* (Paris, 1768).

17. Brunello, p.232.

18. Bancroft, p.xliii; Macquer's comments were made in his Dictionary under the section on dyeing.

19. Chenciner, Robert, *Madder Red: A History of Luxury and Trade: Plant Dyes and Pigments in World Commerce and Art* (Richmond: Curzon, 2000), p.188.

20. Brunello, p.232.

21. Also called Adrianople red or Adrianopolis red. See for example Schoeser, Mary and Dejardin, Kathleen, *French Textiles: From 1760 to the Present* (London: Laurence King, 1991), p.29.

22. The nearest we have to understanding who he was, is that he was connected with the Royal Society for Arts (RSA), Manufacturing and Commerce, see p.114.

23. Anonymous, *The Art of Dyeing Wool Silk and Cotton*, tr. from the French of MM Hellot, Macquer and Le Pileur d'Apligny, (London: 1789), introduction. In the Patent Office list as from 1790.

24. Anonymous, p.i.

25. Anonymous, p.iii.

26. Anonymous, pp.v–vi

27. Berthollet, Claude-Louis, *Elements of the Art of Dyeing Vols 1–2*, tr. Hamilton, W, (Paris: Firmin Didot, 1791), pp.xxix–xxx.

28. This really increased once the bans on cotton printing were lifted in the late 1750s, beginning with cotton fabrics but soon moving to raw cotton, as mills in areas such as Lancashire started weaving their own cottons. See Harris, p.227.

29. Berthollet, (1791), vol.1, pp.45–73.

30. Berthollet, Claude-Louis, *Description du blanchiment des toiles et des fils par l'acide muriatique oxigéné* (1795).

31. Berthollet, Claude-Louis, *Essay on a New Method of Bleaching by Means of Oxygenated Muriatic Acid*, tr. Kerr, Robert (Edinburgh: 1790).

32. Hofenk de Graaff, p.11.

33. Fau, A, *Histoire des Tissus en France* (France: Ouest-France, 2010) p.29.

34. Berthollet Claude Louise, *Eléments de l'Art de la Teinture* (Paris, 1791).

35. Berthollet (1791), pp.viii–ix.

36. Berthollet (1791), p.xxxv.

37. Pörner's original title was *Chemische Versuche und Bemerkungen zum Nutzen der Färbekunst*. Although one might be a little surprised at Berthollet spending his time on this translation when Bancroft, an admirer of Berthollet, said Pörner's work '*contains an account of many experiments made by the author with different dying drugs, but unfortunately his reasonings upon them, and upon every part of the subject, are highly defective.*' Bancroft (1794), p.xlv.

38. Pastoureau, Michel, *Blue: The History of a Colour*, (Princeton: Princeton University Press, 1999), p.136.

39. Varron, A, 'Fashionable Colours', in 'Paris Fashion Artists of the Eighteenth Century' *Ciba Review*, no.25 (1939) p.909.

40. Varron, p.909.

41. Goethe, *The Sorrows of Young Werther* 1792 (London: Penguin, 1989). The opera is by Jules Massenet to a libretto by Édouard Blau, Paul Milliet and Georges Hartmann.

42. Garfield, Simon, *Mauve*, (London: Faber and Faber, 2000), pp.124–5.

43. Eliza Lucas Pinkney (the first woman to grow indigo profitably in South Carolina) from Layne Martin, Eliza, unpublished PhD extract *Eliza Lucas Pinckney: Indigo in the Atlantic World* (n.d.).

44. Rupp, Rebecca, 'Indigo: the Devil's Dye', *Early American Life* (August 2010), p.47.

45. Pastoureau, Michel, *Black: The History of a Colour* (Princeton: Princeton University Press, 2008), p.160.

46. Which also stimulated an opera. Pastoureau, p.166.

47. Varron, A, 'The Fashion Artist at Work', in 'Paris Fashion Artists of the 18th Century' *Ciba Review*, no.25 (1939), p.889.

48. Hofenk de Graaff, Judith H, *The Colourful Past: Origins, Chemistry and Identification of Natural Dyestuffs* (Riggisberg: Abegg-Stiftung; London: Archetype, 2004), p.235.

49. Miller, Philip, *The Method of Cultivating Madder as it is Now Practised by the Dutch in Zealand* (London: 1758), p.vi. (In most of the contemporary references Zeeland is spelled as in Miller's title, not as today.)

50. Now the Chelsea Physic Garden, London.

51. Miller, p.vii.

52. Miller, p.viii.

53. An Act to encourage the Growth and Cultivation of Madder, in that Part of Great Britain called England, by ascertaining the Tithe thereof. *Journal of the House of Lords*, vol.29, 1756–1760 (1767–1830), pp.308–319. Available at http://www.british-history.ac.uk/report.aspx?compid=114450&strquery=1758 Act madder, retrieved on 27 April 2011.

54. Miller, p.ix.

55. Now the Royal Society for the Arts, Manufacture and Commerce, known as the RSA.

56. Hudson, Derek and Luckhurst, Kenneth W, *The RSA 1754–1954* (1954). The RSA document was called, '*Impartial considerations on the cultivation of madder in England: reasons why the greatest encouragement should be given to the cultivation of madder in England*'.

57. The quantity of madder imported into England in 1764 was a total of 20,461 hundred weight; by 1765 it was 14,180, up in 1766 to 21,646 and at 17,750 in 1767. RSA Archive, PR.GE/110/25/30.

58. Hudson and Luckhurst, p.89.

59. Du Hamel du Monceau, *Traité de la Garance et de sa culture* (Paris: 1765).

60. Chenciner, p.57.

61. Letter dated 6 January 1768 from landowner Mr William Laming. RSA Archives, RSA/PR/GE/110/24/153

62. Chenciner, p.57.

63. Brunello, p.250.

64. Mulhouse was not in France at this time so the ban did not apply. The first factory opened in 1746. Harris, Jennifer, *5000 Years of Textiles* (London: British Museum, 1993), p.226.

65. Le Pileur d'Apligny, *Essai sur les moyers de perfectionner l'art de la teinture et observations sur quelques matières qui y sont propres*, (Paris: 1776).

66. Brunello, p.233.

67. Cardon, Dominique, *Natural Dyes: Sources, Tradition Technology and Science* (London : Archetype, 2007), p.116.

68. London, Embroiderers' Guild, *Embroidery* (Nov/Dec 2009), p.50.

69. Field, George, unpublished notebook no.1 (1806).

70. Chenciner, p.67.

71. O'Neill, Charles, *Dictionary of Dyeing and Calico Printing* (London: 1862; facsimile New Delhi: Cosimo Publications, 2008). O'Neill begins the description of Turkey red dyeing with the words, 'the methods of obtaining this red are very complicated and differ very much in different establishments ... many attempts have been made to shorten the processes ... but it does not appear to have much success.' See p.338–9.

72. Chenciner, p.189–90.

73. Williams, Rhiannon, 'The Industrial Revolution 1780-1880'. in Ginsburg, Madeleine (ed.), *The Illustrated History of Textiles* (London: Studio Editions, 1991), p.60.

74. Bancroft, Edward, *An Essay on the Natural History of Guiana* (London, 1769).

75. Schaeper, Thomas J, *Edward Bancroft: Scientist Author, Spy* (New Haven: Yale University Press: 2011), p.34–5.

76. Ponting, Kenneth G, *A Dictionary of Dyes and Dyeing* (London: Bell & Hyman, 1981), p.10.

77. The other was cudbear, developed in 1758 by George Gordon and his brother Cuthbert with Copper Smith, a dyer from Leith in Scotland, from native lichen *Ochrolechia tartarea*, which gave a colour like orchil. For more information on cudbear see Grierson, Su, *The Colour Cauldron* (Perth, Scotland: 1989), pp.27–31.

78. *An act for vesting in Edward Bancroft, Director of Physic, the sole property of his invention of discovery of the use and application of certain vegetables for dyeing, staining, printing and painting certain valuable colours.* House of Lords Journal Vol.37 (May 1785). www.british-history.ac.uk/report.aspx?compid=16772. Notably, it is not called quercitron.

79. Bancroft (1794), p.xxxviii.

80. Bancroft defined 'substantive' as 'colouring matter which requires no basis or mordant to give it lustre or permanency' p.xvi and 'adjective' colours or colouring matter as those which acquire their lustre and permanency by being adjected or applied upon a suitable basis (meaning mordant) (1794), p.xii.

81. A successful book that ran to a second edition in 1813.

82. Given that dyers still wanted to keep their recipes secret not many books go into this much detail, though one can see from the examples, especially the woven silks, that many more colours were available.

83. For a full account see Schaeper.

84. Ponting, p.13.

85. Chassagne, Serge, 'Calico Printing in Europe Before 1780', in Jenkins, David (ed.) *The Cambridge History of Western Textiles* (Cambridge: Cambridge University Press, 2003), p.516.

86. Schoeser, Mary and Dejardin, Kathleen, *French Textiles: From 1760 to the Present* (London: Laurence King, 1991), p.14.

87. Chassagne, p.519.

88. Chenciner, p.56.

89. Hellot described this process in his unpublished notebooks.

90. Chassagne, pp.515–6.

91. Sandberg, Gösta, *The Red Dyes: Cochineal Madder and Murex Purple: A World Tour of Textile Techniques* (Asheville, NC: Lark Books, 1997), p.43.

92. Chassagne, p.515.

93. Harris, Jennifer, 'Printed Textiles' Harris, Jennifer (ed.), *5000 Years of Textiles* (London: British Museum, 1993), p.226.

94. Brunello, p.251.

95. Brunello, p.235.

96. Chenciner, p.66.

97. Schoeser and Dejardin, p.28, 33.

98. O'Brien, *A treatise on Calico Printing, Theoretical and Practical* (London, 1792).

99. Reinhardt, C and Travis, Anthony S, *Heinrich Caro and the Creation of the Modern Chemical Industry* (Kluwer, Dordrecht: Kluwer Academic Publications, 2000), p.27.

100. Diderot's encyclopaedia published between 1751 and 1777 was the first such work, closely followed by the first *Encyclopaedia Britannica*, but Diderot focused on an encyclopaedia of work. Schoeser and Dejardin, p.23.

101. Harris, p.226.

102. In 1783 Marie Antoinette visited the works and Louis XVI granted the Jouy works the title of Royal Manufactory. By this time Oberkampf employed 11,500 and had a model factory, with many social schemes like housing for the workers. Oberkampf was later invested with the Legion d'Honneur by Napoleon I.

103. Harris, p.227.

104. Edwards, Tim, *Fashion in Focus* (London: Routledge, 2011), p.23.

105. Styles, John, *Threads of Feeling* (London: Foundling Museum, 2010), pp.11–12.

106. Styles, John (2010), fig.19, p.28.

107. Styles, John, *The Dress of the People: Everyday Fashion in Eighteenth Century England* (New Haven, Yale University Press, 2007), pp.114–22.

108. Although another researcher says that more are described as 'purple' decoration, Eppie Evans RSN 2012. The purple probably coming from logwood.

109. Chenciner, p.187.

110. Chenciner, p.187.

111. Rio del Tintor (Dyer's Canal); Ponte della Tintoria (Dye Works Bridge); Calle dei Colori (Street of the Colours).

112. Brunello, p.242–3.

113. Brunello, p.239

114. Angelo Natal Talier's *Dell'arte di tingere in filo, in seta, in cotone, in lana e in pelle* in 1793 and Gioachin Burani's *Trattato dell'arte della tintura* in 1794.

115. Brunello, p.238

116. Macquer, P, *The Art of Dyeing Silk*, tr. anonymous (London: 1789), pp.372–6.

8

Ryots, Rewards and Handsome Colours: the 19th century

The 19th century saw the biggest-ever change in the source of dyestuffs and methods used for dyeing. In a mere few decades, centuries of dyeing experience was overturned. However, the transition to synthetic dyeing is not the only story of this century, which is driven forward by war and manufacturing but begins with a new perspective on the theory of colours.

GOETHE AND THE THEORY OF COLOURS

In 1810 Goethe set aside novels to publish his *Theory of Colours*. His starting point was that Newton's work on the spectrum was wrong, that Newton had mistaken *'an incidental result for an elemental principle'*.[1] Goethe's view was that Newton had been *'possessed with an entirely false notion on the physical origins of colours'*.[2] Further, Goethe considered the subject of colour had nothing to do with the science of optics. Instead his own theory reverted more to that of Aristotle, relating to light and dark, when he writes *'we have traced [colour] to an antecedent and a simpler one (than Newton's); we have derived it, in connexion with the theory of secondary images, from the primordial phenomenon of light and darkness, as affected or acted upon by semi-transparent mediums'*.[3] Goethe believed that in *The Theory of Colours* he had *'traced the phenomena of colours to their first sources'*[4] .

Regarding dyes, for red he refers to kermes and cochineal, with no mention of madder, but his theory highlights 'plus' or 'minus' colours achieved by the action of acids or alkalis. He notes that the *'French arrest their operations on the active side, as is proved by the French scarlet, which inclines to yellow. The Italians, on the other hand, remain on the passive side, for their scarlet has a tinge of blue.'*[5] From other things we have discussed we know that French and Italian dyers often had different underlying hints of colour in their reds, though this was not from any sense of 'active' or 'passive' colours, rather it was about what today we might call trademarks, their particular take on a colour.

Perhaps understandably, his views aroused great interest in his fiction readers, and while it achieved little with chemists and dyers, artists did see something in his approach. As Gage comments, this highlighted *'another early indication of the growing division between colour-theory for artists and colour-theory for the world at large.'*[6]

However, even his most ardent reader might have been somewhat upset when he wrote that in terms of fashion *'people of refinement'* have eschewed colours, with women now predominantly wearing white and men black, something which he attributes to poor vision or uncertainty of taste,[7] instead of it having anything to do with the availability of new lighter materials and the use of logwood. He also notes German men wore blue, although he attributes this to it being a permanent colour rather

than one his novel *The Sorrows of Young Werther* had made fashionable.[8]

UNIFORMS IN ENGLAND AND FRANCE

Wars need soldiers and it had long been recognised that soldiers work better as a team if they are in common and recognisable uniforms, not least on a smoke-filled battlefield. As Napoleon put it, '*A soldier must learn to love his profession, must look to it to satisfy all his tastes and his sense of honour. That is why handsome uniforms are useful.*'[9]

In France, even before the revolution there was a mishmash of uniforms. Napoleon brought order into the '*general promiscuity of military dress*' by introducing a new regulation uniform of blues, whites and greys.[10] But without supervision of provisioning, standards slipped and unscrupulous traders made substandard materials (while undoubtedly charging the same price). This was not just a question of colour but of durability, such that, before 1789, fabric had a thread count of 1728, but, with the coming of the republic, production was not monitored and the thread count declined to 1500 or 1400 for the same size of cloth, so that the resulting uniform barely lasted a single campaign.[11]

In terms of colour, there were issues with the impact of exposure to sun, air and sweat, so that greens in particular were prone to fading. White cloth was much favoured, achieving consistently bleached white cloth in quantity was difficult, while distinctive colours could also bring problems in the form of incorrect shades, especially the lighter blues. In other words, the uniformity one imagines from cinematic representations of the wars of the Napoleonic era would not actually have been seen on the battlefield.[12]

The source of blue was imported indigo from France's Caribbean colonies. When the continental blockade against Napoleon was established by the British,[13] supplies ceased. Napoleon offered a prize of 425,000 French francs for anyone able to make woad competitive with indigo in terms of the quantity

Royal Welsh Fusiliers (1855). Print by H. Martens and J. Harris. This was to be the last century in which the British Redcoat would be seen on the field of battle. As locations of wars changed, taking in the more arid regions of India and Africa, it became clear that red was little more than a target. Nevertheless, it remained in use until almost the end of the Victorian era.
Photograph © Susan Kay-Williams

and quality of dyestuff achieved.[14] Unfortunately, this was a practical impossibility: a pound of woad could not generate the same amount of dyed cloth, let alone to the same concentrated shade, as a pound of indigo.[15] Moreover, as a result of the loss of trade in woad, most producers had switched to other crops. As soon as the blockade was removed Napoleon reverted to his former dye source, indigo.

Cochineal imports were also affected by the blockade. Chaptal, the minister for uniforms, offered

a prize of 20,000 francs for someone to find a way to achieve the strong bright red of cochineal (or even the red of Turkey red on cotton) on wool. In 1810, Napoleon himself signed a proclamation inviting dyers to achieve this end. Two years later, a Monsieur Gonin of Lyon solved the problem but rather haughtily refused the prize offered by the Société d'Encouragement d'Arts as he deemed it insufficient recognition of his achievement.[16]

However, the lifting of the blockade did not overcome all the issues. In 1829, Auguste Dupré-Lasale wrote a book on the challenges of manufacturing and dyeing uniforms for the French army. He noted that there had been problems since before the Revolution, that there was in fact no uniformity, that there was no strength in the colours and that they were affected by both sun and atmosphere. He states that, by 1810, the problem was so bad that national leaders had identified urgent objectives, writing that *'The interest of the army was for the accuracy and colour-fastness of the colours, the quality of manufacture and the durability of the cloth to last for a specified period'*, and proposed ways to achieve these objectives.[17] A year later Louis Philippe promoted the French madder industry, which had been decimated during the Revolution and Napoleonic period, by ordering the trousers and caps of the French infantry to be dyed with madder.[18]

Colour chemist Eugène Chevreul also joined the debate on uniforms. His preoccupation was working out which colours would work best when placed next to each other so that the uniform would appear to be in good condition for longer, given the amount of wear and tear it might receive. His perhaps surprising conclusion was that white next to a dark colour such as red or blue would make the dark colour look less shabby. He summed up his reasoning by saying:

For the same reason also a coat, waistcoat and trousers of the same colour cannot be worn together with advantage except when new; for when one of them has lost its freshness, by having been more worn than the others, the difference will be increased by contrast. Thus the new black trousers worn with a coat and waistcoat of the same colour but old and slightly rusty, will bring out this latter tint, while at the same time the black of the trousers will appear brighter. White trousers or –

reddish-grey – will correct the effect of which I speak. We see, then, the advantage of having a soldier's trousers of another colour than his coat… We see also why white trousers are favourable to coats of every colour.[19]

English retainers, yeoman and other guardians of the monarch or nobility when on protection or war duties had worn red or blue since at least the 15th century.[20] Red and blue were popular colours because they were the strongest and stood out, a requirement in warfare until methods changed in the late 19th century. During the English Civil War of the mid-17th century both sides had troops in red, but it was the New Model Army of Cromwell's Roundheads which first wore not just a common colour but uniform clothing, red coats with different coloured facings to indicate different regiments. As Carman puts it, *'the red coat was now firmly established as the sign of an Englishman'*.[21]

Use of the red coat, with its regimental facings, continued into the 19th century for most regiments. There were some exceptions, such as the hussars (who wore blue), the rifles (who wore green), and some Scottish regiments (who wore blue and tartan), but then others reverted to red, such as the lancers (who changed from blue to red in 1831).[22] The scarlet cloth for officers was dyed *'in the grain with cochineal dye and with antique processes,'*[23] while some Scottish regiments protected local manufacturing of military uniforms by using local lichen cudbear for red cloth, as well as cochineal.[24] In the mid 19th century, notwithstanding Chevreul's comments, the British Army changed from white trousers to dark colours[25] as it was said that white trousers required extensive washing, and without the ability to dry them properly, they caused rheumatism.[26]

From the middle of the 19th century, however, a need for concealment in battle became more necessary and, through a series of trials, mostly by troops stationed overseas and making use of materials available locally, the first khaki clothing was developed. Although it was in use by British troops from the late 19th century, we will revisit this issue in the next chapter. Today the only time we see the British soldier in a red coat is on ceremonial occasions such as the Trooping of the Colour.

DYEING IN AMERICA

By the early 19th century the northern states of America had significant centres of population on the east coast, and cloth manufacture and dyeing were burgeoning because they 'add to the beauty and contribute to the economy'.[27] However, dyeing could be costly. If dyestuffs were not available locally then they had to come from, or certainly via, Britain due to the terms of Britain's trade laws with her colonies. This particularly applied to red: 'cochineal is an insect cultivated in South America, it is shipped to Spain, from Spain to England and from thence to America at a high price on account of its accumulated and heavy duties'.[28] Hence it was that in 1802 the American Philosophical Society offered a $150 prize for the best experimental essay on the native red dyes.[29]

There was also a growth in the sharing of knowledge. *The Dyer's Companion* (1806), the second book for commercial dyers to be published in America, was written by Elijah Bemiss (or Bemis). This was the book of a practical, empirical style of dyer – his recipes were all for 20 yards or 16lb of cloth. Cooper called it 'a book marked by such total ignorance of chemical principles',[30] as this extract perhaps illustrates. For mordanting wool with alum and cream of tartar he says that the wool should be 'boiled for six hours and then, let [the wool] cool, place it in a sack, covered close to lay twenty four hours that the pores of the wool may inhale the salts and be the better prepared'.[31]

Cooper (1815) and Partridge (1823)[32] represented the new developments in dyeing in America. Cooper was a man with a good opinion of himself, describing his book as the practical companion to Bancroft's scientific summary of the materials of dyeing, but he was also keen to take the best from the old countries. In this, while he thought the French had written the best information, he accused England of being that 'Manufacturing and jealous nation, conceal[ing] all the knowledge by which other nations could profit' because 'at present, the English manufacture cheaper, dye cheaper, and finish their goods far superior to every other nation as well as our own.'[33] And his aim was that American dyers should achieve the same standards for dyeing and calico printing.

Partridge, however, was as dismissive of Cooper as he had been of Bemiss. Partridge notes that Cooper's work was largely taken from an amalgam of the French writers he so admired but that Cooper had never actually been a dyer as 'in every instance where he has given his own opinion, it is uniformly erroneous'.[34] Partridge, though, had extensive experience of the dyeing business from England, and when he emigrated to America he was able to make comparisons, highlighting some of the problems of the American system. He noted that in England dyers stayed with one organisation; as such, their knowledge grew to achieve 'perfection in the art'. But in America he was asked to troubleshoot where dyers were not achieving the colours they expected, one realisation was that 'dyers who are continually roving will have partly to learn their business over again at every new place'.[35] One reason for this being his ultimate discovery was that 'I had no conception when I left England that water could have had so material an effect in the production of colour as I have since found it to possess.'[36] Clearly, a lot could still be gleaned from empirical learning.

THE HIGH-WATER MARK OF TURKEY RED

At the beginning of the 19th century the last of the great French books on dyeing was written.[37] Entitled *The Art of Dyeing Cotton Red*, Jean-Antoine-Claude Chaptal seemed finally to have solved the Turkey red problem.[38] He described a red that surpassed the beauty and vivacity of the red achieved in the Levant. However, innovation in Turkey red dyeing, (still referred to as Andrinople red in France) continued into the middle of the 19th century, where it would see its highest achievements in terms of colour use, colour range in textile printing and quantity of output. The two major centres in Europe were Mulhouse in Alsace and Manchester in England.

In Mulhouse in 1802, Jean-Michel Haussman developed a new procedure for producing Turkey red which he claimed surpassed materials from the Levant, but the leader of innovation was Daniel

RIGHT: As we can see from one sample recipe, while proportions are given for some colours, this is not consistent, and implies an amount of previous knowledge to turn these clues into the required textile. *Courtesy of Jonathan A Hill*

BELOW: A page from a dye book of the German company Christoffel from 1820, showing samples of 'core' colours and how they are combined into mixed-colour fabrics. *Courtesy of Jonathan A Hill*

Koechlin of Koechlin Frères. By 1810, he was producing the finest-quality Turkey red on cotton. Constantly trying to innovate, the following year he discovered how to remove turkey red dye from calico to create white areas (known as the discharge printing method), so as to enable other colours to be applied: blue from indigo, yellow (which by 1820 was the new chrome yellow) and green (the first fast 'single green' that did not require overprinting of yellow and blue was patented in 1809)[39] thereby pioneering the western manufacture of Kashmir-style multi-coloured table covers and wall hangings. The colour range eventually rose to six main colours: red, blue, yellow, green, black and white, enabling a wider range of patterns. Not surprisingly after so much successful innovation, at the age of 34 Koechlin was presented with the Légion d'honneur for his contribution to the manufacture of colour on calico.[40]

Koechlin decided not to patent the discharge method, generously considering that there was more progress where many people were involved. So it was left to the English company of Thompson, Chippindall & Co. to patent it, with full approval from Koechlin, under what is known in France as *autorisation désinteressée*.[41]

Meanwhile in Manchester, Britain's textile powerhouse for cotton, huge quantities of cloth were being produced annually. Ironically using two French designers, Britain cornered the market with desirable designs and cheaper prices than France, so that during the 1850s 20 million pieces of calico were printed in Britain, mostly in Manchester.[42]

Turkey red dyeing had continued in Scotland, though not quite on the scale of Manchester. In 1898, at the zenith of the Turkey red industry, the Scottish firms of The Vale of Leven amalgamated to form the United Turkey Red Company, lasting until 1936, when naphthol red dyes took over the cotton industry.[43]

In America they had the advantage of being able to start from the knowledge already gained in Europe. Madder flourished in Kentucky and Pennsylvania, to such an extent that by 1840 two companies in the textile town of Lowell were between them producing more than a quarter of a million yards of madder-dyed or printed fabric for shawls, gingham and table coverings.[44]

By the mid-19th century, however, aside from calicos, red fabric was out of fashion, with Victorian ladies seeking something quieter. And the complete eschewing of the colour red, except for red flannelette underwear, was completed with Nathaniel Hawthorne's novel *The Scarlet Letter* and the arrival of the scapegoat figure of the scarlet woman.

INDIA, INDIGO AND WILD SILK

By the 19th century indigo was being used in such quantities that it was being grown on plantations in India, the Caribbean and the southern American states. Producing the dyestuff from the harvested leaves was still a complex, laborious, messy and undoubtedly odorous process, but one that now took place in factories containing large tanks. Indeed, so large were the tanks that, where before the fermented mixture was beaten with sticks to oxygenate it from the outside, now men had to walk through the tanks to ensure oxygen was introduced throughout every part of the fermented indigo before the sediment was left to collect.

The centre of Indian indigo growing was Bengal. As with any crop, the fortunes of the growers could change from one year to the next, but instead of this being due to rain or drought, to a much larger extent it was the effect of demand from the west. This was continually, but unpredictably, rising and falling due to a mixture of competition from America and the Caribbean and the state of the home (British) market – especially after the East India Company stopped buying indigo on the open market in 1830, which led to financial ruin for many Indian farmers and their banks.[45] Each time there was a downturn, such as in 1847, this led to a more repressive regime. As summarised by Richard Long, 'the Indigo System compelled [ryots] (small-scale tenanted farmers) to take advances, to neglect his own land, to cultivate crops which beggared him, reducing him to the condition of a serf and a vagabond'.[46]

As a result, in 1859 the Bengal indigo farmers rioted against their treatment. The following year the officials passed 'An Act to enforce the fulfilment of Indigo contracts and to provide for the appointment of a Commission of enquiry' (known as Act XI). It was referred to by the Indian press as the Ryot Coercion Act. The commission, held in 1860, led to one conclusion, that 'all the defects of the system ... may be traced originally to one bare fact, the want of adequate remuneration'.[47]

That same year, Dinabandhu Mitra wrote a play *Nil Darpan* (The Mirror of Indigo) highlighting the plight of the indigo workers in response to the passing of Act XI. The opening scene sets the picture: 'Sir, decide something about this, or I shall die. If we give the labour of one-and-a-half of our ploughs for the cultivation of nine bigahs of Indigo-fields our boiling pots of rice will go empty.'[48]

John Peter Grant, Lieutenant Governor of Bengal, was dismayed by Act XI. He considered it a lot harsher

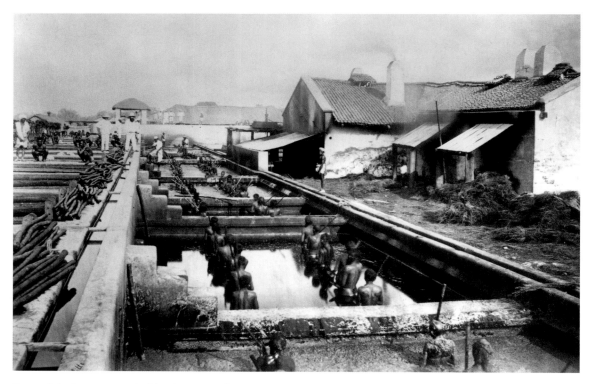

So much indigo was required by the 1870s that in order to satisfy demand larger processing plants were built. Men now had to act as paddles, walking through the fermented indigo to break it up and introduce as much oxygen as possible, in order to facilitate the forming of the sediment. © *Science and Society image library, Science Museum*

than he had originally intended and immediately after the riots wrote, '*if any one thinks that such a demonstration of strong feeling by hundreds of thousands of people as we have just witnessed in Bengal, has no meaning of greater importance, than an ordinary commercial question concerning a particular blue dye, such a person, in my opinion, is fatally mistaken in the signs of the time*'.[49]

The play would have gone unnoticed, being written in the local language, had it not been for the decision of the Governor of Bengal, Berkeley Seton-Karr, to send copies of the translation of *Nil Darpan* to some of the British Planters, represented unflatteringly as characters J J Wood and P P Rose in the play. This act resulted in a court case, a fine and a prison sentence not for the author, printer or distributor (Seton-Kerr) but for the translator, the missionary Richard Long. The following year the

Bishop of Calcutta, Bishop Cotton, commented that it was a good thing that Charles Dickens had not known of the libel law used by the Indian courts or else he would have been imprisoned for his social commentary in books like *Hard Times*.[50]

By the 1870s, India had 2,800 indigo factories producing indigo dye to be used on sailors' uniforms and army greatcoats, among other things. However, they were also, perhaps, in a 'blue bubble', ignoring the lessons of what was already happening to madder, which was being gradually supplanted by synthetic alizarin. Although indigo was the last of the major dyestuffs to become commercially available in a synthetic form (perhaps confusingly indigo retained the same name for natural and synthetic versions), the rate of substitution was merciless: the figure of 18,700 tons of indigo exported from India in 1895 declined to 1000 tons in the year before the First World War.[51]

SIR THOMAS WARDLE

Meanwhile, one person was trying to put some life back into the Indian dye industry through a different route. Sir Thomas Wardle was a dyer and scientist who set about examining the properties of dyes in a systematic and analytical way. His father, Joshua Wardle, had used some 50 dyestuffs[52] at their factory in Leek in the 1830s and 1840s, and his son wanted to really understand the dyes he was using, scientifically, in order to find new colours. As Thomas Wardle entered the business, the new synthetic dyes were becoming available but Thomas was not enamoured of these and turned back to the vegetable dyes.[53]

In 1874 Wardle exhibited his research results to that point. The colours he was achieving still needed something in strength and vibrancy, but were seen by the Marquis of Salisbury, then secretary of state for India, who suggested that India's dyers could potentially have a valuable industry if they could be shown how to apply these colours to India's wild tussur silk.[54] Wardle worked tirelessly to create and test some 200 Indian dyestuffs on the silk, the breakthrough coming when he analysed the Indian mordants and realised that English versions were stronger and produced more vibrant and lasting colours. Eventually, Wardle achieved a near colourfast range of subtle 'art' shades and exhibited them in Paris in 1878.[55] To gain custom he asked his wife to design embroideries using only this floss silk. He then exhibited his *eastern art colours* in the shop window of Liberty of London, becoming their main supplier of dyed and printed silks.[56]

He published his final results as *The Dyes and Tans of India*, running to 15 volumes and containing 4,100 dyed cloth and thread samples of cotton, wool, silk, eria silk (another local Indian variety) and tussur silk.[57] Wardle then travelled to India in 1885/6, taking his publication with him and working to help the Indian farmers re-establish a significant dyeing industry by showing them what was possible and what would be saleable to foreign markets. In 1897, the journal *The Artist* described him as the greatest living authority on the subject of textile dyeing and printing.[58]

This wooden block shows the traditional Paisley teardrop shape, which was used extensively in the 19th century for shawls, throws and other textiles. It also shows the complexity of a pattern block with all these points taking the same colour; subsequent pattern blocks would be made to print additional colours. *Photograph © Susan Kay-Williams*

Wardle focused on natural dyes but took a scientific approach and was constantly looking for new methods or ways of improving existing ones. One does not get the same feeling from the writings and approach of William Morris, Wardle's dye pupil, who from 1875 to 1878 frequently visited Wardle to learn everything he knew about natural dyeing.

WILLIAM MORRIS

William Morris remains one of the best-known English designers, especially for interiors, with wallpapers, fabrics and decorative works featuring fruits, flowers and birds as common motifs. Following his training with Wardle, he set about using natural dyes in all his work, completely eschewing the new synthetic colours.[59] He expressed his views on these new colours in his article 'Of dyeing as an art', printed in the *Arts and Crafts Exhibition Society Catalogue* in 1889, writing that '*there is an absolute divorce between the commercial process and the art of dyeing. Anyone wanting to produce dyed textiles with any artistic quality in them must entirely forego the modern and commercial methods in favour of those*

Dyeing Workshop in the Gobelins by Rene Joseph Gilbert shows the more scientific approach to dyeing now being followed by this famous factory, as it looks like the dyers are examining the colour of the hank of wool against a shade card. © *Mairie du 13th Arrondissement, Paris, The Bridgeman Art Library*

which are at least as old as Pliny who speaks of them as being old in his time.'[60]

It is true that in the last quarter of the 19th century the new dyes were often garish, still experimental and sometimes unstable, but they were about the future. By his complete rejection of them, there are those who think Morris put back Britain's dyeing industry, affecting British competitiveness and industry irrevocably. As Chenciner puts it, '*At the most exciting time of discovery of new materials in history, Morris and Ruskin were arguably responsible for British material culture turning aside and looking to the past.*'[61]

The unanswerable question is what would have happened to the British dyeing industry if Morris had worked with dye companies like Levinstein or Read Holliday to see what the possibilities of the new dyes could become, instead of working with Wardle.

THE GREAT EXHIBITION OF 1851

The Great Exhibition of the Works and Industries of all Nations was not the first trade exhibition; that had been organised by Chaptal in France in 1799. However, with royal patronage and its special building, the Crystal Palace, the Great Exhibition in London was correctly named. Exhibitors came from Russia, China, the continent of Africa and many British colonies such as India and New Zealand. It also attracted huge numbers of visitors from all over the world, setting the tone for future such events including the world fairs held in America, and continuing today with Brisbane, Australia (1988), Seville, Spain (1992), Shanghai, China (2010) and Yeosu, South Korea (2012).

The range of exhibits was enormous. In textiles they included dyestuffs, threads, woven and printed fabrics, and new machines for textile production, such as those for glazing (mercerising) cotton.[62]

From France, Madame Clémencon of Paris exhibited corsets in bleached silk 'for delicate constitutions' Brosse & Co. of Lyon exhibited specimens of plain silk velvet in different colours, and Guinon displayed examples of silk dyed with picric acid. From the Netherlands, Koopmans exhibited Turkey red cloth dyed with Dutch madder. From Germany came Prussian blue, described as '*another pigment upon which a large amount of science has been expended and the result has been the production of most beautiful colours*'.[63] The Prussian display included a variety of samples of blue and grey military cloths for the Royal Prussian Army, one of the first to move away from red.

Reviewers ruminated much on the colour and design on display. Turkey and India were both praised, although in a rather high-handed western imperialist style, for the range and application of colours on fabrics: '*The art of dyeing is still in a rude state in India as far as the methods adopted are concerned, yet if we look at the results which are attained, they are not to be despised even by the side of the scientific dyeing of the west. But in the management of colours the skill with which a number are employed*

Engraving of the French exhibit at the Great Exhibition of 1851. Mrs Merrifield praised the French display for its harmony, artistry and overall display. However, this is one of several versions of hand-tinted engravings so it is not possible to tell the actual colours with any accuracy, as each rendition has different colours. © *Great Exhibition French Room 1851 by Joseph Nash, litho, Guildhall Library, City of London, The Bridgeman Art Library*

and the taste with which they are harmonised whether in their cottons or their carpets, their silks or their shawls, Europe has nothing to teach but a great deal to learn.'[64]

By comparison, Hunt, a commentator on the Exhibition, considered the English dyers had focused on production not research, resulting in 'the tiny production of colours',[65] reserving his most favourable comments for France, particularly that they had put men of science in charge of developments in dyeing 'The rich hues of the French silks, the brilliancy of their pigments and the intense colours of their tapestries are evidence of their most exact attention, and to the investigation of science.'[66]

But if there was disappointment at the limited colour developments in England, there was dismay about English design. After much admiration of the harmony of display as well as individual items from France, Turkey, Tunis and Asiatic areas, Mrs Merrifield complains that the English displays were 'eye-clashing', particularly citing the exhibit of one Mr Monteith, who presented a cotton print 'wherein scarlet is contrasted with very warm green'. Mrs

Merrifield continues, 'The effect ... upon the eye is so dazzling as to be almost painful', and then proceeds to give him a lesson, taken without doubt from Chevreul, on the shade of green that would be more appropriate.[67]

The East India Company had an enormous exhibit and the following year a sale was held of most of the contents. The catalogue ran to more than 2100 items and included many textiles. The largest piece was a complete *howdah* set for an elephant, described in the catalogue as 'a magnificent elephant cloth of rich crimson velvet, beautifully embroidered in silver and gold and silver fringe edging, 15 feet by 9 feet and an elegant frontal piece embroidered with gold and fringed to match, from Moorshedabod'.[68]

The accompanying sale ledger records the amount paid for each item. The elephant cloth was sold for £35. A throne cover of scarlet velvet went for £22, a fine Benares gauze shawl, green with gold flowers and border, 1½ yards square, went for 14 guineas (£14 14s), while two cotton table cloths in bright colours sold for £1 8s. In all, the sale raised £9967 12s 9d.[69]

FOUNDING OF MUSEUMS AND DESIGN COLLEGES

One of the reasons why French design was considered so good was the investment in design education which had begun with the opening of the École des Beaux-Arts in Lyon in 1805. Although Macclesfield, home to the British silk industry outside Spitalfields, established its own college of art and design in 1833, education provision in this field was considered so dire that a parliamentary select committee was formed in 1835 to look at the issue and, by an act of parliament the following year, funding was made available to establish a series of art and design colleges around the country, including one at Somerset House in London. By the mid-1840s there were more than a dozen such colleges already established, though none, it seems exhibited at the Great Exhibition. It is not, however, easy to know why not.[70]

Demand for new designs was growing, with fashion industry manufacturers adopting the practice, begun in Lyon, of producing two sets of seasonal designs every year. In Manchester it was estimated that up to 500 designers and pattern drawers were working in the area by the mid-19th century, to keep pace with demand, with many having come there from France.[71]

The lasting legacy of the Great Exhibition was the establishment of the South Kensington system, beginning with the museum for decorative arts (the first in the world) known today as the Victoria and Albert Museum,[72] the Natural History Museum and the Science Museum. The government bought many objects from the Great Exhibition to form the basis of the museum collections. From this beginning, other cities began to establish similar museums, initially as places of reference and sources of ideas for industry. Hence the textile collections in museums today such as those in Manchester for cotton, Macclesfield for silk and West Yorkshire for wool.[73]

The French were particularly envious of the museum of decorative arts and petitioned Napoleon III for their own institution 'a Museum of Fine Arts as applied to industry'.[74] In Lyon, the idea for the Musée des Tissus et des Arts décoratifs was first mooted in 1856. The library, the first part, opened in 1864 included samples and materials brought back from China by the three delegations France had sent out to study silk production, dyeing and weaving: Mission Lagranée in 1844, Isidore Hedde in 1846 and the Lyon delegation of 1847.[75]

In Germany, the Deutsches Gewerbe-Museum opened in Berlin in 1868, initially as a teaching centre as well as a museum.

PATENT LAWS

We have seen that the early patent laws were monopolies for specific manufacturers – in theory to stop any other company engaging in the same activity. By the 19th century patent law in each European country was inappropriate, ineffectual or both. As a result, manufacturers started to petition for new laws. They did not all have the same result.

The first country to issue new patent laws was France. Unfortunately, they were focused on the product not the process, the result being that by the 1860s this had achieved the opposite of what should have happened, in terms of protecting home industry and supporting process inventors.[76]

In Britain, the stimulus for better copyright laws came with the introduction of rotary printers in the 1830s and 40s. Manufacturers were keen to protect their ownership of designs, and campaigned for an extension to the copyright laws to cover designs for printed cottons. But the new laws left many holes, including allowing foreign companies to take out patents in Britain without having to put them into practice, in relation to synthetic dyes this was very detrimental to British companies developing new colours.[77]

Following the political unification of Germany in 1871, at the end of the Franco-Prussian War, the German colour industry sought self-protection and was instrumental in formulating the country's patent act of 1876. This became the world's strongest law for safeguarding chemical processes and products.[78]

In 1883 Joseph Chamberlain had patents brought under the supervision of the board of trade, but it did not do much for British companies. Ivan

Levinstein was one of the few manufacturers in Britain sufficiently far-sighted to foresee the eventual threat of massive German competition to Britain's trade. He was particularly concerned about British patent law, which he saw would eventually place a stranglehold on British dyeing, in complete contrast to what it was supposed to achieve.[79]

BLUE WORKWEAR

During the 19th century blue became the common colour for working men's clothing, used not just for military uniforms but for a growing number of civilian uniforms for police, postal and transport workers.[80]

Blue was the working colour because it was a solo colour, cheaper, easier to apply and more hardwearing than complex black. It was however, destined to become the most recognisable colour in one particular material, denim. In 1853 Levi Strauss moved from New York to the newly established Gold Rush town of San Francisco, opening a wholesale dry goods business, importing clothing, material and other items and selling to small retailers. One of his customers, Jacob W Davis made work pants, known as waist overalls, from material Strauss supplied. From the early 1870s, in response to a customer's request for pants that would last, Davis added rivets to strengthen the pockets and flies for greater durability. Worrying that his idea would be copied he approached Levi Strauss about co-patenting the idea. Strauss saw the commercial opportunities of the agreement and together they applied for a US patent which was granted on 20 May 1873.[81] The British patent was taken out in 1874.

When the patent was granted Levis Strauss & Co. started selling the riveted waist overalls made in indigo-dyed denim. With the patent secure, the rivets were stamped with the company's initials and the patent date. Aware that when the patent expired in 1890 there were likely to be many imitators, in 1886 the company adopted the 'two horse' logo to brand their waist overalls. The pants continued to be known as work overalls until the 1950s, when the newly invented 'teenagers' renamed them 'jeans' and began wearing them for leisure.[82]

501® jeans, c.1879, known as 'XX'. Courtesy of Levi Strauss & Co. Archives, San Francisco The early days of the most recognisable piece of clothing in the world: indigo-dyed blue denim Levi jeans. © 2005 Photography by Hangauer/Kissinger

CHEVREUL

In 1824, Eugéne Chevreul succeeded Berthollet as director of dyeing at the Gobelins factory. Like his predecessors, he was a chemist (of fats and lipids – soap and margarine) who turned his attention to dyes and dyeing. He wrote more than a thousand essays and books on textiles and colour and lived to the extreme age of almost 103, working until the end; his hundredth birthday was a public celebration. His first study on dyestuffs was published in 1807, and over the next five years he spent time discovering the chemical components of dyes like brazilwood (brazilin) and logwood (haematoxylin), from which he developed logwood extract, which was used on silk into the twentieth century.[83]

Chevreul's particular interest was the science of colour, the laws of colour contrast and especially

Chevreul took a very scientific approach to breaking down the colour circle and then working through all the shades and tones to achieve a total of 14,400 colours that could be used. However, there was still the challenge to the dyer to be able to create all these colours. © *Circle demonstrating colour differences and contrasts from* expose d'un Moyen de definer et des nommer les couleurs *Chevreul Paris published by Firmin Didot in 1861, French school, 19th century, private collection, Archives Charmet, The Bridgeman Art library*

the chromatic wheel, all of which were aimed at helping to enhance the colour range available to the tapestry makers at Gobelins. For while there were more shades of certain colours, in the case of flesh tones Gobelins had only three shades of pink, known as male, female and baby.[84] A limited choice, but Chevreul also wanted to introduce a more rational naming or scaling of colours. His major works began with *Du la loi du contraste simultané des couleurs* (The Laws of Simultaneous Contrast of Colours), published in 1839. After more than 2000 years, Chevreul finally gave a scientific basis to the phenomenon Aristotle had recognised: that

sometimes two adjacent colours had a detrimental impact on one of them, where choosing a different shade or tone enhanced both colours, a concept known as metamerism.[85]

His most important book, *Des couleurs et de leurs applications aux arts industriels à l'aide des cercles chromatiques* (Of Colours and Their Application to Industrial Arts by the Aid of Chromatic Circles), was published in 1864. Continuing on from his ideas on simultaneous colours, he took each pure colour up the scale with white and down the scale with black, ascribing ten separate tones to each one. He started with the three primary colours, then the secondary colours, and then all the intermediate colours. As a result of these extrapolations, Chevreul developed a series of colour wheels and a total of 14,400 tones. However, the one downside was that with seemingly every colour to choose from, the time taken to select the colours for a tapestry took much longer.

Significant advances had also been made in the production of new colours in England. In 1851, Halifax dyer David Smith wrote a practical book on dyeing,[86] including some 800 recipes, and commented on the infinity of colours that were now achievable from nature based on the three primary colours. This book was published in Philadelphia and translated into French and was, possibly the first book on dyeing to go from English into French.

To put this development in dyes into the context of the fine arts, it is instructive to look at a painting first displayed in 1856. Ingres's famous portrait of Madame Moitessier, resplendent in her dress of woven silk complete with a fringe of the individually coloured threads featured in the fabric, was completed that same year after more than ten years' interrupted work.[87] The painting is not merely a statement about the position and interests of Madame Moitessier, but is a living advert for the Lyonnais silk industry. Although it is a painted image (and therefore open to artistic licence) we know from extant samples that this picture certainly does not overstate the skills of dyers and weavers in the French capital of silk. We also know that to achieve these colours the dyers used the dyestuffs mentioned up to this point.

This delightful painting of Madame Moitessier by Ingres was completed in 1856, and as such she has, de facto, become the advert for the silk industry of Lyons using the tried and tested colours that had been used for centuries. *Madame Moitessier*, 1856 (oil on canvas), Jean Auguste Dominique Ingres (1780–1867). *National Gallery, London, UK / The Bridgeman Art Library.* © *National Gallery*

SYNTHETIC DYES

However, neither Smith nor the Lyonnais silk dyers could have imagined the upheaval in dyeing that was just around the corner. Throughout the first half of the 19th century, new dyes were being discovered by combining the new chemicals or chemical sources with some element of plant, insect or mineral salt. Two notable ones were picric acid (which dyed silk yellow), developed by Guinon, Marnas & Co. in France based on an extract from the Australian plant *Xanthorrhea hastilis*;[88] and murexide, which, as the name suggests, was promoted as a shellfish purple although it was actually made from uric acid produced from Peruvian guano – large deposits of solidified bird droppings that were quarried and exported.[89] Each had its moment of glory: picric acid silks were exhibited at the Great Exhibition and in 1855 a factory was established near Lyon for its large-scale production, headed by François-Emmanuel Verguin. Murexide was demonstrated in the presence of Napoleon III in early 1856, and was popular in France for a few years. However, both of them had the disadvantage of fading when washed in water that was too hot, and murexide-dyed fabrics could be 'attacked' by the polluted, sulphurous atmosphere of cities like London and Paris.[90]

In Germany work was done with aniline to gain a blue colour, but this was not considered to be of any practical use.[91] In 1828, Jean-Baptiste Guimet developed synthetic lapis lazuli, later used as the first optical brightener, to compensate for yellow tones in white material. In terms of dyeing ancillaries, there were '*new detergents, bleaches, hypochlorites, sulphuric acid and sodium carbonate, but as far as dyes were*

concerned, the traditional vegetal and animal products were still in use.'[92]

As the new dyes had come from mixing traditional dyestuffs with the new chemicals, the next step seemed to be examining the possibility of increasing the yield of a dyestuff through chemical means. This idea appealed to both chemists and financiers, because large profits could be anticipated if the chemists were able to extract more dye, or enhance its coverage, from the same quantity of original dyestuff. In the end, however, the answer came from a completely different route.

By 1856, William Perkin had been working for three years at the Royal College of Chemistry (RCC) under AW von Hofmann. Hofmann was early to recognise the potential of coal tar and had his students working on a variety of research projects to investigate its potential applications. In particular, he was keen to find a synthetic form of quinine. In 1820, quinine had been isolated from the cinchona bark as a treatment for malaria, which afflicted vast numbers of people in India and other parts of Asia

In his Easter holidays in 1856, 18-year-old William Perkin discovered synthetic mauve dye and the world of dyeing cloth was changed forever. There would be more change over the next 50 years than there had been in the preceding three thousand years. This shawl was woven from yarn dyed in Perkin's mauve. © *Science and Society image library, Science Museum, London*

and Africa. However, cinchona bark was becoming scarce and therefore very expensive. By the 1850s, the Indian government was spending more than £30,000 a year on supplies of cinchona bark and pure quinine, while the East India Company was spending around £100,000 annually on it.[93] Demand grew in the 1840s and 50s, when large numbers of people began demanding it as a prophylactic, so Perkin, along with others, had been set the task of trying to produce synthetic quinine.[94]

In the Easter holidays the 18-year old Perkin was continuing his research in his small home laboratory in south London. Examining one experiment, he realised that what he had discovered was not synthetic quinine, but all the same he persevered. He re-did the experiment with a couple of modifications and achieved an unpromising black substance, but when he added water, it partially dissolved, turning a wonderful purple colour. When tested on a piece of cloth, he found the colour to be both bright and fast. So it was that, through a mixture of science and serendipity, William Perkin discovered the first truly synthetic colour.[95] Realising something of its potential, he sent a sample to commercial dyer John Pullar of Perthshire, who informed him that if the dye could be produced at a reasonable price, it would be commercially viable. On receiving this news, Perkin filed a patent for mauveine[96] and, much to Hofmann's chagrin, left the RCC to set up a factory. So new was the technology that Perkin had to design the factory apparatus from scratch.[97]

Perkin set up his factory at Greenford Green, near Wembley, where he proved his technical approach, finding appropriate but different answers to using mauve on cotton and silk. Initially, his dye had too strong an affinity for silk, adhering quickly but unevenly, and too poor an affinity for cotton.[98] However, through trial and error he found tannic acid combined with a metal oxide to be the mordant giving the best adherence to cotton, while applying a soap solution to silk evened-out the dye absorption, overcoming the initial patchiness. By the following year he could state at the annual meeting of the British Association for the Advancement of Science that one pound of his solid purple could dye two hundred pounds of cotton.[99]

France also still had a role to play in the continuing history of dyestuffs. First, French dyers developed the last of the partially vegetal dyes: *orseille* or French purple, based on lichen, was produced by the company of Guinon, Mornas et Bonnet, formerly Guinon, Mornas & Co. It was ultimately overshadowed by mauve, but not before it had helped to establish the fashion for purple in France. Second, ironically, Perkin's patent application in France failed due to irregularities in the application date. This meant the French were free not only to produce it and but to give it the name mauve.[100]

In May 1857, John Pullar wrote to Perkin, 'I am glad to hear that a rage for your colour has set in among that all-powerful class of the Community – the Ladies. If they once take a mania for it and you can supply the demand, your fame and fortune are secure.'[101] By October, The Illustrated London News featured 'mauve coloured Grenadine', setting it further on its way.[102] The colour was then helped by two significant women: Queen Victoria and the Empress Eugénie. In 1858, Queen Victoria wore a purple gown for the wedding of her daughter the princess royal. Although it is not known if this garment was actually in Perkin's mauve, the colour was certainly noticed. Across the English Channel, the Empress Eugénie, the leading figure of fashion, decided that the mauve colour matched her eyes. This opened the floodgates of desirability and, in the years 1859–61, mauve mania dominated British and French society and the colour was seen all over Europe; in Italy it was called malva.[103]

INDUSTRIALISATION

Britain's early response to technological innovation in textiles and their commercialisation was such that trainee dyers and chemists from many countries, especially Germany, came to Britain, and Manchester in particular, so as to study directly with experienced dyers and textile printers.

Germany had not been a leader in the business of dyes and dyeing during the era of traditional dyestuffs, but with the dawn of a new era, that was about to change. In 1859, Heinrich Caro, the great pioneer of chemistry, came to Britain to study calico printing with Roberts, Dale and Co. In doing so, according to Reinhardt and Travis, he was taking 'his first steps toward membership of an elite band of highly paid professionals: the textile colourists, specialists in preparing and fixing dyes and in creating designs and patterns particularly on cotton fabrics'.[104] As such, he could look forward to an above average salary in a prestigious and much-desired occupation. While in Manchester he developed a new process for mauve, which was patented in 1860, and subsequently went on to develop aniline black for printing cotton. The success of these two products earned him a partnership with the company.

France had one more key role to play through Verguin, who had been running the picric acid factory near Lyon. In 1858, he moved to rivals Renard frères et Franc and there discovered the second major aniline dye – fuchsine, a bright purply-red – and a completely new method.[105] In 1859, he personally took out the patent and then sold the rights to the company. Fuchsine would prove to have a longer lifespan than mauve, until superseded by alizarin, though its name across the channel was short-lived: in 1860, the English changed it to magenta following the Battle of Magenta in the Franco-Austrian War.

However, fuchsine was to sound the death knell of French dyeing and its dyeing research industry: Renard applied for and gained a monopoly on all fuchsine production in France and, with French patent laws protecting the product not the process,[106] there followed an exodus of French dyers to Switzerland over the next few years. Renard even tried to extend their patent monopoly into the US with regard to aniline blue, the first synthetic colour to be patented in America. But Hofmann's arrival in New York put an end to that[107] and in the meantime the French industry lost much of its dyeing expertise. The final blow came after the Franco-Prussian War when, in the Treaty of Frankfurt of 1871, Bismarck enabled French companies to buy German intermediate dyestuff products more cheaply than they could make them. So while there remained a textile industry in France, it lost its position as a leader in research that it had held since the early 18th century. Meanwhile, the new companies in Switzerland flourished, which, after a number of mergers and acquisitions, led to the creation of Geigy in 1864, Sandoz in 1887 and Ciba in 1898.

New companies were also being created in Germany: Hoechst in 1862; Friedrich Bayer & Co. (1863); Badische Anilin & Soda Fabrik (BASF) (1865); and Aktiengesellschaft für Anilinfabrikation (AGFA) (1873).

While Hofmann had been disappointed that his protégé Perkin had forsaken the laboratory for industry, he was scientifically curious enough to start investigating aniline dyes himself. With a supply

of fuchsine crystals, Hofmann analysed the new dye's molecular composition and from that he was able to decipher the components of almost all the new aniline dyes, which in the next decade led to a standard process for producing them.[108]

New colours were subsequently developed everywhere: aniline blue was developed by Girard and de Laire in France; bleu de Lyon and bleu de Paris were developed in their namesake cities; Nicholson's blue was developed by Simpson, Maule and Nicholson and Hofmann himself discovered two new shades of violet.[109] Inevitably, many colours were very short-lived, as fashion was also a driver. Perkin himself acknowledged that by 1861 fashion had moved on from mauve to newer colours such as fuchsine, Manchester brown, Martius yellow, Nicholson's blue and Hofmann's violets.[110]

LONDON INTERNATIONAL TRADE FAIR (1862)

The waning of mauve was not, however, going to stop Perkin showing off his creation. At the International Trade Fair of 1862, held in London, in the middle of the hall was a 'large glass case labelled "William Perkin and Sons"', containing a pillar of solid mauve dye the size of a stovepipe hat. The block was the product of about 2000 tons of coal-tar and was sufficient to print 100 miles of calico. One contemporary writer described it as being 'enough to dye the heavens purple'.[111] Other exhibits included the latest samples of dyed cloth from Alfred Sidebottom of Crown Street, Camberwell, from Henry Monteith & Co. of Glasgow and from John Botterill of Leeds. Robert Pullar of Perth displayed his latest umbrella cloths and dyed cotton. Altogether, 28 dyeing companies from the UK, France, Germany and Switzerland attended the exhibition.[112]

Once again, the French came in for great praise, especially for their tapestries and carpets from Gobelins, Beauvais, Savonnerie and Aubusson. Their display area was dominated by tapestry hangings that revealed what Chevreul had been trying to achieve. The correspondent for Cassell's Illustrated Family Paper wrote that 'we see all the subtle gradations of light and dark, or glitter and gloom', and referring to the Beauvais pieces, which he considered more manageable, the writer ventured that, 'the Beauvais is partly silk, the highlights being worked out in this material with extraordinary painstaking, for in order to graduate the colouring two threads of the silk of slightly different tints are always in use'.[113]

Hofmann had been invited to give the opening speech at the exhibition, and in front of Queen Victoria he stated that before long England would be the leading dye-producing country in the world, even to the point of exporting blue dye to India. At this point James Mansfield, spokesman for the British and Dutch indigo syndicates, interrupted to point out the ruinous consequences of such a development to British world trade.[114] His interruption caused consternation, but he was more right than Hofmann. Indigo-plant producing communities would indeed have their livelihoods decimated over the next few decades, while Britain would not become the leading dye-producing country.[115]

In just five years from 1858, 86 patents for synthetic dyes and relevant mordants were filed with the British patent office. In 1863, Carl Martius joined Caro at Roberts Dale & Co. and between them they developed azo dyes, dyes based around two nitrogen-nitrogen double bonds. They took out their first patent on 31 December that year for what they called Manchester brown (renamed as Bismarck brown when Martius returned to Germany in 1867). Azo colours needed cooler environments, so until commercial ice became available they were always made in winter.[116]

Perkin, too, continued to innovate, discovering a green that was much-loved by calico printers, as well as an aniline pink, though he could not find a commercially viable way to produce this latter colour. Blue, though, remained the challenge, as aniline blue did not have the particular properties of indigo – the back-blue colour and the ability to rub off (that is, cling only to the outside of the fibre rather than penetrate it completely). Schlumberger wrote in relation to British Patent 117 (under the new system started in Britain in 1858) that 'a true blue from aniline has not been achieved – so far all have a reddish, purplish or violet tinge by artificial light'.[117]

COLOURFASTNESS AND POISONS

A perennial challenge for the dye industry has always been, and remains, colourfastness against sun, air, water and detergents.[118] Once alerted to the route to new synthetic colours, scientists started developing them in vast numbers, then launching them, inevitably, with no long-term testing. As a result many of the early synthetic dyes did not have the longevity of the old 'natural' dyes, which led to the coining of a new phrase, 'as fleeting as an aniline dye'.[119] Indeed, as quickly as the early 1860s, synthetic dyes had begun to gain a bad reputation, particularly the tripenylmethane dyes, which included fuchsine (though not, it has to be said, Perkin's mauve, which was very lightfast). Word of their unreliability spread far and wide, to the extent that the Shah of Persia, concerned at the fugitive nature of early aniline dyes, banned their importation in case they should injure the good name of Persian carpets.[120]

One classic example of the deleterious impact of non-lightfast colours can be seen today in the Lady and the Unicorn tapestries in the Musée Cluny in Paris. Originally made in the 16th century, when they were found at the Chateau de Boussac in 1841 the tapestries were in such a poor condition that the damaged sections were later reworked. However, looking at them today, the original parts have retained their colour better than the renovated areas.[121]

There was, however, a more worrying aspect to the new dyestuffs. Within the first ten years of the new dyes becoming available, people wearing the colours next to their skin complained of rashes and other afflictions, a consequence of the arsenic acid used in their manufacture. Accounts of such suffering only multiplied in the 1870s and 1880s.[122]

Gradually, the industry became alert to the danger. In 1869, Tardieu and Roussin published a report in France on the danger posed by aniline red through its content of arsenic acid, referred to in the paper as 'coralline', concluding that this was without doubt a poison of great strength.[123] In 1870, Dr Springmuhl, a German chemist, tested 14 samples

The most frequently written comment about the new colours was that they were bright and garish. If Madame Moitessier encapsulated what a 'naturally dyed' gown could look like, James Tissot's *The Ball* epitomises the new synthetic brights. This egg-yolk yellow dress with all its flounces and finery must have been considered the height of fashion, while the dowager in the background represents yesterday with her softer yellows. *The Ball, c.1878 (oil on canvas), James Jacques Joseph Tissot (1836–1902). Musee d'Orsay, Paris, Giraudon / The Bridgeman Art Library*

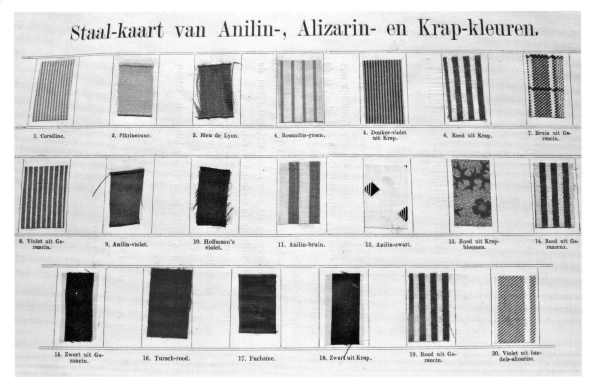

A page of samples from a Dutch pamphlet showing some of the new synthetic dyes made from coal tar. The samples show comparisons between Krap (madder), aniline and alizarin (synthetic madder) colours and also include iconic colours such as picric acid yellow, Hoffman's violet, fuchsine (magenta) and Turkey red. The article is undated but is probably from the 1870s. From the collection of the author. *Photograph © Susan Kay-Williams*

of commercial fuchsine dye and found traces of arsenic as high as 6.5 percent. When used in dyeing, however, the amount of arsenic found in dry cloth dropped to 0.0001 percent. Much to the relief of BASF, AGFA and the other manufacturers who had staked so much on these new dyes, the government chose to ignore this figure as too minimal. However, when the material was damp (through rain, washing or perspiration), especially when worn next to the skin substantial traces of arsenic were found in the damp material, causing 'skin eruptions' to wearers. The Society of Dyers and Colourists undertook some research into the problem but the samples chosen did not appear to contain arsenic. However, only one or two of the new dyes, e.g. magenta, used arsenic and such use was gradually faded out .[124]

ALIZARIN

Two major dyestuffs were yet to be synthesized: madder and indigo. The colour component of madder, alizarin, had already been identified and named in the 1820s by Roubiquet and Colin, from the Levantine word for madder. But it still needed to be synthesised and, even when that had been achieved, there was still an economic process to be developed to mass-produce it. In 1868, based on some of fellow countryman Adolf von Baeyer's work on indigo, Germans Carl Graebe and Carl Liebermann found the answer, while in a separate development William Perkin also achieved alizarin. Initially, the process was very expensive, but by the following year they had each devised a cheaper

alternative method for mass production. The work of both the German and British scientists show very similar processes, yet neither knew of the other's research until after the patents had been registered.[125]

Graebe and Liebermann were the first to begin patenting their process: in Germany, France, Austria, Russia, Prussia and Britain.[126] In Britain their patent application was made one day before Perkin's, but Perkin hastened to submit his final specification, which was duly approved before the German application. This caused much difficulty between Graebe, Liebermann and Caro, who were by then back in Germany and working in the same company, and Perkin. By the end of 1869, Graebe and Caro had met with Perkin in England to work on the German patent and to ensure both patents could divide up the market fairly, achieving for both parties comprehensive protection against others attempting to infringe their intellectual property rights. The German patent was sealed on 11 January 1870, and by March the BASF/Perkin agreement had also been signed.[127] For Perkin this was good timing. In the early days, due to the Franco-Prussian War of 1870/71, he enjoyed a greater share of the manufacture and sale of alizarin than he might have expected. A total output of just one ton in 1869 had risen to 435 tons by 1873; world exports of madder, the natural dye alizarin was replacing, had been worth £3.5m in 1868 but would drop to nothing within a decade.[128]

In 1872, the Société Industrielle de Mulhouse, the major European centre of Turkey red dyeing, offered the prize of a medal to whoever could first produce the synthetic equivalent of 40,000kg (44 tons) of madder with the same colour shade and price as the natural dye. The medal (first class) was presented to Hoechst dye works in June of that year.[129] It was this ability to scale up the synthetic dye for mass production which finally signalled the end of madder growing, along with the not insubstantial fact that it was exceptionally lightfast, that it was free of impurities – repeatedly the bane of dyers – and that consistent batches were much easier to make. Madder had provided half the world with red, but within a very short time it was trading at one third of and then one tenth of its best price.[130] In the

Netherlands, despite a longstanding commitment to madder since the Middle Ages, it continued to be grown for just another ten years, with the final garancine (madder) manufacturer closing in 1878. In Turkey madder lasted a little longer, until 1883, but in that year the roots were left in the ground as it was no longer viable to harvest them.[131]

INDIGO

The discovery of alizarin and its successful manufacture left just one major dye to be synthesised. Adolf von Baeyer had started research on the structure of indigo in 1865; however, it took him many small steps to achieve his goal, an effort that led to physical and mental exhaustion in the process.[132] First, in 1866, he found the 'mother substance', and his next step, two years later was the discovery of 'indigo-white'. The third step, in 1870, was a route to isatin manufacture, but it would be a decade later before he reached a point near enough to constitute the basis of the first artificial indigo patent, using ortho-nitrocinnamic acid.[133] However, the cost of production using this method for any quantity beyond a test tube was prohibitive.

Adolf von Baeyer finally completed his analysis of the structure of indigo in 1883, but by this time he had had enough and handed over commercial development to BASF.[134] Travis describes the period of alizarin and indigo synthesis as *'the changeover from science-based empiricism in the dye industry to a practice in which a sound theoretical basis encouraged the design of total synthetic pathways.'*[135]

An enormous investment was still required. In 1890, Karl Heumann of BASF discovered a new, more commercially viable, route to synthetic indigo, but it took another seven years to bring it to market. By that time, BASF had invested more in indigo research than the entire capitalisation of the company. But the work generated 152 German patents, while the new process enabled BASF to control the supply of synthetic indigo when the dye was launched in 1897 and, initially, to market it at a higher price than the natural equivalent.[136] What gave it the edge over natural indigo, as had been the case with

In a French series of three volumes from 1893 Monsieur J Dépierre gives recipes for the new synthetic colours on wool and cotton shows examples of the new equipment now needed to make these dyestuffs, and includes sample pieces of both cotton and woollen cloth dyed or printed with a variety of colours, including many dye and pattern samples. Among this rare collection is a piece printed in red and blue stripes on blue. While the red is Alizarin, the blue is indigo hydrosulphite, not true synthetic indigo. From the collection of the author. *Photograph © Susan Kay-Williams*

A few pages later the author gives a recipe for indigo 'after BASF', the commercial developer of true synthetic indigo and illustrates the recipe with this red and blue circle piece identified as alizarin red and synthetic indigo. This was published four years before BASF could produce their indigo at a cheap enough price to be commercial. From the collection of the author. *Photograph © Susan Kay-Williams*

alizarin, was the benefit of consistency. Indeed, such was its popularity and reputation that in only two years the volume being bought had driven down the price to a level that was comparable with natural indigo while still delivering handsome profits on BASF's investment.[137] To cap the achievement, in 1905 Adolf von Baeyer was awarded the Nobel prize for his work.

Before synthetic dyes the demand for coloured textiles had been increasing at unprecedented rates. So, on one hand it is true to say that crop production of madder and indigo would have had a hard time keeping pace with rising demand. Equally, with increasing population numbers in cities, ever more agricultural land was required for food crops, which in time would have compromised the land available for growing dye plants. But the demise of dye crops was so fast it had a major impact on communities around the world, with the supply of dyestuffs to European markets coming from places as far-flung as India, China, Brazil, Mexico, Guatemala, the Caribbean, Syria and the Levant, as well as Europe itself. The two longest-serving dyestuffs, madder and indigo, used from pre-history, were each wiped out in a period of roughly 20 years from their chemical equivalents becoming commercially available.[138]

AZO AND DIAZO DYES

The next leap forward began with Peter Griess of the University of Marburg and his study of the action of nitrous acid on aniline and its derivatives which led to the discovery of the diazo compounds in 1858. According to W Bradley of Ciba writing in the *Ciba Review*, '*no single invention which followed the discovery of mauve approached the process of 'diazotisation' in importance and none has yielded so prodigal a harvest of intermediates and dyes.*'[139] Dyes developed from the diazotisation process were known as azo dyes. Initially researchers would seek to find a range of colours, and then how to use them to work with different fibres. While working in Manchester, Martius and Caro had developed the first soluble azo dye based on Griess's work in 1858

as a one-off, creating Manchester brown, but the first important azo dye was chrysoidine – developed by Caro, now back in Germany, and Witt in 1875-6. The first azo dye for wool was developed in 1876 called London Orange The following year Caro developed the first synthetic version of cochineal called Fast red AV.[140] Then in 1879 two researchers working independently each came up with the formula for malachite green.[141]

Many of the new synthetic colours still needed a mordant to fix the chemicals to the fabric. In 1880, Yorkshire company Read Holliday developed the ingrain dyeing process whereby azo colours were formed in situ in the fibre or fabric without the need for mordants. Vacanceine red was formed by treating fabric with naphthol and then dipping in a diazolized amine, creating a very fast category of dyes.[142] These were then called direct azo dyes. However, the first significant direct azo dye, named Congo red, was developed in Germany in 1883, but it was not without controversy. The researcher who discovered it, Paul Boettiger, was an employee of Bayer who promptly left the company to sell his discovery to the highest bidder, AGFA. The following year, 1884, Carl Duisberg, a Bayer employee, came up with an improved version of direct azo red that brought considerable profits to Bayer; the compromise was that Bayer and AGFA set up a cartel to control the supply and price of Congo red.[143]

By 1885, many thousands of azo dyes had been patented but few were actually commercially successful. Over the next three decades, around 1000 commercial azo dyes would be developed. Even synthetic alizarin was soon displaced by para red, and in 1890 Bayer produced 'H' acid, the key intermediate for a large number of black dyes. In 1893, vidal black came on to the market, the first of a hundred new dyestuffs that were much more economical than the original aniline dyes.[144] In the next century, using chrome afterbaths, azo dyes would become the major dye category.[145]

GERMAN DYE RESEARCH DOMINANCE

Martius had returned to Germany in 1863, Caro before 1868, while in 1865 Hofmann had capitulated to the entreaties of the Prussians and assumed the chair of chemistry at the University of Berlin. With the new companies being formed and the commitment to invest in research, Germany was undoubtedly the place to be for the applied chemist, a status underlined by the work of Graebe, Liebermann and Baeyer. British companies were unwilling to make the same level of investment because they could not see the need for it.

Perhaps underlining the different attitudes towards business and research in Britain was William Perkin's next move. In 1873, at the age of just 36, Perkin retired from business, selling his company to Brooke, Simpson and Spiller.[146] After making profits of £60,000 annually for the previous few years, he decided he was more interested in research than in the business side. He retired to his personal laboratory where, among other things, he discovered synthetic perfume which he did not pursue commercially but which is at the base of most perfumes today. Perkin could see the need for research but he understood that to continue in business he would have to grow the company substantially which would in effect take him away from research.[147]

In 1878, the estimated value of products from coal tar was £450,000 in England, £350,000 in France and Switzerland, but already £2 million in Germany. By 1879 there were 17 coal-tar colour works in Germany, but only five in France, four in Switzerland and six in England. By 1881, Germany was producing half the world's supply of synthetic dyes, and by 1900 this figure was 80 percent.[148]

Any response from Britain was reactive and short-lived. In 1883, with the patent coming to an end, Germany raised the price of synthetic alizarin. British dyers were incensed enough to set up the British Alizarin Company in an effort to compete, but this had little influence. Indeed, in 1886 Professor Raphael Meldola undertook a survey of dyes used by British dyers and found that 80 percent of them

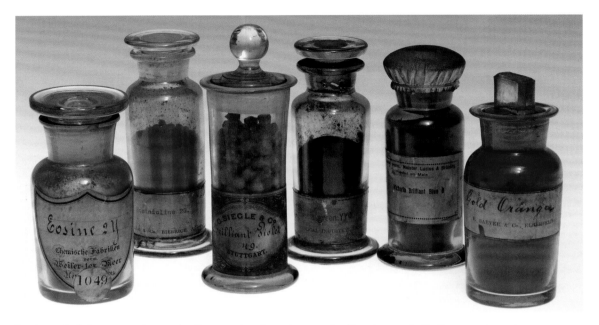

By the end of the century it was the German chemists who were leading the way in finding new dye colours, as can be seen from this collection of new dyestuffs from a range of German companies. © *Science and Society image library, Science Museum*

were of German origin. But then Carl Duisberg claimed that by 1890 Bayer was testing up to 50 new dyes every day, with BASF and AGFA working at a similar pace.[149] Of all the chemical companies BASF was the most dominant colour-producing factory up to 1914, with dyestuffs representing about two-thirds of their business.[150]

One final statistic gives stark evidence of the growing industrial divide. Between 1886 and 1900, 948 patents were taken out in Britain by six of the largest German chemical companies, while in the same period, British companies took out just 86.[151] Such a lack of belief in research investment leads to commercial disadvantages that are rarely overcome. Moreover, as a result of an over-reliance on German dyes and intermediates,[152] dyestuff supplies would became a major issue at the start of the First World War.

NOTES

1. Judd, Deane B, 'Introduction', in Goethe, JW *Theory of Colours* (1840; tr. CL Eastlake) (1970), p.viii.
2. Goethe, section 726.
3. Goethe, section 247.
4. Goethe, p.lviii. Goethe continued that he had taken his studies back to the 'circumstances under which [colours] simply appear and are, and beyond which no further explanation respecting them is possible.'
5. Goethe, section 799.
6. Gage, John, *Colour and Culture* (London: Thames & Hudson, 1993) p.202.
7. Goethe, section 841.
8. Goethe, section 837.
9. Cited in 'Introduction' Uniforms *Ciba Review*, no.93 (1952) p.3334.
10. Gessler, EA and H. Schneider, 'Military Uniforms

from the French Revolution to the Crimean War', in 'Uniforms' *Ciba Review*, no.93 (1952), p.3351.

11. Dupré-Lasala, Auguste, *Traité de Fabrication et de teinture des draps pour l'armée Française* (Paris: 1829), avant-propos p.ii.

12. Dupré-Lasale, p.v.

13. The Continental Blockade (1806–14) stopped Britain trading with continental Europe and France from trading with its colonies in the Caribbean and America.

14. Sandberg Gösta, *Indigo Textiles: Technique and History* (London: A & C Black, 1989), p.20.

15. O'Neill, Charles, *Dictionary of Dyeing and Calico Printing* (London: 1862) describes woad in comparison to indigo: 'it contains very little colouring matter itself so it is hardly possible to dye a deep blue with it'. See p.460.

16. Chenciner, Robert, *Madder Red: A History of Luxury and Trade: Plant Dyes and Pigments in World Commerce and Art* (Richmond: Curzon, 2000), pp.72–3.

17. Dupré-Lasala, p.iii.

18. Gutmann, A, 'The Red Trousers of the French Soldiers' in India its dyers and its colour symbolism *Ciba Review*, no.2 (1937), p.65.

19. Chevreul, ME, *The Laws of Contrast of Colour and their Application to the Arts*, tr. John Spanton (London: Routledge, Warnes & Routledge (1859), p.486.

20. Though Tudor colours also included white and green offset with the Tudor rose. Carman, WY, *British Military Uniforms from Contemporary Pictures* (London: Hamlyn, 1968), p.1–7.

21. Carman, p.24.

22. Carman, p.129.

23. Carman, p.158. Although for the lower ranks madder was used. Chenciner, p.232–3.

24. Scottish local production.

25. One thing that helped with the production of dark colours was the recently discovered chrome mordant. This would go on to be a major adjunct to azo dyes at the beginning of the 20th century.

26. Nalson, David, *The Victorian Soldier* (Oxford: Shire Publications, 2010), p.24.

27. Cooper, Thomas, *A Practical Treatise on Dyeing and Callicoe Printing* (Philadelphia: Thomas Dobson, 1815), preface.

28. Bemiss, Elijah, *The Dyer's Companion* 3rd edition (New York: Dover Publications, 1973), p.263.

29. Chenciner, p.71.

30. Cooper, p.iv.

31. Cooper, p.175.

32. Partridge, William, *A Practical Treatise on Dying of Woollen, Cotton and Skein Silk with the Manufacture of Broadcloth and Cassimere Including the Most Improved Methods in the West of England* (originally published New York: H. Walker and Co. 1823; repr. with notes by KG Pointing by Edington, Wilts: Pasold Research Fund, 1973).

33. Cooper, p.iv and p.vi.

34. Partridge, p.7.

35. Partridge, p.92.

36. Partridge, p.87. He also comments on the Americans' lack of quality assessment when buying dyestuffs and gives advice on what to look for in the best dyes.

37. Chaptal JAC, *L'art de la teinture du coton en rouge* (1807). Excluding Chevreul's work which focuses more on colour and colour contrast than specifically dyeing.

38. According to Brunello, writing nearly two centuries later.

39. Harris, Jennifer, 'Printed Textiles', in Harris, Jennifer (ed.), *5000 Years of Textiles* (London: British Museum, 1993), p.229.

40. Jacqué, Jacqueline, *Andrinople: le rouge magnifique* (1995), p.10.

41. Jacqué, p.15.

42. Jacqué, p.26.

43. Chenciner, p.83.

44. Chenciner, p.72.

45. Kling, Blair Bernard, *The Blue Mutiny: The Indigo Disturbances in Bengal 1859–1862* (Philadelphia: University of Philadelphia Press, 1966) pp.23–4.

46. Long, Richard, *Nil Darpan* (tr. Long), (1860), introduction, p.iii.

47. Report of the Commission in Kling p.140.

48. Mitra, Dinabandhu, *A Nil Darpan: The Indigo Planting Mirror*, tr. Long, Richard (Calcutta: Calcutta Publishing and Printing Press, 1861), pp.7–8.

49. Kling, p.14.

50. Cotton, GEL, *Bishop Cotton's View on the Nil Darpan Question* (Calcutta: Calcutta Christian Intelliger, 1861), p.4.

51. Sandberg, p.35; Bhardwaj HC and Jain, Kamal K, 'Indian Dyes and Dyeing Industry During the 18th–19th Century', *Indian Journal of History of Science*, vol.17 (1), 1982, pp.70–81.

52. Brenda King, Wardle's biographer, notes that all expected dyes are listed, with one exception – weld is missing. King, Brenda, 'Full Circle: India Leek India' in *Journal of Weavers, Spinners and Dyers*, (spring 2011), p.16.

53. King, Brenda, *Silk and Empire* (Manchester: Manchester University Press, 2005), p.86.

54. Also spelled tussah, tussar.

55. King, (2005), pp.108–9. Wardle was invited to join the Silk Industries Jury for the Exhibition and King describes him as earning 'the respect of rival French silk manufacturers'.

56. King, (2005), p.146.

57. A copy has recently been discovered in India by Jenny

Balfour-Paul who alerted Brenda King, Wardle's biographer.

58. King, (2011) p.16.
59. Though Linda Parry, William Morris expert, would contend that while using historic recipes for reference he also applied aspects of modern technology. See Parry, Linda, *William Morris* (London: Philip Wilson, 1997), p.227.
60. Symonds, Mary and Preece, Louisa, *Needlework as Art* (London: Hodder & Stoughton, 1928), pp.361–2.
61. Chenciner, p.270
62. Great Exhibition Illustrated Catalogue, *Art Journal* (London: 1850).
63. Hunt, 'The Science of the Exhibition', in *Art Journal* (London: 1850), p.iii.
64. Great Exhibition Illustrated Catalogue, *Art Journal* (London: 1850), p.917.
65. Hunt, p.iv.
66. Hunt, p.xxx.
67. Merrifield, 'The Harmony of Colours as exemplified in the Exhibition', Great Exhibition Illustrated Catalogue, *Art Journal* (London: 1850), p.v.
68. Hoggart, Norton and Trist, Auction Catalogue of the Collection of the East India Company at the Great Exhibition in 1851 (London, 7 June 1852).
69. Ledger of the above sale (1852).
70. Harris, Jennifer, 'Printed Textiles', in Harris, Jennifer (ed.), *5000 Years of Textiles* (London: British Museum, 1993), p.231; Schoeser, Mary, *English Church Embroidery* (nd) p.29.
71. Harris, p.229.
72. The South Kensington Museum was officially renamed by the Queen in 1899 as the Victoria and Albert Museum.
73. For example, Manchester Whitworth Art Gallery was founded in 1889 with its building being completed by 1908.
74. Symonds and Preece, p.359.
75. Privat-Savigny, Maria-Anne, Le Cacheux, Pascale, Chivaley, Hélène, Ronze, Clémence, *Les prémices de la mondialisataion: Lyon rencontre la Chine au 19e siècle* (Lyon: EMCC, 2009)
76. Travis, Anthony S, *The Rainbow Makers: The Origins of the Synthetic Dyestuff Industry in Western Europe* (Bethlehem: Lettigh University Press, 1993), p.120.
77. Garfield, p.148.
78. Travis, Anthony S, *Colour Chemists* (London: Brent Schools & Industry Project, 1983), p.34.
79. Levinstein, H, 'British Patent Laws – Ancient and Modern', in *The Jubilee Edition of the Journal of the Society of Dyers and Colourists* (1934), pp.83–9.
80. Pastoureau, Michel, *Blue: The History of a Colour*, (Princeton: Princeton University Press, 1999), p.161.
81. Downey, Lynn, *Levi Strauss & Co*, personal

correspondence with author (May 2012).
82. Downey, Lynn, *Levi Staruss & Co.* (Charleston: Arcadia, 2007) p.82.
83. The components for brazilin and haematoxylin were isolated in 1808 and 1810 respectively. Nowik, Witold. 'The Possibility of Differentiation of Red and Blue "Soluble" Dyewoods: Determination of Species Used in Dyeing and Chemistry of their Dyestuffs', in Kirby, J, *Dyes in History and Archaeology*, 16/17 (2001), pp.129–44.
84. Brunello, p.269.
85. Gage (1993), p.14.
86. Smith, David, *The Dyer's Instructor: Comprising Practical Instructions in the Art of Dyeing Silk, Cotton, Wool and Worsted and Woollen Goods, Containing Nearly 800 Receipts* (Philadelphia: Henry Carey Baird, 1860).
87. Ingres' portrait of Madame Moitessier (1856) now hangs in the National Gallery, London.
88. Travis, (1983) p.41–2.
89. Cooksey, Chris; Dronsfield Alan, 'Pre-Perkin Synthetic Routes to Purple', in *Dyes in History and Archaeology*, no.19 (2003), p.120.
90. Travis, (1983), p.43: Cooksey, Christopher J and Dronsfield, Alan T, 'Adolf von Baeyer and the Indigo Molecule', *Dyes in History and Archaeology*, no.18 (2002), p.14.
91. Travis, (1993), p.147.
92. Varichon, Anne, *Colors: What They Mean and How To Make Them* (New York: Abrams, 2006), p.168.
93. Garfield, Simon *Mauve*, (London: Faber and Faber, 2000), p.31–3.
94. Quinine was originally taken in carbonated water to which the colonial set in India added a measure of gin to offset the bitterness and make it more palatable.
95. Or to give it a truly scientific interpretation, Perkin's experiment was the 'first true multistep industrial synthesis of a carbon compound'. Travis (1993), p.40.
96. The patent was filed with the British Patent office on 26 August 1856.
97. Bradley, W, 'Perkin, the Man', in 'Sir William Henry Perkin' *Ciba Review*, no.115 (1956), p.11.
98. The issue regarding cotton became known as 'The Bradford problem' and Perkin had to go to Bradford to develop a solution that would work on cotton. Bradley, p.11.
99. Garfield, p.58. In 1860 the same conference would hear Darwin's theory of evolution.
100. Travis, (1983), p.22. Perkin referred to his colour in his academic papers as 'mauveine'. Garfield, p.63.
101. Garfield, p.55.
102. *The London Illustrated News*, October 1857; Travis (1993), p.46.
103. Ponting, Kenneth G, *A Dictionary of Dyes and Dyeing* (London: Bell & Hyman, 1981), p.15.
104. Reinhardt, Carsten and Travis, Anthony S, *Heinrich Caro and the Creation of Modern Chemical Industry*,

Chemists and Chemistry, vol.19 (Dordrecht: Mass Kluwer Academic Publishers, 2000) p.26.

105. Varron, A, 'Technical Details of Silk Weaving and Dyeing at Lyons' in Silks of Lyons *Ciba Review*, no.6 (1938), p.197.

106. Travis (1983), p.41.

107. Whereas Hoffman had spoken up for La Fuchsine (the company name after its partnership with Crédit Lyonnais) in patent infringement cases, he could not do so when he realised that the company was trying to extend its patent to America.

108. Travis (1993) p.145. As a result, the following year he was the one celebrated at the British Association for the Advancement of Science conference

109. Travis (1993), p.72.

110. Garfield, p.79.

111. Garfield, p.70.

112. The commentator was writing for the exhibition catalogue, Cassell's *The International Exhibition of 1862* (London: Cassell, Petter & Galpin, 1862), p.59. He also described the purple crystals shown, as one step in the process, as 'resembling the gorgeous lustre on the wings of some green tropical beetles'.

113. *Cassell's Illustrated Family Paper* (London: Cassell, Petter & Galpin, 1862a), p.viii.

114. *The International Exhibition of 1862*, pp.93–4.

115. Sandberg, (1989), p.35.

116. Travis (1983), p.40.

117. Patent Office, *Patents for Inventions: Abridgements of specifications Class 2(iii) Dyes and Hydrocarbons and Heterocyclic Compounds and their Substitution Derivatives*, no.117 (London: British Patent Office, 1921).

118. The author bought a skirt in 2010 that came with a large sticker telling her to ignore the washing instructions and wash only by hand in tepid water. The author washed it in cold water and it still ran.

119. Brunello, p.283.

120. Any synthetic dyes found in the country were confiscated and burned in a great public showing to reinforce the importance of the traditional colours. Delvin, Samuel, *Dyes and Pigments* (Delhi: Ivy Publishing House, 2006), p.15.

121. Delahaye, Elisabeth, *The Lady and the Unicorn* (Paris: RMN, 2007), p.17.

122. Brock, William H, *The Case of the Poisonous Socks* (London: Royal Society of Chemistry, 2011) pp.1–14.

123. Tardieu, Ambrose & Roussin, Z, *Mémoire sur la Coralline et sur le danger que présente l'emploi de cette substance dans la teinture de certains vêtements* (Paris, 1869) pp. 11–12.

124. Garfield, pp.107–9.

125. Cooksey, Christopher J and Dronsfield, Alan T, 'Synthetic Alizarin – the Dye that Changed History', *Dyes in History and Archaeology*, no.16/17, (2001) pp.36–8.

126. Travis, (1993), p.179.

127. Travis (1993), p.183.

128. Travis (1993), p.47.

129. Travis (1993), p.192.

130. Chenciner, p.265.

131. Travis (1993), p.193.

132. Travis (1993), p.53.

133. Cooksey, Christopher J and Dronsfield, Alan T, 'Adolf von Baeyer and the Indigo Molecule', *Dyes in History and Archaeology*, vol.18 (2002), pp.13–15.

134. Baker, Rosemary M, 'Patents as a Source of Information About Synthetic Textile Dyes', *Meeting of Dyes in History and Archaeology*, at the V&A London, 2009 Conference paper, p.129.

135. Travis (1993), p.163.

136. Garfield, p.126.

137. Travis (1983), p.54.

138. Travis (1993), p.223.

139. Bradley, W, 'The Legacy of Perkin', in 'Sir William Henry Perkin', *Ciba Review*, no.115 (1956) p.36.

140. This dye also marked the start of dyes having not jolly names (mauve, fuchsine) but formula names of which only one part might represent a colour. This became an even more complex system in the 20th century as the range of colours exploded, further compounded by the different companies selling their own versions when patents expired. Neuberger, MC, 'Modern Scarlet Dyes', in Scarlet *Ciba Review*, no.7 (1938), p.228.

141. Cooksey, Christopher J and Dronsfield, Alan T, 'It Happened By Chance: The Discovery of Malachite Green', *Dyes in History and Archaeology*, 20 (2005), pp.165–75.

142. Delvin, p.14.

143. Travis (1983), p.59.

144. Travis (1983), p.63.

145. Zollinger, Heinrich, *Colour: A Multidisciplinary Approach* (Zürich: Verlag Helvetica Chimica Acta; Weinheim; Chichester: Wiley, 1999), p.44.

146. The company was the successor to Simpson, Maule and Nicholson – the way British companies kept changing is also in contrast to the major German and Swiss companies, which had all settled down to research by this time.

147. Garfield, p.109.

148. Garfield, p.97.

149. Travis (1983), p.71.

150. Travis (1983), p.32.

151. *Patents for Inventions: Abridgements of specifications Class 2(iii) Dyes and Hydrocarbons and heterocyclic compounds and their substitution derivatives* (London: HMSO, 1921).

152. Intermediates are the chemicals needed to facilitate the required reactions in making the dyes. Intermdiates include things like sulphuric and other acids, naphthol and the mordants like chrome.

9

A Hundred Yellows: the 20th and 21st centuries

The dawn of the 20th century saw a very different environment for dyeing than the 19th. Now synthetic dyes reigned, drawing an enormous amount of investment in Germany and Switzerland. Successful dyes were those that replicated their natural counterpart or offered new colours not previously available, and gave repeatable results with a reliability that plant materials couldn't match. By 1900 there were aniline, azo, diazo and direct dyes, and by 1906 some 2,000 colours had been created, offering dyers hundreds of shades in every colour.[1] By 1908, synthetic indigo had reached China, a country where it was estimated that three-quarters of the population were dressed in blue, indicating a potentially enormous future market.[2]

The story of 20th century dyeing is thus one of an exponential growth in colour variety, but also of improvements in the new dyes' colourfastness and durability. However, the interruptions of two world wars had a dramatic impact on the accessi-bility and availability of materials for dyes. Outside the war periods, other dyeing challenges related to the new synthetic textiles – from rayon and nylon to spandex and goretex – with dyes needing to be (re)engineered to work on each of these different fibres.

20TH-CENTURY DYES AND MORDANTS

In 1901, synthetic vat dyes were discovered by René Bohn of BASF. These were processed in the same way as indigo, hence the term 'vat dyes'. They were marketed under the name of indanthrene. The first colour achieved was indanthrene blue RS and the second flavanthrene, a yellow.[3] These colours worked particularly well on cotton and, according to Brunello, were so fast that the fibre would perish before the dye.[4]

Indeed, so good were they that the dyers were worried initially about the trade consequences of strong colourfastness. They feared that such longevity of colour would have an impact on newly burgeoning fashion sales. Would women buy the fabric for a new gown if the colour in their current gown was still as good as new? Such doubts reveal only the dyers' ignorance of women's love of fashion, because they needn't have worried: within just 12 years BASF had expanded the range to 182 indanthrene dyes, further enhancing their world-leading position in dyestuffs.[5]

New dyes were continuing to appear, and with them new categories of dye – in particular, the new chrome dyes. Chrome mordant is potassium dichromate, first used in the dyeing trade during the 19th century. It adds brightness and fastness to the colour but is also considered one of the more undesirable chemicals. It is used in synthetic dyeing, especially for dark colours. Chrome came

into its own as a mordant for use with the neolan dyes invented, also by René Bohn, in 1915. These were effective dyes but their production required extensive use of acid.[6]

20TH-CENTURY MAJOR DYE DEVELOPMENTS

During the first half of the 20th century companies continued to invest in new dyes, the major achievements are listed in the table below. In 1951 the Swiss firm of Geigy developed Irgalan. This group of dyes was similar to Bohn's Neolan but used much less acid to achieve good colour and adhesion. Rival Swiss company Ciba brought out their own version, Cibalan dyes,[8] the following year and, with continuing development, created Cibalan brilliant yellow 3GL in 1953. In turn this led to the final major development of dyeing in the 20th century, by the UK's Imperial Chemical Industries (ICI).

ICI had been formed in 1926, absorbing, among other companies, British Dyestuffs Corp. Ltd and, later, Scottish Dyes Ltd and the British Alizarine Co. to become the home for chemical research into dyestuffs in the UK.

In 1956, 100 years after Perkin's mauve, ICI launched Procion, the first fibre-reactive dyes for synthetic fibres – dyes which bind directly to the fabric, remaining colourfast against washing, light, rubbing and perspiration. These dyes revolutionised the industry overnight.[9] The sample books, in two volumes, highlighted the colour singly on swatches of bleached fabric and then in combination with other colours as a printed fabric. At the beginning of the 20th century Britain had been castigated for not investing enough in dyeing; now there was some good news.

Worldwide, the synthetic dyeing industry grew exponentially as a result of this new innovation. From 160,000 tonnes in 1913, it was up to 300,000 tonnes by 1950, but by 1965 had grown to 500,000 tonnes on the back of the new dyestuffs and the increasing market size, partly fuelled by the post war 'baby boom' as new materials and fashions burgeoned in the early 1960s.[10]

WAR'S IMPACT ON DYEING

In 1914, the British dyeing industry was virtually decimated overnight. All those working the many patents in the English-based German companies were called home. This left five British dye companies, including Levinstein and Read Holliday, but in order

Name of dye	Date of discovery	Inventor	Type of dye
Indanthrene blue RS	1901	Bohn	First anthraquinone vat dye, very colourfast
Diamond black	1901	Bayer	The first significant synthetic dye to replace logwood
Thioindigo red	1905	Friedländer [7]	First indigoid dye
Ciba blue 2	1907	Engi	Tetrabromindigo
Hydron blue	1908	Cassella	Rival to synthetic indigo
Neolan dye	1915	Bohn	Metallised chrome dye
Chlorantine lightfast	1915	Ciba	New dyes for use on cotton
Caledon jade green	1930	Scottish Dyes	Green of great brilliance and fastness
Indigosol O	1924	Baeyer & Sunder	First indigosol dye
Monastrol blue B	1934	ICI	Very fast but needed special fixative

Early 20th century dyes

Found in the dyeing accounts book of Henry Day & Sons, for 1897, now in the care of West Yorkshire Archive Service at Kirklees. The label on this sample says that it is one of the first pieces of khaki fabric manufactured for the South Africa war and is made from natural dyes gambier and cutch; the challenge was to find the synthetic equivalent. © *West Yorkshire Archive Service Kirklees. Ref KC1024/79, Henry Day & Sons Ltd collection. Photograph © Susan Kay-Williams*

By the 20th century the chemical companies had to produce books of all the colours that could be achieved, especially as they had the kinds of names that meant they were indistinguishable even to the experienced commercial dyer. Now there were hundreds of shades of every colour, even those like yellow for which, historically, it had been notoriously difficult to achieve many shades. *From the collection of the author. Photograph © Susan Kay-Williams*

to make the dyes, they needed the various chemical intermediates: chlorine, sulphuric acid, benzene and ammonia. All of these came from Germany (and during the war were diverted into other uses, for explosives and the preparation of chemical warfare). The important textiles business, worth £100m, was virtually brought to its knees for want of the synthetic dyes.[11] Belatedly, the British textile industry began to recognise its shortsightedness.[12]

The colours of warfare also changed for the Great War. For all except the French, by the start of the war the colour of battle dress had been muted to grey for the Germans, following their Prussian forebears, and khaki for the British. Khaki (from the Persian word for dust) had started to be used in the late 19th century in places like India, Egypt and other areas where the local flora and fauna made red too distinctive. Originally, soldiers applied mud and earth dust to white uniforms to help them blend in to arid environments,[13] but eventually a specific colour was developed.

In a dye accounts book in the Henry Day papers, there was a sample of '*one of the first pieces of khaki as used*

in the South African War'. It was located in the journal pages for 1897 though the label on the piece is not dated so it is not possible to know if it referred to the first or second South African Wars. The sample is dyed using two natural dyestuffs, gambier and cutch. The way this fact is noted on the accompanying label implies almost consternation that two natural dyestuffs have been used. But the reason this was to be found in the journal of a chemical dye company was probably that their challenge was to create the synthetic version of khaki for future soldiers.[14] By the beginning of the First World Was there was a need for large quantities of khaki for the mass clothing of thousands of new soldiers.

For the navy the British continued to use blue from indigo, but it was not possible to increase supply from India because so many farmers had stopped planting what was a largely redundant crop by this time.

Even in Germany, though their decision to move to grey uniforms was taken in 1907, it took until 1913 before enough had been made to equip the entire German army.[15] The chosen dye was Helindon (an

indigoid vat dye which gave the 'feldrock' colour).

Only the French were still in red and blue. Indeed in 1911, the war minister, Eugène Étienne, had declared that *'the red pants have a national quality. The red pants c'est la France.'*[16] However, the alternative view was that the French army offered *'un grand panel de rouges'.*[17] Finally, however, as the reality of war struck home, the decision was taken in December 1914 to introduce a uniform in 'horizon blue', so-called as it was considered those wearing it should blend into the horizon.[18]

Read Holliday was one of the British companies that developed and supplied the 'khaki yellow and khaki brown' synthetic dyes. However, they still needed some of the intermediates that were not made here, and the only way to secure them was through a 'neutral door' via Switzerland and Holland.[19] C M Whittaker, a senior dye chemist at Read Holliday, noted how the dye chemists became part of a protected industry, even at the end of the war being feted with a lavish dinner. However, their celebrity was short-lived, as the morning after this grand event 50 chemists were sacked, there being still no vision for the long-term development of the chemical dyeing industry in Britain.[20]

Following the war, the government passed the Dyestuff (Import Regulation) Act (1922) in an effort to encourage dyestuff development and manufacture in Britain, but the effect was not substantive. Writing in the golden jubilee edition of the *Journal of the Society of Dyers and Colourists* in 1934, the president, Gilbert Morgan, praised the opportunity for British manufacturers to import 'novelties' that were not made here, but he warned against a repeat of what had happened in the Great War regarding intermediate supplies. *'Intermediates are the media in which colour chemists and colourists express themselves and unless substantially all our intermediates are home made, we cannot claim to be completely free from subservience to foreign countries. Moreover it must never be forgotten that, in addition to being an important factor in peacetime commerce, the dye-making industry is of vital national importance in war.'*[21]

By this time Germany was producing only 44 percent of world dyestuffs, from 80 percent in 1900, but Britain was producing a mere 12 percent.[22]

DYE SAMPLE BOOKS

Fundamentally, the 20th-century history of dyeing is about opening up the world of colour: from the jealously guarded recipes of individual dye houses to the standard-recipe dyes of the chemical companies. Now companies were rushing to issue colour sample books, showing the range of colours that could be achieved based on various percentages of dyestuff.

The dye sample books were absolutely essential in promoting the individual dye ranges and colours. Because the new synthetic dyes had no historic point of reference, dyers needed the books to see what colour they were supposed to achieve; also, because the colours marketed were just some of those the researchers had developed, many of the names given were jargon, but if these men of colour could see the end product, then they could understand.[23]

Books with swatches of cotton, wool, silk, synthetic, or a combination of these fibres, began to be produced as reference tools for the dye companies, along with the full scientific recipes.[24] The first books of samples were issued in the 1890s, including both single colours on individual fibres and multiple colours printed onto fabrics.[25]

LEARNING FROM EXPERIENCE – STILL

One reason for the lack of British investment in the early 1900s was an underlying belief in many British dye companies that this was not necessary, that future developments were going to be made in the dye house, not the laboratory, simply because the British remained at the forefront of actual textile production. Several books were written by British practitioners and academics to show other countries, especially America, how to produce textiles the British way. Sydney Herbert Higgins wrote a book originally entitled *Dyeing in Germany and America* but by the third edition it included substantial reference to Britain so Higgins changed the title to *The Dyeing Industry*. Writing in 1919

Logwood was still in use for blacks and purples by the early 20th century, but now the ingredients to be used with it all had their chemical names (potassium bichromate, sulphuric acid, ferrous sulphate, oxalic acid and fluorchrome). With the exception of the last named, all the others had been in use for centuries. This book was written by an academic and dyeing practitioner in the UK for dyers in the US. *From the collection of the author. Photograph © Susan Kay-Williams*

he commented that '*to those engaged in industrial research there is little gain to be obtained from the publication of results*'.[26] He noted that research was being carried out in English dye works but the outcomes were treated in two distinct ways; findings which had practical value were employed immediately but the research findings themselves were merely filed, notwithstanding the fact that he also noted that '*the dyeing industry is probably more subject to change than any other branch of manufacture*'.[27] Furthermore he worried for the future. While Higgins pointed out, on more than one occasion, that '*it is a great mistake to state that the German dyeing industry is in advance of [the British]*'[28] he was concerned that the sons of dyers were content to go into the business after leaving school at 15 or 16 while in Germany there was much greater emphasis on them going for technical and scientific training, something which Higgins believed was of great importance for the future development of the industry in Britain.

Higgins taught at Manchester College of Technology but was also a dye-works manager in Yorkshire so understood the practical application of dyeing and had visited both Germany and America before writing his book. In America he noted that, by and large, dyeing was undertaken empirically, rather than through any application of science at this time. '*For instance, at one American works a man who had no scientific training was seen giving directions to the dyers and dispensing dyestuffs in a most crude manner*'.[29] But part of the purpose of this and other books was to give American dyers more insight into the knowledge of their European equivalents.

Walter M Gardner who taught and demonstrated at both the Yorkshire College, Leeds and the Technical College in Stockport, wrote a manual in 1892 for American dyers on the continuing use of logwood, but with the new chemical components as the mordants and colour modifiers.[30] In an early example of commercial sponsorship, the book was published and distributed by WM J Matheson & Co Ltd of New York, Boston, Philadelphia and Providence USA who were manufacturers of logwood extract, undoubtedly as a way of continuing the use of this natural dyestuff even in the face of mounting competition from chemical dyestuffs.

THE COLOUR INDEX

The range of colours developed from 1856 to the first quarter of the 20th century was enormous, though many were never brought to market. But different companies had different names for the same things, so in the early 1920s the Society of Dyers and Colourists decided to bring together all the known colours and producers into a common publication – though with 'recipes' only, no colours, as printed colour samples would have been prohibitively expensive while requesting fibre or fabric samples would have been a logistical nightmare.

The first edition of *The Colour Index* was published in 1924. Drawn from around 150 companies making dyestuffs, the book included recipes for all their dyes, which were listed and grouped by ingredients – a total of 1,230 synthetic colours, followed by a short

section of fewer than 20 natural dyestuffs that were still considered to be in use.[31]

Many of these synthetic colours had vague jargon names, as we have seen – e.g. Direct Fast Red T, which gives absolutely no idea of shade – but one name stood out: synthetic indigo was still known simply as indigo, even after the patent had expired so that other companies could make it.[32]

The range of chemical dyes now included aniline, azo, diazo, vat, direct, acid, chrome and naphthalene colours – and there were choices. For example, the *Index* lists 41 varieties of direct brown. And the following names are all for the same colour: Victoria yellow, English yellow, Victoria orange, saffron substitute, golden yellow and aniline orange – where perhaps only 'saffron substitute' gives a sense of what the colour might actually be.[33]

A key objective of the book was to produce '*as accurate and comprehensive a work of reference as possible*' so the editors sent a set of proofs to each of the 150 companies to check, to which all except the German companies responded.[34]

PATENTS

Ivan Levinstein had continued to fight for patent protection for British companies, with little success until 1907 when Lloyd George finally brought in a new patent law, albeit rather too late. The new law set down the principle that if a company from another country took out a patent in Britain, they had to work it here. Several German companies set up factories, considering that making the dyes and intermediates here would actually be beneficial to sales; again, as had been the case with patent laws in the previous century, this was not quite what had been anticipated.[35] However, even after the new law had been enacted, the majority of patents filed continued to be those of German and Swiss companies. In 1909, in the year the new law came into force, there were 262 patents for dyes in Britain, of which only 45 were not registered by German or Swiss companies.[36]

By 1919, some of the elements of the 1907 act had been repealed, leaving Herbert Levinstein, Ivan Levinstein's son, to state that he was '*not at all convinced that we should not be better off under the broad wording of Section 6 of the Statute of Monopolies (the original Patent Act). The more elaborate the definition of an abuse, the easier it is to get round the law. On the other hand, the simpler and the broader the definition, the greater is the freedom given to the Courts to interpret the law in the interest of the public, as well as that of the patentee.*'[37] This was to be further compounded in the 1920s. When the Dyestuff Importation Act came into force in January 1921 the exclusion of foreign dyes had been promised, however, '*the Board of Trade failed to prevent the importation of foreign dyes*'[38] rendering the Act useless in endeavouring to protect and empower the British dyestuff industry.

THE 1920s: THE NEW FASHIONS

As memories of the war receded, the 1920s brought a wave of new developments. Artists like Sonia Delaunay worked with the Lyon-based company Velours et Peluchés to produce 50 print designs, which she developed and oversaw to such an extent that they were considered individual works of art.[39]

Coco Chanel also seized the zeitgeist in the most daring way with the creation in 1926 of the little black dress. Now considered a staple of a woman's wardrobe, it was a risqué innovation for the time, taking black out of mourning and making it a choice for women for day or evening wear.[40]

Mariano Fortuny, on the other hand, was exploring colour and natural dyes. Analysis of Fortuny fabric samples now in the Whitworth Art Gallery in Manchester has shown evidence of indigo, brazilwood, cochineal, old fustic and even quercitron. However, these would not give the shades he wanted on printed textiles, so he developed a range of colours which were literally painted onto the fabric by hand. This, of course, made them less colourfast when washed, but underlines Fortuny's belief that what he was making was art, not humdrum clothing.[41]

Printed textile design by Sonia Delaunay. Ms Delaunay took printed textiles to a new level of art, checking that the colours were just what she wanted as well as bringing a freshness to the design (colour litho). *Plate 35, from* Compositions, Colours, Ideas, *1931, Sonia Delaunay (1885–1979), Private Collection / The Stapleton Collection / The Bridgeman Art Library. © L & M Services B. V. The Hague 20120802*

Synthetic dyes were spreading round the world by this time, wherever there was transport to take them. Fausto Burgos, in Argentina in 1927, wrote that, 'People dye with anilines in the places connected by the railway, which brings all novelties of civilization; primitive dyeing is only used in the regions the train does not reach.'[42]

By the 1930s the colour of working clothing was now unquestionably blue, giving us the phrase 'blue-collar worker' for those in more manual occupations, mechanics and machinists, for example – as well as the growing number of occupations which used blue uniforms such as railway, postal and other service workers. The quintessential blue workwear was Levi's waist overalls. But in 1934 Levi Strauss & Co. first developed Lady Levi's which were *'tailored to fit and look neat on the feminine figure.'* The following year, women in Levi's were used to illustrate an article in *Vogue* about dude ranching.[43] Levi's for women were, from the start, positioned as leisure wear rather than work wear, however, blue jeans became much more than merely uniform and, as such, in 2000 *Time* magazine named them as their fashion item of the 20th century, beating both the miniskirt and the little black dress.[44]

The other staple of the fashion industry that keeps recurring is the blue blazer, which first began life in the 1920s and 30s and is now reinvented with little touches almost every summer – proving that, while fashionable colours come and go, staple colours, among which navy blue is preeminent, remain timeless.[45]

CIBA REVIEW

The Swiss company Ciba prided itself on research and information as well as the dyes it created,[46] and in the 1930s launched two series of journals, one linked to medical products and one to dyes. The *Ciba Review* in English was launched in 1937 and began a series that initially ran monthly, with well-researched articles on all aspects of historical dyeing interspersed with adverts for Ciba's latest dye products. The first edition examined medieval dyeing and across the series, which ran until the 1970s, it looked at dyeing in historical dye centres, at the principal dyestuffs and the principal fibres and at dyeing in different cultures and across different time periods. Kenneth Ponting, professional British dyer for some 50 years, thought it so important that he listed all the titles in his major work *A Dictionary of Dyes and Dyeing.*[47]

The series presented a wonderful introduction to the history of dyeing and included black and white photographs of historic pieces and places. Given the devastation that was to happen across Europe over the next few years, this record became even more precious when some of the objects it featured were destroyed in bombing. For example, in the edition

entitled 'Guild Emblems and Their Significance', there is a picture of the ceremonial crowns from the Worshipful Company of Girdlers in London. These were destroyed in the war and the picture was one of the few records that could be used by the Royal School of Needlework when they recreated the crowns after the Second World War.[48]

As the series progressed there was more emphasis on the company's own research and products; for instance, for the launch of Cibacron in 1957, the Ciba version of ICI's Procion dyes, they produced a special edition of the magazine.[49] The series ran for 141 editions until shortly after Ciba merged with Geigy (both companies are now part of Novartis). Given its breadth of content, it is a fascinating source of both primary and secondary information.[50]

TOWARDS THE SECOND WORLD WAR AND BEYOND

By the Second World War, European countries had endeavoured to heed the warnings from the First about securing dye sources, and had tried to find new suppliers of dyes and intermediates. However, while there were a number of companies in Switzerland and America, they too were still reliant on Germany for the intermediates. So while the Dutch government, for example, was concerned about reliability of supply as the Nazi regime gained ever greater power, they were obliged to continue to obtain their supply of 'helindonen' for their own uniforms from Germany.[51]

In Britain, uniform clothing was now needed for more than just soldiers on the front line. Everyone from land girls, to women in munitions factories, to those keeping the railways running wore uniforms, usually in khaki denim, which met the need for heavy-duty hardwearing clothing. The colours were now dyed with vat dyestuffs '*so that complete penetration with the fastest possible dye was obtained*'.[52] When Rowe began *The Colour Index*'s colourfastness scale of 1–5, he stated that some of the '*exceptionally fast members of the series of vat dyestuffs ... would require a scale of eight degrees*', so fast were they.[53] Over the course of the war the government used well over 100 million yards of

Dress designed by Elsa Schiaparelli using her signature shocking pink silk for the core of the dress, with an overskirt of machine embroidered organza. Made in 1953. © *Victoria and Albert Museum (T397-1974)*

denim dyed in khaki-drab and jungle-green colours.[54]

After the Second World War, as the chemical companies returned to their principal roles, the range of dye colours began to grow again and new sample books were produced, so much so that designers could now begin to choose their own colours. In 1936, French designer Elsa Schiaparelli invented 'shocking pink', which was first used for the heel of one of her surrealist shoe hats but she soon went on to use the colour in haute couture fashion.[55]

New colours were now coming thick and fast, usually from a combination of the colourants available. For the coronation of Queen Elizabeth II in 1953, companies were keen to introduce appropriate new colours: issue 96 of the *Ciba Review* advertised how to create Elizabethan red, marguerite green, princess grey, beau blue and spun gold.[56]

THE NEW FABRICS

For most of history, as was said in the introduction, fabric had been made from the four core fibres: wool, silk, linen and cotton. However, where synthetic dyes led, synthetic fibres were not going to be far behind. The first synthetic fibre was viscose, developed in 1894[57] and first used commercially in the UK in 1905 by Courtaulds before being launched as rayon in the USA in 1924. A cellulosic fibre, like cotton, it took dye like cotton but was marketed as having the feel of silk. So popular was it that by 1926 the British Dyestuff Corporation could talk about how much development there had been. 'Owing to the greatly improved weaving and wearing qualities of the modern product, the demand for yarn and fabric of this material has achieved wholly unforeseen dimensions.'[58]

The next fabric breakthrough was nylon, developed by Wallace Carothers at DuPont, which first went on sale in 1938.[59] Since then, there has been a steady stream of new fabrics:

Of these new fabrics perhaps only Kevlar, the impact-resistant, protective material developed by Stephanie Kwolek for DuPont, does not take colour itself but is always wrapped in a coloured fabric.[60]

Each new fabric brought its own challenges for the dyer, as the British Cotton and Wool Dyers' Association noted in their 50th anniversary book:

The introduction of rayons and nylons to the textile industry created many problems for the dyer, and it has been necessary to develop new techniques and even new classes of dyestuffs. For instance cellulose acetate rayon will not accept the dyes normally used for viscose and the dyer has exploited this difference of affinity by dyeing mixture fabrics, in the piece, in one dye liquor and obtaining two-colour effects by dyeing with different dyes suitable for each fibre present.[61]

Furthermore, the most important elements of dyed fabric remained the same – will the colour run in the wash, fade in sunlight, rub off as a result of wear or be affected by deodorants?[62]

Fibre name	Date created	Developing company
Terylene	1941	created in England and commercially developed by ICI
Polyester	1940s 1950s	developed in Britain it became popular as a textile in the 1950s
Crimplene	1950s	created by ICI
Spandex (aka Lycra)	1958	created by DuPont
Goretex	1989	created by W.L. Gore as the first breathable fabric.

THE DOWNSIDES OF DYEING

In the last chapter we looked at the issue of arsenic in the new synthetic compounds, a matter that was quite quickly resolved by finding alternative formulae to enable arsenic to be omitted altogether. By comparison, azo dyes were first identified in 1875 by Caro and Witt and went on to be used for decades. However, some were finally outlawed as carcinogens in 1997 after suspicion led to extensive testing, with the German government declaring

... a second amendment to German Regulations on Consumer Goods that any azo dye which could release one or more of the listed 20 carcinogenic aromatic amines should not be used in the manufacture of consumer goods. The import of consumer goods dyed with azo dyestuffs containing the harmful amines was prohibited from 1 Jan 1995 and sales of already imported goods from 1 July 1995. (However, in the event, all dates went back several months and the final prohibition went into 1996 and for the rest of the EU was effective from October 1997.[63]

As health and safety laws tighten around the globe, the production of dyes containing harmful substances should diminish, but one can never tell what unexpected consequence may arise from experimenting with new dyes on new materials or simply changing one aspect of the process.[64]

COLOUR AND FASHION

From Coco Chanel's black to the prints of the 1930s to the bright new colours of Mary Quant in the 1960s, through the Day-Glo years and the extravagant colours of Versace, into the recent trend for block colours – colour has been central to the fashion industry throughout the 20th and 21st centuries. Some, like Zandra Rhodes, embrace it fully, with vibrant gowns in wonderful colours; others may use it more sparingly. However, there are many books on fashion which reveal individual designers' relationships with colour, and that is not the purpose of this book. Now that every colour is available, that is not the challenge.

COLOUR IN THE 21ST CENTURY

When I asked a professional dyeing consultant *'what's been the most significant innovation in the last 20 years?'*, surprisingly the answer was not a colour, or a dyestuff, but rather the location of dyeing: the industry is now predominantly based in China, India and Bangladesh. While Germany still makes the best-quality dyestuffs, the only other elements that remain in Europe are the niche dye products. Many European chemical companies have been merged or taken over by larger concerns as they moved out of textile dyes into more specialist areas. Meanwhile the industrial research institute of India (NIIR) reports that the market for dyestuffs in India is some 30 billion rupees, of which some three billion rupees are still from organic sources, principally indigo.[65] However, China is the largest dyestuff producer, accounting for one third of the global output, some 1.153 million tons in 2006. It is also the largest dyestuff exporter, accounting for more than 20 percent of world trade volume, mainly for textiles in the EU and US.[66]

As a result, the Society of Dyers and Colourists today holds more of its training days in Asia than in Europe, while the factories of Lancashire cotton, Macclesfield silk and Yorkshire wool have been demolished or turned into upmarket apartments,

with any remaining company records, if we're lucky, handed over to the local archive service.

Meanwhile the major issue concerning dyers is that of sustainability – how can the energy-demanding dye industry reduce its energy needs? This is particularly the issue with water; as we have seen repeatedly, access to large quantities of clean water is essential for dyeing. One answer is standing-bath technology, in which a dyer uses just one bath of water. On day one they start by dyeing a batch in a very pale colour such as yellow, then that afternoon they go for a darker yellow, continuing over the course of the week to dye successively darker colours until by Friday afternoon they are working on black, each time using the same bath of water. This is only disposed of after the black dye bath, with the dyer's aim each time being to achieve 100 per cent exhaust, i.e. no colour left in the dyebath. In practice, there will still be small traces of colour left in the water after each dyeing which is why they work through a series of colours from light to dark so that the next colour is unaffected by any remaining colourant in the water.[67]

The holy grail, however, is air-dyeing – dyeing without any water at all. There have been some small successes with this method, but it is a bit on the scale of dyeing a pocket handkerchief in one colour you don't want, rather than being able to dye a bale of cloth in a colour of your choice.[68]

Meanwhile, dyers are looking at how they might shorten processes, though this has to be done with care. Dye processes have been honed over decades; deciding to lower the temperature of a steam (fixing) bath, or the time the fabric is in the dye bath, could have serious consequences for the old issues of colour and wash fastness. For example, fabric ordered for military use must meet a very high specification; anything found to be substandard will be burned and destroyed. Above all else, an army needs to have a commonly identifiable uniform, especially in 21st-century camouflage combat, and as such a material that looks faded before it starts could lead to unnecessary casualties; unfortunately, colour fraud still goes on as some dyers seek to make that little extra profit by not using the approved dyestuffs.[69]

In one positive development, dyers are trying to

The last major development in dye technology was ICI's Procion dyes, which in effect fused fabric and colour, making it very colour fast against washing, rubbing, sun and perspiration – the four major problems for dyeing. Procion-type dyes are still in use today, not least because they work very well with some of the new synthetic fabrics. *From the collection of the author. Photograph © Susan Kay-Williams*

find ways to increase the absorption of dyestuff in the dye bath so that the fibre takes up the whole of the active ingredient, leaving as little waste as possible. This is, of course, not a new topic – it applied also to natural dyes – but the synthetic industry needs to rediscover this habit for itself.

In China, one of the new centres for research into textiles, work was published in 2010 which examined the efficacy of using ionic liquid processing to enhance the dye absorption of wool fibres. The results of the study showed that this treatment *'could produce a remarkable modification on wool ... the dyeing rate, dye exhaustion and colour depth increased quickly'*. But there was also a downside. The researchers noted the degradation of the wool caused by the initial process, that *'there were changes to the internal structure of the wool, all of which ... might well have had a detrimental effect on the longevity of the wool'*. The researchers also noted that *'the quickly increased dyeing rate and improved colour yields together may not lead to a*

successful dyeing process. Sometimes evenness of dyeing may also be very important'.[70] All of which rather takes us back to the issues dyers were grappling with as long ago as the Middle Ages.

One further issue is of environmental pollution. Recently Greenpeace undertook research into effluent dishcharge from Chinese dye factories. This resulted in highly critical headlines, although as one reviewer wrote, looking at the discharge rate as parts per million and bearing in mind the water was tested at the point of leaving the factory, it could be said that the factory should be applauded for managing how little was being discharged, to be further broken up by the effect of the river. Overall the author reflected that Greenpeace should be applauded for raising this issue, that the companies should be recognised for what they were trying to do to further minimise discharge but that there were still a lot of small companies who would carry on just as they were and this was where the focus should be.[71]

COLOUR MATCHING

It is the role of designers to create new concepts and then to work out how to realise them. If the aim is to achieve a finished colour on fabric, the colour on a swatch (or especially a computer screen) may look different to the finished fabric or garment. So the first challenge is deciding what colour you want to see. The second thing is to decide on the kind of fibre it is going to be applied to. The more complex the fibre blend, the more difficult the dyeing challenge. As we have seen, cotton, wool and now synthetic fabrics all take colour differently, requiring a specialist to achieve an even appearance of colour across the now common blended fabrics or yarns.

It is therefore vital to use experienced colour technologists to help translate the designer's wishes into reality. At the time of writing, the London Olympics 2012 are yet to happen, but the people producing all the outfits for the volunteers and the officials have been hard at work for some time endeavouring to achieve the required colours from designers' swatches on the various fabrics chosen.[72]

But this is not the end of the challenges for the

dyer. If the manufacturer of a detergent, bleach or other intermediary product changes the ingredients, (because they are also looking for cost savings and greater effectiveness), through the law of unintended consequences, this might have a serious impact on the final colour achieved, clouding or lightening it. Such seemingly 'workaday' changes are often made unannounced, but while one part of the industry may see them as a step forward because they save money, they can, introduce new problems for the dyer.[73]

COLOUR TRENDS

Colour trend planning is another big industry involving designers, colour specialists, retailers and others from a variety of sectors whose job it is to look ahead and predict what are going to be the 'on trend' colours for at least two years ahead in areas such as fashion, paint, household furnishings and even car interiors. As Kate Scully a colour consultant and lecturer in fashion promotion notes 'Colour is the first thing to catch the shopper's eye.'[74]

The choice of colours is based on a number of factors including social issues, lifestyles, the economy, the natural world, technology not to mention 'the needs, moods, fantasies and aspirations of consumers'.[75] As such, trend colours are not single colours; instead, they are a range of palettes within which designers can work, with several palettes often produced each year. This involves companies in development costs but, as Michelle Lamb, editorial director of Trend Curve™, observes, it is just as expensive to put an item in an old colour as an on-trend colour, so this should always make it more sensible to use on-trend. However, she also notes how quickly trend colours now come and go. Whereas in the middle of the 20th century trend colours for home interiors stayed around for up to 15 years, today this period is just three years, demanding much more investment in trend but a shorter period to harvest a return on this investment.[76]

Scully and Johnston Cobb reinforce the economic aspect commenting that a positive approach to colour forecasting is about meeting customer need and expectations (the fundamental principles of marketing) to achieve positive sales.[77]

NATURAL DYES IN THE 21ST CENTURY

It is possible to claim that there is no future for natural dyes, but this author does not believe it to be so. Natural indigo is still a commercial product because of the demand for jeans, although synthetic indigo behaves in the same way, that is rubbing off the fabric, a feature which has become desirable in this one product area.[78]

Secondly, there are people who, since the 1980s, have established small new textile initiatives initially using natural dyestuffs. The first of these was probably the DOBAG project started by Harald Böhmer in Turkey, creating employment for local weavers by examining the old carpets to discover which natural dyes were used on them and growing the necessary plants to create new textiles including rugs, using the same materials.[79] There is also the Wissa Wassef weaving project in Egypt where natural dyes are used.[80]

This concept has been taken by westerners to parts of India, Nepal, Laos and other countries in Southeast Asia, where they are working with local communities and using some locally grown natural dyes to make rugs, hangings and other pieces for interior decoration that are then sold in the west. The best of these offer a good wage to the local people – often women's groups for whom this is a first opportunity to gain some economic independence. Good projects are happy to discuss which dyes come from natural sources and which from chemical products.[81] It is certainly the case that where an organisation is making a small rug in a range of colours, it is often easier to use natural colours. On the other hand, making a large bespoke carpet means that it may not be practical to use natural dyes, with their many variations in batch colour, in which case synthetic colour is used to ensure consistency.[82]

Thirdly, there are a growing number of craft dyers in Europe and America who enjoy creating their own colours for a wide variety of textile projects: knitted, woven, embroidered or multimedia and new

There is still an interest in natural dyeing through craft dyers who can emulate some of their forefathers with an experimental approach to dyeing, mixing dyestuffs to see what colours might appear. *Photograph © Susan Kay-Williams*

books are frequently being produced to meet this practical demand.[83] Websites and blogs are alive with people's experiments in trying to create their own colour using natural dyes.[84] For some it is the sheer enjoyment of experiment, while for others such a hobby can develop into a viable business – one such is Shilasdair, based on the Isle of Skye, where Eva Fleg Lambert creates wonderful hanks of naturally hand-dyed wools for knitters.[85] And in Japan there remain a number of National Living Treasures who work in natural indigo, whether for kimono or for individual pieces of art.[86] There are also a growing number of conferences on natural dyestuffs and fibres, mirroring the revival of interest in textile arts such as knitting, sewing and embroidering.[87]

Finally, there is the ultimate in 'full circle' developments; in the spirit of the 21st-century environmental and ecological movements, new ideas are being looked for in the old. In Korea, scientists are testing the *Citrus grandis Osbeck* tree for a bioactive dye which is then impregnated in a knitted cotton fabric to see if citrus extract will improve skin conditions. The citrus lends both colour and what might be called a medicinal quality to the cloth. In tests the dyestuff was used on underwear that was worn next to the skin. But first it was tested for the colourfastness of the dye and for whether the wearer had any negative reactions to the dyed clothing. Then it was tested as to whether there was any relief of symptoms for people with atopic dermatitis when wearing the specially impregnated underwear.

The researchers concluded that it did provide relief of the skin condition when patients wore the cotton underwear dyed with the citrus extract. However, they were disappointed at the colourfastness, which deteriorated after a small number of washes and further work was needed to ascertain how long the medicinal benefits might last. The research is continuing.[88]

Such initiatives, of course, take us back to pre-history when dyestuffs were known as drugs and prized for their medicinal properties as well as their colour.

COLOUR ON DEMAND

So where next for colour? Scientists are developing fabrics that change colour in sun or rain for modern designers to work with,[89] but in many ways this would constitute a fashion rather than a long-term direction. A couple of years ago, a British advert for Dulux paints claimed that if you took a swatch of colour from any source – clothing, postcard, picture – into a paint store, the assistants would be able to mix it for you.

Today stores like Uniqlo, Gap, Benetton and Marks & Spencer are able to offer clothing in a myriad of colours. However, it is always the case that they never have that sweater or cardigan in the colour you really want. Perhaps the ultimate holy grail is being able to purchase a white shirt, cardigan, sweater or dress and have it bespoke-dyed on demand – not printed, not sent away for weeks, but in-store. Today this is just a dream – the antithesis of sustainability: too messy, too wasteful and too impractical – but who knows what might happen next.

NOTES

1. Garfield, Simon *Mauve*, (London: Faber and Faber, 2000), p.8.
2. Travis, Anthony S, *The Rainbow Makers: the Origins of the Synthetic Dyestuff Industry in Western Europe* (Bethlehem: Lehigh University Press, 1993), p.226.
3. Travis, Anthony S, *Colour Chemists* (London: Brent Schools and Industry Project, 1983), p.64.
4. Brunello, Franco, *The Art of Dyeing in the History of Mankind*, tr. Hickey, B (Vicenza: N. Pozza, 1973), pp.302–3.
5. Travis (1983), p.64.
6. From a late 1920s/1930s dyebook from IG Farbenindustrie Aktiengesellschaft for Chrome dyes one of the methods requires 20% Glauber's salt crystals, 4% oxalic acid or 3% sulphuric acid 96% later adding 2–4% chromium fluoride. *The Chrome Dyestuffs*, (Frankfurt: 1G, nd), p.6.
7. This is the same Friedländer who investigated the quantity of molluscs to achieve 1g of pure dye; see chapter one.
8. Cibalan dyes required 1–4% acetic acid 40% or 0.5–2% formic acid 85%, according to depth of shade. Cibalan trade shade card 1950s.
9. Garfield, p.169. As Garfield points out, the centenary of the discovery of mauve was also the year in which Lawrence Herbert established the Pantone company and colour system.
10. Hedayatullah, M, *Les Colorants Synthetiques* (Paris: University Press of France, 1976).
11. Garfield, p.147.
12. Travis (1993), p.219.
13. Galster, Kjeld and Nosch, Marie-Louise, 'Textile History and the Military: An Introduction', *Textile History and the Military*, 41(1) supplement (2010), pp.2–3.
14. Fellow Huddersfield company Read Holliday were certainly asked to work on synthetic khaki.
15. Kraus, J, *Die deutschen Armee im Ersten Weltkrieg: Uniformierung und Ausrüstung: 1914–1918* (Wenen: Militaria Verlag, 2004), pp.12–17.
16. Cited in Pastoureau, Michel, *Blue: The History of a Colour*, (Princeton: Princeton University Press, 1999), p.160.
17. 'Alerte Rouge' exhibition Museé du Louvre, Paris in 2010.
18. Pastoureau, (1999), p.160.
19. Travis (1983), p.92.
20. Garfield, p.148.
21. Morgan, Gilbert (Bradford: SDC, 1934) *Jubilee Edition of the Journal of the Society of Dyers and Colourists*,

The photographer of this picture of a cotton fabric store works for the Society of Dyers and Colorists in India. He entitled it 'Rainbow on my shelf' which fully sums up the ability of dyers today to achieve almost any colour they want, especially on the four classic fabrics: silk, cotton, linen and wool. © *Abhijit Naikdesai | SDC India*

introduction, p.v.
22. Travis (1983), p.89.
23. Names picked at random from some of my dye colour manuals include Chlorazol Fast Red FG 9202K, a dark red; Napthol AS-SWFast Red FG Base, a shocking pink at 0.15g per litre; Kiton Fast Yellow AE, at 4% looks terracotta; Diamond Blue 3B, a dark navy that looks black at 4%. A range of browns, from beige to milk chocolate, were made from combining Kiton Fast Yellow AE, Kiton Fast Red 2 BLE and Alizarine Sapphire Blue 2 G – all of which are impossible to tell from the names.
24. While some of the books contain little more than a recipe and the named colour swatches, the more comprehensive include colour-fastness scales, samples from at least two different percentages of dyestuff, examples of best usage, and even reveal if there may be a problem with evenness of dyeing, such as one from the British Dyestuffs Corporation which informs the reader of possible difficulties of dyeing viscose artificial silk evenly and/or the colours to choose if evenness was critical. (BDC, *Direct Basic, Sulphur and Vat Colours* [1926], p.5.) Furthermore, some contained the text in up to four languages: English, German, French and Spanish; indicative of the world market of dyes.
25. In 1897 J Dépierre published *Traité de la Teinture et de L'impression des Matières Colorantes Artificielles* in three parts. I have a copy of part three, which includes

many printed samples based on blacks and blues including printed cottons, cotton threads, wools and woollen materials coloured with the range of early synthetic colours.

26. Higgins, Sidney Herbert, *The Dyeing Industry in Germany, America and Britain* (Manchester: University of Manchester, 1919), p.79.

27. Higgins, p.80.

28. Higgins, p.96.

29. Higgins, p.73. He further stated that 'the author's experience is that America has not much to teach us as regards the dyeing industry.' p.49.

30. Gardner, Walter M, *Logwood and its Use in Wool-Dyeing* (New York: Matheson, 1892).

31. Rowe, JM (ed.), *The Colour Index* (Bradford: Society of Dyers and Colourists, 1924).

32. Rowe. Indigo has nearly a whole page including Indigo BASF/S.

33. Rowe. This was just one group of the now extensive range of yellows.

34. Rowe, editor's preface.

35. Hoechst and BASF were two of the first German companies to open factories in Britain after the 1907 Patents Act.

36. *Patents for Inventions* (1921).

37. Levinstein Herbert, 'British Patent Laws, Ancient and Modern', *The Journal of the Society of Dyers and Colourists*, Jubilee Edition (1934), p.88.

38. Green, Arthur G, 'Landmarks in the Evolution of the Dyestuff Industry During the Past Half Century', *The Journal of the Society of Dyers and Colourists*, Jubilee edition (1934), p.63.

39. Tuchscherer, JM, 'Colour Consciousness', *Ciba Review* (1973/4), pp.10–12. Tuchscherer describes Delaunay as 'a pioneer of the modern print pattern', p.10.

40. Pastoureau, Michel, *Black: The History of a Colour* (Princeton: Princeton University Press, 2008), p.189.

41. Pritchard, Frances, 'Mariano Fortuny (1871–1949): His Use of Natural Dyes', in Kirby, Jo (ed.), *Dyes in History and Archaeology*, 16/17 (2001), pp.39–42.

42. Taranto, Enrique and Marí, Jorge, *Argentine Textiles* (Buenos Aires: Maizal Editions, 2003), p.35.

43. Downey, Lynn, *Levi Strauss & Co.* (Charleston: Arcadia, 2007), p.62.

44. Downey, p.111.

45. A quick Internet trawl in early 2012 shows the blue blazer will be available for men and women on almost every high street in the UK this year.

46. Personal correspondence with the company (now Novartis), 2011.

47. Ponting, Kenneth G, *A Dictionary of Dyes and Dyeing* (London: Bell & Hyman, 1981), pp.38–41.

48. Personal correspondence with the Worshipful Company of Girdlers.

49. Widmer, W, 'Cibacron Dyes' Special Number, *Ciba Review*, no.120 (1957). Unlike editions before or after, until the end of the decade, this copy of *Ciba Review* was the first one to have colour pictures. More than that, for this special edidition there was both spot colour, based on their lead colour Cibacron Brilliant Yellow 3G, and a full colour chart on black card as part of the 'special'. The chart features four colours for piece dyeing: a darkish red, a mid-grey, a bright green and a dark terracotta brown; then there are eight colours: two yellows, one orange, three reds and two blues and two samples of Cibacron dyes for roller printing. The special edition is introduced not by the company Chairman, but by F. Brichet, a manager in the Sales Department for dyes. He begins by saying, 'The significance of the event justifies this interruption of a tradition by which each issue of *Ciba Review* presents a historical or technical topic, without promotional implications. The discoveries of our research department and the applied work of our dyehouse laboratories are of such consequence to dyers and printers of cellulosic fibres that we feel it our duty to make this new knowledge immediately and widely known by means of our periodicals.' p.2.

50. I am particularly indebted to the National Art Library at the Victoria and Albert Museum for allowing me to look at the series as a whole to track its development.

51. Van Hattem, Mark and Pool, Mariska, 'The Monotonousness of this Grey Uniform', *Textile History*, vol.41 (1), supplement (2010), p.78.

52. *Jubilee 1900–1950* (Bradford: The British Cotton and Wool Dyers Association, 1950), p.14.

53. Rowe, p.iii.

54. *Jubilee*, p.14.

55. *Shocking: the Art and Fashion of Elsa Schiaparelli* exhibition at Philadelphia Museum of Art, Philadelphia (September 2003–January 2004).

56. Appropriately, this edition of the *Ciba Review*, no.96, February 1953, focused on velvet, the fabric from which Queen Elizabeth's 18 foot long coronation train was made. It was woven by Warners, designed and embroidered by the Royal School of Needlework and edged with ermine by Ede and Ravenscroft. The advert for the special colours on p.3444 was opposite an article on the technical aspects of how velvet was made and followed a double-page spread entitled 'The Return of Velvet' featuring models in the latest fashions, a major departure for the *Review*. (The order of and topics covered by the editions was extremely eclectic. While the series began with 'Medieval Dyeing' and 'Purple' was number four, 'Madder' was not featured until issue 39 and 'Indigo' not until issue 85, while 'Umbrellas' was issue 42.)

57. Developed by Charles Cross, Edward Bevans and Clayton Beadle.

58. BDC (1926), p.3.

59. Nylon became Du Pont's most important discovery economically, see http://corporatewatch.org/?lid=202, 'History and Strategy'.

60. See www.Inventors.about.com, accessed 28 December 2011; discussion with dyeing consultant.

61. *Jubilee*, p.32.

62. Many of the dye colour books have whole sections on colours' fastness to washing, water, light, scrooping (a particular technique to make synthetic fabrics feel and behave more like silk) and chlorine, e.g. BDC (1926) pp.22–3.

63. Oh, SW, Kang, MN, Cho, CW, and Lee, MW, 'Detection of Carcinogenic Amines from Dyestuffs or Dyed Substrates', *Dyes and Pigments*, vol.33, no.2 (1997), p.120.

64. Personal communication with dyeing consultant 2012.

65. NIIR/NPCS (2011) *Dye and pigment intermediates, acid dyes, basic dyes and dye intermediates report* www.niir.org/pigment/pigments/dye ; see also www.chemicals.nic.in

66. Business Wire 2007, *China Dyestuff Industry Report 2007–8* (10 October 2007), available at www.businesswire.researchandmarkets.com/reportsc71113, retrieved 31 December 2011.

67. Lacasse, Katia and Baumann, Werner, *Textile Chemicals: Environmental Data and Facts* (Berlin: Springer, 2004).

68. For example, Airdye™ is one company pioneering this techonology.

69. Personal communication with dyeing consultant 2012. I have seen examples of correct and incorrect dyeing and it can make a staggering difference.

70. Yuan, Jiugang, Wang, Qiang, Fan, Xuerong and Wang, Ping, 'Enhancing Dye Absorption of Wool Fibers with Ionic Liquid Processing', *Textile Research Journal* vol.80, no.18 (Nov 2010), pp.1898–904.

71. Patterson, Phil, 'Report Gives Brands Toxic Shock', *Ecotextile News* (Oct/Nov 2011). The Greenpeace report is called *Dirty Laundry*. Since the report a number of companies such as Nike, PUMA, adidas, C&A, H&M Li Ning and G-Star have joined a campaign called the 'Joint Roadmap: Toward Zero Discharge of Chemicals' (listed in *Textiles*, issue 1 (2012) p.21.

72. Personal discussion with dyeing consultant working on Olympic clothing for volunteers and officials.

73. Personal discussion with dyeing consultant.

74. Scully, Kate and Johnston Cobb, Debra, 'Colour Forecasting: Science, Art or Magic Wand?', *Textiles* issue 1 (2012), pp.8–10.

75. Pressman, Laurie, vice president of Pantone's fashion, home and interiors division in a message to www.apparelinsiders.com (2012).

76. Michelle Lamb, www.thetrendcurve.com.

77. Scully and Johnston Cobb, p.9.

78. Balfour-Paul, Jenny, *Indigo*, (London: British Museum Press, 1999), p.87.

79. Chenciner, p.15.

80. The Rameses Wissa Wassef Art Centre near Cairo was started in 1941 as an 'after school club' and has been called 'an experiment in creativity'. Exhibition catalogue *Egyptian Landscapes* (London: 2006).

81. For example, Alain Rouveure who has rugs manufatured in Tibet and sells them in the Cotswolds, UK.

82. Personal discussion with Adam Gilchrist founder, of the large-scale bespoke carpet maker Veedon Fleece, where evenness of colour requirements rule out the use of natural dyes.

83. Fereday, Gwen, *Natural Dyes* (London: British Museum, 2003); Dean, Jenny, *The Craft of Natural Dyeing* (Tunbridge Wells: Search Press, 1994); Crook, Jackie, *Natural Dyeing* (London: Gaia Books, 2007); Rudkin, Linda, *Natural Dyes* (London: A & C Black, 2007); and van Stralen, Trudy, *Indigo, Madder and Marigold* (Colorado: Interweave Press, 1993) are just a selection

84. Online Guild of Weavers, Spinners and Dyers (www.onlineguildwsd.org.uk); Community of Dyers (www.pburch.net); are just a couple of examples.

85. I was fortunate to visit Eva at her home in Skye several years ago, and have never forgotten her wonderful dyeing outhouse.

86. In 2006 I was fortunate to visit a master indigo dyer in his traditional Kyoto house and studio where the indigo vats were half buried in the classic manner.

87. A website search will reveal a number of conferences around the world focusing on natural dyeing today, and many more looking at the historical aspects (e.g. 'Dyes in History and Archaeology' annual conferences).

88. Yi, Eunjou and Yoo, Eun Sook, 'A novel bioactive fabric dyed with unripe *Citrus grandis Osbeck* extract', *Textile Research Journal*, vol.80, issue 20, Dec 2010, pt.1 pp.2117–23; pt.2 pp.2124–31.

89. Masters degree students from Chelsea College of Art (part of the University of the Arts London) have experimented with these fabrics for umbrellas and raincoats, where the colours change according to rain or sun.

BIBLIOGRAPHY

Abrahams D.H., S.M. Edelstein, 'A study of the textiles from the colour standpoint' in Y. Yadin, *The Finds from the Bar-Kokhba Period in the Cavers of Letters (Judean Desert Studies)*, (Jerusalem: Israel Exploration Society, 1963), pp.270–279.

Albers, Joseph, *Interaction of Colour*, revised edn, (New Haven: Yale University Press, 2006).

Albo, M., *Instructions générale pour la teinture des laines et manufactures de laine de toutes couleurs et pour la culture des drogues ou ingredients qu'on y employe*, (Paris: Vve de F Muguet, 1671).

Alexis of Piedmont, *A Little Book of Household Management (Venice: 1555)*.

Allgrove McDowell, Joan, 'The Mediterranean' in Jennifer Harris (ed), *5000 Years of Textiles*, (London: British Museum Press, 1993).

Allgrove McDowell, Joan, 'Ancient Egypt 5000–300BC' in David Jenkins (ed), *The Cambridge History of Western Textiles*, (Cambridge: Cambridge University Press, 2003).

Andres, G.M., J. Hunisak & T. Richard, *The Art of Florence*, (New York: Artabras, 1999).

Anonymous, *The Art of Dying Wool, Silk and Cotton*, (London, 1789).

Arduino, P., *Memorie di osservazioni: e di sperienze sopra la colutra, e gli usi di varie piante che servono, o che server possono utilmente alla tintura, all'economia all'agricoltura*, (Padua, 1766).

Arnold, Janet, *Queen Elizabeth's Wardrobe Unlock'd: The Inventories of the Wardrobe of Robes Prepared July 1600*, (Leeds: Maney, 1988).

Ashelford, Jane, *The Art of Dress: Clothes and Society 1500 – 1914*, (London: National Trust, 1996).

Aughton, Peter, *Voyages that Changed the World* (London: Quercus, 2007).

Baker, Rosemary M., 'Patents as a source of information about synthetic textile dyes', *Meeting of Dyes in History and Archaeology*, at the Victoria & Albert Museum, London: [conference paper], 2009, p 129.

Balfour Paul, Jenny, *Indigo*, (London: British Museum Press, 1999).

Ball, Philip, *Bright Earth: The Invention of Colour*, (London: Viking, 2001).

Bancroft, Edward, *Experimental Researches Concerning The Philosophy of Permanent Colours and The Best Means Of Producing Them*, (London: Cadell, 1794).

Barnard, Mary, Dudley Fitts, *Sappho: A New Translation*, (California:University of California, 1999).

Batchelor, David, *Chromophobia*, (London: Reaktion Books, 2000).

de Beauvais, Raseau, *L'art de l'indigotier*, (Paris: L.F. Delatour, 1770).

Beltrán de Heredia Bercero, J., 'Los restos arqueológicos de una *fullonica* y de una *tinctoria* en la colonia Romana de *Barcino* (Barcelona, Complutum, 11, 2000), pp.253–259

Beltrán de Heredia Bercero, J., Jordi y Tresserras, 'Nuevas aportaciones para el studio de las *fullonicae* y *tinctoriae* en el mundo romano in Archéologie des textiles des origins au Ve siècle' in D. Cardon, M. Feugère (eds), *Archéologie des Textiles des origines au Ve siècle*, (Montagnac: Editions Monique Mergoil, 1999), pp 241–246.

Bemiss, Elijah, *The Dyer's Companion*, 3rd edn, (New York: Dover Publications, 1973).

Bender Jørgensen, Lise, 'Europe' in David Jenkins (ed), *The Cambridge History of Western Textiles*, (Cambridge: Cambridge University Press, 2003).

Bender Jørgensen, Lise, 'Northern Europe in the Roman Iron Age 1 BC to 400 AD' in David Jenkins (ed), *The Cambridge History of Western Textiles*, (Cambridge: Cambridge University Press, 2003).

Berlin B., and P. Kay, *Basic Colour Terms: Their Universality and Evolution*, (Stanford CSLI Publications, 1999).

Berthollet, Claude Louis, *Éléments de l'art de la teinture*, 2nd edn, (Paris: Firmin Didot, 1804).

Berthollet, Claude Louis, tr. W Hamilton, *Elements of the Art of Dyeing*, vols.1–2, (London: Couchman /Johnson, 1791).

Berthollet Claude Louis, *Description du blanchiment des toiles et des fils par L'acide muriatique oxigéné*, (Montana, USA: Kessinger Publishing, 1795).

Best, Susan Marie, 'Japan' in Jennifer Harris (ed), *5000 Years of Textiles*, (London: British Museum Press,1993).

Bhardwaj, H.C. Kamal K. Jain, (1982) 'Indian Dyes and Dyeing Industry During the 18th–19th century', *Indian Journal of History of Science*, vol.17, no.1, 1982, pp.70-81.

Birch, T., *History of the Royal Society of London For Improving Of Natural Knowledge from its First Rise*, (London: A Millar, 1756).

Bird W., 'Medieval Dyeing', *Ciba Review*, vol.1, 1937.

Blum, Dilys, *Shocking: The Art and Fashion of Elsa Schiaparelli*, (New Haven: Yale University Press, 2003).

Bomford, David, Ashok Roy, *A Closer Look: Colour*, (National Gallery London), (London: Yale University Press, 2009).

Born, Wolfgang, 'Purple', *Ciba Review*, vol.4, 1937.

Born, Wolfgang, 'Scarlet', *Ciba Review*, vol.7, 1938.

Boutell, Charles, *English Heraldry*, 10th edn, (London: Reeves & Turner, 1908).

Bradley, W, 'Perkin', *Ciba Review*, vol.115, 1956.

Brock, William H., *The Case of the Poisonous Socks*, (London: Royal Society of Chemistry, 2011).

Browne, Clare, (2010) 'The influence of the Cartoons on sixteenth century tapestry design' in M. Evans, C. Browne, with A. Nesselrath, *Raphael Cartoons and Tapestries for the Sistine Chapel*, (London: V&A Publishing, 2010), pp.44–47.

Brunello, Franco, *The Art of Dyeing in the History of Mankind*, tr. B. Hickey, (Vicenza, Italia: Neri Pozza Editore, 1973).

Buchanan, Rita, *A Dyer's Garden: From Plant to Pot Growing Dyes for Natural Fibres*, Loveland, CO, USA: Interweave, 1995).

Buc'hoz, Pierre, *Traité des Plantes qui servent à la teinture et à la peinture* (Paris: Vve Valade, 1785).

Bucklow, Spike, *The Alchemy of Paint*, (London: Marion Boyars, 2009).

Burani, Gioachin, *Trattato dell'arte Tintura*, (Venice, Italy, 1794).

Butler Greenfield, Amy, *A Perfect Red*, (New York: Black Swan Press, 2008).

Campbell, Thomas, 'Tapestry' in, Jennifer Harris, *5000 Years of Textiles*, (London: British Museum Press, 1993).

Cannon, John and Margaret, *Dye Plants and Dyeing*, (London:

Herbert Press/RBG Kew, 1994).

Cardon, Dominique, *Natural Dyes: Sources, Tradition Technology and Science*, (London: Archetype Publications, 2007).

Carman, WY, *British Military Uniforms from Contemporary Pictures*, London: Hamlyn, 1968).

Cassell's, *The International Exhibition of 1862*, (London: Cassell, Petter & Galpin 1862).

Cassell's, *Cassell's Illustrated Family Paper*, (London: Cassell, Petter & Galpin, 1862).

Cennini, Cennino, *The Craftsman's Handbook*, tr. D.V. Thompson, (New York: Dover Publications, 1960).

Chaptal, J.A.C., *L'art de la teinture du cotton en rouge*, (Paris: Deterville, 1807).

Chassagne, Serge, 'Calico Printing in Europe before 1780' in David Jenkins (ed), *The Cambridge History of Western Textiles*, (Cambridge: Cambridge University Press, 2003).

Chateau, Theodore , *Étude historique et chimique pour server à l'histoire de la fabrication du rouge Turc ou d'Andrinople et à la théorie de cette teinture*, (Paris, 1876).

Chenciner, Robert, *Madder Red: A History of Luxury and Trade*, (Richmond: Curzon, 2000).

Chevalier, Medieval Dyeing *Ciba Review*, vol.1, 1937.

Chevreul, Michel Eugène, *Cercles chromatiques: exposé d'un moyen de definer et denommer les couleurs d'après une method precise et experimentale, avec l'application de ce moyen à la definition et a la denomination des couleurs d'un grand nombre de corpe naturels et de produits artificiele*, (Paris: Firmin Didot, 1861).

Chevreul, M.E., *The Laws of Contrast of Colour and their Application to the Arts*, tr. John Spanton, (London: Routledge, Warnes & Routledge, 1859).

Chevreul, M.E., *The Principles of Harmony and Contrast of Colours; and their Applications to the Arts*, tr. C Martel, (London: Longman, Brown, Green and Longman, 1855).

Chevreul, M.E., *Contraste simultane des couleurs*, (Paris: 1865).

Ciba Review, 162 editions, (Basle: Ciba, later Ciba Geigy, 1937–1975).

Cooksey, Christopher J., Alan T. Dronsfield, 'Adolf von Baeyer and the Indigo Molecule' in *Dyes in History and Archaeology*, vol.18, 2002, pp.13–20.

Cooksey, Christopher J., Alan T. Dronsfield, 'Pre-Perkin Synthetic Routes to Purple' in *Dyes in History and Archaeology*, vol.19 2003, pp.118–135.

Cooksey, Christopher J.,Alan T. Dronsfield, 'It Happened by Chance: the Discovery of Malachite Green' in *Dyes in History and Archaeology*, vol.20, 2005, pp.165–175.

Cooper, Thomas, *A Practical Treatise on Dyeing and Callicoe Printing*, (Philadelphia: Thomas Dobson, 1815).

Cotton, GEL, *Bishop Cotton's View on the Nil Darpan Question*, (Calcutta: Calcutta Christian Intelligencer, 1861).

Crook, Jackie, *Natural Dyeing*, (London: Gaia books, 2007).

D. C., 'Dress habits of the Italian Renaissance', *Ciba Review*, vol.17, 1939, pp.611–615.

Davidson H., 'Dressing the Spanish Way: prestige and usage of Spanish attire at the European Court', *Textile History*, vol.39, no.1, 2008, pp.111113.

Dean, Jenny, *Colours from Nature: A Dyer's Handbook*, (Tundbridge Wells: Search Press Ltd,2007).

Dean, Jenny, *The Craft of Natural Dyeing: Glowing Colours from the Plant World*, (Tunbridge Wells: Search Press Ltd, 1994).

Dean, Jenny, *Wild Colour: How To Grow, Prepare and Use Natural Plant Dyes*, (London:Mitchell Beazley, 1999).

Delahaye, Elisabeth, *The Lady and the Unicorn*, (Paris: RMN, 2007).

Delamere, François, Bernard Guineau, *Colour: Making and Using Dyes and Pigments*, (London: Thames and Hudson, 2000).

Delvin, Samuel, *Dyes and Pigments*, (Delhi: Ivy Publishing House, 2006).

Dépierre, J., *Traité de la Teinture et de l'impression des matières colorants artificielles: troisième partie noir d'aniline indigo-divers*, (Paris, Baudry & Cie, 1893).

Deruisseau L.G., 'Dress Fashions of the Italian Renaissance', *Ciba Review*, vol.17, 1939.

Downey Lynn, *Levi Strauss & Co*, (Charleston: Arcadia, 2007).

Du Fay, *Instruction Générale*, (Paris, 1937).

Du Fay, 'Observations de quelques couleurs dans la teinture' (1737) in L'institue de France, *Mémoires de l'Academie des Sciences*, (Firmin-Didot: Paris, 1904).

Du Hamel du Monceau, *Traité de la Garance et de sa culture*, (Paris, 1765).

Duke, Dee, Rowena Edlin-White, *The Medieval Dye Pot*, (Nottingham: Woolgatherers, 2001).

Dumas, Jean-Baptiste, *Précis de l'art de la teinture*, (Paris: Young Bechet, 1846).

Dupré-Lasala, Auguste, *Traité de Fabrication et de teinture des draps pour l'armée Française*, (Paris, 1829).

Dwivedi, B., 'The Bazar Dyer: Embroidery in India', *Ciba Geigy Review*, no.3, 1972, pp.20–26.

Edelstein, S., tr. M. Sidney & Hector C. Borghetty, *The Plictho of Gloanventura Rosetti: Instructions in The Arts of the Dyers which Teaches the Dyeing of Woollen Cloths, Linens, Cottons and Silk by the Great Art as well as by the Common* (Cambridge, Mass., USA: MIT Press, 1969)

Edmonds, John, *The History and Practice of Eighteenth Century Dyeing*, (Little Chalfont: John Edmonds, 1999).

Edmonds, John, *The History of Woad and the Medieval Woad Vat*, (Little Chalfont: John Edmonds, 2000).

Edmonds, John, *Tyrian or Imperial Purple Dye*, (Little Chalfont: John Edmonds, 2000).

Edwards, Tim, *Fashion in Focus* (London: Routledge, 2011).

Escudier, Denis, 'Documents sur les metiers de la teinturerie à Orleans (XVIIe et XVIIIe siècles)' in *Pigments et colorants de l'antiquitè et du Moyen Age*, (Paris: CNRS, 1990).

Evans, Grace, *Fashion in Focus*, (Chertsey: Chertsey Museum, 2011).

Evans, Mark, 'The Commission and the Cartoons' in C. Browne & M. Evans, with Arnold Nesselrath, *Raphael Cartoons and Tapestries for the Sistine Chapel*, (London: V&A Publishing, 2010), pp.18–20.

Evans, Mark, Clare Browne, with Arnold Nesselrath, *Raphael Cartoons and Tapestries for the Sistine Chapel*, (London: V&A Publishing, 2010).

Eve, G.W., *Decorative Heraldry: A Practical Handbook of its Artistic Treatment* (1897), (London: BiblioBazaar, 2010).

Faber, G., 'Dyeing and Tanning in Classical Antiquity', *Ciba Review*, vol.9, 1938, pp.283–286.

Fau, A., *Histoire des tissus en France*, (France: Ouest-France, 2010.)

Fereday, Gwen, *Natural Dyes*, (London: British Museum Press, 2003).

Fields, John A., 'Analysis of Dyes on Jordanian Textiles from Khirbet

Qazone' in *Dyes in History and Archaeology*, vol.19. pp.94–99.

Finlay, Victoria, *Colour: Travels Through the Paintbox*, (London: Sceptre, 2002).

Fourer C., M. Vasser, *Petites histoires de la couleur et du travail du Moyen Age a nos jours*, (Paris: Somogy, 2004).

Fraser, Jean, *Traditional Scottish Dyes and How to Make Them*, (Edinburgh: Canongate, 1988).

Fereday, Gwen, *Natural Dyes*, (London: British Museum Press, 2003).

Flinders Petrie, W.M., *Arts and Crafts of Ancient Egypt*, (London: T.N. Foulis, 1910).

Flinders Petrie, W.M., *Athribis*, (London: School of Archaelogy in Egypt, 1908).

Gage, John, *Colour and Culture*, (London: Thames and Hudson, 1993).

Gage, John, *Colour and Meaning*, (London: Thames and Hudson, 1999).

Galster, Kjeld, Maire-Louise Nosch, 'Textile History and the Military: An introduction', *Textile History and the Military*, vol.41, no.1, [supplement], 2010, pp.1–5.

Gardiner Davenport, Frances, *European Treaties Bearing on the history of the United States and its Dependencies*, (Washington D.C., USA: Carnegie Institute of Washington,1917).

Gardner, Walter M., *Logwood and its use in Wool-dyeing*, (New York: Wm J. Matheson,1892).

Garfield, Simon, *Mauve*, (London: Faber & Faber, 2000).

Geijer, Agnes, *A History of Textile Art*, (London: Philip Wilson Publishers, 1979).

Ginsburg Madeleine, *The Illustrated History of Textiles*, (London: Studio Editions, 1991).

Goethe, J.W., *Theory of Colours (1840)*, tr. C.L. Eastlake (1970), (Cambridge, Mass., USA: MIT Press).

Goethe, J.W., *The Sorrows of Young Werther*, (London: Penguin Classics, 1989).

Golikov, Valery, 'The Technology of Silk Dyeing by Cochineal II The Experimental Investigation of the Influences of Types and Concentrations of Cations' in J. Kirby (ed), *Dyes in History and Archaeology* 16/17, (London: Archetype Publications, 2001), pp.10–20

Gordon, W.J., *Flags of the World Past and Present: Their Story and Associations*, (London: Frederick Warne, 1915) .

Grierson, Su, *The Colour Cauldron: History and Use of Natural Dyes in Scotland*, (Perth, Scotland: Su Grierson, 1989).

Gutman, A.L., 'Cloth making in Flanders', *Ciba Review*, vol.14, 1938.

Guy, John, *Woven Cargoes: Indian Textiles in the East*, (London: Thames and Hudson, 1998).

Hali Rug Guide, (London: Hali Publications, 1996).

Hall, Margaret, 'India and Pakistan, Historical Development and Trade' in Jennifer Harris, *5000 Years of Textiles*, (London: British Museum Press, 1993).

Haller, R., 'The production of Indigo' *Indigo Ciba Review*, vol.85, 1950, pp.3072–3075.

Hardman, Judy, Sally Pinhey, *Natural Dyes*, (Marlborough: The Crowood Press, 2009).

Hardiman, J.P., *Silk in Burma*, (Burma: Rangoon Government Printing,1901).

Harris, Jennifer, *5000 Years of Textiles*, (London: British Museum Press, 1993).

Hayward, Maria, *Dress at the Court of King Henry VIII*, (Leeds: Maney Publishing, 2007).

Hayward, Maria, *Rich Apparel: Clothing and the Law in Henry VIII's England*, (Farnham: Ashgate, 2009).

Hedayatullah, M., *Les colorants synthetiques*, (Paris: University Press of France, 1976).

Hellot, Jean, *L'art de la teinture des laines et des étoffes de laine*, (Paris: Widow Pissot, 1750).

Helmecke, Gisela, 'Textile for the interiors: some remarks on curtains in the written sources' in De Moor, Fluck, *Clothing the House*, (Tielt: Lannoo Publishing, 2010).

Hicks, Carola, *Girl in a Green Gown: the History and Mystery of the Arnolfini Portrait*, (London: Chatto and Windus, 2011).

Higgins, Sidney Herbert, *The Dyeing Industry in Germany, America and Britain*, (Manchester: University of Manchester, 1919).

Hofenk de Graaff, H. Judith, *The Colourful Past: Origins, Chemistry and Identification of Natural Dyestuffs*, (London: Archetype Publications, 2004).

Hofmann-de Keijzer, Regina; Maarten R. van Bommel, 'Dyestuff analysis of two textile fragments from late antiquity', *Dyes in History and Archaeology*, vol.21, 2008, pp.17–25.

Hoggart, Norton, Trist, *A catalogue of the highly important and by far the greater portion of the valuable and interesting collection as exhibited by the Honourable the East India Company at the Great Exhibition in 1851 which will be sold by auction by Messrs Hoggart, Norton, & Trist Monday the 7th day of June, 1852 Monday the 28th day of June, 1852* (London: Hoggart, Norton and Trist, 1852).

Hollander, Anne, *Fabric of vision: Dress and Drapery in Painting*, (National Gallery London), (London: National Gallery, 2002).

Hooper, Geoff, Rouveure Alain, 'Tibetan Rugs in Exile', *Warp and Weft*, vol.227, 2007.

Hopkins, David, *The Art of the Dyer 1500–1700*, (Bristol: Stuart Press, 2000).

Huebner, J., 'Early History of Dyeing', in Rowe & Clayton (eds), *The Jubilee Edition of the Journal of the Society of Dyers and Colourists*, (Bradford: SDC, 1934) pp.1–6.

Hudson, Derek ,Kenneth W. Luckhurst, *The Royal Society of Arts 1754–1954*, (London: John Murray, 1954).

Hunt, Robert, 'The Science of the Exhibition', *The Illustrated Catalogue of the Great Exhibition*, vol.1, (London: Spicer Brothers, 1851).

Irwin, John, 'Indian Textile Trade in the Seventeenth Century', *Journal of Indian Textile History*, vol.1, 1955.

Itten, Johannes, *The Elements of Colour*, (New York: Van Nostrand Reinhold, 1970).

Jacqué, Jacqueline, *Andrinople: le rouge magnifique*, (Paris: La Martinière, 1995).

Jenkins, David (ed), *The Cambridge History of Western Textiles*, (Cambridge: Cambridge University Press, 2003).

Joosten, Ineke, Maarten R. van Bommel, Regina Hofmann-de Keijzer, Hans Reschreiter, 'Micro Analysis on Hallstatt Textiles', Eu ARTECH, 2011, www.eu-artech.org/files/Ext_ab/Joosten.pdf

Journal of Indian Textile History, (Ahmedabad: Calico Museum of Textiles)vol.1, no.1, 1955..

Juvet-Michel, A. 'Pile Carpets of the Ancient Orient', *Ciba Review*, vol.15, 1938.

Kay-Williams, Susan, 'Adventures of a Novice Dyer', *Journal of Weavers Spinners and Dyers*, vol.4, 1998.

Kennedy, Alan, *Japanese Costume: History and Tradition*, (London: Greenwich Editions, 1994).

Kerr, Robert, 'Essay on a new method of bleaching by means of oxygenated muriatic acid from the French of Berthollet', (Edinburgh, 1790).

Khadi workers' woes, *Textile dyer and printer*, vol.30, no.4, 1997.

Khalili N.D., *Visions of Splendour in Islamic Art and Culture*, (London: Thames and Hudson, 2008).

King, Brenda, *Silk and Empire*, (Manchester: Manchester University Press, 2005).

King, Brenda, 'Full Circle: India Leek India', *Journal of Weavers Spinners and Dyers*, 2011.

Kirby, J., (ed) *Dyes in History and Archaeology*, vol.16/17, (London: Archetype Publications, 2001).

Kirby, J., (ed) *Dyes in History and Archaeology*, vol.18, (London: Archetype Publications, 2002).

Kirby, J., (ed) *Dyes in History and Archaeology*, vol.19, (London: Archetype Publications, 2003).

Kirby, J., (ed) *Dyes in History and Archaeology*, vol.20, (London: Archetype Publications, 2005).

Kirby, J., (ed) *Dyes in History and Archaeology*, vol.21, (London: Archetype Publications, 2008).

Kling, Blair Bernard, *The Blue Mutiny: The Indigo Disturbances in Bengal 1859–1862*, (Philadelphia: University of Philadelphia Press, 1966).

Koren, Zvi C., 'A successful Talmudic-Flavoured HPLC analysis of Carthamin from Red Safflower Dyeings', *Dyes in History and Archaeology*, vol.16/17, 2001, pp.158–166.

Kraus, J., *Die deutschen Armee im Ersten Weltkrieg: Uniformierung und AusrÐstung -1914–1918*, (Wenen: Militaria Verlag, 2004), pp.12–17

Kumar, Ritu, *Costumes and Textiles of Royal India*, (Woodbridge: Suffolk Antique Collectors' Club, 2006).

Layne Martin, Eliza, unpublished PhD extract, *Eliza Lucas Pinckney: Indigo in the Atlantic World*

Leggett, W.F. *Ancient and Medieval Dyes (1944)*, (London: Coachwhip Publications, 2009).

Leix, Alfred, 'Medieval Dyeing', *Ciba Review*, vol.1, (1937), pp.11–14.

Leix, Alfred, 'India, its dyers and its colour symbolism', *Ciba Review*, vol.2, 1937.

Leix Alfred, 'Trade Routes and Dye Markets in the Middle Ages', *Ciba Review*, vol.10, 1938.

Leix, Alfred, 'Dyeing in Flanders', *Ciba Review*, vol.14, 1938, pp.485–7.

Levey, Michael, *The World of Ottoman Art*, (London: Thâmes and Hudson, 1975).

Levinstein, H., 'British Patent Laws – Ancient and Modern', *The Jubilee Edition of the Journal of the Society of Dyers and Colourists*, Bradford, SDC, 1934, pp.83–89.

Liles, J.N., *The Art and Craft of Natural Dyeing*, (Knoxville: University of Tennessee Press, 1990).

Macquer, P.J., *Art de la Teinture en Soie*, (Paris, 1763).

Mairet, Ethel, *Vegetable Dyes*, (London: Faber & Faber, 1944).

Marchant, Leslie Ronald, *The Papal Line of Demarcation and its Impact in the Eastern Hemisphere on the Political Division of Australia, 1479–1829*, (Greenwood, Western Australia: Woodside Valley Foundation, 2008).

Mayer Thurman, Christa C., *Textiles*, (Chicago: Art Institute of Chicago, 1992).

McDowell, Lola, Ptolemy Mann, 'The Dynamics of Colour, Architecture and Woven Textile Art', *Warp and Weft*, vol.226, 2007.

Merrifield (Mrs.), 'The harmony of colours as exemplified in the exhibition', *The Official Illustrated Catalogue of the Great Exhibition*, (London: Spicer Brothers, 1851).

Miller, Philip, *The Method of Cultivating Madder as it is now practised by the Dutch in Zealand*, (London,1758).

Mitra, Dinabandhu, *A Nil Darpan: The Indigo Planting Mirror*, tr. Richard Long, (Calcutta: Calcutta Publishing and Printing Press,1861).

Mola, Luca, *The Silk Industry of Renaissance Venice*, (Baltimore: Johns Hopkins University Press, 2000)

Monnas, Lisa, 'Italian Silks 1300–1500' in Jennifer Harris, *5000 Years of Textiles*, (London: British Museum, Press, 1999).

Monnas, Lisa, *Merchants, Princes and Painters*, (New Haven: Yale University Press, 2008).

Morris, Barbara, *The History of English Embroidery*, (London: HMSO, 1951).

Munro, John H., 'Medieval Woollens Textiles, Technology and Organisation' in David Jenkins (ed), *The Cambridge History of Western Textiles*, (Cambridge: Cambridge University Press, 2003).

Muthesius, Anna, 'Byzantine Silks' in Jennifer Harris (ed), *5000 years of Textiles*, (London: British Museum Press, 1993).

Muthesius, Anna, 'Silk in the Medieval World' in David Jenkins (ed), *The Cambridge History of Western Textiles*, (Cambridge: Cambridge University Press, 2003).

Nalson, David, *The Victorian Soldier*, (Oxford: Shire Publications, 2010).

Neuburger, 'Trade Routes and Dye Markets in the Middle Ages', *Ciba Review*, vol.10, 1938.

Nieto-Galan, A., *Colouring Textiles: A History of Natural Dyestuffs in Industrial Europe*, (Dordrecht: Kluver Academic Publishers, 2001).

Norwich, John Julius, *The Popes: A History*, (London: Chatto & Windus, 2011).

Nowik, Witold,'The Possibility of Differentiation of Red and Blue 'Soluble' dyewoods: determination of species used in dyeing and chemistry of their dyestuffs', J. Kirby (ed), *Dyes in History and Archaeology* 16/17, 2001, pp.129–144.

Oh, S., M. Kang, C. Cho & M. Lee, 'Detection of Carcinogenic Amines from Dyestuffs or Dyed Substrates', *Dyes and Pigments*, vol.33, no.2, 1997, pp.119–135.

O'Brien, C., *A Treatise on Calico Printing, Theoretical and Practical*, (London, 1792).

O'Neill, Charles, *Dictionary of Dyeing and Calico Printing (1862)*, (New Delhi,:Cosimo Publications, 2008).

Parry, Linda, *William Morris*, (London: Philip Wilson Publishers, 1997).

Partridge, William, *A Practical treatise on dying of woollen, cotton and skein silk with the manufacture of broadcloth and cassimere including the most improved methods in the West of England* (technical notes by KG Ponting) (Edington Wilts: Pasold Research Fund Ltd, 1823 facsimile, 1973).

Pastoureau, Michel, *The Devil's Cloth: a History of Stripes and Striped Fabric*, (New York: Columbia University press, 1991).

Pastoureau, Michel, *Heraldry: Its Origins and Meaning*, (London: Thames and Hudson, 1997).

Pastoureau, Michel, *Blue: The History of a Colour*, (New York: Princeton University Press, 1999).

Pastoureau, Michel, *Petites histories de la couleur*, (Paris, 2004.)

Pastoureau, Michel, *Black: The History of a Colour*, (New York: Princeton University Press, 2008).

Pastoureau, Michel , Dominique Simonnet, *Le Petit livre des couleurs*, (Paris: Editions du Panama, 2005)

Patent Office, *Patents for inventions 1617–1876 vol.14 in Bleaching, Dyeing and Printing Calico and other Fabrics and Yarns* (London: HMSO, 1865).

Patent Office, *Patents for Inventions: Abridgements of specifications Class 2(iii) Dyes and Hydrocarbons and heterocyclic compounds and their substitution derivatives*, (London: HMSO, 1921).

Petty, Sir William, 'An Apparatus to the History of the Common Practices in Dying' in Thomas Sprat, (London: *The History of the Royal Society*, 1667), pp.284–306.

Petzold, Andreas, 'The Dawn of the Modern Era 1550–1780' in Madeleine Ginsburg, *The Illustrated History of Textiles*, (London: Studio Editions, 1991).

Phillips, Barty, *Tapestry*, (London: Phaidon, 1994).

Philips, Clare, 'The earliest times to 1550' in Madeleine Ginsburg, *The Illustrated History of Textiles*, (London: Studio Editions, 1991).

Phipps, Elena, *Cochineal Red: The Art History of a Colour*, (New Haven, Yale University Press, 2010).

Le Pileur d'Apligny, *Essai sur les moyens de perfectionner l'art de la teinture et observations sur quelques matières qui y sont propres*, (Paris, 1773).

Pliny the Elder, tr. H. Rackham, *Natural History with an English Translation*, (Cambridge, MA, USA: Harvard University Press, 1979).

Ponting, Kenneth G., *A Dictionary of Dyes and Dyeing*, (London: Bell & Hyman, 1981).

Ponting, Kenneth G., *Discovering Textile History and Design*, (London: Shire Publications, 1981).

Pritchard, Frances, 'Mariano Fortuny (1871–1949): His use of natural dyes', *Dyes in History and Archaeology* 16/17, vol.39-42, (London: Archetype Press, 2001).

Privat-Savigny, Maria-Anne, Pascale Le Cacheux, Hélène Chivaley, Clémence Ronze, *Les prémices de la mondialisataion: Lyon rencontre la Chine au 19e siècle* (Lyon: EMCC, 2009).

Reinhardt, C., Anthony S. Travis, *Heinrich Caro and the Creation of the Modern Chemical Industry*, (Kluwer, Dordrecht: Kluwer Academic Publishers, 2000).

Reininger, Walter, 'Textile Trades of Medieval Florence', *Ciba Review*, vol.27, 1939).

Robinson, Stuart, *A History of Dyed Textiles*, (London: Studio Vista, 1969).

Roland de la Platière, Jean-Marie, *L'art de preparer et d'imprimer les étoffes en laines, suivi de l'art defabriquer les panes ou peluche, les velours façon d'Utrecht et les moquettes*, (Paris: de Moutard, 1780).

Rosetti, Giovanventura, *Plictho de l'arte de tentori che insegna tenger pani telle banbasi et sede si per larthe magiore come per la commune*, (Venice: Augustino Bindoni, 1548).

Rosetti, Giovanventura, *Plictho de l'arte de tentori che insegna tenger pani telle banbasi et sede si per larthe magiore come per la commune*, (Venice: Francesco Rampazetto, 1540/60).

Rowe, F.M., *Colour Index*, (Bradford: Society of Dyers and Colourists). (1924)

Rowe, F. M., E. Clayton (eds), *The Jubilee Issue of the Journal of the Society of Dyers and Colourists*, (Bradford: Society of Dyers and Colourists, 1934).

Rudkin, Linda, *Natural Dyes*, (London: A & C Black, 2007).

Rupp, Rebecca, 'Indigo: the Devil's Dye' *Early American Life*, 2010, pp.42–49.

Russell, Carol K., *The Tapestry Handbook*, (London: A&C Black, 1991).

Ryder, M., 'Medieval sheep and wool types', *The Agricultural History Review*, vol.32, part 1, 1984, pp.14–28.

Sandberg, Gösta, *Indigo Textiles: Technique and History*, (London: A&C Black, 1989).

Sandberg Gösta, *The Red Dyes: cochineal madder and murex purple a world tour of textile techniques*, (Asheville N. Carolina, USA: Lark Books, 1997).

Schaefer G., 'The cultivation of madder in Madder and Turkey Red', *Ciba Review*, vol.39, 1941, pp.1398–1432.

Schaeper, Thomas J., *Edward Bancroft: Scientist Author, Spy*, (New Haven: Yale University Press, 2011).

Schoeser, Mary, C. Weaver, M. Bolger & B. Patton Moss, *English Church Embroidery*, (London: Watts & Co. Ltd).

Schoeser, Mary, *Silk*, (New Haven: Yale University Press, 2007).

Schoeser, Mary, *World Textiles: a Concise History* (London: Thames & Hudson 2003).

Schoeser, Mary, 'Colonial North America (1700–1990s) in Jennifer Harris, *5000 Years of Textiles*, (London: British Museum Press, 1993).

Schoeser, Mary and Kathleen Dejardin, *French Textiles: From 1760 to the Present*, (London: Laurence King, 1991).

Scott, Philippa, *The Book of Silk*, (London: Thames and Hudson, 1993).

Scully, Kate, Debra Johnston Cobb, Colour Forecasting: science art of magic wand?', *Textiles*, vol.1, 2012, pp.8–10.

Selvedge Magazine, London, est. 2004.

Singer, Charles, *The earliest chemical industry: an essay in the historical relations of economics and technology illustrated from the alum trade*, (London: Folio Society, 1948).

Smith, Cyril S., John G. Hawthorne, *Mappae Clavicula: A Little Key to the World of Medieval Techniques (translated and annotated)* (Philadelphia: American Philosophical Society, 1974).

Smith, David, *The Dyer's Instructor: Comprising practical instructions in the art of dyeing silk, cotton, wool and worsted and woollen goods, containing nearly 800 receipts*, (Philadelphia: Henry Carey Baird, 1860).

Smith ,H.G., 'Guild emblems and their significance', *Ciba Review*, vol.13, 1938.

Sprat, Thomas, *History of the Royal Society*, (London: Royal Society, 1667).

Strathern, Paul, *Death in Florence: the Medici, Savonarola and the Battle for the Soul of the Renaissance City*, (London: Jonathan Cape, 2011).

Strobel de, Anna Maria, 'Weaving the Sistine Chapel Tapestries' in M. Evans, C. Browne, with Arnold Nesselrath, *Raphael Cartoons and Tapestries for the Sistine Chapel* (London: V&A Publishing, 2010) , pp.33–37.

Styles, John, *The Dress of the People: Everyday Fashion in Eighteenth Century England*, (New Haven: Yale University Press, 2007).

Styles, John, *Threads of Feeling*, (London: The Foundling Museum, 2010).

Symonds, Mary, Louisa Preece, *Needlework through the ages: a*

short survey of its development in decorative art with particular regard to its inspirational relationship with other methods of craftsmanship, (London: Hodder and Staughton, 1928).

Talier, Angelo Natal, *Dell'arte di tingere in filo, in seta, in cotone in lana e in pelle*, (1793).

Taranto, Enrique, Jorge Marí, *Argentine Textiles*, (Buenos Aires: Maizal Editions, 2003).

Tardieu, Ambrose, Z. Roussin, *Mémoire sur la Coralline et sur le danger que présente l'emploi de cette substance dans la teinture de certains vêtements*, (Paris, 1869).

Temkin, Ann, *Colour Chart: Reinventing Colour, 1950 to Today*, (New York: The Museum of Modern Art, 2008).

Thomson, Hugh, *Cochineal Red: Travels Through Ancient Peru*, (London: Weidenfeld and Nicolson, 2006).

Travis, Anthony S., *Colour Chemists* (London: Brent Schools and Industry Project, 1983).

Travis, Anthony S., *The Rainbow Makers: the Origins of the Synthetic Dyestuff Industry in Western Europe*, (Bethlehem: Lehigh University Press, 1993).

Tuchscherer, J.M. 'Colour consciousness', *Ciba Review*, 1973/4, pp.10–12.

Van Hattem, Mark, Mariska Pool, 'The Monotonousness of this Grey Uniform', *Textile History*, vol.41, no.1 [supplement], 2010, pp.66–82.

Van der Kleuren, B., *Steenkolen, een goumijn van kleuren*, (n.d.).

Van Stralen, Trudy, *Indigo, Madder and Marigold*, (Colorado, USA: Interweave Press, 1993).

Varichon, Anne, *Colors: what they mean and how to make them*, (New York: Abrams, 2006).

Varron, A., 'The Early History of Silk', *Ciba Review*, vol.11,1938.

Varron, A., 'Tapestry', *Ciba Review*, vol.5, 1938.

Varron, A., 'Silks of Lyons', *Ciba Review*, vol.6, 1938.

Varron, A., 'Paris Fashion Artists of the 18th century', *Ciba Review*, vol.25, 1939.

Vasari, Giorgio, tr. George Bull, [*A selection from*] *Lives of the Artist*, (London: Book Club Associates , 1979).

Vetterli, W.A., Indigo, *Ciba Review*, vol.85, 1951).

Vogelsang Eastwood, Gillian, 'The Arabs AD 600–1000' in David Jenkins (ed) *The Cambridge History of Western Textiles* (Cambridge: Cambridge University Press, 2003).

Walton Rogers, Penelope, 'Dyes and Dyeing' in David Jenkins (ed) *The Cambridge History of Western Textiles*, (Cambridge: Cambridge University Press, 2003).

Walton Rogers, Penelope, 'The Anglo Saxons and Vikings in Britain', in David Jenkins (ed) *The Cambridge History of Western Textiles*, (Cambridge: Cambridge University Press, 2003).

Wescher, H., 'Great Masters of Dyeing in 18th century France', *Ciba Review*, vol.18, 1939.

Wild, John Peter, 'The later Roman and Early Byzantine East 300–1000 in David Jenkins (ed), *The Cambridge History of Western Textiles*, (Cambridge: Cambridge University Press, 2003).

Wild, John Peter, 'The Eastern Mediterranean 323BC to 350AD' in David Jenkins (ed), *The Cambridge History of Western Textiles*, (Cambridge: Cambridge University Press, 2003).

Williams, Rhiannon, 'The Industrial Revolution 1780–1880' in Madeleine Ginsburg, *The Illustrated History of Textiles*, (London: Studio Editions),

Wilson, David, *The Bayeux Tapestry*, (London: Thames and Hudson, 1985).

Wilson, Ming, *Imperial Chinese Robes*, (London: V&A Publishing, 2010).

Wizingerm, R., 'Tannin black and logwood black', *Ciba Geigy Review*, vol.2, 1973.

Wouters, Jan, 'The Dye of Rubia peregrina I preliminary investigations', *Dyes in History and Archaeology* 16/17, pp.145–157.

Wouters, Jan, Ina Berghe Vanden,; Ghislaine Richard, René Breniaux & Dominique Cardon, 'Dye analysis of selected textiles from three Roman sites in the Eastern desert of Egypt: A hypothesis on the dyeing technology in Roman and Coptic Egypt', *Dyes in History and Archaeology*, vol.21, 2008, pp.1–16.

Yi, Eunjou, Eun Sook Yoo, 'A novel bioactive fabric dyed with unripe *Citrus grandis Osbeck* extract pt 1 dyeing properties and antimicrobial activity on cotton knit fabrics', *Textile Research Journal*, vol.80, no.20, 2010, pp.2117–2123.

Yi, Eunjou, Eun Sook Yoo, (2010) A novel bioactive fabric dyed with unripe *Citrus grandis Osbeck* extract pt 2 effects of the *Citrus* extract and dyed fabric on skin irritancy and atopic dermatitis in *Textile Research Journal*, vol.80, no.20, pp.2124–2131.

Ziderman, Irving, 'Revival of Biblical *Tekhelet* Dyeing with banded dye-murex, *Dyes in History and Archaeology*, vol.16/17, pp.87–90.

Zollinger, Heinrich, *Colour a Multidisciplinary Approach*, (Chichester: Wiley, 1999).

MANUSCRIPTS

Brigg & Sons Batley Pattern Books 1880–1882, KC73/4 & 5, West Yorkshire Archive Service, Kirklees.

Dye Recipe Book 1789–1844, KC313/13/2, West Yorkshire Archive Service, Kirklees.

Field, George, *Experiments Book 1 & 2*, (London: unpublished manuscript, 1805.)

Henry Day & Co Ledger 1885–1889, KC1024/27, West Yorkshire Archive Service, Kirklees.

Henry Day Sample Book 1897–1960, KC1024/79, West Yorkshire Archive Service, Kirklees.

Henry Day Sales Book 1848–1864 KC1024/43, West Yorkshire Archive Service, Kirklees.

Henry Day Stock Book 1930–1937, KC1024/133, West Yorkshire Archive Service, Kirklees.

Henry Day Notebook re blends 1926–1984, KC1024/109, West Yorkshire Archive Service, Kirklees.

Henry Day Recipe Books 1913–1921,1926–1937, KC1024/115, West Yorkshire Archive Service, Kirklees.

Henry Day Samples, KC1024/142 & 143, West Yorkshire Archive Service, Kirklees.

Henry Day Blend Book, 1944–1946, KC1024/100, West Yorkshire Archive Service, Kirklees.

Henry Day Blend Book 1968–1975, KC1024/108, West Yorkshire Archive Service, Kirklees.

Henry Day Blend Books 1917–1946, KC1024/91, West Yorkshire Archive Service, Kirklees.

Henry Day (Henry Cullingworth & Sons) Folder range of samples, KC1024/179, West Yorkshire Archive Service, Kirklees.

Holliday Dyes Patterns/Samples 1970s, WYK 1075/3/2/1, West Yorkshire Archive Service, Kirklees.

Hollidays Dyes Dye Recipes 1921–1970 2 vols, WYK 1075 3/1/2 & 3, West Yorkshire Archive Service, Kirklees.

Joseph Haigh Royds Hall Dyeing Book 1803–1845, West Yorkshire Archive Service, Kirklees.

John Blackburn Newling Mill 1852, KC197/42, West Yorkshire Archive Service, Kirklees.

Letter of Mr W Laming, 6 January, 1768, RSA Archive, London.

Letter from Thomas Giles, 30 December, 1767, RSA Archive, London.

Madder Certificates, 1767, RSA Archive, London.

1767 Tables of Figures for Madder Imported 1764–1767, PR.GE/110/25/30 RSA Archive, London.

ACTS AND STATUTES

'Close Rolls, Edward I, May 1281', *Calendar of Close Rolls, Edward I*, vol.2: 1279–1288, 1902, pp.120–126, British History Online, retrieved 18 November 2009, http://www.british-history.ac.uk/report.aspx?compid=112793&strquery=woad.

'Folios XCI – C: Aug 1344', *Calendar of letter-books of the city of London: F: 1337–1352*, 1904, pp.110–121, British History Online, http://www.british-history.ac.uk/report.aspx?compid=33537&strquery=dieghere>.

'Folios 131–140: 1433–34', *Calendar of letter-books of the city of London: K: Henry VI*, 1911, pp.172–182, British History Online, http://www.british-history.ac.uk/report.aspx?compid=33719&strquery=woad.

'Close Rolls, Edward III: June 1343', *Calendar of Close Rolls, Edward III: volume 7: 1343–1346*, 1904, pp.68–70British History Online, http://www.british-history.ac.uk/report.aspx?compid=100802&strquery=Philip Nhete 1343.

'Milan: 1459', *Calendar of State Papers and Manuscripts in the Archives and Collections of Milan: 1385–1618*, 1912, pp.19–21, British History Online, http://www.british-history.ac.uk/report.aspx?compid=92246&strquery=milan, genoa, woad.

Act 27, Richard III, Parliament Rolls of Medieval England, January 1484. Available at British History Online http://british-history.ac.uk/report.aspx?compid=116561.

Edict du Roy pour le Reformation, Police, Reiglement sur les façons & tainctures des draps, estamets sarges & autres étoffes de laine, qui se sont en ce Royaume avec 'état de ce quisera payé pour chacune piece desdicts draps, estamets & sarges, (Paris: 1571), reissued 1581 and subsequently.

Cecil Papers, 'Statute at Westminster Palace 4 February, 40 Elizabeth' 1598, *Calendar of the Cecil Papers in Hatfield House*, vol.8., 1598,pp.36–49, British History Online, retrieved 31 Dec 2011, http://www.british-history.ac.uk/report.aspx?compid=11727&strquery=indigo.

Edict du Roi, contenant prohibition et défence de l'usage de l'inde et Anil, et entree dans la Royaume (Paris, 15 April 1601).

Addenda James I, vol.39, Oct, 1608, *Calendar of State Papers Domestic*, Elizabeth Addenda 1580–1625, 872, pp.510–511, British History Online, retrieved 3 February 2012, http://www.british-history.ac.uk/report.aspx?compid=62006&strquery=logwood Elizabeth.

By the King Proclamation for preventing of deceipt used in the importing of madder, (1631 c112.h.3(i)) London.

Edict du Roy portant creation en tiltre d'office formé des offices de controlleurs, visiteurs, essayeurs des teintures des estoffes de laine, (Paris, May 1639).

An Act for the importing of Madder pure and unmixed (14/4/425, 1662) London. Charles II Statutes 1662 Journal of the House of Commons 27 Feb 1662 p.374, vol.8, 1660–1667, 1802, http://www.britishhistory.ac.uk.

Lettres Patentes: Statuts, ordonnances & reglemens que sa Majesté veut être observez par les marchands, maîtres teinturers en grand & bon teint des draps, serges & autres étofes de laine de toutes les ville & bourgs de son Royaume, (Paris, 1669).

Lettres Patentes: Instruction sur le debouilli des laines destinées à la Fabrique des Tapisseries, (Paris, 1737).

'It is as impossible to find madder without sand as wines without lees. The dyers that use the madder have means enough to make themselves amends upon such as sell it to them without this officer's help', from: 'Charles I – volume 229: Undated 1632', *Calendar of State Papers Domestic: Charles I, 1631–3*, 1862, pp.471–495, British History Online, retrieved 4 February 2012, http://www.british-history.ac.uk/report.aspx?compid=52183&strquery=George Bedford 1631, 1632.

An Act to encourage the Growth and Cultivation of Madder, in that Part of Great Britain called England, by ascertaining the Tithe thereof from: 'House of Lords Journal Volume 29: April 1758, 21-30', Journal of the House of Lords volume 29: 1756–1760 (1767–1830), pp.308–319. British History Online, 27 April 2011, http://www.british-history.ac.uk/report.aspx?compid=114450&strquery=1758 Act madder.

An act for vesting in Edward Bancroft, Director of Physic, the sole property of his invention of discovery of the use and application of certain vegetables for dyeing, staining, printing and painting certain valuable colours (1785).

WEBSITES

China Dyestuff industry report 2007–8, Business Wire, 10 October 2007, Business Wire, retrieved 31 December 2011, www.businesswire.researchandmarkets.com/reportsc71113.

Chronological list of the Acts of Charles I and Charles II, British History Online.

Catholic Encyclopaedia Online, New Advent, www.newadvent.org/cathen/04134a.htm/liturgicalcolours.

Clothworkers Company, *The Craft of the Clothworker*, The Clothworkers Company, (n.d.), retrieved 1 January 2012, http://www.clothworkers.co.uk/Textiles/Craft-of-Clothworking.aspx.

Gospel of Philip, Metalog.org, www.metalog.org/files/philip.html.

The Infancy Gospel of Thomas, section 37, IntraText, http://www.intratext.com/IXT/ENG0833/_PT.HTM

Discover Natural Fibres, International Year of Natural Fibres , 2009, retrieved 1 January 2012, ,http://www.naturalfibres2009.org.

Lesney, M.S., *Paints, Pigments and Dyes*, (n.d.), Enterprise of the Chemical Sciences, retrieved 20 December 2011, http://pubs.acs.org/supplement/chemchronicles2.

Maxwell Lyte H.C., 1902, *Close Rolls Edward I, 1281*, British History Online, retrieved 18 November 2009, www.british-history.ac.uk/report.aspx?compid=1127937strquery=woad.

NIIR (NPCS), 2011, *Dyes and Pigment intermediaries, acid dyes, basic dyes, dye intermediates* NIIR Project Consultancy Services, retrieved 31 December 2011: www.niir.org/projects/dye.

Parliament Rolls of Medieval England, January 1484, British History Online, retrieved 20 December 2011, www.british-history.ac.uk/report.aspx?compid=116561&strquery=Italiangoldwork.

'True Blue', The Phrase Finder, retrieved 20 January 2012, www.phrases.org.uk/meanings/true-blue.ht.

INDEX